FANTASTIC ILLUSTRATION AND DESIGN IN BRITAIN, 1850-1930

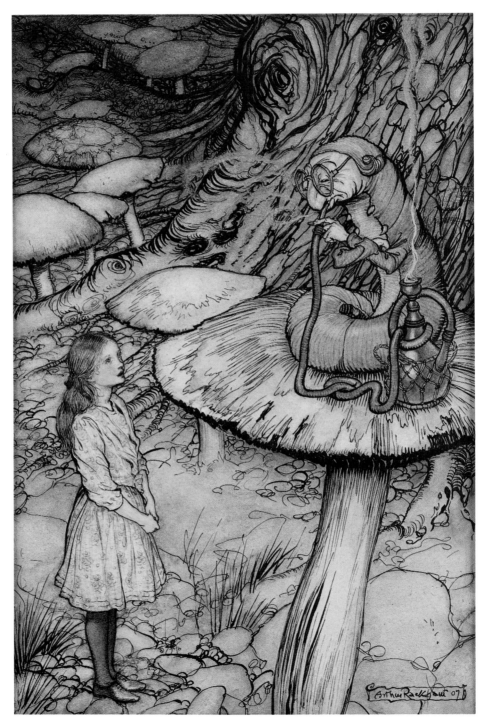

cat. no. 163 RACKHAM

Fantastic Illustration and Design in Britain, 1850-1930

BY DIANA L. JOHNSON

WITH AN ESSAY BY GEORGE P. LANDOW, BROWN UNIVERSITY

MUSEUM OF ART, RHODE ISLAND SCHOOL OF DESIGN

COOPER-HEWITT MUSEUM,
THE SMITHSONIAN INSTITUTION'S NATIONAL MUSEUM OF DESIGN

This project was supported by a grant from the National Endowment
for the Humanities in Washington, D.C., a Federal Agency.

The exhibition is supported by a Federal indemnity from the
Federal Council on the Arts and the Humanities

The Museum of Art receives partial support for its programs and activities through an
Institutional Support Grant from the Rhode Island State Council on the Arts.

Fantastic Illustration and Design in Britain, 1850-1930
Catalogue for exhibition, March 29 - May 13, 1979
at Museum of Art, Rhode Island School of Design;
June 5 - September 2, 1979 at Cooper-Hewitt Museum.

Also published as
Bulletin of Rhode Island School of Design
Museum Notes
Vol. 65, No. 5, April, 1979

Cover: cat. no. 76; Edward Julius Detmold,
"The Story of Baba Abdalla," *The Arabian Nights,* 1922.

Preface

In the spring of 1972, Mrs. Diana Johnson, then Associate Curator of Graphics at this Museum, organized a small exhibition of prints and drawings by British illustrators drawn from our collections. The exhibition concentrated on the late 19th and early 20th centuries, and a majority of the works were of fantastic or visionary subjects. The show was an instant success with such diverse members of our audience as students of literature and art, illustrators, draughtsmen, most children, and those adults who have maintained their delight in fantasy. The possibilities suggested by this brief glimpse into what was then relatively uncharted territory, combined with the enthusiastic response to the show, led to the idea of attempting a much more thorough investigation of both the illustrations and the social and literary climate in which they were conceived.

Unfortunately, other Museum priorities intervened, so that Mrs. Johnson could not follow through with her project until the autumn of 1975. At that time she invited Dr. George P. Landow, Professor of English at Brown University and a scholar of aesthetic theory and its concomitant art history, to participate in organizing a larger exhibition, which would focus on original drawings for fantasy illustrations and also include related material in the decorative arts. We applied to the National Endowment for the Humanities for a planning grant that would allow us to identify a central group of art objects of the highest quality. With the assistance of the grant Mrs. Johnson and Dr. Landow spent much of 1976 and 1977 in museum print cabinets and decorative arts storage, in libraries, and in private collections in the United States and in England, identifying and compiling the nucleus of material from which this show is drawn. The National Endowment for the Humanities awarded an implementation grant and the Cooper-Hewitt Museum (The Smithsonian Institution's National Museum of Design) agreed to participate in the exhibition.

It should be remembered that while this publication does function as a book on the subject of fantastic illustration, it is also the catalogue of an exhibition, its contents in part determined by what could be borrowed. In spite of this potential limitation, it is our hope that we have combined all of the best qualities of a "book" and a "catalogue" in this volume.

We are deeply grateful to Mrs. Diana Johnson, Chief Curator and Curator of Graphics at this Museum, for conceiving of the exhibition, insisting upon its being undertaken, and devoting so much of her time, her expertise, and her energy to the project; to Professor George P. Landow of Brown University, for his expert advice and information as Consultant in Literature and Art and for his cogent essay on the literary parallels; to the National Endowment for the Humanities, whose several grants made the exhibition and catalogue possible; to Ms. Lisa M. Taylor, Director of the Cooper-Hewitt Museum, New York, for agreeing to sponsor the exhibition at her institution; to the many people who shared their knowledge and love of the material with us; and to the collectors, museums and libraries who so generously placed their works of art in our care during the course of the exhibition.

Additionally, a number of people who became involved in the exhibition more deeply than would be expected in their guise of scholar, or collector, or lender, must be singled out for our special thanks. These include Anne Clarke, Albert Gallichan, Lionel Lambourne, Peter Rose, Peyton Skipwith, Clive Wainwright and Colin White in England; Michael Laurence Clarke, Betty and Rowland Elzea, Jay Fisher, William Larson, Clarence John Laughlin, John D. Merriam, Justin Schiller, Richard Vogler, Raymond Wapner and Charlotte and David Zeitlin in the United States. We must also thank the staff of the library, Rhode Island School of Design, under Mrs. Jeanne Borden; Karen T. Campbell, Valerie Hayden, Patricia Hurley and Jane Teschner of the Museum of Art; the staff of the Cooper-Hewitt Museum, especially Christian Rohlfing and Elaine Evans Dee; and the editors of the catalogue, Katrina H. Avery and Ruth M. Landow. Finally we should like to thank Malcolm Grear Designers, Inc., Providence, for the magnificent volume they have created.

These few lines are an insufficient expression of our gratitude and of our indebtedness to all those who participated in this project. We can only hope that the exhibition and the catalogue will serve as some reward for their sharing of information, ideas, enthusiasm and works of art.

Stephen E. Ostrow
Director
August 15, 1978

Acknowledgments

We would like to thank the following for granting permission to reproduce works on which they hold copyright: Mrs. Barbara Edwards (and Elgin Court Designs Limited, London) for the works of Arthur Rackham; Mr. Oliver Robinson for the drawings of William Heath Robinson; the Clarke family and the publishers George G. Harrap & Co., Ltd. (London) for the work of Harry Clarke; E. P. Dutton & Co., Inc. (New York), publishers, for the drawings of Ernest H. Shepard (from *Winnie-the-Pooh* by A. A. Milne, copyright 1926 by E. P. Dutton & Co.; renewed 1954 by A. A. Milne), and the publishers Hodder & Stoughton (London) for Arthur Rackham's "The Three Grey Women" from *A Wonder Book* by Nathaniel Hawthorne and Edward Julius Detmold's original illustrations for *The Arabian Nights*.

Lenders to the Exhibition

ANONYMOUS LENDERS

ASHMOLEAN MUSEUM, OXFORD

THE BALTIMORE MUSEUM OF ART

CITY MUSEUMS AND ART GALLERY, BIRMINGHAM

MUSEUM OF FINE ARTS, BOSTON

BOSTON PUBLIC LIBRARY

THE ROYAL PAVILION, ART GALLERY & MUSEUMS, BRIGHTON

CITY MUSEUM & ART GALLERY, BRISTOL

BRITISH MUSEUM, LONDON

MICHAEL LAURENCE CLARKE

RARE BOOK AND MANUSCRIPT LIBRARY, COLUMBIA UNIVERSITY, NEW YORK

MR. AND MRS. D. J. COOPER

COOPER-HEWITT MUSEUM, NEW YORK

DELAWARE ART MUSEUM, WILMINGTON

RICHARD DENNIS, LONDON

THE DETROIT INSTITUTE OF ARTS

THE FINE ART SOCIETY LTD., LONDON

FITZWILLIAM MUSEUM, CAMBRIDGE

FOGG ART MUSEUM, HARVARD UNIVERSITY, CAMBRIDGE, MASS.

THE FREE LIBRARY OF PHILADELPHIA

ALBERT GALLICHAN AND PETER ROSE

HENRY HAWLEY

MICHAEL HESELTINE

THE HOUGHTON LIBRARY, HARVARD UNIVERSITY, CAMBRIDGE, MASS.

ROBERT ISAACSON

LEO KAPLAN ANTIQUES, NEW YORK

KENNETH KENDALL

LIONEL LAMBOURNE

SYDNEY AND FRANCES LEWIS

THE LINDER COLLECTION (HOUSED AT THE NATIONAL BOOK LEAGUE, LONDON)

MACKLOWE GALLERY, NEW YORK

CITY OF MANCHESTER ART GALLERIES

JOHN D. MERRIAM

THE METROPOLITAN MUSEUM OF ART, NEW YORK

THE PIERPONT MORGAN LIBRARY, NEW YORK

THE NEW YORK PUBLIC LIBRARY

PHILADELPHIA MUSEUM OF ART

THE ART MUSEUM, PRINCETON UNIVERSITY

PRINCETON UNIVERSITY LIBRARY

LIBRARY OF THE RHODE ISLAND SCHOOL OF DESIGN, PROVIDENCE

MUSEUM OF ART, RHODE ISLAND SCHOOL OF DESIGN, PROVIDENCE

JUSTIN G. SCHILLER, LTD., NEW YORK

ERIC SILVER AND DR. GAIL EVRA

THE SOCIETY FOR PSYCHICAL RESEARCH AND THE MARY EVANS PICTURE LIBRARY, LONDON

SCOFIELD THAYER

ART GALLERY OF ONTARIO, TORONTO

VICTORIA AND ALBERT MUSEUM, LONDON

RICHARD VOGLER

MR. AND MRS. CLIVE WAINWRIGHT

WALKER ART GALLERY, LIVERPOOL

DRUSILLA AND COLIN WHITE

WOLVERHAMPTON ART GALLERY

YALE CENTER FOR BRITISH ART, NEW HAVEN

MR. AND MRS. DAVID E. ZEITLIN

HENRI ZERNER

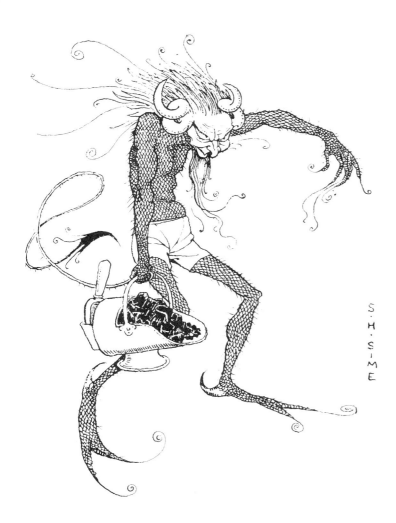

S.H.SIME

Fantastic Illustration and Design in Britain, 1850-1930

"And time and place are lost."
(Milton, *Paradise Lost*, II, 891)

Few periods in British history have presented as many paradoxical contrasts as the Victorian era: great public optimism versus much individual frustration and pessimism, expanding national wealth versus pockets of abysmal poverty, an increasing faith in the actual and potential benefits of science and industrialization versus what seemed to many to be an erosion of standards of workmanship and craft. Paralleling these socio-economic dichotomies were equally discernible contrasts within both the literature and the art of the period. Popular periodicals such as *Punch* and *The Illustrated London News*, in existence since 1841 and 1842 respectively, provided the opportunity for numerous illustrators to catalogue with wit and shrewd observation the cultural, social and political mores of Victoria's reign. Graphic artists like John Leech and his contemporaries and successors Charles Keene, George Du Maurier, Sir John Tenniel, Phil May and others who charted and often satirized the everyday reality of Victorian life, achieved just renown for their skillful reportage. But coexisting with these and similar recordings of reality were representations from a quite different and very rapidly developing tradition of illustration—that of fantasy.

In Britain during the second half of the nineteenth century and the early decades of the twentieth century, fantastic and visionary themes informed literature, illustration and design to a degree not equaled before or since. Alongside the pragmatic, apparently stable and productive efforts of daily life, and the cultural expressions to which they gave rise, was an amazing aesthetic and literary "counter-world." While overlapping in some respects the Symbolist movement in England and on the Continent, this period of intense concern with fantasy was far longer in duration and broader in scope.

This powerful current of fantasy, which found its purest and perhaps strongest artistic expression in book illustration but was by no means limited to that mode of representation, seems to have been fostered by a variety of circumstances. The growth of Empire had led to a fascination with the non-Western world as strong as its parallel in late eighteenth- and early nineteenth-century France, albeit generally finding in England a more fanciful and imaginative form of presentation. Concurrently, the demands of an increasingly complex and constantly changing urbanized society (by mid-century fully half of Britain's population lived in cities) placed pressures upon the rapidly developing middle class from which it was natural to seek escape, whether to an "exotic" shore or to some past or purified world of supposed grace and richness. Without overstating the degree to which Victorian society built its foundations upon restraint and repression, there is no doubt that a more than superficial concern with at least the outward signs of respectability frequently gave birth to its opposite in the form of creative flights of fancy and visions of phantoms which resulted in many extraordinary and unique pictorial inventions.

Fantastic and visionary subjects appeared in varied guise — from episodes drawn from Arthurian legends through the strangely delicate and simplified representations and verses of Kate Greenaway to scenes from Shakespeare, that master of transformations of all kinds. Figures that are half-flower and half-human, elves, fairies, genii, a plethora of assorted monsters, all the figures of Alice's Wonderland and many others populate this alternative existence, an existence generally far removed from daily realities. John Ruskin, the great Victorian critic of art and society, in praising the illustrations of Kate Greenaway, exclaimed, "And more wonderful still, — there are no gasworks! no waterworks, no mowing machines, no sewing machines, no telegraph poles, no vestige, in fact, of science, civilization, economical arrangements, or commercial enterprise!!!"[1]

Ruskin continued in this vein, but then, feeling the need to reconcile the imaginative faculty with his doctrinal views on truth to nature, noted again of Kate Greenaway's art:

> It is true that the combination or composition of things is not what you can see every day. You can't every day, for instance, see a baby thrown into a basket of roses; but when she has once pleasantly invented that arrangement for you, baby is as like baby, and rose as like rose, as she can possibly draw them and the fairy land she creates for you is not beyond the sky nor beneath the sea, but nigh you, even at your doors.[2]

Ruskin's predilection for realistic detail in imaginative or fanciful representations was certainly not accepted by every illustrator of fantasy during this period, but an insistence on precise and accurate detail in conjunction with an almost photographic rendering of subject matter was a concern shared by the artists of the mainstream dealing with subjects from everyday life and the more literary-minded Pre-Raphaelites. Thus, a fair number of artists had anticipated Ruskin's arguments, which encouraged the tendency to favor making undeniably palpable even that which was unreal. Whether an obviously fantastic or visionary subject

should be expressed through one stylistic mode or another is not a central issue here, but the manner of presentation can be very important when the subject itself is more neutral. The suppression of realism can be effected pictorially in diverse ways, most obviously perhaps through a manner rather opposed to that Greenaway used — that is, straightforward distortions in form, scale, or perspective. A concentration upon or superabundance of detail, an insistence on decorative patterning (an aspect of Kate Greenaway's work criticized by Ruskin), the juxtaposition of incongruous elements and the use of unexpected or jarring colors can also have the same effect.

To describe how a fantastic image is achieved is in part to suggest a definition of what is meant by the term "fantastic," in particular relation here to the illustration and design of the period under discussion. Dictionary definitions of the word, understandably vague, range from "odd or quaint" to "fanciful, grotesque and irrational." While it would be of questionable validity to attempt some singular, overriding definition of the term, neither is it acceptable to avoid the problem altogether on the assumption that everyone knows a fantastic picture or object when he sees one. There are degrees of fantasy in political and social caricature and in many allegorical representations as well, but in these cases the element of fantasy or unreality is generally neither the major motif nor the central intention of the image, and thus both caricature and allegory fall into a borderline category. Perhaps one comes closest to furthering an explanation or description rather than a definition by returning to the concept of a "counter-world" to reality where, to quote Milton, "time and place are lost." For, from the mid-nineteenth century to the period immediately following World War I, it was precisely the creation and description of such counter-worlds that became the major preoccupation of a wide range of artists, writers and designers, who, while not all English by birth or even by nationality, all produced their work in England or for the very receptive English market. The possibilities they drew forth from this illusionary domain were endless, but there are, nevertheless, recognizable and recurring themes or thematic groupings in both the art and the literature of the period. Examination of the artistic categories alone reveals a rather broad range of persistent themes: fairy paintings and illustrations, scenes derived from historical romance and legend, anthropomorphized representations of animals, horrific fantasies and the most familiar category, illustrations of exotic, folk or fairy tales. Richard Doyle's fairy illustrations, Dante Gabriel Rossetti's and Edward Burne-Jones' designs for historical romance, Beatrix Potter's animal actors, Harry Clarke's terrifying images after Poe and Arthur Rackham's illustrations of fairy and folk tales are well-known examples of their type, but they represent only the tip of what might be termed a fantastic iceberg.

Despite the renown of many of its practitioners, illustration in the fantastic mode has been largely ignored until quite recently by art historians and critics alike. Although

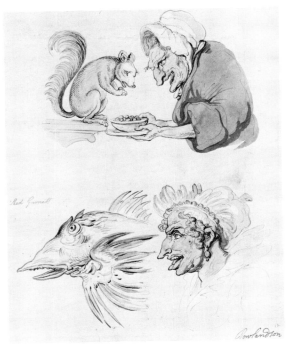

cat. no. 199 ROWLANDSON

there have always been occasional denials, illustration has generally been considered a rather secondary art. Fantastic subject matter has tended likewise to exist under a cloud, in part because it has become too easy to approach or categorize all such imaginative material by invoking Freudian revelations about the subconscious (however profound some of these comments might be). It has also been usual to assume in many cases that an artist's insistence on certain types of fantastic imagery resulted from a more or less personal obsession rather than trying to establish to what degree he was partaking of the illustrative tradition of a particular period. In any case, by attempting to chart the development of representations within the fantastic tradition informing British art from 1850 to 1930 it is our intention neither to present final answers to all the questions raised regarding this tradition nor to defend the reputations of the various individual artists. Suffice it to say that the quality of many of the works demands a reassessment of much earlier critical opinion, and a reexamination of these works in their role as alternatives to the so-called main-stream or "realist" tradition will make possible a clearer picture of the art of the entire period.

The manner in which the social and political climate in Britain during mid-century favored the emergence of fantastic representations has already been suggested. While much remains to be done in investigating the artistic sources in England in particular which fostered this tradition, several areas can be indicated. Caricature, already noted as balancing on the borderline of fantasy, immediately comes to mind. If, as several authors have recently asserted,[3] the second half of the nineteenth century and early decades of the twentieth may be considered the golden age of illustration in Britain, then the late eighteenth and early nineteenth century might be termed the golden age of English caricature. The comic portrayals by such artists as James Gillray, George Moutard Woodward, Isaac Cruikshank and, above all, Thomas Rowlandson exerted enormous influence on future generations of illustrators, as did the work of that great storyteller, William Hogarth. For example, Rowlandson's comparative anatomies (cat. no. 199), to some extent a humorous and popular equivalent of J. C. Lavater's physiognomic studies, helped to provide inspiration for later grotesque and anthropomorphic representations, although one of the most influential sources for this latter type of imagery appeared in France slightly later — J. J. Grandville's *Scènes de la vie privée et publique des animaux* (published in installments between 1840 and 1842). A comparison of Grandville's caricature of the "eloquent toad" (fig. 1) and Sir John Tenniel's "Frog-Footman" (cat. no. 218) from *Alice's Adventures in Wonderland* reveals the degree of indebtedness owed by British illustrators to their predecessor in France. Also of interest here is the fact that it was the caricaturist George Cruikshank, the famous son of Isaac Cruikshank, who illustrated the first translation into English of the fairy tales of the Brothers Grimm (cat. no. 60). His enchanting designs for this publication, which appeared in

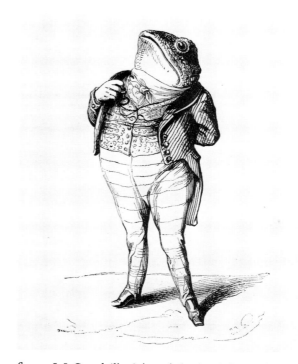

fig. 1 J. J. Grandville, *Scènes de la vie privée et publique des animaux*

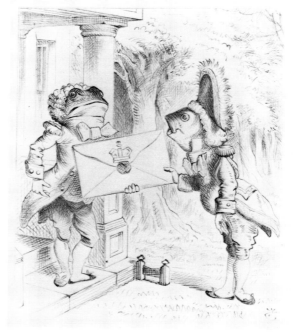

cat. no. 218 TENNIEL

cat. no. 60 CRUIKSHANK

two volumes during 1823 and 1824 under the title *German Popular Stories,* paved the way not only for his own later fanciful illustrations but for future fantasy illustrators as well. (Ruskin was so taken with these early etched illustrations that he compared Cruikshank's skill to Rembrandt's!)

Equally and perhaps more influential than caricature were eighteenth-century representations of horrific, sublime or visionary themes, a category of painting in some prominence towards the end of the century but still forming part of that great tradition of historical, allegorical and religious painting which Reynolds tried so valiantly to uphold in his *Discourses.* Reynolds' fellow Academician of the next generation, Henry Fuseli, was one of the most important masters of the horrific and the visionary, and his complex, provocative and disturbing paintings, such as those after Shakespeare and Milton, were highly significant works in what can be considered this precursor tradition. (Among the earliest prefigurations, in fact, of a genre which became important during the second half of the nineteenth century, that of fairy painting, is a 1784 drawing by one of Fuseli's pupils, William Locke, of several diminutive fairy-like figures playing about a candlestick.[4]) The sublime visions which pervade the profoundly mystical art of William Blake are also an obvious and very major influence. Blake's personal and inventive representations of the grotesque, the mythical and the divine, often appearing in the form of book illustration, directly inspired later artists from Rossetti and Burne-Jones to Walter Crane and Arthur Rackham. To the examples of Fuseli and Blake must be added John Martin's dramatically bizarre compositions both in painting and in mez-

zotint (cat. no. 139). Some of Martin's most fanciful works, in seeming paradox, appear to derive their imagery in part from the blast furnaces of the Industrial Revolution, an observation that has also been made in relation to Blake's literary and artistic visions. The imaginative conceptions of all three artists are important precursors to the later, generally less exalted expressions of enchantment and horror. A particularly charming piece of evidence linking the visionary tradition of Blake and Martin to fairy tale illustration, for example, is found in a design for *Jack and the Beanstalk* done around 1830, most probably by an inspired amateur artist with a certain *horror vacui* (cat. no. 2). On another level, Francis Danby's elegant watercolors from the 1830s for *A Midsummer Night's Dream* establish a link between the art of Blake and Martin and the fairy painting of the succeeding generations.

An example akin to that provided by the works of these and other eighteenth-century masters of the horrific and sublime was that which stemmed from those romantic and often compellingly mysterious representations associated with seventeenth-century Italian artists like Salvator Rosa. These came to England largely through the agency of John Hamilton Mortimer, an eighteenth-century painter whose own highly developed imagination and inventiveness made him an ideal intermediary. Mortimer, in addition to painting and drawing, also did illustrations to the works of such writers as Chaucer and Shakespeare. Many of the grotesqueries he derived from Rosa (cat. no. 147) had a classical reference consonant with the great revival of interest in the antique during the late eighteenth century, and dramatic

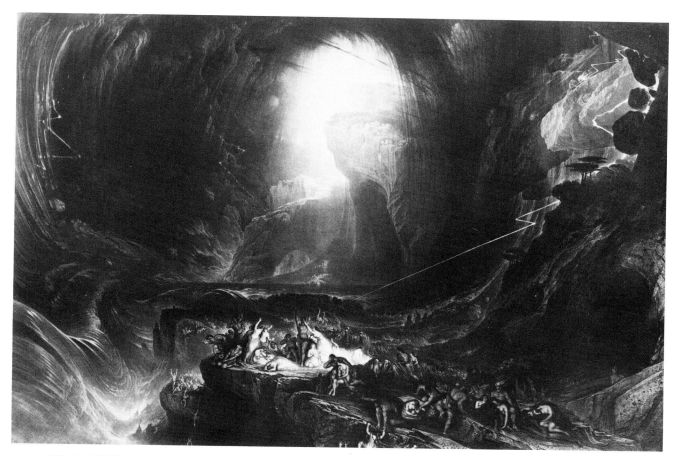

cat. no. 139 MARTIN

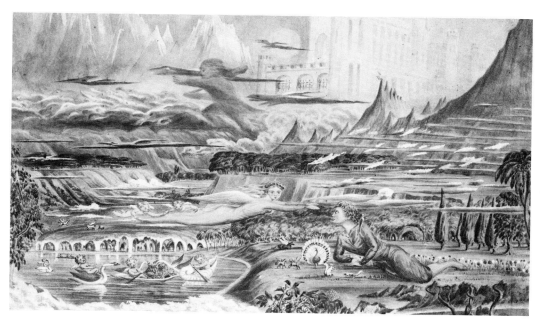

cat. no. 2 ANONYMOUS, BRITISH

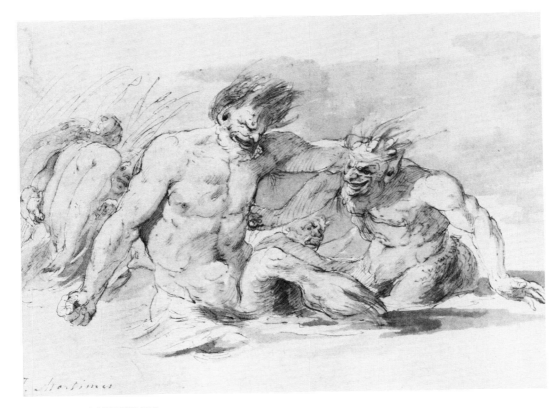

cat. no. 147 MORTIMER

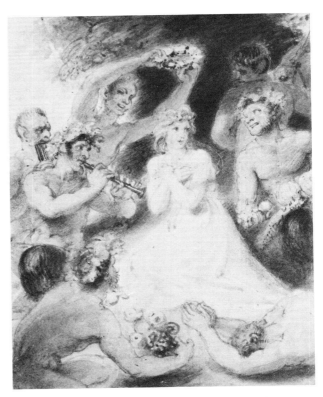

fig. 2 Thomas Stothard, "Una among the Fauns and Satyrs," *The Faerie Queene* by Edmund Spenser
The Pierpont Morgan Library, New York

mythological or quasi-mythological scenes by Mortimer, J.M.W. Turner and many other artists formed yet another fertile background to the later imaginative tradition.

From the foregoing, it can be seen that the most significant precursors to the fantastic tradition were by no means restricted to the narrow realm of eighteenth-century book illustrations *per se* in England. The graceful and delicate designs of two of the most important illustrators of fiction in the eighteenth century, Francis Hayman and Thomas Stothard, are typical of the work produced during the period and for the most part had less influence upon later fantastic portrayals than those sources previously noted. Stothard, for example, in illustrating Spenser's *The Faerie Queene* (fig. 2), tended to render the scenes with a pastoral charm rather than attempting to enhance possible fantasy elements.

Thus far we have not considered the audience for which fantasy illustrations and other works in the fantasy mode were primarily intended, that is, adults or children. Here again it is not possible to give a simple answer, for there are often no clear-cut boundaries between the two. As J. H. Plumb has pointed out in a recent essay on children's literature, "it should be remembered that fairy stories, ballads, riddles, and fables were intended as much for adults as for children."[5] It was not, in fact, until the mid-eighteenth century that a specialized literature for children began to develop in England. Many so-called children's stories have been adapted from works originally written for adults (for example, Aesop's *Fables* and *Gulliver's Travels)*, while much literature supposedly composed for children appeals at least as much, albeit on a different level, to adults (as in the case of *Alice's Adventures in Wonderland*). In attempting to pinpoint the intended audience, one could argue that volumes of nursery stories might be expected to attract few adults, while some of the fantastic novels of Arthur Machen, Lord Dunsany, and similar authors could be considered strong fare for children. But even in these cases a consideration outside the purely literary must be taken into account and that is the role played by illustration. As soon as illustrations became valued as a significant part of a book, the reception of these designs by the book-buying public often served as a major factor in determining the popularity of a particular edition with both children and adults alike, and the volumes illustrated by Arthur Rackham or Edmund Dulac provide excellent examples of the type of work which seems always to have had unlimited marketability. Relying upon the work or even merely the name of the illustrator to sell a book is generally considered to have begun in the 1860s. Publishers did not take long to realize that endless editions of favorite texts such as *The Arabian Nights* or compilations of Andersen's *Fairy Tales* would never lose their interest if the illustrations were sufficiently engaging. From another point of view, the artists themselves were generally glad of the opportunity to try their hand at illustrating a "classic," whether old (*A Midsummer Night's Dream, The Arabian Nights*) or new (again, *Alice's Adventures in Wonderland* or Charles Kingsley's *The Water-Babies*). In addition to Lewis Carroll himself and Sir John Tenniel, for example, more than a hundred artists took their turn at illustrating *Alice,* which undoubtedly establishes some sort of record.

In at least one important sense there was a very direct link between children's literature and fantasy. This had to do with ideas concerning the role and development of the faculty of imagination. Children's literature was at first intended to teach and inculcate various virtues and only much later did it come to be concerned with providing amusement for the child; even then the idea that some positive benefits should be gained from the volumes was never entirely lost. Thus there were on the one hand books which instructed the child and catalogued the marvels constantly unfolding in daily life and the new applications of the sciences and on the other, fabulous stories and tales which nourished the imagination. In contrast to the rationalist writers of the eighteenth century, nineteenth- and early twentieth-century critics and writers from Charles Lamb to Ruskin and G. K. Chesterton wrote about the importance of encouraging fantasy in children, but nowhere is the idea expressed in more delightful terms than in Richard Le Gallienne's report of an exchange between Oscar Wilde and Wilde's eldest son Cyril:

> "It is the duty of every father," he said with great gravity, "to write fairy tales for his children. But the mind of a child is a great mystery. It is incalculable, and who shall divine it, or bring to it his own peculiar delights? You humbly spread before it the treasures of your imagination, and they are as dross. For example, a day or two ago, Cyril yonder came to me with the question, 'Father, do you ever dream?' 'Why of course, my darling. It is the first duty of a gentleman to dream.' 'And what do you dream of?' asked Cyril, with a child's disgusting appetite for facts. Then I, believing, of course, that something picturesque would be expected of me, spoke of magnificent things: 'What do I dream of? Oh, I dream of dragons with gold and silver scales, and scarlet things coming out of their mouths, of eagles with eyes made of diamonds that can see over the whole world at once, of lions with yellow manes, and voices like thunder, of elephants with little houses on their backs, and tigers and zebras with barred and spotted coats . . .' So I laboured on with my fancy, til, observing that Cyril was entirely unimpressed, and indeed quite undisguisedly bored, I came to a humiliating stop, and, turning to my son there, I said: 'But tell me, what do you dream of, Cyril?' His answer was like a divine revelation: 'I dream of *pigs*,' he said."[6]

Despite Wilde's rather tongue-in-cheek despair over his son's apparent lack of imagination, most children fall prey to fantasy literature at an early age and never forget that counter-world they first discover in childhood. The memories are often intense, and not always pleasant. Kenneth Clark, in the first volume of his autobiography, spoke of his fondness for the Golliwogg stories and that "staple fare of Edwardian children — Beatrix Potter," but most fairy tales unnerved him. It was more than the stories which frightened

him, however, and he made a most apposite comment upon the impact of illustrations:

> Perhaps there are some less alarming stories in Grimm, but I did not dare to open them on account of Arthur Rackham's illustrations. This quiet, gentle man of genius certainly had a vein of *schadenfreude* (what is now misleadingly described as sadism) and took an intense delight in scraggy fingers. I sometimes caught sight of his drawings, before I was on my guard, and they stamped on my imagination images of terror that troubled me for years. Many people told me that they had the same experience as children. I wonder if anyone ever told Rackham.[7]

Quite possibly the best general advice, appropriate to young and old alike, was given by Charles Dickens in his oft-quoted statement from an 1853 issue of *Household Words:* "In an utilitarian age, of all other times, it is a matter of grave importance that Fairy tales should be respected."[8] This edict finds its modern echo in far more clinical terminology in the recent book *The Uses of Enchantment* by the psychologist Bruno Bettelheim:

> Through the centuries (if not millennia) during which, in their retelling, fairy tales became ever more refined, they came to convey at the same time overt and covert meanings—came to speak simultaneously to all levels of the human personality, communicating in a manner which reaches the uneducated mind of the child as well as that of the sophisticated adult. Applying the psychoanalytic model of the human personality, fairy tales carry important messages to the conscious, the preconscious and the unconscious mind, on whatever level each is functioning at the time.[9]

(Bettelheim, nevertheless, rejects the "other half" of the fairy tales, that is the illustrations, as interfering with the reader's personal and unconscious understanding of the imagery of the stories themselves.)

Fairy tales, as already noted, are but one category among the several through which fantasy was expressed, but before turning to a closer examination of the varied fantastic themes in both illustration and design, some mention should be made of the general manner in which fantasy images were created, reproduced and presented to the public. Although fairy pictures tended to form almost an independent category often represented by individual paintings or drawings of fairy subjects, the majority of fantasy images appeared most consistently through the familiar channels of periodicals and books. Early in the nineteenth century etching, used to great advantage by such artists as George Cruikshank, was still highly favored as a reproductive technique, but by mid-century etching and engraving (usually on steel) and to a lesser extent lithography had given way to wood engraving. The artist would draw his design upon a boxwood block, but generally left the engraving itself, that is the cutting away of the areas not to be printed, to a skilled technician. Several of these "technicians" received their own share of fame, with the Dalziel family at the top of this list.[10] The Dalziels' early engraving technique, such as that seen in Moxon's *Tennyson* of 1857, effectively rendered the combination of precise description and expressive chiaroscuro initiated by the Pre-Raphaelite illustrators, as opposed to the quicker, bolder strokes and rather simple contrasts required of them later in the century. Electrotypes were frequently made of the engraved blocks and the actual printing was done from these rather than from the blocks themselves. (This method was used for Tenniel's famous engraved illustrations to *Alice's Adventures in Wonderland,* for example.)

Although most early engraved illustrations were in black and white, it was possible to print in color using multiple blocks, and it was the skillful management of just this complex technique which gained the well-known printer Edmund Evans his reputation. Many of the popular successes of the great triumvirate Walter Crane, Kate Greenaway and Randolph Caldecott are counted among his productions. Another technique for printing in colors, chromolithography, was used for both decorative "illumination" and illustration during this period, but it was not until towards the end of the century that wood engraving was superseded by other, less laborious methods of reproduction.

By the 1860s photography had begun to play an important role in the production of the illustrated book. The artist no longer had to draw directly upon the woodblock with the consequent loss of his original drawing during the cutting; rather it became possible to reproduce the drawing upon the block photographically, and thus to save the original for reference or future use.

In the following decade another major change took place with the general introduction of the photographic line block, first developed as early as the 1850s. Whereas wood engraving had allowed the engraver a rather free hand in interpreting the artist's drawing or its photographically reproduced image, the use of photoengraved zinc line blocks or "process," as the technique came to be called, took this power away from the engraver and more or less returned the image to the artist. The process method of photomechanical reproduction, firmly established by the 1880s, insured that the artist's drawing could be reproduced with complete fidelity to the original, blemishes and all. However, in order to obtain the clearest and cleanest images, process engravers preferred the illustrators to emphasize contrasts by drawing in black India ink on white board. In addition, to enhance further the quality of the printed work, the artists would draw their designs one and a half times larger than they were eventually to appear in print, instead of to size as they had generally done for wood engraving. Thus the earlier tyranny of the wood engraver was replaced to some extent by the tyranny of the process engraver, although the most inventive artists were more than able to accommodate themselves to the demands of the technique. Aubrey Beardsley, for example, turned these possible drawbacks into advantages, with many of his bold yet elegant drawings finding perfect expression through process engraving.

During this same period, half-tone screens came into use to reproduce tonal drawings, and photogravure was employed for both illustration and the creation of numerous reproductive prints after paintings. The equivalent of half-tone printing in color, generally referred to as three-color or trichromatic printing, while practiced in England during the '90s, did not come into widespread use until after the turn of the century. Most of Beatrix Potter's and Arthur Rackham's illustrations were produced by the trichromatic process and some illustrations, like many of Edmund Dulac's, were printed in four colors. Once the economic and technical problems of printing in tones and colors by photomechanical means had been overcome, the revolution in the production of illustrated books and periodicals was complete. This development also meant that artists could now conceive of their illustrations more in terms of painting rather than being tied to a more linear mode of expression.

The ease and accuracy of photomechanical reproduction led to a proliferation of new magazines and publishing ventures aimed at the ever-growing middle-class and upper-middle-class market. *Pick-me-up* appeared in 1888, *The Idler* in 1892, *The Sketch* in 1893, *The Savoy* and *The Pageant* in 1896, and *Eureka* in 1897, to name just a few of the many and varied periodicals and papers. The pages of these new arrivals were soon filled with the imaginative drawings of Beardsley, Heath Robinson, Sidney Sime and numerous other inventors of fantasy.

At the same time, there was a counter-movement to re-establish the art of fine printing, explore the expressive possibilities of wood engraving and other reproductive techniques, and revive the medieval ideal of the book as a beautiful totality. This had developed to some extent from the intimate relationship between literature and art which was so much at the heart of the Pre-Raphaelite movement, but it was also part of the artist-craftsman's revolt against the feared over-mechanization of any art form. The best-known of the leaders in this struggle was William Morris, whose interest in fine books began during his student days at Oxford and ended with the founding of the Kelmscott Press which began operation at Hammersmith in 1891. Also in the vanguard of this movement were the devoted friends and collaborators, Charles Ricketts and Charles Shannon. Ricketts' book *A Defence of the Revival of Printing* (1899) documented their cause, while their artistic ideals were realized in part through *The Dial*, a periodical they founded in 1889, and the publications of their own firm, The Vale Press (1896-1904), although neither Shannon nor Ricketts shunned involvement with commercial publishers.

The eventual commercial response, or more accurately commercial parallel, to this craftsmanly revival came after the turn of the century. By that time the high level of technical excellence maintained by the best publishers and color printers had paved the way for another sort of revival, that of the deluxe gift book. The foremost illustrators of the 1860s had been commissioned to design engraved plates for elegant and elaborate volumes which were by no means intended for the nursery. A similar situation prevailed with the commercial revival of the gift book trade in the early 1900s. Tiny fingers were not meant to touch the gilt-stamped fine bindings (often vellum) or the tipped-in color plates of the typical gift book of the period, but less expensive trade editions of the volumes were generally available for younger readers and those who did not wish to invest in the deluxe versions.

With the successful development of full color printing, the possibilities for expressing fantastic themes seemed infinite. Although Arthur Rackham's earliest designs were in black and white and he never lost his graphic facility with line, there is no doubt that his reputation rests largely on his beautifully subtle color-plate books[11]—from the early *Peter Pan in Kensington Gardens* and *Alice's Adventures in Wonderland* to the posthumously published *The Wind in the Willows*. As the center of color-book production, London became a mecca for illustrators of fantasy during the early decades of the twentieth century. Rackham and his English colleagues shared the healthy market for fantasy literature with a fair number of foreign-born artists, among them Edmund Dulac, Kay Nielsen and the elusive Alastair, and it was not until the economic and political upheavals of World War I followed by those of the Great Depression that these prospects changed radically.

Important as the revolution in printing undoubtedly was, printing techniques are never a determining factor in choice of subject matter (although they obviously could influence the manner in which subjects were presented). The intense concern with fantastic imagery endured for a relatively long period of time and cut across not only technical boundaries but stylistic boundaries as well. In the arts the period under discussion was one of great eclecticism, in some respects quite similar to our own, and a variety of influences and styles coexisted in relative harmony. It is possible to identify significant expressions of fantasy within most of the major movements, whether Pre-Raphaelite, Art Nouveau, Aesthetic Movement, Arts and Crafts or Art Deco. The sources and influences which lay behind fantastic and visionary representations (aside from those already noted as forming part of a "precursor tradition") were likewise extremely diverse.

Whistler is known to have made "frequent jibes at the story-telling motive in English art,"[12] and many other critics concurred with his observation if not with his rather negative assessment. Literature and art in Britain were closely aligned throughout the nineteenth century, and in many cases a successful literary effort helped to renew or further stimulate a related effort in the arts. Thus Sir Richard Francis Burton's definitive translation of *The Arabian Nights* and Edward Fitzgerald's translation of *The Rubaiyat of Omar Khayyam* helped to quicken the existing interest in Eastern art forms, and William Butler Yeats' *The Wanderings of Oisin* and *The Celtic Twilight* did much the same for Celtic art. Moreover, it is clear that many of the same influences affected both literary and artistic expression. The

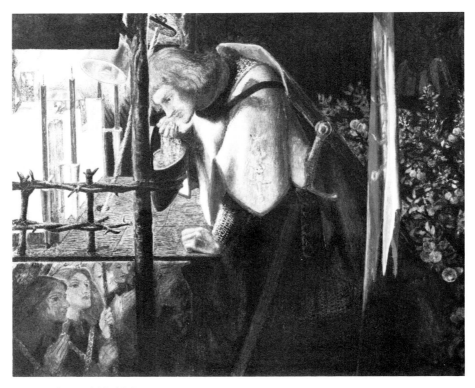

cat. no. 196 ROSSETTI

most influential currents will be classified here under the headings of revivalism, exoticism and spiritualism, although none of these admittedly oversimplified categories are mutually exclusive.

One cannot speak of revivalism in nineteenth-century England without mentioning first Horace Walpole, whose novel *The Castle of Otranto* (1764) and remarkable "Gothick castle" at Strawberry Hill did so much to usher in the Gothic revival movement in both literature and the arts. Later artists, from George Cruikshank to Burne-Jones and from Augustus Welby Pugin to his follower, the designer William Burges, owed much to the example of Walpole and Walpole's equally eccentric contemporary William Beckford. In his enthusiasm for the Middle Ages Burges, in fact, might appropriately be regarded as the Walpole or Beckford of the later nineteenth century. His antiquarian interests went a good deal further back in time than the Gothic period, however, and included the arts of non-Western cultures as well. Even his intense commitment to the Gothic revival extended to a more general "medievalism" (which included wearing medieval costume at home), and in this he was not alone. The romantic conceptions which Tennyson sought to convey through literature the Pre-Raphaelites expressed primarily through art and design. Rossetti, Burne-Jones and William Morris, for example, in their individual approaches to Arthurian romance, historical legend and medieval methods of facture were, like Burges, involved in the aesthetic investigation and to some extent recreation of an earlier literary and artistic world which would always be beyond their grasp and could therefore be considered an ideal. This in itself is a form of make-believe (if not always the degree of play-acting indulged in by Burges), but the results of their endeavors varied in the extent to which they might be termed fantastic. The Pre-Raphaelite approach to history was both romantic and symbolistic; it was history translated through myth and legend rather than a coherent attempt at rigid objectivity, and thus could be turned into a fertile source for fantasy. But while the potential for fantasy was there, both Rossetti and Burne-Jones often produced images which in their straightforward presentation and historicity do not suggest that sense of unreality which characterizes fantasy. Pre-Raphaelite "revivalism" is in many ways on a difficult borderline of the fantastic tradition where the relevance of individual examples can be argued. In a work like "Sir Galahad at the Ruined Chapel" (cat. no. 196), Rossetti has portrayed a subject which in a more neutral presentation would not necessarily be considered fantastic, but by pressing the scene so close to the foreground, distorting the sense of space and heightening the disturbing qualities of the image through the use of intense, jarring colors he has gone beyond a straightforward albeit romantic portrayal of a literary-historical moment and created an image which can properly be viewed as within the fantasy tradition.

The Pre-Raphaelite interest in stained glass was another aspect of medieval revivalism, as was the more general interest in manuscript illumination. Medieval manuscripts provided both a repertoire of decorative and ornamental motifs and also the splendid example of marginal grotesques, which Richard Doyle, Arthur Rackham and many other illustrators were quick to turn to their own uses.

Similarly, Celtic manuscripts served as inspiration for the entire Glasgow School, whose geometrically stylized and fanciful form of Art Nouveau derived its controlled linear patterns in part from this early source. Like Celtic literature, Celtic art had both historical and mystical connotations in addition to being a highly developed source of ornamental designs. The impact of the Celtic revival was particularly strong in the decorative arts and appeared in the work of numerous goldsmiths and jewelers, in the metalwork and ceramics of designers like Dr. Christopher Dresser, and, on a more popular level, in the "Barum Ware" and "Cymric" designs of Liberty & Company.

A straightforward and uncomplicated type of revivalism is found in varying degrees in the work of artists like Randolph Caldecott, Walter Crane and Kate Greenaway. All three borrowed from England's past to create their charming and safe imaginary worlds. Kate Greenaway's magical realms were the most consistent. These miniature kingdoms are populated by graceful, angelic children dressed in a manner reminiscent of the early nineteenth century; the houses are delightful seventeenth- and eighteenth-century cottages with gardens that fancifully combine earlier styles from the medieval to the eighteenth-century.

In contrast to the Medieval revival, the Renaissance revival of the nineteenth century was a somewhat less coherent and less readily identifiable phenomenon; its borrowings from the past were more piecemeal, but appeared with some frequency and still formed part of a common stock of inspiration. Renaissance woodcuts and engravings, for example, served as something of a bible for nineteenth-century illustrators in black and white, but the lessons these artists learned from Dürer and the early Italians like Giulio Campagnola had more far-reaching effects than merely providing a manual of style for translation into wood engraving. Various motifs, both figural and ornamental, were borrowed as well. Dürer's figure of Melancholia reappeared in the guise of numerous Pre-Raphaelite contemplative maidens, his engraving of "The Knight, Death and the Devil" went through endless transformations, and Walter Crane's *King Gab and his Story Bag* (1869) was actually advertised as having "Illustrations after Albert Durer."[13] Renaissance art did function, of course, as a more general source, from the Pre-Raphaelite response to Quattrocento and early Cinquecento painting, to the "neo-Renaissance" book illustrations and jewelry designs of Charles Ricketts and the transmutations of Bosch and Breughel by artists like Jean de Bosschère and John Anster Fitzgerald. Classical art, whether directly or indirectly through a Renaissance intermediary, was put to similar use and many of the most successful borrowings were whimsical translations of nymphs and putti such as those found on the porcelains of Marc Louis Solon (cat. no. 215). One of the most extreme forms of antique revivalism appeared not in the decorative arts or book illustrations, but in the "Roman" revival paintings of artists like Sir Lawrence Alma-Tadema, whose home was more or less a Roman villa, Victorian style.

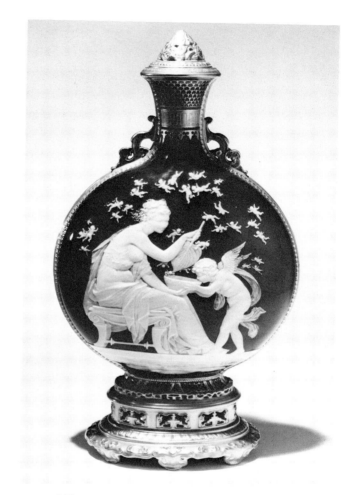

cat. no. 215 SOLON

cat. no. 69　DE MORGAN

Equally as significant as revivalism were the assorted influences, primarily Eastern, which can be included under the heading of exoticism. The term "Eastern" must be taken broadly to refer to both Far Eastern and Middle Eastern styles. The impact of oriental art, particularly that of Japan, was profound. The eighteenth-century love of chinoiserie had been exceptionally strong in England and persisted well into the nineteenth century, paving the way for the "Japonisme" of the later nineteenth century. Although until quite recently it was thought that significant English contact with Japanese art began with the Great International Exhibition of 1862, Japanese prints were, in fact, shown in London at the Great Exhibition of 1851. Three years later a large exhibition of Japanese porcelain and lacquer was held at the Old Water-Colour Society. William Burges is again a central figure in this context and is known to have had by the late 1850s a collection of Japanese prints which included eighteenth- as well as nineteenth-century examples. When Whistler arrived in London in 1859, he had already formed his own collection of eighteenth-century Japanese prints, and his Japonisme played an important role in reinforcing the English taste for oriental art. At first, Japanese and Chinese styles were at times confused with one another (as in Owen Jones' *The Grammar of Ornament*, 1856) or melded into a composite "exotic" style. As more and more Far Eastern, Middle Eastern and Indian goods entered England, and merchants such as Farmer and Rogers whetted the middle-class appetite for these items in their Great Cloak and Shawl Emporium with its Oriental Warehouse next door, a more sophisticated awareness of the various styles emerged. Major displays of Japanese art were included in the Paris Expositions Universelles in the late '60s and in the London International Exhibition of 1871. This led to what might be considered a second phase of Japonisme, which coincided with and formed an integral part of the so-called Aesthetic Movement that captured English taste from the mid-1860s until almost the turn of the century.[14]

Artists and designers were among the most sensitive to the imaginative possibilities suggested by non-Western art forms, whether Indian, Persian, Arabian, Chinese or Japanese, and in contrast to their brethren in France, rarely used exotic styles in support of realism. After Walter Crane had been given a book of Japanese prints in 1867 by a naval officer, he soon began to infuse his own book designs with translations from the clearly outlined, flattened forms and decorative patterns found in Japanese art. The Martin Brothers' fascination with Far Eastern art was allied with their interest in the Gothic and both influences are reflected in such elements as the earth colors, glazes and incised linear designs found in their ceramic grotesqueries. The "Persian" (often early Syrian) designs of William De Morgan (cat. no. 69) found numerous parallels in equally fanciful illustrations, such as those by Edmund Dulac, who was extremely knowledgeable about and constantly drew upon Persian and Indian miniatures both as a general source of inspiration and as a repertoire of stylistic motifs. Dulac, Edward Det-

cat. no. 93 DULAC

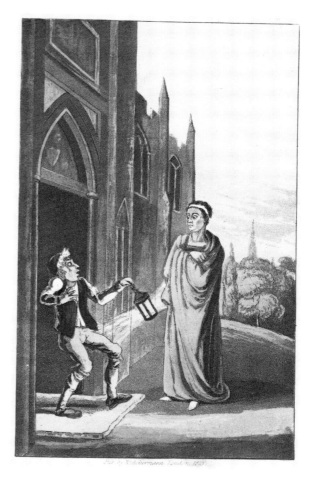

cat. no. 1 ANONYMOUS, BRITISH

fig. 3 "Frances and the Leaping Fairy," *Fairies, The Cottingley Photographs and Their Sequel* by Edward L. Gardner
The Theosophical Publishing House Ltd.

mold, Charles Robinson, Thomas Mackenzie and many other color-book illustrators active during the early decades of the twentieth century delighted in illustrating stories like those from *The Arabian Nights* in which the subject matter coincided with their penchant for the rich colors and lush designs of non-Western art. But the coincidence of subject matter and style was by no means a necessity and their "exoticism" was extremely eclectic. Dulac, for example, in his illustrations to Nathaniel Hawthorne's *Tanglewood Tales* combined stylistic borrowings from Greek vase painting, Persian miniatures and Far Eastern art to create a rather successful and intriguing hybrid style (cat. no. 93).

A world even farther removed from daily life in England than that of the East or even that of the legendary historical past was the incorporeal world of the spirit, filled with strange thoughts, phantasmagoric visions, and echoes of the supernatural. During the first half of the nineteenth century literary investigations of topics like the nature of the afterlife or the existence of demons, spirits and ghosts were not lacking. These discussions varied in their degree of seriousness. One of these offerings, bearing the title *Ghost-Stories; collected with a particular view to counteract the vulgar belief in ghosts and apparitions . . .*, by an unnamed author and published by Rudolph Ackermann in 1823, contained a series of illustrations which recorded in precise terms the supposed manifestations of certain notable ghosts (cat. no. 1). It is hard to imagine a portrayal further removed from Blake's poetic visions, yet the concern with nonrational experience, although not the same point of view, is common to both.

Around mid-century the arrival in England of several well-known mediums from America gave great impetus to the spiritualist movement. Seances and similar attempts to reach beyond generally observable reality became a fashionable craze for some, but to others investigations of the occult were taken with utmost seriousness. Among the members of the Society for Psychical Research in London, for example, were a bishop and several university dons; Andrew Lang, editor of the Coloured Fairy Books, was one of the Society's founders. Sir Arthur Conan Doyle's interest in psychic phenomena is also well known. As late as 1922 he published *The Coming of the Fairies* and *The Case for Spirit Photography*. These volumes supplemented his article on fairies and fairy lore in *The Strand Magazine* for December of 1920, in which he also supported the validity of a series of photographs of the so-called Cottingley Fairies (fig. 3). This interest in spiritualism and psychic science can be viewed in counterpoint to the burgeoning interest in Freudian psychology during the same period.

It is perhaps not generally known that Conan Doyle was the son of Charles Doyle, an amateur illustrator of fairy subjects (fig. 4), and the nephew of Richard Doyle, fairy painter *extraordinaire*. Richard Doyle's designs for William Allingham's poem *In Fairyland* (1870), which were published nearly two decades after his fanciful images for Ruskin's *The King of the Golden River*, are among the quin-

fig. 4 Charles Doyle, "Fairyland or Fairy Pages"
Henry E. Huntington Library and Art Gallery, San
Marino

tessential fairy illustrations. They not only influenced later illustrators, but were themselves the inspiration for Andrew Lang's fairy story *The Princess Nobody,* which was published in 1884, accompanied by the original Doyle illustrations from *In Fairyland.*

Doyle was certainly not the first artist to gain a reputation as a painter of fairy subjects, and this genre of fantasy, which expressed in visual terms an aspect of the general interest in the unseen and nonrational, is now recognized as a uniquely Victorian contribution to the history of British art.[15] While fairy themes had been of some interest to a small number of artists and illustrators prior to 1850, among them Fuseli, Thomas Stothard and Francis Danby, during the second half of the century fairy painting became a major artistic preoccupation. Just as *The Arabian Nights* and *The Rubaiyat of Omar Khayyam* had provided a fertile source of subject matter and inspiration for exotic illustrations and designs, so did Shakespeare's *The Tempest* and *A Midsummer Night's Dream,* Spenser's *The Faerie Queene* and the fairy tales of the Brothers Grimm, Hans Christian Andersen and Charles Perrault serve as vital literary references for fairy subjects. Later sources included Sir James Barrie's *Peter Pan* (1904) and Maurice Maeterlinck's *The Blue Bird* (1908). Although in some instances the need to express these themes might have come primarily from the emotional imbalance of the artist, as was the case with Richard Dadd and perhaps John Anster Fitzgerald, most of the artists were making a positive response to the widespread popularity of such subjects. Sir Joseph Noël Paton, Rossetti's great friend the painter and poet William Bell

Scott, Arthur Hughes and Sir John Everett Millais were among the well-known artists who painted fairy pictures, although their degree of commitment to the genre varied. The number of illustrators who depicted fairy subjects was legion, however, and long after fairy painting had declined in popularity (by the last decades of the nineteenth century), fairy themes still persisted in book illustrations. *A Midsummer Night's Dream* was illustrated by Robert Anning Bell in 1895, for example, by William Heath Robinson in 1914 and by Arthur Rackham in 1908, 1929 and 1939.

Book illustrations and other two-dimensional art forms in their capacity to create illusion are natural outlets for the expression of fantasy. In addition, an illustrated book is generally a very private object, indulged in by one reader at a time, and thus provides an ideal mode in which to reveal some phantasmagoric vision or flight of fancy. Yet when the interest in fantasy becomes as generalized as it did during the Victorian and Edwardian periods, one can expect fantastic subject matter to pervade all the arts, and this is precisely what occurred. Fantasy was expressed in the decorative and applied arts in everything from single objects intended to adorn a tabletop to the interior decoration of an entire house. In this latter case, there was in essence an attempt to create an actual "counter-world" in the midst of more mundane reality. William Burges designed two remarkable private fantasy worlds for the Marquis of Bute, one at Cardiff Castle and one at Castell Coch. Both castles were characterized by a bold emphasis on exaggerated architectural elements, highly ornamented surfaces and fanciful figural decorations of every conceivable type — as if

24

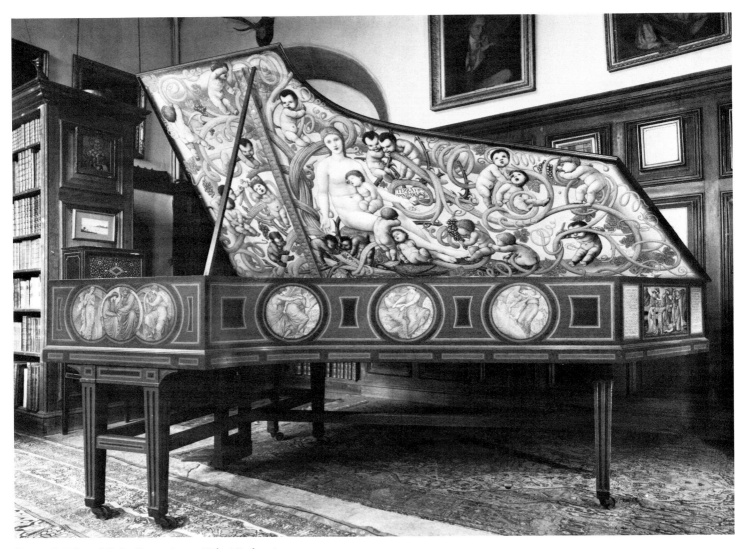

fig. 5 Sir Edward Coley Burne-Jones, "The 'Graham'
Piano"
The Earl of Oxford and Asquith

fig. 6 Sir Edward Coley Burne-Jones, "The 'Graham'
Piano," detail
The Earl of Oxford and Asquith

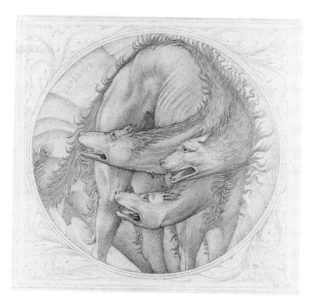

cat. no. 30 BURNE-JONES

myths or legends had been brought to life. The two castles, in fact, "stand out among all the Victorian fancy-dress country houses in having been conceived from the first as places of dream."[16] Burges' own house in London, on Melbury Road, was, if possible, an even more fabulous imaginary world and, like Alma-Tadema's "Roman villa" and Lord Leighton's "Moorish palace," represented the height of aesthetic make-believe.

While such elaborate fantasy worlds were within the reach of very few, individual objects of fantastic design, whether primarily utilitarian or purely ornamental and decorative, were extremely popular and fed the great public appetite for exotic and unusual wares. Least interesting are those decorative objects which were merely extensions of popularized imagery taken over directly from book illustrations, as in the case of the many tiles printed with transfer designs borrowed quite literally from illustrations by such artists as Kate Greenaway or Walter Crane. Most objects were more imaginatively conceived, however, and most of Crane's own designs for tiles, for example, cannot be considered mere pastiches of images first expressed in another medium.

Perhaps no more fascinating example exists of the storytelling motive applied to the decorative arts than the painted or "illustrated" furniture of the Victorian period. The Pre-Raphaelite painters, in particular, as part of their commitment to the revival of medieval art forms, developed a great interest in painted furniture, which, leaving aside eighteenth-century "japanned" examples, had not been an important feature of European interior design since the late Middle Ages. Burne-Jones painted and decorated several pieces of furniture in the medieval style during the early years of his association with William Morris, but undoubtedly one of the most spectacular objects in the category of "illustrated furniture" was the piano he both designed and painted for William Graham (figs. 5, 6). Graham had commissioned the instrument as a present for his daughter Frances. Burne-Jones decorated the sides with scenes in grisaille from the legend of Orpheus, while the lid was ornamented on the inside with the figures of "Terra Omniparens" and her children and on the outside with the "Inspiration of a Poet." Many studies exist for various stages in the progress towards the final magnificent designs, including an earlier series of exquisitely worked tondos in pencil which were eventually used as the bases for the scenes from Orpheus (cat. no. 30). Comparable to Burne-Jones' achievement in the "Graham" piano, but preceding it by several decades, is an impressive painted cabinet (now in the Victoria and Albert Museum) which was designed by William Burges and decorated with illustrations to the legend of Cadmus and other scenes by the painter Edward J. Poynter (whose important role in this movement which brought together painting and the applied arts has not yet received the same degree of attention bestowed upon Burne-Jones, Rossetti, Morris or Burges). Although the great vogue for illustrated and painted furniture had considerably abated by the turn of the century, individual examples of this extension of fantasy continued to appear, such as the print cabinet designed and decorated by Frank Brangwyn around 1910. This remarkable object was ornamented with a scene of servants bearing heavily laden platters to an Eastern potentate *à la* familiar imagery from *The Arabian Nights*.

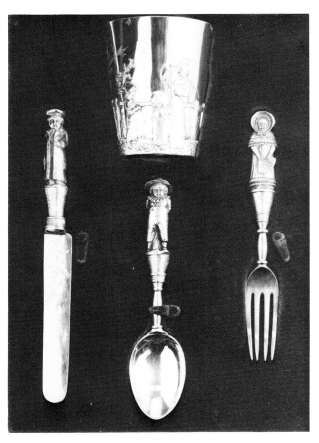

cat. no. 105 GREENAWAY, after

In their usual presentation as a series of individual paintings, the scenes portrayed on painted furniture bear comparison with the individual plates in an illustrated book. Even in such highly elaborate constructions as the "Cadmus" cabinet, the individual episodes from the legend are presented in a series of compartments and may be "read" across the surface of the piece.

Individual objects in the fantastic mode varied greatly in their relationship to illustration, of course. In some instances, as with the splendid silver christening set derived from Kate Greenaway's illustrations to *Under the Window* (cat. no. 105), there is a very direct relationship. Equally dependent upon book illustration but usually not so directly translated are the remarkable ceramic fantasies created by Daisy Makeig-Jones for Wedgwood. She frequently appropriated motifs from the major fantasy illustrators and included them among the designs on her fabulous Fairyland Lustreware and seems to have been particularly fond of H. J. Ford's contributions to Andrew Lang's Coloured Fairy Books (cat. nos. 97, 134).

Obviously, many objects which can clearly be described as fantastic do not specifically draw upon the illustrative tradition, although they may be representative of a common source of inspiration or express an interest similar to that found in book illustration. The bizarre yet amiable ceramic birds by the Martin Brothers would fall within this category. These delightful, rather cockeyed fellows are portrayed with much of the same sense of whimsy as many of Arthur Rackham's earnest feathered creatures, but it is the same spirit which seems to animate them both rather than any more direct relationship (although such a relationship is not inconceivable). Anthropomorphism was a major means of expressing fantasy and appeared with such frequency that it is often extremely difficult to isolate or even suggest the origins of a particular type of representation.

Oscar Wilde's son Vyvyan Holland, who inherited a fair share of his father's wit, once explained that tales about animals behaving more or less like humans were the most popular form of children's story "because the child's mind is always a little puzzled and distressed by the fact that animals, which are obviously superior to humans, are unable to talk, or to possess other human qualities."[17] What Holland was implying by this rather arch observation on anthropomorphism was that fantasy very often functions as a "corrective" to reality as well as an escape. But the capacity to be beguiled by a dreamworld could not remain unaffected by two world wars and an unprecedented economic depression. These events did much to destroy the naive enjoyment of fantasy as well as to disrupt thoroughly the markets through which fantastic imagery was diffused. Perhaps during this period reality itself had become too much like a frightening fantasy world.

We have touched upon the achievements of many of the artists and designers who devoted their talents to expressing various aspects of fantasy, but the subject is vast and, like most thematic investigations, far more open-ended than

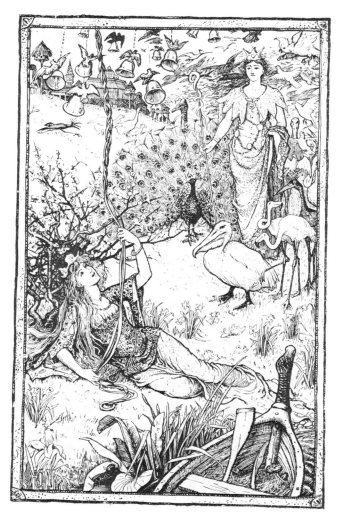

cat. no. 97 FORD

cat. no. 134 MAKEIG-JONES

a preliminary glance would suggest. Because the need to fantasize had become a significant cultural preoccupation during the Victorian and Edwardian eras, the period cannot be accurately described without giving serious consideration to expressions of the fantastic mode.

Aside from cult figures like J.R.R. Tolkien, who has provided not only an endless literary source of inspiration (beginning with the publication of *The Hobbit* in 1937) but also the example of his own illustrations, the current heirs to the fantasy tradition in art are to be found mainly in such obvious manifestations of popular culture as comic books, science fiction magazines, and of course, films. However, photography, a discipline formerly considered to be primarily informational, has yielded a surprising array of imaginative material, from the haunting images of the New Orleans photographer Clarence John Laughlin to the striking manipulations of Jerry Uelsmann. It is now, as it always has been, the intention and not the means of expression which calls forth the image.

FOOTNOTES

1. John Ruskin, "Lecture IV, Fairy Land," in *The Art of England, Works (Library Edition)*, eds. E. T. Cook and Alexander Wedderburn (London, 1908), XXXIII, p. 347.

2. Ruskin, pp. 347-348.

3. See, for example, Brigid Peppin, *Fantasy, The Golden Age of Fantastic Illustration* (New York, 1975) and Gordon N. Ray, *The Illustrator and the Book in England from 1790 to 1914* (New York, 1976), p. xii.

4. The drawing is in the collection of the Huntington Art Gallery, San Marino. See Robert R. Wark, "English Fantasy Drawing," *Calendar* of the Huntington Library, Art Gallery and Botanical Gardens (November, 1976), p. 1.

5. J. H. Plumb, "The First Flourishing of Children's Books," New York, The Pierpont Morgan Library, *Early Children's Books and Their Illustration* (New York, 1975), p. xviii.

6. Quoted in H. Montgomery Hyde, *Oscar Wilde* (New York, 1975), p. 120.

7. Kenneth Clark, *Another Part of the Wood* (New York, 1974), p. 7.

8. "Frauds on the Fairies," *Household Words*, 8, No. 184 (October 1, 1853), p. 97.

9. Bruno Bettelheim, *The Uses of Enchantment* (New York, 1976), pp. 5-6.

10. In addition to their work as engravers, they also functioned as artists, printers and publishers, creating a virtual printing empire.

11. For a general description of the manner in which Rackham, Heath Robinson and the color-book illustrators produced their drawings, see John Lewis, *Heath Robinson, Artist and Comic Genius* (London, 1973), p. 105.

12. Malcolm C. Salaman, *British Book Illustration Yesterday and To-Day* (London [The Studio], 1923), p. 5.

13. See Isobel Spencer, *Walter Crane* (New York, 1975), p. 38.

14. I am indebted to Deborah Johnson of the Department of Art, Brown University, for sharing with me her knowledge of English Japonisme.

15. See, for example, the chapter on "Fairy Painting" in Jeremy Maas, *Victorian Painters* (London, 1969), pp. 148-161.

16. Olive Cook, "The Fabric of a Dream" in *The Saturday Book*, 34 (1975), p. 198.

17. Vyvyan Holland, "Once Upon a Time . . . ," in *The Complete Fairy Stories of Oscar Wilde* (London, 1971), p. 195.

And the World Became Strange: Realms of Literary Fantasy

GEORGE P. LANDOW

For the past two centuries fantasy has provided a capable and compelling alternative to the realistic novel. The recent attention to this literary mode, which comes in part from the new academic and intellectual respectability of popular culture, is a radical departure from standard views of nineteenth- and twentieth-century fiction. According to F. R. Leavis' extremely influential formulation of this usual view in *The Great Tradition* (1948), "The great English novelists are Jane Austen, George Eliot, Henry James and Joseph Conrad."[1] Although Leavis willingly admits that there are many other novelists well worth reading, he believes that the four he has named constitute the major continuum of English fiction and that such fiction is great chiefly because it devotes itself to presenting human life in terms of social and societal realities. Like all such critical taxonomies, that popularized by Leavis valuably directs attention to major works while encouraging the neglect of others which are equally as important. Although one might question his neglect of the Brontës, one perceives that it is Dickens, possibly *the* great English novelist, who most suffers from such definitions of major fiction in terms of realistic modes. In fact, traditional assessments of the art and literature of the period offer obvious similarities: students of the visual arts have considered fantastic representations, when they have considered them at all, as relatively unimportant, and they have devoted most scholarly and critical attention to the traditions of Realism, Impressionism, and Post-Impressionism. Students of literature have similarly devoted themselves largely to the Great Tradition while neglecting that stream which runs from the German *Märchen* through Carlyle, MacDonald, Carroll, Meredith and Morris to Lewis, Lindsay, and Tolkien.

Valuable insights that enable us to perceive the characteristic strengths and beauties of literary fantasy and thus redress this critical imbalance appear in Richard Chase's *The American Novel and Its Tradition* (1957). Although this apparently unlikely source of insight into British fiction does not specifically concern itself with fantasy as a literary mode, its description of the American novel in terms of Romance provides us with several points of departure for our voyage through the lands of fantasy. As Chase points out, novel and romance differ primarily in the attitudes they take towards reality. The novel, which emphasizes plausible, possible events, "renders reality closely and in comprehensive detail. It takes a group of people and sets them going about the business of life. We come to see these people in their real complexity of temperament and motive. They are

in explicable relation to nature, to each other, to their social class, to their own past." Whereas the novel (or realistic fiction) makes character more important than plot or action, romance, which distantly follows medieval example, prefers action to character and

> feels free to render reality in less volume and detail The romance can flourish without providing much intricacy of relation. The characters, probably rather two-dimensional types, will not be complexly related to each other or to society or to the past. Human beings will on the whole be shown in ideal relation—that is, they will share emotions only after these have become abstract or symbolic Astonishing events may occur, and these are likely to have a symbolic or ideological, rather than a realistic, plausibility. Being less committed to the immediate rendition of reality than the novel, the romance will more freely veer towards mythic, allegorical, and symbolistic forms.[2]

Much of Chase's description of romance applies directly to fantasy, which would seem to be a more extreme form of this mode, one which emphasizes its antithetical relation to the real as we normally conceive it. Indeed, as Eric S. Rabkin suggests in *The Fantastic in Literature* (1976), an emphasis upon this antithetical relation to reality continually appears in the individual work itself:

> While fairy tales use the World of Enchantment as their location, and are therefore highly fantastic, a true fantasy such as *Alice* continues to reverse its ground rules time and time again Fantasies may be generically distinguished from other narratives by this: the very nature of ground rules, of how we know things, on what basis we make assumptions, in short, the problem of knowing infects Fantasies at all levels, in their settings, in their methods, in their characters, in their plots.[3]

Rabkin's useful working definition of literary fantasy leads us to several central points about this imaginative mode in both the visual and verbal arts. First, fantasy and our conception of what is fantastic depend upon our view of reality: what we find improbable and unexpected follows from what we find probable and likely, and the fantastic will therefore necessarily vary with the individual and the age. Many of the basic assumptions which the Middle Ages or the eighteenth century made about society, human nature, the external world and the laws that govern it appear bizarre today, while many of our century's attitudes towards body and spirit, like its technological, artistic, and political creations, would appear as pure fantasy to earlier

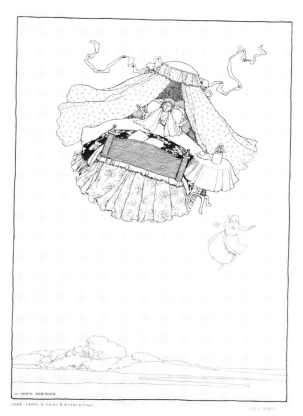

cat. no. 193 W. H. ROBINSON

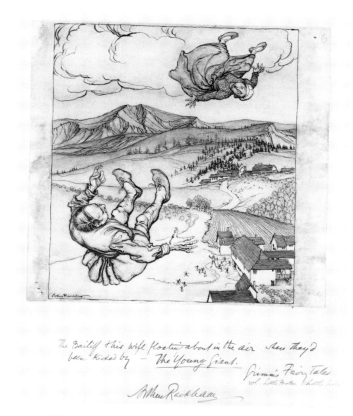

cat. no. 168 RACKHAM

times. Air travel, telecommunication, lasers, and creation of new elements were found only in the realms of magic and faerie but a short time ago.

Nonetheless, obsolete ideas of reality in earlier works of painting and literature do not, by themselves, create in us today a sense of the fantastic — a second element is required. Something, whether the reactions of a character within a literary work or some other device, must signal us that we are to take certain elements as fantastic. Whereas literature possesses several such devices, they are far harder to employ in painting and book illustration — a fact which creates problems and fascinations for the student of fantasy in the visual arts. One does not, for example, perceive as fantastic a *sacra conversazione* because it contains saints who lived in different ages, just as one does not take as bizarre floating human figures whom we perceive to be angels, emblems of fame, or the Virgin Mary rising to heaven. And yet when one encounters the floating or flying figures in W. Heath Robinson's illustration to "Cosey Hokie" (cat. no. 193) or Arthur Rackham's portrayal of the bailiff and his wife (cat. no. 168), one does take them as fantastic. Similarly, we take the figures in J. Noël Paton's "Elves and Fairies" and Richard Dadd's "Songe de la Fantasie" as fantastic, and the reason is that these works depend upon our conventions of reality, our commonplace, shared assumptions about what is real. Religious and mythological paintings, as well as those based purely on literary subjects, may have major elements of unreality; and yet because we accept them as conventional ways of embodying conventionally accessible ideas, we do not focus our attention upon their ontological status. For example, we do not react importantly to the potentially fantastic elements in Veronese's "Venus and Mars" in large part because we recognize both that mythological figures are a Renaissance painterly convention and that this particular image provides the artist with a culturally accepted way to make a statement about the way that love and fertility prevent conflict. This example suggests that fantastic art, art which is created to be perceived as fantastic, works under the great difficulty of employing conventions relied on by non-fantastic art and yet it must in some crucial way appear as improbable or bizarre — in other words, as unconventional. Since the signals that artists use to inform the audience that a work is to be taken as fantastic themselves become conventions, they are always in danger of failing to achieve their intended effect, which is to stimulate in the reader that sense of wonder at encountering something delightfully or fearfully strange. One common response to this problem, which is made by artists as different as Rackham, Potter, and Sime, is to emphasize the element of whimsy.

Subject is one of the devices which artists, like writers, employ to immerse us in a fantastic world, for when coming upon a picture of the lands of faerie or the Arabian Nights, the land beyond the Looking Glass or that inhabited by Kate Greenaway's children, we immediately recognize that we have left our normal, everyday reality and entered

cat. no. 34a CALDECOTT

cat. no. 47 CRANE

another imaginative cosmos. Similarly, an encounter with grotesque or anthropomorphic forms, which we do not expect to meet in our waking life, signals us that the artist is working with the fantastic. George Tinworth's "Steeple-chase," Beatrix Potter's "The Day's News," and Randolph Caldecott's "A Frog he would a-wooing go" (cat. no. 34a) present us with images of animals engaged in human activities, while Walter Crane's "A knife and a fork" (cat. no. 47) and Richard Bentley's "A Prospect of Vapourland" animate inanimate objects to create a fantastic effect.

Essentially, fantastic subjects, like anthropomorphic renderings of objects and animals, are devices of transformation, and both art and literature possess the capacity to use many such devices, the most powerful of which change our usual means of perception. Such informing distortion, which Ruskin took to be one of the chief effects of high imagination, can be produced in many ways. The artist can, for instance, show us his subject from an unusual physical vantage point, revealing a bizarre aspect of the reality we believe we already know. Although Edward Detmold's illustrations for *Fabre's Book of Insects* are in one sense merely precise entomological studies, the fact that he presents his "Field Cricket" and "White-Faced Decticus" from a point closer than the human eye usually perceives them, and hence in much larger scale, produces the effect of the strange and exotic. Part of Detmold's effect derives from the great precision, the uncanny sharpness of outline and detail, which his insects now transformed into bizarre monsters possess. As both Ruskin and Tennyson well knew, rendering objects in more precise detail than they are normally perceived can produce an hallucinatory effect, for such precision changes our relations to our world. The photographs of Wynn Bullock proffer such a fantastic vision of a shimmering, unnaturally precise reality which we never perceive with our waking eyes, and early Pre-Raphaelite works, such as Millais' "Ophelia" and Seddon's "Jerusalem and the Valley of Jehosophat," similarly convey a realistic description so heightened as to become fantastic. But although markedly increasing the precision and detail of our perceptions of otherwise prosaic matters can create the sensation of the fantastic, it is the transforming of usual perception, and not the detail itself, which is crucial, for the artist can work in the opposite manner, as does Detmold in his *Arabian Nights* illustrations (cat. no. 77), rendering objects within a dreamlike haze; or, again, like Ruskin, another master of visual detail, the artist can surround a more or less precisely outlined object by hazy forms and thus produce within his picture a powerful suggestion of strange, unnatural movement (cat. no. 200).

As these works by Detmold and Ruskin remind us, fantasy occasionally appears in unexpected ways in the art of the last century; and while literary and visual fantasy have much in common, not all important fantastic art derives from narrative or dramatic literature. Nonetheless, most of the greatest creations of strange and wondrous worlds do appear as illustrations, some of them for works written long

cat. no. 77 E. J. DETMOLD

cat. no. 200 RUSKIN

before, such as *A Midsummer Night's Dream* and *The Arabian Nights.* Illustration of older works permits us to compare the ways in which masters of fantastic art visualize well-known subjects, and one of the pleasures of preparing for this exhibition has been to observe the way men as different as Rackham, Dulac, Detmold and Crane approach the same work. It has been equally enjoyable to observe how artists illustrate either their own writings or those of major contemporary masters of literary fantasy: although we do not include examples of them all, Martin Timlin, Rudyard Kipling, Edward Lear, W. Heath Robinson and Walter Crane all provided pictures for their own works, while wonderful pairings of contemporaries appear in Arthur Hughes' work for George MacDonald's fictions and Sir John Tenniel's justly famous illustrations for the Alice books.

In order to examine the characteristics of literary fantasy during the period covered by this exhibition in the most economical manner, I propose in the following pages to survey this literary form in terms of one work by each of five major authors — John Ruskin (1819-1900), George MacDonald (1824-1905), George Meredith (1828-1909), William Morris (1834-1896), and William Hope Hodgson (1875-1918). These five works, each of which represents a particular form of fantastic fiction, will enable us to perceive the defining characteristics of this literary form while also permitting us to observe what the verbal and visual arts in this mode have in common.

John Ruskin's *The King of the Golden River* exemplifies the literary fairy tale, a form which, like the literary ballad, imitates the anonymous products of popular or folk tradition. Ruskin's tale, which he wrote in 1841, two years before he began *Modern Painters,* tells of Hans and Schwartz, two selfish, evil brothers whose greed costs them their Edenic Treasure Valley and then their lives, and of the third brother, Gluck, whose generosity and self-sacrifice restores the valley's fertility. One cold winter evening when Gluck is minding the house, a fairy visitor arrives and demands entrance:

> It was the most extraordinary looking little gentleman he had ever seen in his life. He had a very large nose, slightly brass-coloured, and expanding towards its termination into a development not unlike the lower extremity of a key bugle; his cheeks were very round, and very red, and might have warranted a supposition that he had been blowing a refractory fire for the last eight-and-forty hours; his eyes twinkled merrily through long silky eyelashes, his moustaches curled twice round like a corkscrew on each side of his mouth, and his hair, of a curious mixed pepper-and-salt colour, descended far over his shoulders. He was about four-feet-six in height, and wore a conical pointed cap of nearly the same altitude, decorated with a black feather some three feet long. His doublet was prolonged behind into something resembling a violent exaggeration of what is now termed a "swallow tail," but was much obscured by the swelling folds of an

enormous black, glossy-looking cloak, which must have been very much too long in calm weather, as the wind, whistling around the old house, carried it clear out from the visitor's shoulders to about four times his own length.[4]

When the cruel, avaricious brothers return home, they order their strange visitor, who turns out to be South West Wind Esquire, to leave. At the stroke of midnight, the brothers are awakened by a tremendous crash to discover that their room is flooded. "They could see in the midst of it an enormous foam globe, spinning round, and bobbing up and down like a cork, on which, as on a most luxurious cushion, reclined the little old gentleman, cap and all. There was plenty of room for it now, for the roof was off" (1.323). The morning light reveals that their precious valley, whose riches they never shared, has been transformed into a desert of red sand, and so, not having learned their lesson, they decamp for the nearest city where they set themselves up as cheating goldsmiths. Failing to prosper, they soon melt down all their hoarded gold until they have only Gluck's mug which an uncle had given the little boy.

> The mug was a very odd mug to look at. The handle was formed of two wreaths of flowing golden hair, so finely spun it looked more like silk than metal, and these wreaths descended into, and mixed with, a beard and whiskers of the same exquisite workmanship, which surrounded and decorated a very fierce little face, of the reddest gold imaginable, right in the front of the mug, with a pair of eyes in it which seemed to command its whole circumference. (1.326-27)

Placing the mug in the melting pot, the brothers leave for the alehouse and instruct their younger brother to watch over the pot. While gazing out of a window at the desiccated remains of his beloved Treasure Valley, Gluck is astonished to hear the melted gold singing, and when on its orders he decants it, out jumps a golden dwarf a foot and a half high — the King of the Golden River, who had been enchanted by an evil spell. The grateful king thereupon rewards Gluck by telling him how to make his fortune:

> "Whoever shall climb to the top of that mountain from which you see the Golden River issue, and shall cast into the stream at its source three drops of holy water, for him, and for him only, the river shall turn to gold. But no one failing in his first, can succeed in a second attempt; and if any one shall cast unholy water into the river, it will overwhelm him, and he will become a black stone."
> (1.331)

Predictably, the two brothers, who try to cheat each other, turn themselves into black stones, whereas Gluck, who gives his last holy water to an old man, a child, and a dog (all of whom turn out to be the dwarf king in magic guise), is rewarded again by the King of the Golden River with three drops of dew. When sprinkled on the source of the river, they transform the desert valley once again into an earthly paradise.

Although Ruskin uses the fairy tale to enforce the moral

that selfishness is evil and destructive, its chief point is one central to his entire career as a critic of art and society — namely, as he put it in *Unto This Last* (1860), that "THERE IS NO WEALTH BUT LIFE. Life, including all its powers of love, of joy, and of admiration" (17.105). Nonetheless, his later statements about fantasy and imagination suggest that the understanding of these ideas is at most a secondary experience and not the primary one he intended. According to his lecture "Fairy Land" in *The Art of England* (1884), fantastic or fairy art is "the art which intends to address only childish imagination, and whose object is primarily to entertain with grace" (33.332). For him, such an aim is an extremely important one. Ruskin has all too often been mistakenly thought to espouse a crude didacticism, in part because he advances so emphatically the notion that beginning artists should present visual truth. But, in fact, as he several times urges in *Modern Painters* and his other writings, the most valuable, most educational, most *moral* function of art is simply to be beautiful. He can take such an undidactic approach to the arts because his theories of beauty assume that beauty is a divinely intended pleasure the enjoyment of which is itself a moral and spiritual act. Similarly, when he writes of fairy literature and art for children, he opposes its vulgarization by didactic intent because he believes that exercising the young imagination is itself a most valuable purpose. Appropriately, Ruskin begins his lecture on fairy art by announcing that he will take on Dickens' Gradgrind, the archtypal utilitarian educator who wanted children to learn facts and suppress their imaginations. Like Dickens, Ruskin works within a moral and philosophical tradition which held that feeling and imagination play, and should play, crucial roles in moral decision; so that to develop the imagination is to develop a mature human mind. Ruskin therefore tells his audience that "it is quite an inexorable law of this poor human nature of ours, that in the development of its healthy infancy, it is put by Heaven under the absolute necessity of using its imagination as well as its lungs and its legs; — that it is forced to develop its power of invention, as a bird its feathers of flight" (33.329).

Although in "Fairy Land" Ruskin concerns himself largely with art and literature for children, his remarks decades before in *Modern Painters* make it abundantly clear that he conceives the fantastic imagination as one of the defining characteristics of humanity and its highest art. According to him, whereas the student artist and those of lesser imagination must concentrate upon topographical, realistic studies which store the mind with visual fact, the great artist, such as Turner, creates imaginative transformations of reality which most of his audience will receive as fantastic distortions — thus the need for criticism and for Ruskin to have begun *Modern Painters* in order to demonstrate to hostile critics that Turner's later visions of mist and fire were firmly based on reality. By creating such unusual images of the world of matter and spirit, the great artist produces a work which enables us to perceive with his eyes and imagination. Each artist necessarily transforms the world according to

the strengths and limitations of his own character, imagination, and age, and in the third volume of *Modern Painters* (1856) Ruskin endeavors to explain the various imaginative modes in which artists work. Purist art, for example, arises in "the unwillingness . . . to contemplate the various forms of definite evil which necessarily occur in . . . the world" (5.103-04). Artists like Fra Angelico "create for themselves an imaginary state, in which pain and imperfection either do not exist, or exist in some edgeless and enfeebled condition" (5.104). Turning to a lesser English example, he describes Thomas Stothard in terms strikingly like those with which he was later to describe Kate Greenaway:

> It seems as if Stothard could not conceive wickedness, coarseness, or baseness; every one of his figures looks as if it had been copied from some creature who had never harboured an unkind thought, or permitted itself an ignoble action. With this intense love of mental purity is joined, in Stothard, a love of mere physical smoothness and softness, so that he lived in a universe of soft grass and stainless fountains, tender trees, and stones at which no foot could stumble. (5.105)

Although such art can provide us some brief respite from the pains of this life, it is, finds Ruskin, essentially childish and incomplete.

A potentially higher art appears in the grotesque, which takes three forms. The central mode of the grotesque arises from the fact that the human imagination

> in its mocking or playful moods . . . is apt to jest, sometimes bitterly, with under-current of sternest pathos, sometimes waywardly, sometimes slightly and wickedly, with death and sin; hence an enormous mass of grotesque art, some most noble and useful, as Holbein's Dance of Death, and Albert Dürer's Knight and Death, going down gradually through various conditions of less and less seriousness into an art whose only end is that of mere excitement, or to amuse by terror. (5.131)

In addition to this darker form of the grotesque, which includes work ranging from traditional religious images of death and the devil to satire and horrific art, there is a comparatively rare form which arises "from an entirely healthful and open play of imagination, as in Shakespeare's Ariel and Titania, and in Scott's White Lady" (5.131). This delicate fairy art is so seldom achieved because

> the moment we begin to contemplate sinless beauty we are apt to get serious; and moral fairy tales, and such other innocent work, are hardly ever truly, that is to say, naturally, imaginative; but for the most part laborious inductions and compositions. The moment any real vitality enters them, they are nearly sure to become satirical, or slightly gloomy, and so connect themselves with the evil-enjoying branch. (5.131-32)

The third form of the grotesque, which served as the basis for Ruskin's conception of a high art suited to the Victorian age, is the "thoroughly noble one . . . which arises out of the use or fancy of tangible signs to set forth an otherwise less expressible truth; including nearly the whole range of

cat. no. 172 RACKHAM

cat. no. 143 MARTIN BROTHERS

symbolical and allegorical art and poetry" (5.132). Ruskin's valuable perception that fantastic art and literature form part of a continuum which includes sublime, symbolic, grotesque, and satirical works is particularly useful to anyone interested in this mode. One of the purposes of *Fantastic Illustration and Design in Britain, 1850-1930* has been to explore the boundaries of fantasy in the arts, showing where it touches upon other territories. Examination of the paintings, drawings, books and works of decorative art which have here been assembled makes it clear that fantastic art does, in fact, share much with satire and symbol, caricature and sublime. After all, much of the delight of Rackham's witches (cat. no. 172) arises from the way they caricature normal humanity, and, similarly, when we receive pleasure from his wonderfully humanized birds and those of the Martin Brothers (cat. no. 143), it is precisely because they are so human; because, in other words, they share so much of the human that they enable us to see ourselves better because we see ourselves in such strange guise.

Such delightful, and often unsettling, presentation of aspects of our everyday reality in strange form is also a common feature of literary fantasy and appears in works as different as *Alice's Adventures in Wonderland* and *Peter Pan in Kensington Gardens*. But the literary fantasy's primary method is to transform not single elements in our world, but that entire world itself, thus immersing us in another reality whose laws are different, often disconcerting, and occasionally terrifying. George MacDonald's *Phantastes* (1858), which will serve as our second major example, takes as its province the world of fairyland. Although MacDonald's fairyland, like that of Lord Dunsany's *The King of Elfland's Daughter*, borrows many features from the fairy tale, this far more complex fictional world is essentially a new creation through which its inventor can explore adult themes.

MacDonald opens *Phantastes* in our world, but by the second chapter he has transformed it into a very strange place indeed. The morning after his twenty-first birthday, when the orphan Anados has come into his estate, he is greeted by a tiny fairy-figure able to vary her size at will who announces that she is his grandmother and that she has come to inform him that he is about to make a voyage to Fairy Land. Anados, who does not even believe in Fairy Land, is astonished to awaken the next morning to

the sound of running water near me; and looking out of bed, I saw that a large green marble basin, in which I was wont to wash, and which stood on a low pedestal of the same material in a corner of my room was overflowing like a spring; and that a stream of clear water was running over the carpet, all the length of the room, finding its outlet I knew not where. And, stranger still, where this carpet, which I had myself designed to imitate a field of grass and daisies, bordered on the course of the little stream, the grass-blades and daisies seemed to wave in a tiny breeze that followed the water's flow; while under the rivulet they bent and swayed with every motion of the changeful current, as if they were about to dissolve

with it, and, forsaking their fixed form, become as fluent as the waters.

My dressing-table was an old-fashioned piece of furniture of black oak, with drawers all down the front. These were elaborately carved in foliage, of which ivy formed the chief part. The nearer end of this table remained just as it had been, but on the farther end a singular change had commenced. I happened to fix my eye on a little cluster of ivy-leaves. The first of these was evidently the work of the carver; the next looked curious; the third was unmistakably ivy; and just beyond it a tendril of clematis had twined itself about the gilt handle of one of the drawers. Hearing next a slight motion above me, I looked up and saw that the branches and leaves designed upon the curtain of my bed were slightly in motion. Not knowing what change might follow next, I thought it high time to get up; and springing from the bed, my bare feet alighted upon a cool green sward; and although I dressed in all haste, I found myself completing my toilet under the boughs of a great tree.[5]

This transformation of the main character's everyday reality into a far different one well exemplifies a central device of the literary fantasy.

Whereas the artist working with visual fantasy must place us immediately within his fantastic kingdom, the creator of literary fantasy, who works with a narrative, sequential art, has two choices. Like the artist, he can open his work by immediately immersing us in his new world, and such is the manner of proceeding adopted by William Morris in *The Water of the Wondrous Isles* and George Meredith in *The Shaving of Shagpat*, two works at which we shall soon look. The far more usual strategy is for the writer to employ some narrative device which displaces us from our everyday world into his created one. The most prosaic such device occurs in C. J. Cutliffe Hyne's *The Lost Continent* (1899), in which an adventurer discovers an ancient manuscript in a South American cave; when deciphered, this manuscript (which provides the bulk of the novel) turns out to contain the tale of Deucalion, the last survivor of Atlantis. A similar favorite device of this lost-world fiction so popular around 1900 is the discovery of a map which then leads the adventurous protagonists on a voyage of discovery which culminates in the fantastic world. In contrast, William Hope Hodgson's *The Night Land* (1912), William Morris' *The Dream of John Ball* (1888), and Lewis Carroll's *Alice* books (1865, 1871) use the device of the dream to move us into the fantastic realm, while the magic doorway or mirror, which appears in George MacDonald's *Lilith* (1895) and C. S. Lewis' Narnia books, is another effective means of transporting us to a fantastic world. Occasionally, as in *Through the Looking-Glass,* an author may first employ a magical transformation and only later, at the story's end, reveal that the metamorphosis of reality actually occurred within a dream. Since much of the fascination and delight which characterize the finest literary fantasies derives from their continual sharp contrast of fantastic and everyday

existences, such devices of transformation are central to the form. Even Morris, who begins *The Water of the Wondrous Isles* within his imagined world, must find a means of displacing us from our usual conceptions of things, and so he employs a peculiar invented language and geography — a technique adopted by many subsequent authors — to insulate us from our world and our prosaic expectations of it.

Once we have entered the world of *Phantastes*, we soon discover that its laws, its principles of order, are completely different from those we know. As Anados remarks, "it is no use trying to account for things in Fairy Land; and one who travels there soon learns to forget the very idea of doing so, and takes everything as it comes; like a child, who, being in a chronic condition of wonder, is surprised at nothing" (33). In *Phantastes*, unlike more prosaic forms of fantastic fiction, such as that devoted to lost worlds, the principle of transformation continues to operate throughout the narrative, creating surprising incident and novel delight. Anados finds a statue of a woman which springs to life, then he receives advice from an animated tree, finds a magic boat which takes him to a fairy palace, leaves it and finds himself in a wasteland, enters a cottage whose magic doors return him to his past, and so on. Such episodic narrative is entirely in keeping with the main drive of fantasy, which is to deny the primacy of our everyday laws of cause-and-effect. Although *Phantastes* and similar works, such as David Lindsay's *A Voyage to Arcturus* (1920), deny the applicability of some of our basic facts of existence, these episodic plots are hardly random or chaotic, for as C. S. Lewis explains, "to construct plausible and moving 'other worlds,' you must draw on the only 'other world' we know, that of the spirit."[6] This fantastic world can take as many forms as the human spirit itself. For Lewis himself "the world of the spirit" is the world of Christian theology, and both his Perelandra and Narnia series, like MacDonald's *Lilith*, are allegorical embodiments of the Christian truths of redemption and spiritual growth. David Lindsay, who finds such belief irrelevant to human needs, presents an entirely different set of embodied human (and alien) possibilities. For Morris, also a secular thinker, the world of the spirit takes the form of an ideal of sexual and social development. In *Phantastes*, which relates Anados' discovery of the moral truth that one cannot find oneself until one loses sight of oneself and one's desires, the spirit is largely moral, though imbued with theological overtones.

Following the German art fairy tale or *Märchen*, MacDonald employs a dream or dreamlike structure, revealing that to him the world of the spirit must be seen in terms of human psychology, the human inner world. In fact, a great many Victorian and later fantasies employ such dream structure, for the movement into the subjective world of the mind is the first step into fantasy. Essentially, there are two ways to claim that the world of everyday reality, the world of the realistic novel, is inadequate to human needs: the first is to claim that a higher world of religious or political ideas and ideals is more important, more relevant, while the second is to claim that the inner world of the human mind, its subjective experiences, has primary value. Lewis and MacDonald embody the first view; Kafka and Lovecraft, the second.

Novel and fantasy touch upon each other in this matter of the inner world, and if one envisages a spectrum of fictions with the realistic novels of Eliot and Trollope at one end and the fantasies of MacDonald and Lindsay at the other, the novel of psychological realism occupies a middle position — and shares qualities of both. Thus, *Jane Eyre*, which purports to convey both the objective experiences and inner world of its orphan protagonist, has as much in common with the creations of MacDonald as it does with those of Thackeray, Trollope, and Gaskell. Modernist and later fiction which employs stream-of-consciousness and episodic, discontinuous structure often seems far closer to *Phantastes* than to *Middlemarch* or *The Way We Live Now*.

Although one of the most imaginative of fantastic tales in its rich incident, unexpected transformations, and completely imagined landscapes, *Phantastes* ends by returning us to this world. MacDonald chooses to have Anados leave Fairy Land in part because the now-wiser hero must learn to apply the lessons learned there in this world. An even more important reason is that excessive dwelling in the inner world is dangerous and destructive: *Phantastes*, which opens with an epigraph from Shelley's "Alastor," demonstrates that an excessive yearning for the ideals created by our imaginations can destroy the self and others, particularly when the self has a Pygmalion-like vision and attempts to possess another human being as a means of fulfilling it. In contrast, some of the greatest authors of later fantasy, including H. P. Lovecraft, Clark Ashton Smith, and Lord Dunsany, have chosen the road MacDonald rejected and written of dreamworlds more "real" than the waking world. Whereas Hodgson and Morris use the dream as a way of entering a supposedly existent future world, whether it be hundreds or millions of years distant in time, these others have employed the dream as a way into an entirely subjective realm to which the power of desire gives a higher reality — though one which is almost always destructive and cruel.

MacDonald's *Phantastes*, which combines the worlds of the fairy tale and the *Märchen*, exemplifies one chief form of literary fantasy. Another major form is the exotic tale set in the magical universe of *The Arabian Nights*, and this form has always held great appeal for illustrators. Like Shakespeare's *The Tempest* and *A Midsummer Night's Dream*, *The Arabian Nights or the Book of a Thousand and One Nights* has provided a great source of inspiration for artists including John Dickson Batten, Edward Julius Detmold, Edmund Dulac, Arthur Boyd Houghton, Henry Justice Ford, Charles, Thomas and William Heath Robinson, and Sir John Tenniel. Artists and writers conceive of this exotic realm as sensual, lush with heavy perfumes, strange vegetation, and bright intense colors, a world of fierce justice and bizarre adventure in which lamps contain djinns or genies

and great risks can bring great success. The visual side of this fascination with the exotic, which is one of the important currents of European and British romanticism, appears not only in fantastic illustration but also in scenes of life in the Middle East painted by so many nineteenth-century artists, including W. J. Müller, David Roberts, J. F. Lewis, William Holman Hunt, Joseph Farquharson, and Andrew Geddes.

George Meredith's first work of extended fiction, *The Shaving of Shagpat* (1855), offers us a glimpse at the literary use of the exotic fantasy at its most delightful. Like Dulac who later imitated the stylistic inventions of Persian, Chinese, and Japanese art for his illustrations, Meredith uses the exotic style known to readers of *The Arabian Nights* to displace us into his fantastic imagined world:

> Now, the story of Shibli Bagarag, and of the ball he followed, and of the subterranean kingdom he came to, and of the enchanted palace he entered, and of the sleeping king he shaved, and of the two princesses he released, and of the Afrite held in subjection by the arts of one and bottled by her, is it not known as 't were written on the finger-nails of men and traced in their corner-robes?[7]

This tale of a brave and adventurous, if vain, barber begins as a spoof of the genre, because it has such an unusual hero and even more unusual villain, who at first seems little more than an obese pile of black hair — "indeed a miracle of hairiness, black with hair as he had been muzzled with it, and his head as it were a berry in a bush by reason of it.... Now he would close an eye, or move two fingers, but of other motion made he none, yet the people gazed at him with eagerness" (8-9). Meredith turns this apparent parody of the adventure tale into a straightforward exotic fantasy when he reveals that Shibli's future wife, the good sorceress Noorna, had unwittingly created this apparently comical monster, who possesses strong supernatural powers, when she placed in Shagpat's scalp the magical hair of the Genie Karaz, from whom she was fleeing. To save the world, which is increasingly coming under Shagpat's power of illusion, Shibli must pass repeated tests, obtain a magic sword, and destroy the source of evil magic.

Like the art and poetry of Beardsley (and like Wallace Stevens in "The Comedian as the Letter C"), Meredith employs the barber as a grotesque figure of the artist in a fallen world — a man who attempts to establish order and beauty which time and nature continually destroy. In Meredith this conception of the artist — for Shibli, like his creator, is a teller of tales — is treated only half-seriously. Meredith similarly handles and much qualifies traditional notions of adventure, heroism, and masculine strength. As the clear-sighted Noorna tells her father, the good Vizier Feshnavat, "there is all in this youth . . . that's desirable for the undertaking 'Tis clear that vanity will trip him, but honesty is a strong upholder; and he is one that hath spirit of enterprise and the mask of dissimulation" (95). In this unpuritanic, un-English, un-Victorian world, dissimulation is a virtue, for Meredith has caught the tone of all great

adventurers who descend from Odysseus to entertain us with cunning and resourcefulness. But despite the fact that Shibli is well aware of the dangers of vanity, he continually succumbs to it and is victorious only because Noorna scolds and rescues him until he is finally able to rescue her in turn. Like MacDonald's almost exactly contemporaneous *Phantastes*, *The Shaving of Shagpat* uses its fantastic events to present serious themes of human illusion, the dangers of pride, and the nature of true heroic action. In fact, its guiding ideas much resemble those of the usual nineteenth-century *Bildungsroman*, but unlike the realistic novel of growth and self-discovery, *Shagpat* does not dramatize major changes in the main character. We are warned against his immature vanity, we see its dangerous effects, and we see him conquer it, but as we close the covers of the book, we do not find Shibli, the barber turned monarch, essentially changed. We wonder what would happen to him without Noorna and hope she will never be far from his side.

As delightfully as Meredith enacts these serious themes, which incidentally also inspired his far different novels of high comedy, he most impresses us with his depiction of magical weapons and an underground world. Escaping the wiles of the evil sorceress Rabesqurat by means of a lily rooted in a living heart, Shibli enters the underground lands and begins a series of tests which gain him the magic sword he needs to destroy Shagpat. He strikes a magic door

> and discovered an opening into a strange dusky land, as it seemed a valley, on one side of which was a ragged copper sun setting low, large as a warrior's battered shield, giving deep red lights to a brook that fell, and over a flat stream a red reflection, and to the sides of the hills a dark red glow. The sky was a brown colour; the earth a deeper brown, like the skins of tawny lions. Trees with reddened stems stood about the valley, scattered and in groups, showing between their leaves the cheeks of melancholy fruits swarthily tinged, and towards the centre of the valley a shining palace was visible, supported by massive columns of marble reddened by that copper sun. (177)

Entering the palace, Shibli survives a series of tests characteristic of the romance to gain the magic sword at last. The book closes after his triumphant battle against Shagpat, the Genie Karaz, and the evil sorceress Rabesqurat, who rely upon magical weapons and strange transformations. *The Shaving of Shagpat* is thus an important nineteenth-century precursor of the so-called "Sword and Sorcery" school of fantasy literature. This form, which was inspired largely by Lord Dunsany in his "The Fortress Unvanquishable, Save for Sacnoth" and similar writings, combined the ancient materials of *The Arabian Nights* with chivalric legend and dragonlore of the North. In the twentieth century this kind of fantasy became a mainstay of pulp magazines, and, like space operas with science fiction, did much to lower the reputation of fantasy as a serious form. These elements have been developed far more successfully in recent decades by J. R. R. Tolkien and the Americans Ursula K. LeGuin and Anne McCaffrey.

Ruskin and MacDonald have guided us into the fantasy world of Fairy Land and Meredith has shown us the universe of the exotic fantasy. An historically more important imaginative cosmos appears in the prose romances of William Morris. According to Lin Carter, the author of fantasy literature whose paperback editions of the masters of this mode have done so much to popularize it in America, Morris is the true creator of heroic fantasy:

> Oriental tales like *Vathek* and *The Shaving of Shagpat* are set—not in completely imaginary worlds of their authors' invention, as are the romances of William Morris —but in "literary" versions of the actual Middle East No one ever tried to write another *Vathek* or *Shagpat,* and only a few books (such as the *Perelandra* trilogy of C. S. Lewis and David Lindsay's brilliant and astounding novel *A Voyage to Arcturus*) show to any extent the influence of *Lilith* and *Phantastes.* But the genre of heroic fantasy laid in an imaginary world descends from William Morris to Lord Dunsany and E. R. Eddison, and from thence to whole generations of writers such as James Branch Cabell, Fletcher Pratt (*The Blue Star*), Robert E. Howard, J.R.R. Tolkien, L. Sprague de Camp (*The Tritonian Ring* and *The Goblin Tower*), Fritz Leiber, Jack Vance, Jane Gaskell, [and] Lloyd Alexander From the world of the Wood and the world of the Well descend all the later worlds of fantastic fiction, Poictesme and Oz and Tormance, Barsoom and Narnia and Zothique, Gormenghast and Zimiavia and Middle-Earth.[8]

Writers in the twentieth century have advanced farther down the road towards imagining alternate universes, for increasingly they have attempted, like de Camp, to people their worlds with new sentient creatures, societies, and entire congeries of legend, religion, and culture. Such movements of fantasy literature into the realm of speculative anthropology and theology make it clear that fantasy and romance create their imagined worlds as a means of exploring this one. It is important to emphasize once more the essential seriousness and potential humanistic contributions of such genres, since until recently their claims have been consistently scanted by academic critics and other advocates of "high" culture.

Similarly, students of Morris and Victorian culture have in general failed to see in his great prose romances anything more than escapist fiction. Although the obvious connections between his political beliefs and the propagandistic *A Dream of John Ball* (1888) and *News from Nowhere* (1891) have long been perceived, the equally important relation between these beliefs and the prose romances have not. One importance of the imagined world in *The Water of the Wondrous Isles* and similar writings is that it permits Morris to solve a basic problem confronting an author of political fiction — the problem of how to represent life in an ideal society which, by definition, does not exist under present conditions. The difficulty of dramatizing a positive political program is very great, and most successful political novels in fact take the form of satire or of a quasi-journal-istic exposé of existing abuses. In contrast, Morris' romances take the more daring approach of creating the image of a better world for which man can strive. *A Dream of John Ball* is set in the fourteenth century and *News from Nowhere* takes place in the near future. *The House of the Wolfings* (1888) and *The Roots of the Mountains* (1889) take place at that historical moment when Roman armies came into conflict with German tribal society; and although these works have major fantastic elements, their worlds are still largely historical reconstructions. Only with the great allegorical romances, *The Well at the World's End* (1896) and *The Water of the Wondrous Isles* (1897), does he bring to fruition his search for an ideal world in which to dramatize the problems of self and society which he had begun with his first prose fiction, *The Wood Beyond the World* (1894).

The Water of the Wondrous Isles, one of the finest as well as the most unusual of fantasies, well represents Morris' contribution to the genre. It is the tale of a young girl, Birdalone, who was kidnapped by a witch and raised in isolation. She escapes from her captor in the witch's magic Sending Boat and voyages to the Castle of the Quest by the way of a series of fantastic islands. At the castle she falls in love with one of the knights, flees from him after she causes the death of another knight, and goes to live and work in a city. At last, she recognizes her duties to self, lover, and society, and she rescues her Arthur. As Barbara J. Bono, author of the most important study of Morris' fiction, points out:

> Birdalone's sojourn in and around the Water of the Wondrous Isles forms an extended allegory of sexual maturation. Her journey away from the Castle of the Quest to the City of the Five Crafts reverses this pattern as she gains experience of the world of societal relations. In her first journey across the lake she encounters many emblems of the destructive extremes of pure femaleness and pure maleness, beginning with the two offshore islets, Green Eyot and Rocky Eyot, and continued and developed in much more grotesque form in the isles of her later journey. If the witch's Isle of Increase Unsought is a Bower of Bliss of extreme female sensuality, the Isle of Nothing is the reductive expression of male sterility, while neither the lush beauty of the Isle of Queens nor the fierce stoniness of the Isle of Kings prevents these places from being essentially dead After Birdalone's journey across the water she has both the nature-derived power and the experience of sexual awakening which will enable her to love.[9]

She must now learn the proper social context for her love, and the second half of the book is occupied with this social education, which "culminates in Birdalone and Arthur's decisions to leave their idyll of love to be reunited with their friends."[10] Although Morris always presents nature as the source of his characters' strength, he emphasizes that such strength can only be developed and fulfilled within a community of other human beings.

Like Rossetti and Burne-Jones, Morris creates an ideal quasi-medieval fantasy world whose keynote is a spiritualized eroticism. Dante Gabriel Rossetti, who early came under the spell of chivalric romance and Dante's *Vita Nuova*, set the tone for many of his associates when he placed his pensive, yearning lovers within medieval settings. In his early works Burne-Jones eagerly followed him into this fantasy world of passionate love and heroic rescues with "Clerk Saunders" (1861), "Iseult on the Ship" (1857), "The Knight's Farewell" (1858 [cat. no. 28]), and "Sir Galahad" (1858). Such Pre-Raphaelite visions of idealized romantic love in a medieval setting had an enormous influence on English Victorian fine and decorative arts. Painters as different as John William Waterhouse, J. R. Spencer Stanhope, John Melhuish Strudwick, and Walter Crane continued to paint in this mode for more than half a century after Rossetti began it, and its influence upon the decorative arts was equally long-lived and interesting. The close association of this idealized medieval fantasy world with Pre-Raphaelite conceptions of ideal love had a particularly important effect on the decorative arts, for they gave a major impetus to the attempt by Morris and his associates to create a complete, aesthetically satisfying environment. They not only wanted to create well-designed implements and total settings for a full, humane existence, but they also wished to use them to transform their own living space into miniature fantasy worlds. The Victoria and Albert's "Saint George" Cabinet (1861), designed by Webb with scenes painted by Morris himself, and the "King René of Anjou's Honeymoon" Cabinet, designed by Seddon and decorated by Rossetti, Brown, Burne-Jones, and Prinsep for Morris, Marshall, Faulkner and Co., exemplify such use of Pre-Raphaelite themes to fantasize the implements of daily life.

Nonetheless, although Morris resembles other members of the Pre-Raphaelite movement when he makes romantic love in a quasi-medieval setting central to his prose romances, his characterization of Birdalone as a heroic, active, sensual young woman sounds an entirely new note. Both the early Pre-Raphaelite Brotherhood and the later aesthetic Pre-Raphaelitism which evolved under Rossetti's direction and influence depicted love from the male point of view. As a result both earlier and later forms of Pre-Raphaelitism tend to present a particularly masculine conception of woman. Their peculiarly Victorian notion of female nature conceives of it dividing quite sharply into two diametrically opposed categories — the active Lilith figure who devours men and the passive, pensive maiden who waits for a man to awaken or complete her partially formed nature. The active woman, of whom Victorian men seemed so fearful, appears as Rossetti's "Lady Lilith" (1868) and "Astarte Syriaca" (1873) and as Swinburne's Dolores and his Venus in "Laus Veneris." This conception of the fatal, devouring woman, which so inspired illustrators such as Aubrey Beardsley and Alastair (cat. no. 4), plays a comparatively minor role in Pre-Raphaelite work. Far more important is the other more central conception of woman as a passive, contemplative creature awaiting the lover for awakening, salvation, or even creation. Many of the most important paintings of the early Brotherhood form a series on the theme of romantic love and its frequently tragic aftermath for such passive maidens: Millais' "The Woodsman's Daughter" (1851), which is an illustration of Patmore's poem on the unrequited love of a young country girl for a squire's son, presents the first act of a drama which ends with the seduced girl's death, while his "Mariana" (1851) presents a young woman from Tennyson's poem awaiting her lover who does not arrive. The paintings by Hunt and Millais of "The Eve of St. Agnes" (1848, 1863) follow Keats' poem in depicting a successful close to a tale of romantic love, while Millais' "Lorenzo and Isabella" (1849) and Hunt's "Isabella and the Pot of Basil" (1867) illustrate another poem by this poet which ends tragically. Hunt's "The Pilgrim's Return" (1847) and his illustration to Tennyson's "The Ballad of Oriana" (1857) represent the lover mourning over his dead beloved, but the most famous example of the "dead woman" theme is, of course, Millais' "Ophelia" (1851), though Arthur Hughes and many other artists and sculptors attempted the same subject.

Whereas these early works in the Pre-Raphaelite hard-edge style present a precise historically locatable world in sharp outline and bright colors, Burne-Jones' paintings, which represent the high point of the aesthetic Pre-Raphaelitism that descends from Rossetti, set their figures in a sensual, penumbral world. A large proportion of Burne-Jones' major works concern themselves with embodying his fascination, almost obsession, with the relations of men and women. Taken together, these works comprise a sexual myth that had great appeal for the artist and his contemporaries. "St. George and the Dragon" (1868), "Cupid Delivering Psyche" (c. 1871), and the "Perseus" series (1875-1888), like Rossetti's "The Wedding of St. George and the Princess Sabra" (1857), present various stages in the dominant male's rescue of the helpless maiden. Similarly, in the "Briar Rose" series (1870-1890) the heroic prince pierces the forbidding enchanted thicket in order to awaken this sleeping beauty, thus restoring her and her entire world to life. "King Cophetua and the Beggar Maid" (1880), which appropriately repeats the disposition of figures employed in the "Annunciation" (1876-1879), depicts a powerful male character essentially creating his beloved — a subject Burne-Jones rendered most elaborately in the "Pygmalion" series (1868-1870), a work which can stand as the type of his sexual myth. Here the young man literally creates his own ideal beloved and is blessed when Venus vivifies her — a Victorian dream come true! MacDonald's Anados learns all too painfully that such attempts to discover, capture, and possess one's ideal in another person are a self-destructive form of aggression. The Pre-Raphaelites, on the other hand, tended to see this as the ideal form of romantic love — and as one attainable both in art and life. As is well known, members and associates of the Pre-Raphaelite circle married relatively uncultured and even illiterate young women

whom they then sought to remake according to a desired image. Although Holman Hunt ultimately failed to be either Cophetua or Pygmalion to Annie Miller, Brown, Rossetti, and Morris married their young women. Many of Burne-Jones' major depictions of this sexual fantasy derive from Morris' own *Earthly Paradise,* for which they began as illustrations, and it is certainly tempting to see Morris' radically different women of the late prose romances as his mature reaction against the results of attempting to embody such attitudes in real life. At any rate, Birdalone is a development of Pre-Raphaelite conceptions of idealized womanhood. Although she shares the innocent beauty and grace as well as the rich inner life of the Pre-Raphaelite heroine, she is a strong, active figure who not only shapes her own destiny but who also rescues her beloved and restores him to self, sanity, and civilization.

In contrast to Morris' progressive use of the fantasy, William Hope Hodgson, whose *The Night Land* (1912) exemplifies the darker or horrific form of this mode, uses it to embody reactionary social and sexual belief. His vision of a sunless earth millions of years in the future inhabited by Boschian monsters and fearsome spiritual and physical horror clearly is the product of that major cultural anxiety which John A. Lester, Jr., has analyzed in *Journey Through Despair, 1880–1914*.[11] Hodgson's vision of "the Last Redoubt — that great Pyramid of grey metal which held the last millions of this world from the power of the Slayers"[12] well expresses the attitudes of those many thinkers who feared that Western civilization was drawing to a close.

Hodgson relates his bizarre tale of the dark future in an archaic, almost Morrisian diction, which serves, like that of his predecessor, to displace the reader into his imaginative world. The unnamed teller of the tale is an English landowner of some unspecified but pre-modern age who grieves for his dead wife, Mirdath the beautiful. He discovers that

at night in my sleep [I] waked into the future of this world, and [have] seen strange things and utter marvels In this last time of my visions, of which I would tell, it was not as if I *dreamed*; but, as it were, that I *waked* into the dark, in the future of this world. And the sun had died. (34)

The narrator, who preserves a memory of his earlier identity, discovers that he is a telepathically gifted youth trained to help preserve the great Redoubt. The burden of the tale, which follows the pattern of medieval romance, takes the form of the young man's perilous adventures in the Night Land to save a telepathic girl from the Lesser Refuge, a smaller redoubt of which all knowledge had been lost for thousands of years until the hero makes mental contact with it. The young woman, Naani, discovers herself to be the reincarnation of Mirdath, and so the two lovers are reunited after millions of years — but first they must make the journey to safety, crawling for days through total darkness, avoiding giants, "ab-humans," enormous spiders, and a spiritual evil which is far more terrifying than these physical dangers. Hodgson's archaic and often repulsive ideas of the ideal

relations between man and woman are appropriate to a work derived from chivalric romance, but his disturbing mixture of chivalric devotion and brutality — he obviously takes great pleasure in having the hero physically punish his beloved — adds a bizarre dimension to an already strange work. The weird love interludes which punctuate the return journey nonetheless do serve as effective counterpoints to the characters' horrific adventures, the imagination of which provides the main appeal of *The Night Land.*

Introducing us to this nightmarish future, the protagonist explains that the monstrously evil beings surrounding the Great Redoubt had their origin in the

Days of the Darkening (which I might liken to a story which was believed doubtfully, much as we of this day believe the story of the Creation). A dim record there was of olden sciences (that are as yet far off in *our* future) which, disturbing the unmeasurable Outward Powers, had allow [sic] to pass the Barrier of Life some of these Monsters and Ab-human creatures And thus there has materialised, and in other cases developed, grotesque and horrible Creatures, which now beset the humans of this world. And where there was no power to take on material form, there had been allowed to certain dreadful Forces to have power to affect the life of the human spirit As that Eternal Night lengthened itself upon the world, the power of terror grew and strengthened. (44, 46)

Like the American H. P. Lovecraft, whose work also was often marred by repetition, stilted writing, and reactionary ideas, Hodgson's great gift was the ability to communicate this "power of terror." Both in *The Night Land* and *The Boats of the "Glen Carrig"* (1907), a tale of men shipwrecked on a monstrous island, he embodies all the fears that haunt man sleeping and waking — fears of dissolution, loss of identity, and helplessness in the presence of hideous evil.

Horror fiction takes two basic forms, the most popular of which is the horror or ghost story which reveals the presence of often unexpected terrors within a realistically conceived world. Edgar Allan Poe, Sheridan Le Fanu, Algernon Blackwood, Charles Dickens, Arthur Machen, and many authors of recent years have excelled in writing this sensational cousin to the realistic novel. Frequently, the narrator or main character is a skeptical, even unimaginative person who, by the tale's end, is either convinced of the existence of fantastic horror breaking into his everyday world or punished for his skepticism by it. In contrast, the horrific fantasy, like the allegorical romances of Morris, either takes place in a fully created world or so emphasizes the hidden presence of such a world bordering on our own (or lying beneath it) that it subsumes the everyday world with which it began. Hodgson's books, Mervyn Peake's "Boy in Darkness," and Lovecraft's many tales exemplify such worlds of terrifying fantasy.

The evil which provides the horror in both forms of fiction — horror story and horrific fantasy — appears in a lim-

ited number of forms. First, there is the common use of Satanism and witchcraft, which obviously relies heavily on a Judaeo-Christian conception of evil that often receives a distinctly Manichean twist: the presence of Satanic evil in such overwhelming form makes the devil appear another deity of potency equal to God. Medieval grotesques, medieval and later representations of temptations and the Last Judgment, and the work of Bosch, Brueghel and their imitators have provided powerful inspiration for artists and writers who work in this fantastic mode. In the period covered by this exhibition that mode appears in illustration both in seriously horrific forms and in the more whimsical creations of Rackham's witches and Sime's "Devil with a Coal Scuttle." A second, closely related source of evil, which presents the continued existence of older, all but forgotten divinities and forces, derives from classical and Northern mythology and the darker side of fairy lore. Arthur Machen's "The Lost Brother" (from *The Three Impostors*, 1890) and Lovecraft's "The Dunwich Horror" exemplify the use in horrific fantasy of these dangerous, destructive, and often hideously cruel forces which remain outside the Judaeo-Christian scheme of things, while Sime's drawings for *The Fantasy of Life* (1901) represent their appearance in fantastic art. The third source of horror, which occasionally combines with the previous two, derives from man's fear of formlessness, chaos, and devolution. Machen's "Novel of the White Powder" (1901), Lovecraft's "The Dunwich Horror," and the giant slugs and other creatures of *The Night Land* draw upon both our normal antipathy to slimy, decaying substances and our instinctive revulsion at the way death and dissolution reduces living form to shapelessness. As Barton L. St. Armand has pointed out in his study of Lovecraft, the American writer's use of such horrifying dissolution, which embodies his existential nausea and fear of universal corruption, derives largely from the classical example of such an image — Poe's "The Facts in the Case of M. Valdemar."[13] At the conclusion of Poe's tale, Valdemar, who had been hypnotized at the point of death, is awakened from his trance and "his whole frame — within the space of a single minute, or even less, shrunk — crumbled — absolutely *rotted* away beneath my hands. Upon the bed, before the whole company, there lay a nearly liquid mass of loathsome — of detestable putrescence."[14] In Harry Clarke's wonderfully grisly illustration of this passage, the onlookers recoil in horror at the disintegrating body from which part of an arm has detached itself and from whose eyes and mouth run blood and gore.

Although Hodgson's *The Night Land* relies frequently on such horrific sensationalism, it is equally concerned with emphasizing the ability to endure this horror possessed "by that lonely and mighty hill of humanity, facing its end — so near the Eternal, and yet so far deferred in the minds and to the senses of those humans. And thus it hath been ever" (46). Hodgson frequently attempts to show that his nightmarish cosmos has a serious general significance, that it is relevant to human experience throughout the ages. His re-marks about evolution, science, and spirituality suggest that he took these points quite seriously and that they are not, as is often the case in such stories, merely attempts to establish the credibility of a fictional world. The miraculous intervention of a good divinity in this Manichean world at points when the hero has otherwise no chance of survival further suggests that Hodgson believed that if man strove heroically to preserve love and humanity against the forces of evil, he might expect to be rewarded by supernatural aid which, while it might not bring him final victory, would allow him to battle on equal terms.

In fact, all the examples of fantasy at which we have looked turn out to be not mere escapist fictions but rather vehicles by which their authors dramatize ideas of high seriousness. The essential seriousness of much fine fantastic literature in the mid-nineteenth to early twentieth centuries appears nowhere more clearly than in works such as Charles Kingsley's *The Water-Babies* (1863) and George MacDonald's "The Golden Key" and *At the Back of the North Wind* (1871), which employ the great potential of fantasy as a literary mode to convey Christian ideas of the afterlife. *At the Back of the North Wind*, for instance, relates the magical adventures of a young boy in the company of the mysterious North Wind who, we gradually come to realize, is Death itself. In the nineteenth century, when diseases carried away many children before they reached their teens, sermons, tracts, and fiction often sought to console parents and prepare children for an early death by removing its terrors. Fantasy is far better suited than the tract or sermon to convey the essentially paradoxical notion that earthly life, which is but a preparation for a higher, fuller eternal life, is a form of death; while death, which at first seems so fearful, is the only means to true life. In the Gospels Christ tells His disciples that a seed can only bear fruit if it dies — if it loses its initial state and develops into another. The Christian lives with this paradox and must learn to redefine death, ultimately finding in it a new, higher, and essentially fantastic meaning. Since the central principle of literary and visual fantasy is precisely such shifting of basic laws or meanings by which we experience the world, this artistic mode is well suited to embodying views which deny that everyday reality, the here and now, is either all-important or the only form of reality.

As the various works at which we have looked suggest, fantasy in fact comprises a second great tradition of English fiction. Even the Marxist critic Arnold Kettle, who despises the romance as the escapist fiction of a ruling class, recognizes that

> all art is, in an important sense, an escape There is a sense in which the capacity to escape from his present experience ... is man's greatest and distinguishing ability This fantastic quality of art, that it takes us out of the real world so that, as Shelley put it, it "awakens and enlarges the mind by rendering it the receptacle of a thousand unapprehended combinations of thought," this quality is not a trivial or accidental by-product but the

very essence of art. If art did in fact—as the ultra-naturalistic school tends to assume—merely paint a picture of what is, it would be a much less valuable form of human activity, for it would not alter men's consciousness but merely confirm it.[15]

Kettle's important recognition of the essential value of escape or withdrawal from everyday life and its assumptions is developed independently by Morse Peckham into a compelling theory of the arts. According to his *Man's Rage for Chaos: Biology, Behavior, and the Arts* (1965), the arts are "an adaptational mechanism" which acts as a

> rehearsal for those real situations in which it is vital for our survival to endure cognitive tension, to refuse the comforts of validation . . . when such validation is inappropriate because too vital interests are at stake; art is the reinforcement of the capacity to endure disorientation so that a real and significant problem may emerge. Art is the exposure to the tensions and problems of a false world so that man may endure exposing himself to the tensions and problems of the real world.[16]

Although neither Kettle nor Peckham concern themselves with fantastic literature and art, it seems probable that the strange worlds of such paintings and fictions have an equal, if not greater, capacity to return us to everyday life with our imaginations exercised and strengthened as do works of the realistic schools. Fantasy's essential abilities to entertain, instruct, and exercise the mind and spirit make it, in short, a major mode and one well worth serious, if delighted, attention.

FOOTNOTES

1. F. R. Leavis, *The Great Tradition* (Garden City, 1954), p. 9.

2. Richard Chase, *The American Novel and Its Tradition* (Garden City, 1957), pp. 12-13.

3. Eric S. Rabkin, *The Fantastic in Literature* (Princeton, 1976), p. 37.

4. John Ruskin, *The King of the Golden River, Works (Library Edition)*, eds. E. T. Cook and Alexander Wedderburn (London, 1903-1912), I, p. 316. Hereafter cited in text.

5. George MacDonald, *Phantastes* (Grand Rapids, Michigan, 1964), pp. 19-20. Hereafter cited in text.

6. C. S. Lewis, "On Stories," *Of Other Worlds: Essays and Stories*, ed. Walter Hooper (New York, 1975), p. 12.

7. George Meredith, *The Shaving of Shagpat* (New York, 1970), p. 1. Hereafter cited in text.

8. Lin Carter, "About *The Well at the World's End*, and William Morris," *The Well at the World's End*, 2 vols. (New York, 1970), I, x-xi; II, [iii].

9. Barbara J. Bono, "The Prose Fictions of William Morris: A Study in the Literary Aesthetic of a Victorian Social Reformer," *Victorian Poetry*, 13 (1975), p. 52.

10. Bono, pp. 52-53.

11. John A. Lester, *Journey Through Despair* (Princeton, 1968). See also Samuel Hynes, *The Edwardian Turn of Mind* (Princeton, 1968).

12. William Hope Hodgson, *The Night Land* (Westport, Conn., 1976), p. 34. Hereafter cited in text.

13. Barton Levi St. Armand, *The Roots of Horror in the Fiction of H. P. Lovecraft* (Elizabethtown, N.Y., 1977), pp. 59-77.

14. Edgar Allan Poe, "The Facts in the Case of M. Valdemar," *The Complete Tales and Poems* (New York, 1938), p. 103.

15. Arnold Kettle, *An Introduction to the English Novel*, 2 vols. (London, 1934), I, p. 35.

16. Morse Peckham, *Man's Rage for Chaos: Biology, Behavior, and the Arts* (New York, 1967), p. 314.

Notes on the Catalogue

Place names refer to England unless otherwise indicated.

Descriptive titles are provided for works which do not bear specific or generally accepted titles. Descriptive titles do not appear in quotation marks.

Italics are used only for the titles of books; the titles of individual works of art, regardless of medium, appear within quotation marks.

The date appearing on the title line is that of the specific work (drawing, watercolor, etc.) and not the date of the publication unless the work is a book.

Variations in the spelling and punctuation of all titles, particularly those of books, reflect the differing forms used in various editions, translations and the like.

Measurements are given with height preceding width unless otherwise noted.

Catalogue

Anonymous, British

1 Frontispiece to *Ghost-Stories; collected with a particular view to counteract the vulgar belief in ghosts and apparitions, and to promote a rational estimate of the nature of phenomena commonly considered as supernatural,* 1823
Aquatinted plate from bound volume, 7 x 4″
ARENTS COLLECTIONS, THE NEW YORK PUBLIC LIBRARY, ASTOR, LENOX AND TILDEN FOUNDATIONS

This anonymous volume, published by Rudolph Ackermann in 1823, contains a delightful series of plates recording the reputed manifestations of several remarkably substantial-looking ghosts (although the intent of the book was to refute their existence).

Anonymous, British

2 "Jack Courting The Fairy" from *Jack and the Beanstalk, c.* 1830
Pen, watercolor and bodycolor over traces of pencil, 10¼ x 17¼″
Ref.: London, The Maas Gallery, *Victorian Fairy Paintings, Drawings & Water-colours,* no. 46.
MICHAEL HESELTINE

Most likely the work of an amateur draughtsman around 1830, this illustration is the final image in a series of designs, with accompanying handwritten text, which tell the story of *Jack and the Beanstalk.* Stylistically the portrayal suggests a rather intriguing blend of John Martin and William Blake: the architecture and overall setting owe much to the influence of the former, while the Fairy herself, the charming animal figures and the general color scheme indicate a debt to the latter. The image of the Giant's widow being transformed into a cloud appears to be the personal invention of the author/artist. Drawings such as these form an extremely important link between the eighteenth-century visionary tradition and the fantasy illustrations of the second half of the nineteenth century.

Anonymous, British

3 Plate
Glazed earthenware, 13½″ diameter
Marked on the reverse with impressed maker's mark: "Minton," also an apparently unattested year mark and an indecipherable potter's mark, possibly "RV" or "RB"
MR. AND MRS. DAVID E. ZEITLIN, MERION, PA.

Although a date of *c.* 1850 has been suggested for this piece, the "Minton" mark is that recorded as being in use between 1862 and 1873. A neoclassical motif has here been turned into a charming Victorian fancy. The flat, opaque colors in warm cream and brown tones emphasize the surface quality of the decoration, which consists of a nymph surrounded by putti emerging from eggshells. The winged infants are amusingly portrayed at various stages in the hatching process.

Alastair (Hans Henning von Voight), 1889-

Alastair was the pseudonym of Hans Henning, Baron Voight, an artist whose mixed background included English, Spanish and Russian ancestry. Although he apparently lived for much of his life in Germany, his sophisticated and generally bizarre designs show Beardsley's influence rather than that of the continental tradition. He illustrated the writings of both English and continental authors, and much of his work was published in England. To his credit are illustrations for Oscar Wilde's *The Sphinx* (1920), Walter Pater's *Sebastian van Storck* (1927), the Abbé Prévost's *Manon Lescaut* (1928), Edgar Allan Poe's *The Fall of the House of Usher* (1928) and a Black Sun Press edition of Choderlos de Laclos' *Les Liaisons Dangereuses* (1929). In 1914 John Lane published a volume of his designs entitled *Forty-three Drawings by Alastair.* An exhibition of his work was held in 1925 at the Weyhe Gallery, New York, and in the same year Knopf published *Fifty Drawings by Alastair* with an introduction by Carl Van Vechten.

4 "The Death of Salome" after *Salome* by Oscar Wilde
Pen, India ink and watercolor, 12 x 9″
Signed on verso across top: "Salome Oscar Wilde—Alastair—la fin—Qu'on tue cette femme—"
Ref.: Alastair, *Fifty Drawings by Alastair,* Pl. 9.
JOHN D. MERRIAM

Unlike Alastair's published illustrations to Wilde's *The Sphinx* which were commissioned specifically to accompany the 1920 edition, the artist's designs for *Salome* were apparently conceived as a series of independent illustrations. Condemned as "decadent" like much of Beardsley's work, Alastair's fashionably perverse designs, in their intense concern with the minutely detailed rendering of fanciful costumes and props, suggest an ultra-refined sensibility which in periods before our own would have been referred to as "feminine."

5 "Marguerite Gautier" from *La Dame aux Camélias* by
Alexandre Dumas fils
Pen, India ink and white watercolor on buff paper,
12⁵⁄₁₆ x 8⅝"
Signed on verso at l.r.: "—Alastair—la dame aux camilias
[sic]—"
Ref.: Alastair, *Fifty Drawings by Alastair*, Pl. 14.
JOHN D. MERRIAM

The "Marguerite Gautier" is a fine example of Alastair's
personal form of "Rococo Revival."

Thomas Allen, *c.* 1831-1915

Allen, the son of a plumber and glazier, was born in Trent
Vale, Stoke-on-Trent. He joined the Minton factory at Stoke
around 1845 as an apprentice porcelain painter. With the
encouragement of Herbert Minton, Allen enrolled at the
Stoke School of Design in 1849 (studying mainly in the eve-
nings), and in 1852 he won the first National Scholarship
to the School of Design at South Kensington, London. After
studying there for two years, the young artist returned to
Minton's, where he specialized in decorating fine porcelains
in the Sèvres style. He also painted "Majolica" and tiles for
the company, including part of the tiling (which was re-
ferred to as "Keramic Mosaic") at what is now the Victoria
and Albert Museum. In 1876 he left Minton's to join Wedg-
wood and four years later was made Art Director of the
latter firm, a position he held for twenty years. In addition
to painting elaborate mythological and classical subjects
like the decorations for two large vases (ornamented with
nymphs and amorini) which formed part of the Wedgwood
display at the 1878 Paris Exhibition, Allen often drew upon
the writings of Shakespeare and Sir Walter Scott for inspira-
tion for his designs. His later work shows the stylistic influ-
ence of both the Pre-Raphaelites and the Arts and Crafts
Movement. He retired in 1905, ten years before his death.

6 Characters from *A Midsummer Night's Dream* by Wil-
liam Shakespeare, 1888
Set of twelve stoneware tiles, polychrome glaze, each 6"
square
Unsigned, but marked with the maker's name on the
reverse: "Josiah Wedgwood & Sons Etruria"
Ref.: Julian Barnard, *Victorian Ceramic Tiles*, Pl. 74,
p. 93; Bruce Tattersall, "Victorian Wedgwood," *The An-
tique Collector*, 45, No. 3 (May 1974), pp. 67-72.
MR. AND MRS. DAVID E. ZEITLIN, MERION, PA.

The twelve tiles have been mounted in two panels by the
current owners. Each tile bears the name of the fairy figure
portrayed: the cast of characters consists of Titania, Lysan-
der, Helena, Cobweb, Peasblossom, Bottom, Demetrius,
Hermia, Oberon, Moth, Mustard and Puck. The basic
brown transfer designs have been overlaid with glazes in
soft tones, primarily lavenders, pinks and blues.

William James Audsley and George Ashdown Audsley,
Active Second Half of the Nineteenth Century

Little information is available on the early years of the
Audsley brothers, whose professional reputation rests upon
achievements in two areas: the establishment of a success-
ful architectural practice in Liverpool and the publication of
several important volumes on ornamental design and archi-
tecture. Their architectural firm, considered to be rather
"roguish" at the time, was responsible for designing numer-
ous churches and public buildings, among them St. Mar-
garet's, Anfield (1873), the Synagogue, Toxteth (1874), and
the YMCA, Mount Pleasant (1875-1877), all in Liverpool.
They also designed the church of Edward the Confessor in
Philadelphia, Pennsylvania. Among the most important of
the "ornamentists," the Audsleys produced several exqui-
sitely illuminated books, including *The Sermon on the
Mount* (1861) and *The Prisoner of Chillon* (1865). They
contributed articles to the periodical *The Chromolithograph*
(founded in 1867), but their ideas were transmitted most ef-
fectively through the publication of volumes like *Outlines of
Ornament* (1881) and *Polychromatic Decoration* (1882).
George Audsley (in collaboration with Maurice Ashdown
Audsley) produced one of the last significant British chromo-
lithographed books, *The Practical Decorator and Orna-
mentist* (1892), in addition to publishing several books on
the art of Japan, including *A Descriptive Catalogue of Art
Works in Japanese Lacquer* (1875), *The Ornamental Arts of
Japan* (1884) and, together with Lord Bowes, *The Keramic
Arts of Japan* (1875). At least one piece of furniture designed
by W. & G. Audsley is documented, a piano in ebonized
wood made by W. M. H. & G. Dreaper and Company and
exhibited at the 1878 Paris Exhibition, where it won a
medal.

7 Cabinet, *c.* 1875
Carved and painted wood, 88 h. x 39 w. x 19" d.
Ref.: London, The Royal Academy of Arts, *Victorian and
Edwardian Decorative Art, The Handley-Read Collec-
tion*, no. B26, p. 28.
VICTORIA AND ALBERT MUSEUM, LONDON

The suggested attribution of this cabinet to the Audsley
brothers has been made on the basis of the similarity of its
grotesque surface ornamentation to design motifs by W. &
G. Audsley, such as those depicted in their *Polychromatic
Decoration* of 1882. The dating of the piece is based on the
rather ambiguous combination of geometric elements typical
of High Victorian Gothic and such Anglo-Japanese features
as the asymmetrically positioned decorations (a squirrel and
a bird) at the base of the upper section of the cabinet.

8 "Bands of elaborate designs in rich colours," Plate XIX
in *Polychromatic Decoration As Applied to Buildings in
the Mediaeval Styles* by W. & G. Audsley, 1882
Chromolithographed plate from bound volume, 15¾ x
11"
Signed at center beneath image: "W. & G. Audsley, Inven.
et Del."

Ref.: London, The Royal Academy of Arts, *Victorian and Edwardian Decorative Art, The Handley-Read Collection*, no. B138, pp. 42-43; Ruari McLean, *Victorian Book Design*, p. 133.

MUSEUM OF ART, RHODE ISLAND SCHOOL OF DESIGN, GIFT OF MRS. BARNET FAIN

The Audsley volume was published by Henry Sotheran & Company in 1882 with chromolithographed plates by the Paris firm of Firmin-Didot. Similar in feeling to much of William Burges' work, the designs in this splendid volume were already somewhat out of vogue by the time the book was published. The ornamental motifs on this plate have much in common with the painted decoration of the cabinet here attributed to the Audsleys.

Gilbert Bayes, 1872-1953

Bayes was born in London to a family of artists. His father was the painter and etcher Alfred Walter Bayes; his older brother, Walter John Bayes, became a painter, critic and teacher and helped to found the Camden Town Group in 1911; and his sister Jessie painted miniatures and murals. Bayes himself first studied sculpture at the City and Guilds Technical College in Finsbury, and by 1896 he had qualified to enter the Royal Academy Schools. He left for Paris three years later with an award and a travel stipend. Bayes made regular contributions, primarily sculptures of antique, mythological and fanciful subjects, to the Royal Academy exhibitions. From 1922, when he won an honorable mention, until 1933 he exhibited at the Salon des Artistes Français. He served as president of the Royal Society of British Sculptors from 1939 to 1944.

9 "The Underwold," 1913
 Bronze, parcel-gilt, on wooden stand; 9½" h. (figure), 17" h. (with stand)
 Signed and dated on base: "Gilbert Bayes 1913"
 Ref.: London, The Royal Academy of Arts, *Victorian and Edwardian Decorative Art, The Handley-Read Collection*, p. 105, no. F6 (similar example).
 ALBERT GALLICHAN AND PETER ROSE

Bayes' sculpture "illustrates" a verse from Kipling's 1893 poem "The Last Rhyme of True Thomas." A partially destroyed label on the base of the piece bears the inscription, "The Underwold. Bronze Statuette by Gilbert Bayes suggested by Kipling's [The] Last Rhyme of [True Thomas]." The appropriate verse from "True Thomas" is also included (here corrected for omissions):

> My lance is tipped o' the hammered flame,
> My shield is beaten o' moonlight cold;
> And I won my spurs in the Middle World,
> A thousand fathom beneath the mould.

Aubrey Vincent Beardsley, 1872-1898

Beardsley was born in Brighton and attended Brighton Grammar School, where his talent for drawing was recognized and encouraged. Among his earliest drawings were copies after Kate Greenaway. He worked as a clerk for an insurance company for several years and during this time

the praise of Burne-Jones and evening classes at the Westminster School of Art helped to strengthen his decision to become an artist. Some of the diverse influences upon the young Beardsley's artistic production included the work of Burne-Jones and Botticelli, the prints of Dürer and Mantegna, and Japanese prints and decorative designs. In 1892 he met the publisher John Dent who commissioned him to illustrate Malory's *Le Morte d'Arthur*. The following year he received an offer to contribute to the first volume of *The Studio* and agreed to do the illustrations for Oscar Wilde's *Salome* (published in 1894). By the time the quarterly periodical *The Yellow Book* appeared in April of 1894 with Beardsley as art editor, his reputation and notoriety were assured, for his elegant, erotic and frequently bizarre black and white representations shocked all but the most sophisticated Englishmen. He became a contributor to and art editor for yet another new magazine, *The Savoy*, and illustrated such classics as *The Lysistrata of Aristophanes* (1896), Pope's *The Rape of the Lock* (1896) and *Ben Jonson his Volpone: or The Foxe* (1898). Beardsley's last years were ones of frantic productivity before he finally fell victim to the consumption which had been diagnosed as early as 1879. He died at Menton, France in March 1898.

10 "How Queen Guenever rode on Maying," two drawings from Book XIX, Chapter i of *Le Morte d'Arthur* by Sir Thomas Malory
 Pen and India ink, 8⅛ x 6⅝" (each drawing)
 Ref.: Brian Reade, *Aubrey Beardsley*, no. 141, p. 323 and Pl. 137.
 VICTORIA AND ALBERT MUSEUM, LONDON

The bookseller Frederick Evans introduced Beardsley to the publisher John Dent in 1892 and recommended him as a possible illustrator for Dent's projected edition of *Le Morte d'Arthur*. The book appeared during 1893-1894 in two volumes with Beardsley's illustrations printed from line blocks (process engraving). Two of the most complex plates (one of them the frontispiece) had to be printed in photogravure. The two drawings of Queen Guenever form a double-page illustration which elegantly combines medievalism with a bold, flat patterning derived from Japanese prints.

11 "Siegfried, Act II" after *Siegfried* by Richard Wagner
 Pen, India ink and wash, 15¾ x 11¼"
 Signed with initials towards l.r.: "AVB"
 Ref.: Brian Reade, *Aubrey Beardsley*, no. 164, p. 325 and Pl. 164.
 VICTORIA AND ALBERT MUSEUM, LONDON

Beardsley's illustration to Wagner's *Siegfried* is executed in the extraordinarily delicate calligraphic style which the artist used during 1892-1893 for drawings like "How King Arthur saw the Questing Beast" (the frontispiece to Volume I of *Le Morte d'Arthur*). The background of the scene is derived from Pollaiuolo's painting *The Martyrdom of St. Sebastian*. Beardsley gave the "Siegfried" drawing to Burne-Jones, whose widow later presented it to Beardsley's mother.

12 "Enter Herodias" from *Salome* by Oscar Wilde
 Annotated photoengraved proof, 6⅞ x 5⅛"

Signed with the artist's emblem beneath the arm of the figure at l.r. and within the accompanying inscription across bottom of sheet: "Alfred Lambert from Aubrey Beardsley —"

Ref.: A. E. Gallatin, *Aubrey Beardsley, Catalogue of Drawings and Bibliography*, p. 47; New York, The Gallery of Modern Art, *Aubrey Beardsley* (catalogue by Brian Reade), no. 351; Brian Reade, *Aubrey Beardsley*, no. 285, pp. 336-337 and Pl. 285.

PRINCETON UNIVERSITY LIBRARY. GALLATIN BEARDSLEY COLLECTION

This is a line-block proof of the first state of Beardsley's illustration to *Salome*: in the final version in the book, published by Elkin Mathews and John Lane in 1894, a fig-leaf covers the genitals of the male figure at the right. Oscar Wilde appears in an owl-cap at the lower right, gesturing towards the bizarre scene above him. Beardsley's image is filled with various erotic puns and complicated sexual references, but his unself-conscious approach to such material is delightfully expressed in the inscription he has noted above the scene: "Because one figure was undressed This little drawing was suppressed It was unkind — But never mind Perhaps it all was for the best—." Beardsley apparently inscribed a similar proof to Frank Harris.

13 "The Cave of Spleen" from *The Rape of the Lock* by Alexander Pope
 Pen and India ink, 10 x 6⅞"
 Ref.: London, Victoria and Albert Museum, *Aubrey Beardsley* (catalogue by Brian Reade and Frank Dickinson), no. 508; Brian Reade, *Aubrey Beardsley*, no. 410, p. 353 and Pl. 411; Cambridge, The Houghton Library, Harvard University, *The Turn of the Century 1885-1910*, no. 29a, p. 32; Brigid Peppin, *Fantasy, The Golden Age of Fantastic Illustration*, p. 46.
 MUSEUM OF FINE ARTS, BOSTON. GIFT OF THE ESTATE OF WILLIAM STURGIS BIGELOW

Beardsley did nine drawings to accompany Pope's poem and also designed the cover for the volume, which was published in 1896 by Leonard Smithers. Close examination of this elegant, rather rococo triumph of linear design reveals a disturbing cast of characters, comprising more or less human, vaguely human and humanoid types (including at the lower left one of the fetus images so much favored by the artist).

14 "The Fruit Bearers" from *Under the Hill* by Aubrey Beardsley
 Pen and India ink, 9¾ x 6⅞
 Ref.: Brian Reade, *Aubrey Beardsley*, no. 425, p. 355 and Pl. 425.
 SCOFIELD THAYER

"The Fruit Bearers" is an illustration to Chapter iii of Beardsley's unfinished erotic novel *Under the Hill*. John Lane was to have published the work under the title *The Story of Venus and Tannhäuser*. Instead, portions of the story appeared in expurgated form in *The Savoy* magazine as *Under the Hill*, although Leonard Smithers eventually published a version of *The Story of Venus and Tannhäuser* in 1907. "Fruit Bearers," far more luscious than lascivious, appeared in *The Savoy* for January 1896.

15 "The Third Tableau of *Das Rheingold*" after *Das Rheingold* by Richard Wagner
 Pen and India ink, 10¹/₁₆ x 6⅞"
 Ref.: A. E. Gallatin, *Aubrey Beardsley, Catalogue of Drawings and Bibliography*, no. 1003, p. 60; Brian Reade, *Aubrey Beardsley*, no. 430, p. 356 and Pl. 430.
 MUSEUM OF ART, RHODE ISLAND SCHOOL OF DESIGN

This drawing was one of several illustrations which Beardsley executed for "The Comedy of the Rhinegold." He never completed the series and it was therefore never published in book form, although the drawings did appear in various issues of *The Savoy*. "The Third Tableau," published in *The Savoy* for April 1896, is the finest and most elaborate of the completed designs. The characters represented are Wotan, Loge and the monster Fafner.

16 "Ali Baba in the Wood" from *A Book of Fifty Drawings by Aubrey Beardsley*
 Pen and India ink, 9⅜ x 6⅜"
 Ref.: Brian Reade, *Aubrey Beardsley*, no. 459, p. 360 and Pl. 459.
 SCOFIELD THAYER

Beardsley designed the "Ali Baba" for a projected publication to be entitled *The Forty Thieves*. The project was never carried out, however, and the drawing was first published in *A Book of Fifty Drawings by Aubrey Beardsley* (London, Leonard Smithers, 1897). The "Ali Baba," a tour de force in black and white, served as the inspiration for Sidney Sime's drawing of "The Brother of Ali Baba in the Wood," which was published in *The Idler* in March 1899 (see cat. no. 211).

Robert Anning Bell, 1863-1933

Robert Anning Bell was born in London and began his education at University College School. Following an apprenticeship with an architect, he studied at the Westminster School of Art and the Royal Academy Schools (1881). Shortly thereafter, he left for Paris and studied there with Aimé Morot. Upon his return to the English capital, he received further training under Sir George Frampton. From 1885 Anning Bell exhibited at the Royal Academy, and he became a full member in 1922. During his long career he held several teaching positions, first at University College, Liverpool (from 1894), later at the Glasgow School of Art (from 1911), and finally at the Royal College of Art, London (as Professor of Design, from 1918 to 1924). He mastered many media: his artistic activity encompassed both oil and watercolor paintings of figural, landscape and religious subjects; stained glass design; bas-reliefs; mosaics (including work at the Houses of Parliament and Westminster Cathedral) and book illustrations. In this last category his work ranged from designs for *Jack the Giant Killer* (1894) to editions of Shakespeare (*A Midsummer Night's Dream*, 1895; *The Tempest*, 1901) and compilations of fairy tales (*English Fairy Tales*, edited by Ernest Rhys, 1913), as well as contributions to *The Yellow Book*. In 1921 he was made Master of the Art Workers' Guild.

17 Frontispiece to *A Midsummer Night's Dream* by William Shakespeare
Pen and ink, 7¹⁵⁄₁₆ x 6⁹⁄₁₆"
VICTORIA AND ALBERT MUSEUM, LONDON

Anning Bell's illustrations to *A Midsummer Night's Dream* were published by J. M. Dent in 1895.

Richard Bentley, 1708-1782

Richard Bentley was the son of Dr. Richard Bentley, the classical scholar and master of Trinity College, Cambridge. The younger Bentley was an engraver and draughtsman of some repute as well as a writer. Perhaps his best-known designs were the illustrations for an edition of Gray's works printed by Horace Walpole at Strawberry Hill, *Designs by Mr. R. Bentley for Six Poems by Mr. T. Gray*, 1753.

18 "A Prospect of Vapourland," 1759
Brush, brown and gray ink over pencil, 18½ x 27⅞"
Inscribed on verso possibly in Horace Walpole's hand: "By Mr Bentley 1759"
YALE CENTER FOR BRITISH ART, PAUL MELLON COLLECTION

On the verso of the sheet is a brown ink label which is indicated by a later pencil notation as being in Bentley's hand:

"A Prospect of Vapourland/The Batavia Plane Tree./The Dragon Tree./The Ficus Peoeides maximus, caule Hibernia/foliis hirsutis./The Rattan Palm Tree./Lapis andromorphites./The Gibbet Tree./Mount Lion./Phisic Road./Calves-head hillock./The Sky after Polonius"

An early and fascinating example of transformation and anthropomorphization, Bentley's drawing prefigures the type of disturbing, activated setting which would become a major aspect of the work of later fantasy artists like Arthur Rackham.

Stephen Baghot de la Bere, 1877-1927

Active as a watercolorist and book illustrator, Baghot de la Bere was educated at Ilkley College in Yorkshire and then studied art at Leicester and at the Westminster School of Art in London (under William Mouat Loudan). He was a friend of Edmund Dulac, living near him in Cranleigh, and like Dulac was a member of the London Sketch Club. In 1907 he was elected to membership in the Royal Institute of Painters in Water Colours.

19 "The Famine" from *The Song of Hiawatha* by Henry Wadsworth Longfellow, 1911
Pen, ink and watercolor, 12½ x 8¾"
Signed and dated at l.l.: "• S • Baghot De La Bere • 1911 •"
THE FINE ART SOCIETY LTD., LONDON

This drawing was published in *The Bystander* and illustrates the lines from "The Famine" inscribed by the artist on the verso of the sheet: "Into Hiawatha's wigwam Came two other guests — And the foremost said 'Behold me! I am Famine, Bukadawin' And the other said 'Behold me I am Fever, Ahkosewin'." Baghot de la Bere has selected the moment when the dying Minnehaha is visited by the spirits who determine her fate. His treatment of the scene is similar in manner to Rackham's horrific fantasies.

William Blake, 1757-1827

Blake was born in London, the second son of a prosperous hosier. He began his artistic education at the age of ten, studying at Henry Pars' drawing school in the Strand. By his twelfth year, he had begun to write poetry, having already experienced the first of a long series of poetic visions which continued throughout his life. From 1772 until 1779 Blake served an apprenticeship with the engraver James Basire, and during this time he frequently did sketches at Westminster Abbey, several of which later appeared as engravings in such publications as Richard Gough's *Sepulchral Monuments in Great Britain* (1786–). In 1779 Blake became a full-time student at the Royal Academy, where he formed friendships with two fellow students, John Flaxman and Thomas Stothard. In the following year he exhibited for the first time at the Royal Academy annual exhibition. Flaxman and another friend helped in 1783 to finance the publication of Blake's *Poetical Sketches*, a compendium of poems written since 1770. In 1784 Blake set up a print shop wtih James Parker, a fellow apprentice from Basire's studio, but little came of this venture. He devoted much time to experimenting with technical procedures such as painting with tempera and glue or methods of etching in relief. Blake claimed that a vision from his brother Robert, who had died in 1787, revealed the secret of accomplishing relief-etching or "Illuminated Printing." He used this technique during the next decade in the production of many of his illustrated books, including *Songs of Innocence* and *The Book of Thel* which appeared in 1789; *Visions of the Daughters of Albion*, *America* and *For Children: The Gates of Paradise* in 1793; and *Europe, The First Book of Urizen* and *Songs of Experience* in 1794. He was commissioned in 1795 to illustrate an edition of Edward Young's *Night Thoughts*. Four volumes were projected, and Blake produced over five hundred sketches; but because of the economic disruptions caused by the war with France, only the first volume was published. Blake's next important commission, which came from his friend Flaxman, consisted of a series of illustrations to the poems of Thomas Gray. Over one hundred watercolors were completed, but no evidence exists that he intended to reproduce them in engraving. Blake was very dependent on two loyal patrons during his later years: Thomas Butts, a clerk, and the painter John Linnell, whom he met in 1818; both not only gave him a variety of commissions to support him during lean times but also bought individual works from his hand. Flaxman and Henry Fuseli were also loyal supporters. In the first two decades of the nineteenth century Blake was occupied with commissions from Butts and the Reverend Joseph Thomas for various illustrations to Milton, with a series of watercolors to the Book of Job (for Butts alone), and with his own great illus-

trated book-length poem, *Jerusalem* (c. 1804-1820). Blake also experimented during this period with the newly developed technique of lithography, producing a single lithograph entitled *Job in Prosperity* (c. 1807), and worked in wood engraving on illustrations for the third edition of Robert John Thornton's *The Pastorals of Virgil* (1821). The magnificent engraved version of *Illustrations of the Book of Job* appeared in 1826. At the time of his death the following year, Blake left unfinished an illuminated manuscript of the Book of Genesis, drawings for the Book of Enoch, watercolor illustrations to Bunyan's *The Pilgrim's Progress* and a series of watercolors, preliminary drawings and engravings for Dante's *Divine Comedy*. Despite a relative lack of success during his lifetime, his poetic and mystical works have influenced generations of artists since his death.

20 "With Dreams upon my bed thou scarest me & affrightest me with Visions," Plate II from *Illustrations of the Book of Job*, 1825
Engraving from bound volume, 8⅜ x 6⅝"
Signed and dated on plate across bottom within the publisher's address: "March 8:1825 by Will^m Blake" and inscribed "proof" at l.r.
Ref.: Laurence Binyon, *The Engraved Designs of William Blake*, no. 116, p. 70 and Pl. 24.
MUSEUM OF ART, RHODE ISLAND SCHOOL OF DESIGN, GIFT OF MRS. JANE W. BRADLEY IN MEMORY OF MR. CHARLES BRADLEY

Blake designed a group of twenty-one watercolors to the Book of Job for Thomas Butts. In 1823 John Linnell commissioned a similar group of watercolors and a series of engravings on the same theme, for which the artist then executed a set of small pen and ink designs. Twenty-one engravings and an engraved title page were published by Blake and Linnell in 1826, although the prints themselves bear the date of 1825. In this powerful image Job's deity appears in the form of Satan entwined with the Serpent, or Nature. Blake's personal interpretation of the Book of Job stressed the internal conflict between good and evil within man rather than focusing solely on man's relation to the godhead.

21 "The Whirlwind of Lovers" from Canto V, line 137 of *The Inferno* by Dante Alighieri
Engraving, 12 x 13⅜"
Ref.: Laurence Binyon, *The Engraved Designs of William Blake*, no. 127, Pl. 33; G. E. Bentley, Jr., *The Blake Collection of Mrs. Landon K. Thorne*, no. 35, p. 62; Martin Butlin (Tate Gallery), *William Blake*, no. 321, p. 149.
THE BALTIMORE MUSEUM OF ART, BLANCHE ADLER COLLECTION

Blake's death in 1827 prevented him from completing the major series of illustrations to Dante's *Divine Comedy* which John Linnell had commissioned from him three years earlier. Between 1824 and 1827, Blake produced more than a hundred drawings and seven engravings for the project. The latter were first published by Linnell in 1838 under the title *Blake's Illustrations of Dante*. A splendid watercolor version of this scene, "The Circle of the Lustful: Francesca da Rimini," is in the collection of the City Museums and Art Gallery, Birmingham.

Jean de Bosschère, 1881-1953

De Bosschère was born in Uccle, Belgium, but spent much of his working career in France and England. Prior to his arrival in London in 1915 as a war refugee, he had become an intimate of the French Symbolist poets Paul Claudel and Paul Valéry. In England he furthered his literary contacts when he formed friendships with Ezra Pound and T. S. Eliot as well as with the French-born illustrator Edmund Dulac. He wrote novels and poetry (under both his own name and the pseudonym J. P. Aubertin), but his reputation rests to an equal degree upon his illustrations for the works of others, including such diverse authors as Swift, Flaubert, Baudelaire and Wilde. His typical many-figured compositions are peopled by somewhat grotesque characters often reminiscent of those in the works of Northern Renaissance masters like Bosch and Breughel. Among the volumes which he both wrote and illustrated are *Christmas Tales of Flanders* (1917) and *Weird Islands* (1921).

22 "The awful Tournament," 1918
Pen and black ink, 13⅛ x 9⁹⁄₁₆"
Signed and dated at l.l.: "The awful Tournament by Jean de Bosschère 1918" and signed upon the saddle of the horse at l.: "Jean de Bosschère"
JOHN D. MERRIAM

The drawing is inscribed at the lower right: "Five Gardeners were happy in their Garden there came a fair Lady with a Raven then many a quarrel ensued and even an awful Tournament." The subject matter and the linear handling of the puppet-like figures indicate de Bosschère's affinity for late medieval and early renaissance grotesqueries. In this representation there is a purposefully naïve, almost child-like combination of the grotesque and the humorous.

Sir Frank William Brangwyn, 1867-1956

Born in Bruges, Belgium, Brangwyn was the son of a Welsh architect who encouraged his son's early interest in art. Although largely self-taught, the young Brangwyn studied briefly at South Kensington and sought the aid and advice of both Harold Rathbone and A. H. Macmurdo. From 1882 to 1884 he copied Flemish tapestries at William Morris' Oxford Street workshops. He left Morris & Company to travel abroad, one of many journeys he undertook during his lifetime. In 1885 he exhibited for the first time at the Royal Academy. His early paintings and watercolors were usually of marine subjects, but his work became more varied and exotic as his travels increasingly inspired him. He evolved into an extremely versatile artist, producing paintings, prints, watercolors, designs for furnishings, and book illustrations. Included in the last category were an edition of *The Arabian Nights* (1897) and designs for *Don Quixote* (1898). Much of his early decorative work (from carpet designs to stained glass) was for Samuel Bing's shop "L'Art Nouveau" in Paris. Numerous honors were awarded Brangwyn throughout his career. He won a medal for painting at the Columbian Exposition in Chicago (1893)

and designed furniture for the English section of the Venice International Exhibition (1905). He was elected to full membership in the Royal Academy in 1919, served as president of the Royal Society of British Artists, and was knighted in 1941. He devoted much of his career to designing murals in England and abroad, and was particularly active in this capacity around the time of World War I, when the colorful exoticism of his earlier style was in part supplanted by a somewhat less vibrant, more draughtsmanly approach appropriate to portraying workers involved in the war effort.

23 Print cabinet and stand, *c.* 1910
 Cherry wood decorated with colored gesso composition in imitation of incised lacquer, and steel fittings, 68 h. x 53¾ w. x 34⅝″ d.
 Ref.: *The Studio Year-Book of Decorative Art,* 1914, pp. 7-8, 60-61; London, Victoria and Albert Museum, *Catalogue of an Exhibition of Victorian & Edwardian Decorative Arts,* no. U4, p. 111; Helena Hayward, ed., *World Furniture,* no. 888, p. 231.
 VICTORIA AND ALBERT MUSEUM, LONDON

Brangwyn had this cabinet in his studio at Temple Lodge, Hammersmith, before offering it as a gift to the Victoria and Albert Museum in 1932. The Museum's Keeper, O. Brackett, who inspected the piece while it was still in the artist's studio, reported in a note to the Director (29 November 1932): "it has exactly the effect of incised Chinese lacquer." Brangwyn wrote on the Museum's declaration of gift form that the cabinet was of cherry wood and had been "designed by Frank Brangwyn Made by Paul Turpin." Unfortunately, little information on Turpin (q.v.) has been uncovered.

24 Figures bearing offerings
 Charcoal and watercolor, 35¾ x 51″
 Ref.: *The Studio Year-Book of Decorative Art,* 1914, pp. 7-8, 60-61.
 WOLVERHAMPTON ART GALLERY COLLECTION, ENGLAND

This drawing is a study for the impressive scene executed in "incised lacquer" on the doors of the print cabinet Brangwyn presented to the Victoria and Albert Museum in 1932.

Leonard Leslie Brooke, 1862-1940

An active book illustrator as well as a landscape painter and portrait artist, Brooke studied at Birkenhead School and the Royal Academy Schools in London and won the Armitage Medal at the latter in 1888. At about this time he began doing book illustrations and designs for book covers, and eventually he succeeded Walter Crane as the illustrator for the annual volumes of children's stories by Mrs. Mary Molesworth. In 1897 his first children's book for Frederick Warne and Company appeared, *The Nursery Rhyme Book,* edited by Andrew Lang. Among the better-known works which he illustrated are *The Golden Goose Book, The Pelican Chorus* and *The Jumblies* (these two written by Edward Lear and published in 1900), *The Truth about Old King Cole,* and a series of "Johnny Crow" stories. Flat tints and a fluid outlining of forms characterize his best work; not surprisingly, he was an admirer of Randolph Caldecott.

25 "Goldenlock's Escape" from "The Three Bears" in *The Golden Goose Book*
 Watercolor, 9½ x 7½″
 Signed with initials at l.r.: "L • L • B •"
 CITY OF MANCHESTER ART GALLERIES

Brooke illustrated *The Golden Goose Book* (1905) for Frederick Warne and Company. The volume contained the stories of "The Golden Goose," "The Three Bears," "The Three Little Pigs" and "Tom Thumb." The illustrations to "The Three Bears" were reprinted in *Tom Thumb and Other Favorites,* which was published by The Grolier Society, New York, in 1967.

William Henry Brooke, 1772-1860

The grandson of the portrait painter Robert Brooke and the son of the painter and draughtsman Henry Brooke, William Henry Brooke studied art under Samuel Drummond. In 1812 Brooke was hired by *The Satirist* to do a series of satirical drawings; he remained with the monthly until the fall of 1813 when he was succeeded by George Cruikshank. In addition to his work in this vein, he was active as a portrait painter and an illustrator, his designs in this latter category owing much to the influence of his friend Thomas Stothard. Brooke exhibited at the British Institution between 1808 and 1829 and at the Royal Academy from 1810 to 1826. He was elected to associate membership in the Royal Hibernian Academy in 1828. Among the better-known books he illustrated are Thomas Moore's *Irish Melodies* (1822), Thomas Crofton Croker's *Fairy Legends and Traditions of the South of Ireland* (1828) and Thomas Keightley's *The Fairy Mythology* (1828). He died in Chichester at the age of eighty-eight.

26 Six illustrations to *Fairy Legends and Traditions of the South of Ireland* by Thomas Crofton Croker, 1828
 Pen and ink on tracing paper, each approx. 2 x 1½″
 Ref.: Katherine M. Briggs, *An Encyclopedia of Fairies,* reproductions in text.
 LIONEL LAMBOURNE

An inscription accompanying the designs explains the nature of the diminutive beings represented: "Fairies — which in their true shape are but a few inches high, have an airy, almost transparent body:—so delicate is their form, that a dew-drop, when they dance on it, trembles only, but never breaks."

William Burges, 1827-1881

The son of a successful engineer, the English artist William Burges was very much a renaissance man, active as an architect, antiquary, and designer of furniture, jewelry, wallpaper and metalwork. He was also among the earliest collectors of Japanese prints in England. In 1849 he became the assistant of the architect and writer Sir Matthew Digby Wyatt, but did not remain long in Wyatt's employ. An exponent of

the Gothic Revival style, Burges espoused the ideals of the medieval and renaissance craftsmanly tradition. He was one of the designers for the "Medieval Court" furniture display at the International Exhibition in London in 1862, which included a remarkable cabinet of his design embellished with elaborately painted panels by E. J. Poynter illustrating the legend of Cadmus. In 1865 he began the first of two major commissions for the Marquis of Bute, a project which involved him in rebuilding and furnishing Cardiff Castle and included the creation of a splendid "Moorish" smoking room. In the same year Burges also published a volume outlining his artistic philosophy, *Art Applied to Industry*. A decade later he redesigned Castle Coch in Wales for the Marquis of Bute and began work on his own London house (1875-1881), which many consider his masterpiece. Some of his more lavish designs were for metalwork, where fanciful combinations of medieval and Eastern motifs were frequently elaborated in a wealth of precious materials.

27 Decanter, 1865
 Green glass bottle mounted in silver, parcel-gilt, with ornamentation in malachite, rock crystal, ivory, coral and antique coins, 10⅝" h.
 Signed and dated around neck: "WILLIELMUS BVRGES ME FIERI FECIT ANNO DI MDCCCLXV [. . .] VEX NON SAECULAE CONSTANTINOPOLITANAE [MD]CCCLXV" and London hallmark for 1865 on base, handle, spout and hoop and maker's mark "JM" in same locations as hallmark except for hoop which bears the mark of George Angell
 Ref.: R. P. Pullan, ed., *The House of William Burges*, Pl. 35; London, The Royal Academy of Arts, *Victorian and Edwardian Decorative Art, The Handley-Read Collection*, no. B88, p. 33.
 FITZWILLIAM MUSEUM, CAMBRIDGE

Burges' diverse interests are gloriously summarized in this decanter made for his own collection. Elements like the Chinese lion carved in rock crystal and the classical coins evidence the artist's orientalism and his antiquarian tastes. The partially obscured inscription around the neck of the piece would seem to indicate that Burges paid for the work from the proceeds of his designs for the Crimea Memorial Church in Constantinople. At least two other similar decanters by Burges are known; one was included with the Fitzwilliam decanter in the Handley-Read collection (no. B87 in the Handley-Read exhibition catalogue), and the other is in the collection of the Victoria and Albert Museum. Designs for several of the decanters (some dated as early as 1858) appear in Burges' *Orfèvrerie Domestique*, a volume of drawings for secular plate in the Burges Collection (now in the Royal Institute of British Architects Drawings Collection).

Sir Edward Coley Burne-Jones, 1833-1898

Burne-Jones was born in Birmingham and educated there at King Edward's School. In 1853 he entered Exeter College, Oxford, where he intended to prepare for the Church, but he left in 1856 without completing his studies. While at Oxford, he had met William Morris and with him had toured Belgium and the cathedrals of northern France. This experience, together with his exposure to the art of the Pre-Raphaelites (Rossetti above all), led to his decision to become a painter. Rossetti and Ruskin were soon among his friends, and he eventually became a major figure in the second phase of the Pre-Raphaelite movement. Having studied with Rossetti during 1856 and attended classes at several art schools including Leigh's Academy, he then worked with Rossetti on the Morte d'Arthur murals at the Oxford Union (1857-1858). In 1860 he married Georgiana Macdonald, and in the following year he became a founding member of Morris, Marshall, Faulkner and Company, for which he did numerous designs for such decorative wares as stained glass and tapestries before the dissolution of the firm in 1875. During these early years he worked on various illustrations and decorative cycles, beginning with a title page and frontispiece for Archibald Maclaren's *The Fairy Family* (1857) and then proceeding to designs for Morris' *The Earthly Paradise* (from 1865), never completely realized in print. Although Burne-Jones had a rather uneasy relationship with official art societies like the Royal Academy and the Royal Society of Painters in Water Colours (then the Old Water-Colour Society) and resigned from both organizations at various stages in his career, an exhibition of his work at the newly opened Grosvenor Gallery in 1877 was a phenomenal success. Other successes and honors came his way. He exhibited at the Exposition Universelle in Paris in 1878 and 1889 and won the Cross of the Legion of Honor after the second show. In 1881 he received an honorary degree at Oxford, and four years later he was elected president of the Birmingham Society of Artists. His collected works were exhibited in a major retrospective show at the New Gallery during the winter of 1892-1893, and in the following year he was created a baronet. He died in June 1898, several months before a final major exhibition of his work at the New Gallery. This was the largest show devoted to his art until the recent one in London in 1975.

28 "The Knight's Farewell," 1858
 Pen and black ink on vellum, 6¼ x 7½"
 Signed and dated at l.l.: "EJB 1858"
 Ref.: Fortunée de Lisle, *Burne-Jones*, p. 44; Martin Harrison and Bill Waters, *Burne-Jones*, pp. 40, 64 and fig. 36; London, Arts Council of Great Britain, *Burne-Jones*, no. 12.
 LENT BY THE VISITORS OF THE ASHMOLEAN MUSEUM, OXFORD

"The Knight's Farewell" and several related drawings similar in subject and handling were completed shortly after Burne-Jones' work with Rossetti and others on the Oxford Union murals. The graceful scene is set in a medieval *hortus conclusus*; the figures are surrounded with familiar medieval symbols such as the lilies of purity. Scholars have pointed out the relationship of the drawing to Rossetti's "Froissartian" watercolors executed in the same year and have also suggested a possible link between this highly fin-

ished drawing and the type of imagery found in William Morris' volume of poems *The Defence of Guinevere* (also dated 1858). Morris, in fact, owned "The Knight's Farewell" and it was included with many other works from his collection in the Kelmscott sale of July 1939.

29 Cabinet decorated with "The Backgammon Players," 1861
 Painted wood and oil paint on leather, 73 h. x 45 w. x 21″ d.
 Ref.: Malcolm Bell, *Edward Burne-Jones, A Record and Review*, p. 35; R. W. Symonds and B. B. Whineray, *Victorian Furniture*, fig. 53; Martin Harrison and Bill Waters, *Burne-Jones*, pp. 49, 53; London, Arts Council of Great Britain, *Burne-Jones*, no. 31, p. 28; Rowland and Betty Elzea, *The Pre-Raphaelite Era 1848-1914*, no. 4-46, pp. 90-91.
 LENT BY THE METROPOLITAN MUSEUM OF ART, ROGERS FUND, 1926

This important cabinet in the medieval style, made by Morris, Marshall, Faulkner and Company in 1861, was designed and ornamented by Philip Webb and decorated with a painting by Burne-Jones. The following year the piece was exhibited at the London International Exhibition. The simple design of Webb's cabinet is the perfect foil for Burne-Jones' painting. When Morris and Burne-Jones shared rooms in Red Lion Square, London, Morris designed several pieces of "medieval" furniture for their own use which Burne-Jones then painted, and this interest later carried over into their commercial partnership. A pencil drawing of "The Backgammon Players," signed and dated 1861, was formerly in the collection of Charles Ricketts and Charles Shannon and is now in the Fitzwilliam Museum, Cambridge. Another version, in watercolor, is in the City Museums and Art Gallery, Birmingham. The model for the female figure was Jane Morris.

30 "Cerberus" from "The Story of Orpheus," 1875
 Pencil, 9 9/16 x 9 9/16″
 Signed and dated at l.r.: "EBJ 1875"
 Ref.: Fortunée de Lisle, *Burne-Jones*, p. 116; Martin Harrison and Bill Waters, *Burne-Jones*, p. 125; London, Arts Council of Great Britain, *Burne-Jones*, no. 209.
 LENT BY THE VISITORS OF THE ASHMOLEAN MUSEUM, OXFORD

Originally designed in 1872 but dated 1875, "Cerberus" is one of a series of drawings illustrating the legend of Orpheus and Eurydice. During 1879-1880 Burne-Jones used the sequence as the basis for grisaille decorations on the sides of the piano he was commissioned to design for William Graham's daughter Frances. The instrument was one of the most striking and elaborate pieces of painted furniture of the Victorian age. According to the artist, his intention was to "make a thing of beauty out of an ugly mass."

31 "The Pilgrim in the Garden" or "The Heart of the Rose" from *The Romaunt of the Rose* by Geoffrey Chaucer, 1881
 Black chalk over graphite on two sheets of paper joined vertically at center, 35 7/8 x 47 7/8″
 Signed and dated at l.r.: "EBJ 1881"
 Ref.: Malcolm Bell, *Edward Burne-Jones: A Record and*

Review, p. 62 and reproduction; Fitzroy Carrington, *Pictures of Romance and Wonder by Sir Edward Burne-Jones, Bart.*, unpaginated; Eva Zimmerman, "Der Pilger im Garten oder Das Herz der Rose," *Jahrbuch der Staatlichen Kunstsammlungen in Baden-Württemberg*, 10 (1973), pp. 212-214; London, Arts Council of Great Britain, *Burne-Jones*, nos. 189, 231 (related works).
MUSEUM OF FINE ARTS, BOSTON. GIFT IN MEMORY OF CHARLES ELIOT NORTON FROM HIS CHILDREN, RICHARD NORTON, SARA NORTON, RUPERT NORTON, ELIOT NORTON, MARGARET NORTON, AND ELIZABETH GASKELL NORTON.

Around 1872, Burne-Jones and William Morris designed a needlework frieze illustrating Chaucer's *The Romaunt of the Rose* for the dining-room at Rounton Grange, Northallerton. The piece was completed in 1880, but Burne-Jones returned to the designs of the frieze on several occasions. In addition to this drawing of 1881, there is another version of "The Heart of the Rose," in colored chalks, from around 1890 (now in the William Morris Gallery, Walthamstow, London). In 1901 two tapestry versions of the subject were produced by Morris & Company at Merton Abbey. One of these is currently in a private collection; the other is in the Badisches Landesmuseum, Karlsruhe.

32 A medieval scene (possibly an illustration for *The Romaunt of the Rose* in *The Works of Geoffrey Chaucer*)
 Proof wood engraving, 12 1/4 x 8 3/4″
 VICTORIA AND ALBERT MUSEUM, LONDON

William Morris first announced his projected Kelmscott Press edition of Chaucer in 1892. In June 1896 *The Works of Geoffrey Chaucer*, with decorations by Morris and eighty-seven illustrations by Burne-Jones, became available to subscribers. The Kelmscott *Chaucer* represented the final collaboration of the two men and is an undoubted masterpiece of book production. This proof, engraved like all the Chaucer plates by W. H. Hooper, is quite possibly an unpublished illustration for *The Romaunt of the Rose*.

33 "The Passing of Venus," 1908, rewoven 1926
 High-warp wool tapestry, 107 x 231″
 Ref.: Aymer Vallance, "Some examples of tapestry designed by Sir E. Burne-Jones and Mr. J. H. Dearle," *The Studio*, 36, No. 141 (November 1908), pp. 16, 18; Henry Currie Marillier, *History of the Merton Abbey Tapestry Works founded by William Morris*, pp. 21-22, 35; Adele C. Weibel, "The Passing of Venus," *Bulletin of The Detroit Institute of Arts*, 8, No. 7 (April 1927), pp. 78-80; Rowland and Betty Elzea, *The Pre-Raphaelite Era 1848-1914*, no. 4-63, pp. 96-97; "Textiles in Detroit," *The Magazine Antiques*, 114, No. 3 (September 1978), p. 392.
 THE DETROIT INSTITUTE OF ARTS, GIFT OF GEORGE G. BOOTH

Burne-Jones had portrayed this subject several times earlier in his career, beginning in 1861 with a design for a tile panel. He designed this tapestry shortly before his death in 1898; a gouache study for the work is in the Metropolitan Museum of Art, New York. The study outlines the main elements of the composition, but much of the specific detail in the finished tapestry was due to the work of J. H. Dearle, Morris' assistant at Merton Abbey, where the piece was woven. The original tapestry, completed in 1908, was shown at the New Gallery Summer Exhibition (London) for

that year, but was destroyed in a fire around 1910. This second version, woven by Percy Sheldrick at Merton Abbey in 1926, is virtually identical to the original except for the addition of the inscription across the top and a more elaborate border (the first version had a simple acanthus-leaf pattern).

Randolph Caldecott, 1846-1886

Caldecott was born in Chester. Despite his early interest in art, his father persuaded him to become a bank clerk. While still employed in this capacity in Manchester, Caldecott began to study art and contribute drawings to various periodicals and newspapers. In 1872 he left Manchester and settled in London, where he studied with E. J. Poynter and developed friendships with the illustrators George Du Maurier and Charles Keene. He soon became a frequent contributor of humorous sketches to *Punch*, *The Graphic* and other periodicals. In the fall of 1875 (but post-dated 1876) Washington Irving's *Old Christmas* appeared with illustrations by Caldecott and was a great success for author and artist alike. Shortly thereafter, on the advice of Walter Crane and the printer Edmund Evans, Caldecott started work on his popular series of Picture Books, which were greatly admired by his friend Kate Greenaway. In 1886, after much success in England, he undertook a visit to America to do a series for *The Graphic* on American life. Poor health prevented him from carrying out this project, and he died in St. Augustine, Florida, at the age of forty. The American Library Association annually awards the Caldecott Medal to an outstanding illustrator of children's books, thus paying homage to an artist whose influence, like Beardsley's, extended far beyond his short life.

34 Two illustrations from *A Frog he would a-wooing go*
Pen, ink and watercolor; 6⅜ x 7¼″ (dinner scene), 6½ x 7⅞″ (frog courting)
Both drawings signed with initials (one at l.l. and the other at l.r.): "RC"
Ref.: Elizabeth Aslin, *The Aesthetic Movement*, pp. 171, 173; Charles Spencer, ed., *The Aesthetic Movement 1869-1890*, no. 130, p. 82; Rodney Engen, *Randolph Caldecott*, pp. 18, 68.
VICTORIA AND ALBERT MUSEUM, LONDON

Caldecott produced his series of Picture Books between 1878 and 1885 in collaboration with the printer Edmund Evans. These were issued in sixteen parts, appearing in pairs, but in later editions they were published in various formats. *A Frog he would a-wooing go* was published by George Routledge & Sons in 1883 in conjunction with *A Fox Jumps Over the Parson's Gate*. The animal actors in *A Frog* carry on their activities in a late-eighteenth-century house more or less adapted to the "Queen Anne" style. Caldecott has added delightful touches, like the peacock feather over Miss Mouse's mantel, to indicate that she was *au courant* with such emblems of the Aesthetic Movement.

Harry Clarke, 1889-1931

Clarke was born in Dublin, Ireland and educated by the Jesuits at Belvedere College. He was first apprenticed to an architect before joining his father's firm of stained glass designers. During this period he also studied with great success at the Dublin Metropolitan School of Art and won a traveling scholarship to study early stained glass in the French province of Île de France in 1914. In 1911, 1912 and 1913 he won the only gold medals given in stained glass at the South Kensington exhibitions. Clarke was an active member of his father's Dublin workshop, which designed stained glass for religious institutions and secular clients from Ireland to Africa. Following his father's death in 1921, he extended the company (which eventually came to bear his name) and served as its managing director and principal designer. The delicate intensity of his designs in glass found a parallel in the elegant yet often horrific illustrations he did for such volumes as Andersen's *Fairy Tales* (1916), Poe's *Tales of Mystery and Imagination* (1919) and *The Fairy Tales of Charles Perrault* (1922), all published by George Harrap (whom he had met on a trip to London in 1915). To his reputation as a book illustrator and designer of stained glass, Clarke added that of textile designer before his untimely death from consumption in Switzerland.

35 "Upon the bed there lay a nearly liquid mass of loathsome detestable putridity" from "The Facts in the Case of M. Valdemar" in *Tales of Mystery and Imagination* by Edgar Allan Poe, 1919
Pen and black ink, 13½ x 10¼″
Signed in pencil on verso: "Harry Clarke"
Ref.: Malcolm C. Salaman, *British Book Illustration Yesterday and To-Day*, pp. 40, 171 (unpublished version).
DRUSILLA AND COLIN WHITE

Tales of Mystery and Imagination was published by George Harrap in 1919 and, as the title might suggest, it contained some of Clarke's most horrifying images. In Clarke's first version of this illustration to "M. Valdemar" the corpse was depicted in a more advanced state of decay and the scene was set slightly closer to the front of the picture plane. When the publisher found this portrayal too shocking, the artist altered the representation of the corpse and moved the accompanying figures farther into the background. This second version was then used in the book. The original illustration is currently in the possession of the artist's family and is considered by many to be, in fact, less disturbing than the published version.

36 "A long black pudding came winding and wriggling towards her" from "The Ridiculous Wishes" in *The Fairy Tales of Charles Perrault*
Pen, ink, pencil and watercolor, 12½ x 9⅞″
Signed at u.r.: "Harry Clarke"
JOHN D. MERRIAM

Harrap published *The Fairy Tales of Charles Perrault* in 1922. Three years later Clarke added to this drawing for the volume an inscription which reads: "For H. Byrne Hackett from Harry Clarke. Aug 1925." The scene at first glance is a

rather humorous costume piece until the viewer notes the wriggling pudding at the lower left and the chain of sprites dancing across the composition.

37 Endpaper design from *Selected Poems of Algernon Charles Swinburne*
Pen and ink, 14½ x 12¾″
Signed at l.r.: "Harry Clarke"
MICHAEL LAURENCE CLARKE

Harry Clarke's illustrations to the *Selected Poems* were published in 1928 by John Lane in London and Dodd, Mead and Company in New York. The endpaper design exhibits a typical array of fanciful figures and patterns representative of Clarke's wide range of imaginative ideas.

38 "Faustine" from *Selected Poems of Algernon Charles Swinburne*
Pen and wash, 9¾ x 6″
Signed with monogram at l.l.: "C"
MICHAEL LAURENCE CLARKE

An illustration to the poem of the same title, "Faustine" represents a perfect marriage between author and illustrator. The aura of Swinburne's images of decadence and decay is totally captured in Clarke's portrayal of this fatal woman surrounded by grotesque and macabre figures, most of which are overtly sexual.

39 Tailpiece from "Aholibah" in *Selected Poems of Algernon Charles Swinburne*
Pen and ink, 3¼ x 2″
Signed on verso: "Clarke"
MICHAEL LAURENCE CLARKE

Clarke's effectively chilling image is far removed from the type of whimsical fancies generally appearing in tailpiece designs.

Charles Conder, 1868-1909

Born in London, Conder moved with his family to India while still a child. As a young man he was sent to Australia to work as a surveyor for his uncle, but he also studied painting in both Melbourne and Sydney. He contributed drawings to the *Illustrated Sydney News,* an activity which encouraged his uncle to undrewrite Conder's move to Paris in 1890 for further artistic training. There he studied at the Académie Julian. Conder was elected to membership in the New English Art Club in 1893 and in 1897 he made England his permanent home, although he continued to travel widely. He exhibited at the Leicester and Grafton Galleries in addition to the New English Art Club, was a founding member of the Society of Twelve, and frequently had works reproduced in *The Yellow Book.* Poor health forced him to abandon painting in 1906, and he died three years later. Although he often painted in oil, Conder's reputation rests mainly on the delicate and evocative watercolors he painted on silk in the form of fans or decorative panels. He was an accomplished illustrator as well and engraved his own sketches on wood for such volumes as the English translation of Balzac's *La Fille aux Yeux d'Or (The Girl with the Golden Eyes,* 1896).

40 "The Romantic Excursion," 1899
Brush, wash and watercolor with touches of gold on silk, 6½ x 16¼″ (fan format)
Signed at u.r.: "Conder"
Ref.: Frank Gibson, *Charles Conder, His Life and Work,* p. 96.
HENRY HAWLEY

Walter Crane, 1845-1915

Crane was born in Liverpool, the son of a portrait painter and illustrator, and began his artistic training as an apprentice in wood engraving at the shop of William James Linton in London (1859-1862). He also studied at the Heatherley School of Fine Art. His early work as a free-lance illustrator included designs for John de Capel Wise's *The New Forest* (1862) and for such periodicals as *London Society* and *Once a Week.* In 1863 Crane met the color printer Edmund Evans, whose earliest commissions to the artist seem to have been for illustrations to cheap novelettes, and later for children's stories. Crane provided drawings for dozens of inexpensive Toy Books while collaborating with Evans, beginning with *The House that Jack Built* in 1865. A decade later the first of nearly a score of books he would illustrate for Mrs. Mary Molesworth's stories appeared. During this period the artist began a succession of decorated books which did not form part of a series like the Toy Books or the Mrs. Molesworth stories. One of the first of these, *The Baby's Opera,* issued at Christmas, 1876, was an extremely successful small volume, which derived its format from a series of tiles Crane had designed. (It was supposedly as a companion to the popular *Baby's Opera* that Kate Greenaway produced her early success *Under the Window.*) Crane's illustrations in later years showed various stylistic influences as diverse as Blake, Burne-Jones, Japanese prints and early herbals. In addition to illustrating books, Crane exhibited paintings at, among other places, the Royal Academy, the Grosvenor Gallery and the New Gallery in London. He also made major contributions to the decorative arts movement, designing textiles, carpets, tiles, stained glass, pottery and decorative gesso work. From 1875 on he created wallpaper designs for Jeffrey and Company and began an association with the Royal School of Art Needlework. He was a founder and Master of the Art Workers' Guild and the president of the Arts and Crafts Exhibition Society from its inception in 1888 until 1912 (except for the years 1893-1896 when William Morris held the office). Crane's book, *The Claims of Decorative Art,* which appeared in 1892, took a position on art and economics close to that of Morris. He had become, in fact, an ardent Socialist, and he joined Morris' Socialist League shortly after its establishment in 1885. In the same year he became a member of the Fabian Society, and for the rest of his life he often placed his versatile talents at the service of the Socialist cause. His late works include numerous decorative arts commissions, book illustrations such as those for William Morris' *The Story of the Glittering Plain*

(Kelmscott Press, 1894) and Spenser's *The Shepheard's Calendar* (1898), as well as his own writings, including *Of The Decorative Illustration of Books Old and New* (1896) and *Ideals in Art* (1905). Crane had an enormous influence on the arts both as an artist and as an art educator. During his career he served as Director of Design at the Manchester School of Art, Director of the Art Department at Reading University College and Principal of the Royal College of Art.

41 "Butterfly's Ball"
 Pen, ink and watercolor, 9⁷⁄₁₆ x 6⅝″
 TRUSTEES OF THE BRITISH MUSEUM

This combination of anthropomorphic fantasy and fairy painting is rather more delicately rendered than most of Crane's work. The scene may have been intended as an actual illustration to William Roscoe's famous poem for children, *The Butterfly's Ball and the Grasshopper's Feast* (which first appeared in book form in 1807), or Crane may simply have been inspired by the theme.

42 "Puss Kills the Ogre" from *Puss in Boots*
 Pen, ink and watercolor, 8 x 6⅛″
 Signed with monogram at l.l.: "C" (with the figure of a crane)
 MUSEUM OF FINE ARTS, BOSTON. GIFT OF MRS. JOHN L. GARDNER, 1892

Puss in Boots was one of the many popular Sixpenny Toy Books by Crane, and was published by George Routledge in 1873. The central portion of the drawing is given to a handwritten text which accompanies the three episodes portrayed on the sheet.

43 "Beauty and the Beast" from *Beauty and the Beast Picture Book*
 Color wood engraving from bound volume, 10¾ x 9″ (each page)
 Signed with monogram at l.l.: "Cvv" (with the figure of a crane)
 Ref.: Ruari McLean, *Victorian Book Design and Colour Printing*, p. 204 and Pl. 13; Rodney Engen, *Walter Crane as a Book Illustrator*, pp. 19, 53-54.
 JOHN D. MERRIAM

Beauty and the Beast first appeared in 1874 as a Shilling Toy Book published by Routledge. In 1901 John Lane reissued the story along with "The Frog Prince" and "The Hind in the Wood" under the title *Beauty and the Beast Picture Book*. A reissue was also published in America by Dodd, Mead and Company, New York, of which this volume is a copy. (Edmund Evans' blocks seem to have been used for all of these editions.) In "Beauty and the Beast," a double-page illustration, Crane has placed the demure young heroine and the rather swashbuckling beast in the midst of a very elegant classical-revival setting. He has included such details as a leopardskin rug on the floor and appropriately cloven boots for the beast.

44 Frontispiece to *The Baby's Bouquet, A Fresh Bunch of Old Rhymes with New Dresses*, collected and arranged by Lucy Crane
 Pen, ink and watercolor, 6⅛ x 6¹⁄₁₆″
 Signed with monogram at l.l.: "Cvv" (with the figure of a crane)
 TRUSTEES OF THE BRITISH MUSEUM

The Baby's Bouquet was printed by Edmund Evans and published by George Routledge and Sons in 1878. It was issued as a companion to *The Baby's Opera*, which Crane had produced in time for Christmas 1876 (although the volume was dated 1877).

45 "The Sleeping Beauty"
 Glazed and embossed stoneware tile or plaque, 14½ x 12½″ (hexagonal)
 Signed with monogram at l.l.: "Cvv" (with the figure of a crane) and impressed with an illegible maker's mark on the reverse
 ALBERT GALLICHAN AND PETER ROSE

Crane used the Sleeping Beauty theme for a variety of decorative commissions, including the well-known wallpaper derived from his earlier Toy Book edition of the story and issued by Jeffrey and Company in 1879. Although Crane had done some ceramic designs for Wedgwood in the 1860s, his major ceramic and tile commissions came from Maw and Company, the London Decorating Company (of which he became Art Superintendent in 1880) and Pilkington's Tile and Pottery Company.

46 Cover design for *A Pocket Full of Rhymes*
 Pen, ink and watercolor, 9 x 7⅜″
 Both the artist's name and monogram appear within the design: "Walter Crane" and "Cvv" (with the figure of a crane)
 THE BALTIMORE MUSEUM OF ART, NELSON & JUANITA GREIF GÜTMAN COLLECTION

A Pocket Full of Rhymes is not listed in any of the available sourcebooks on Crane. Between 1879 and 1890 the artist did a number of picture books for his own children, Beatrice, Lionel and Lancelot. Most of these books were unpublished, and it is possible that *A Pocket Full of Rhymes* falls into this category. In theme and handling it is quite close to *Legends for Lionel*, which Crane did for his son in 1885. Published by Cassell & Company two years later, this was one of the few books executed for his family to appear in print.

47 "A knife and a fork" from *A Pocket Full of Rhymes*
 Pen and black ink, 9 x 7⅜″
 Signed with monogram at l.r.: "Cvv" (with the figure of a crane)
 THE BALTIMORE MUSEUM OF ART, NELSON & JUANITA GREIF GÜTMAN COLLECTION

Crane's facility as a designer is put to good use in this delightful scene, which could serve as a humorous catalogue of British taste in tableware of the period.

48 "Little Timmie Timkins" from *A Pocket Full of Rhymes*
 Pen and black ink, 9 x 7⅜″
 THE BALTIMORE MUSEUM OF ART, NELSON & JUANITA GREIF GÜTMAN COLLECTION

49 "Middle of the Forest of Rosedale," Act I, Scene i, from *The First of May, A Fairy Masque* by John R. de Capel Wise
 Pencil, pen and brown ink, 8¹³⁄₁₆ x 11⅜″

Ref.: Bertha E. Mahony, Louise Payson Latimer and Beulah Folmsbee, *Illustrators of Children's Books 1744-1945*, pp. 59-61; Isobel Spencer, *Walter Crane*, pp. 82-83.
JOHN D. MERRIAM

Crane has inscribed the title in ink across the top of this pencil drawing: "The • First • of • May: A • Fairy • Spectacle." The word "Spectacle" is crossed out and "Masque" has been written above it in pencil. *The First of May*, with fifty-two designs by Crane, was published by Henry Sotheran & Company in 1881 and dedicated to Charles Darwin. The splendid photogravure plates reproducing Crane's pencil drawings were printed by Goupil in Paris. The artist's relationship with Wise began during the early years of his career as an illustrator when he was commissioned to provide drawings for Wise's elegant gift book *The New Forest*. In *The First of May*, Wise, under the obvious inspiration of *A Midsummer Night's Dream*, has created a fairy fantasy set in Sherwood Forest. Both author and artist spent much time at Sherwood Forest during the preparation of the volume.

50 "A gloomy dell of firs," Act II, Scene ii, from *The First of May, A Fairy Masque* by John R. de Capel Wise, 1881
Photogravure plate from portfolio, 9½ x 12″
Ref.: Bertha E. Mahony, Louise Payson Latimer and Beulah Folmsbee, *Illustrators of Children's Books 1744-1945*, pp. 59-61; Isobel Spencer, *Walter Crane*, pp. 82-83.
JOHN D. MERRIAM

The influence of William Blake is particularly apparent in this portrayal of Mandrake amidst a motley crew of imps and monsters. This influence can be sensed not only in such figures as the scaly monster at the left and that of Mandrake himself, but also in the basically symmetrical presentation of the scene, which is reminiscent in feeling of the type of balanced composition favored by Blake.

51 "While Tulips lift the banner red" from *Flora's Feast: A Masque of Flowers* by Walter Crane
Pen lithograph proof and watercolor, 8¹/₁₆ x 6″
Signed with monogram at l.l.: "Cvv" (with the figure of a crane)
Ref.: Boston, Museum of Fine Arts, *Catalogue of Paintings and Drawings in Water Color*, 1949, pp. 58-59.
MUSEUM OF FINE ARTS, BOSTON. GIFT OF MRS. JOHN L. GARDNER, 1892

Flora's Feast, the first and most popular of several flower books by the artist, was published by Cassell and Company in 1889. The original drawings were reproduced in lithography with watercolor tints added to the outline proofs to insure controlled and careful printing of the rich designs. The personified flowers represent an extremely decorative and quite gentle type of fantastic transformation in comparison with the dramatic anthropomorphized trees to be found later in the work of Arthur Rackham.

52 Swan vase, c. 1889
Earthenware with ruby lustre glaze, 9⅛″ h.
Signed with Crane's monogram on the base and inscribed: "Maw & Co. Limited"
Ref.: P. G. Konody, *The Art of Walter Crane*, p. 122 and reproduction; Hugh Wakefield, *Victorian Pottery*, Pl. 85 (similar example); Geoffrey A. Godden, *An Illustrated En-*

cyclopedia of British Pottery and Porcelain, p. 221, Pl. 390 (similar example); London, The Royal Academy of Arts, *Victorian and Edwardian Decorative Art, The Handley-Read Collection*, no. G25, p. 118; Isobel Spencer, *Walter Crane*, pp. 111-112 (similar example).
FITZWILLIAM MUSEUM, CAMBRIDGE

This intriguing grotesquerie was one of seven pots Crane designed for Maw and Company around 1889. The body of the piece unites the head of a swan and the tail of a fish to a galley-shaped base, while the surface decoration includes the figures of two sailors and several dolphins. Another version of the vase, less finely worked, is in the Victoria and Albert Museum.

53 "Peacock Garden" wallpaper, 1889
Block-printed design on machine-made paper, 59¾ x 43¼″ (framed segment)
Ref.: P. G. Konody, *The Art of Walter Crane*, p. 118; Isobel Spencer, *Walter Crane*, pp. 106-107; Rowland and Betty Elzea, *The Pre-Raphaelite Era 1848-1914*, no. 5-16, p. 119.
COOPER-HEWITT MUSEUM, THE SMITHSONIAN INSTITUTION'S NATIONAL MUSEUM OF DESIGN, GIFT OF GRACE LINCOLN TEMPLE

Between 1875 and 1912 Crane designed several dozen wallpapers which were printed by Jeffrey and Company, London. The first of these, "The Queen of Hearts," was a machine-printed nursery paper. "Peacock Garden," sold with an accompanying frieze entitled "White Peacock," was shown at the Paris Exhibition in 1889. In its fluid interlacing of forms "Peacock Garden" comes suspiciously close to Art Nouveau, which Crane had referred to as "that strange decorative disease." Along with the sunflower and the lily, the peacock had become one of the most popular motifs of late Victorian design; all three were, in fact, emblems of the Aesthetic Movement. Peacocks seem to have first appeared in Crane's illustrations to children's books during the 1870s (such as the *Baby's Own Alphabet*, 1875).

54 "Fairy Garden" wallpaper, 1890
Machine-printed design on paper, 27¾ x 21″
Ref.: Isobel Spencer, *Walter Crane*, pp. 92, 104.
VICTORIA AND ALBERT MUSEUM, LONDON

"Fairy Garden" is one of seven nursery papers designed by Crane, all of which were machine-printed by Jeffrey and Company. The nursery papers derived from Crane's picture books, and "Fairy Garden" was based on such plates as "Sweet Hyacinths" and "Wide Oxeyes" in *Flora's Feast*.

55 "And spread with 'broidered hangings gay, Till all was ready for the fray" from *Queen Summer or The Tournament of the Rose* by Walter Crane
Pen, ink and watercolor over pencil, 8 x 6¹⁵/₁₆″
Signed with monogram at l.l.: "Cvv" (with the figure of a crane)
Ref.: Rodney Engen, *Walter Crane as a Book Illustrator*, Pl. 16 (published version).
JOHN D. MERRIAM

Crane did forty color plates for *Queen Summer*, which Cassell and Company published in 1891. The over-all patterning in this graceful drawing is reminiscent of medieval tapestry design. The artist has used quick, thin strokes of his pen

and delicate touches of color in contrast to the bolder, flat tints found in much of his earlier work.

56 "Guyon findes Mamon in a delve" from Book II of *The Faerie Queene* by Edmund Spenser
Pen, black ink and white heightening, 9½ x 7⅝"
Signed with monogram at l.l.: "Cvv" (with the figure of a crane)
Ref.: P. G. Konody, *The Art of Walter Crane*, pp. 71, 74; Isobel Spencer, *Walter Crane*, p. 135.
VICTORIA AND ALBERT MUSEUM, LONDON

Crane's illustrations to Thomas J. Wise's edition of Spenser's poem were published by George Allen in nineteen parts between 1894 and 1897. Guyon's gesture of amazement as he spies the hoard of gold is a reprise of Hallblithe's pose in "Hallblithe beholdeth the Woman" from *The Glittering Plain* (1894), which Crane had illustrated for William Morris' Kelmscott Press.

57 "Flora's Train," set of six tiles, 1902
Lead-glazed molded earthenware, each 6" square
Initialed on reverse with maker's mark: "P"
Ref.: London, Victoria and Albert Museum, *Catalogue of an Exhibition of Victorian & Edwardian Decorative Arts*, no. M52, p. 69; Julian Barnard, *Victorian Ceramic Tiles*, Pl. 51; Isobel Spencer, *Walter Crane*, p. 112.
VICTORIA AND ALBERT MUSEUM, LONDON

Crane designed this series of tiles for Pilkington's Tile and Pottery Company. They were executed in the so-called "cuenca" technique of molded earthenware with the design filled in with colored glazes. The designs were wrongly attributed to Lewis F. Day in both the catalogue of the Arts and Crafts Exhibition Society for 1903 (no. 353) and an article in *The Studio* of the same year (vol. 28, p. 181).

58 "Mistress Mary" wallpaper, 1903
Machine-printed design from engraved rollers, 21 x 25½"
Ref.: Isobel Spencer, *Walter Crane*, pp. 104, 138.
VICTORIA AND ALBERT MUSEUM, LONDON

Crane's "Mistress Mary" wallpaper, produced by Lightbown, Aspinall & Company, was shown at the Arts and Crafts Exhibition Society in 1906. The flat, elegant design has much in common stylistically with those in Crane's flower book *A Floral Fantasy in an Old English Garden* (1899).

59 "But up there rose with grace & ease the sprightly sultan of the fleas" from *Rumbo Rhymes or, The Great Combine, A Satire*, by Alfred C. Calmour
Pen, ink and watercolor, 9 x 6½"
Signed with monogram at l.l.: "Cvv" (with the figure of a crane)
Ref.: Isobel Spencer, *Walter Crane*, pp. 138-139.
SPENCER COLLECTION, THE NEW YORK PUBLIC LIBRARY, ASTOR, LENOX AND TILDEN FOUNDATIONS

Calmour's satire attacking man's inhumanity to the non-human inhabitants of the earth was published by Harper & Brothers in 1911. Crane's designs were extremely witty and rather bolder in handling than most of his earlier work. There are still traces of Japanese influence in the outlining of the figures and in the compositional structure of the page.

George Cruikshank, 1792-1878

Cruikshank was born in the Bloomsbury section of London. The son of the caricaturist Isaac Cruikshank, he learned to etch plates while still a child. After the death of James Gillray in 1815, George Cruikshank, who had completed some of Gillray's last plates, became the leading chronicler in caricature of the political scene, particularly the decline and fall of Napoleon. Until the 1820s he frequently collaborated with his elder brother Robert. During 1823-1824 the two-volume *German Popular Stories* (the first English translation of fairy tales by the brothers Grimm) appeared with etched illustrations by Cruikshank. He soon began to devote his talents less to individual caricatures and more to book illustration. Among the better-known illustrations to his credit during this period are designs for Sir Walter Scott's *Demonology and Witchcraft* (1830) and illustrations for Dickens' early works, *Sketches by Boz* (1836-1839) and *Oliver Twist* (1837-1839). From 1835 to 1853 he contributed regularly to *The Comic Almanack*; indeed, this periodical was essentially a vehicle for his work. His plates for *The Bottle* (1847) with accompanying text by Dr. Charles Mackay were an instant and spectacular success. The same year he allied himself with the temperance cause. From 1853 to 1864 Cruikshank issued his own moralizing versions of traditional fairy tales along with etched illustrations in the series entitled *George Cruikshank's Fairy Library*. Although never abandoning his art, he spent much of the remainder of his life furthering the temperance movement as a member of such groups as the Havelock Volunteer Temperance Corps of the Middlesex Rifles Militia (1859-1868).

60 "Jorinda and Jorindel" from Volume I of *German Popular Stories* translated from the *Kinder und Haus Märchen*, collected by M. M. Grimm from oral tradition, 1823
Etched plate from bound volume, 7¹⁄₁₆ x 3¹⁵⁄₁₆"
Signed at bottom center: "G CK"
Ref.: Albert M. Cohn, *George Cruikshank, A Catalogue Raisonné*, no. 369; Richard Vogler, *George Cruikshank: Printmaker (1792-1878)*, no. 71, p. 32.
PRINCETON UNIVERSITY LIBRARY

The *Kinder und Haus Märchen* made their appearance in Germany between 1812 and 1815. Later to be known simply as "Grimm's Fairy Tales," these enormously popular stories were first translated into English by Edgar Taylor. The translation was published in London in two volumes, the first by C. Baldwyn in 1823 and the second by James Robins in 1824. Cruikshank's etched illustrations, in vignette form, appeared in both volumes. In this scene, set in a Gothic interior whose furnishings seem to take on human characteristics, the old fairy is attempting to flee with Jorinda, who has been transformed into a nightingale.

61 "A Fantasy"
Watercolor and bodycolor over pencil, 11¹³⁄₁₆ x 15⅝"
Signed at bottom center: "GeorgeCruikshank"
TRUSTEES OF THE BRITISH MUSEUM

Cruikshank's delight in minutiae is apparent in this portrayal of a popular fairy theme, the "fairy ring." Here the fairies dance by the light of the moon, while one of their number rides a bat overhead.

62 "The Bean Stalk makes a prisoner of the Giant — ./ The Bean Stalk takes the Giant prisoner" and "The Fairies tie the Giant, up in the Bean Stalk" from *The History of Jack & the Bean-Stalk* by George Cruikshank
Original pencil and watercolor drawing and a proof etching; 8½ x 6¹⁵⁄₁₆" (drawing), 7⅞ x 5¼" (etching, sheet)
Proof signed along right edge: "Designed & Etched by George Cruikshank" and inscribed in pencil across bottom: "From Geoʳ. Cruikshank to his friend Fredᵏ. Arnold"
Ref.: Albert M. Cohn, *George Cruikshank, A Catalogue Raisonné*, no. 197; Richard Vogler, *George Cruikshank: Printmaker (1792-1878)*, no. 121, p. 45.
PRIVATE COLLECTION

The History of Jack & the Bean-Stalk, published by David Bogue in 1854, was one of four fairy tales written (or, more appropriately, retold) and illustrated by the artist which made up *George Cruikshank's Fairy Library*. The four stories were originally issued separately in cardboard covers and were later published together in book form. This unique volume contains nine original pencil and watercolor sketches for the etched illustrations and proof states of the etchings themselves, each of the latter inscribed by the artist to the publisher Frederick Arnold.

63 "Tam pursued by demons" from *Tam O'Shanter* by Robert Burns, 1854
Oil on panel, 15¾ x 20"
Signed and dated in block letters at l.c.: "George Cruikshank 1854"
Ref.: Richard Vogler, *George Cruikshank: Printmaker (1792-1878)*, no. 3, pp. 11-12.
FROM THE RICHARD VOGLER CRUIKSHANK COLLECTION

The painting illustrates the scene from Burns' *Tam O'Shanter* in which Tam and his horse Maggie flee from a horde of warlocks, witches and goblins whom they have disturbed in a churchyard. Cruikshank drew upon the repertoire of monsters he used in his prints for several of the figures in the painting. *Tam O'Shanter* offered fertile stimulation to Cruikshank's imagination, and an exhibition of the artist's work at the Victoria and Albert Museum in 1974 included two more versions of the subject, a painting and a drawing.

Richard Dadd, 1817-1886

The son of a chemist who later became a carver and gilder, Dadd was born at Chatham but moved to London where he attended the Royal Academy Schools. Between 1837 and 1842 he exhibited portraits, landscapes, figure compositions and fairy paintings at the Royal Academy, the Society of British Artists, and the British Institution. With his friend William Powell Frith and several other artists he became a founding member of a sketching group known as "The Clique." During this period he received a commission from Lord Foley to do an extensive series of paintings illustrating Byron's *Manfred* and Tasso's *Jerusalem Delivered* for Foley's house in Grosvenor Square (their current whereabouts is unknown), and in 1842 he was commissioned to design several wood engravings to illustrate "The Ballad of Robin Goodfellow" in S. C. Hall's *Book of British Ballads*. On his return in 1843 from an extended trip through Europe and the Middle East with Sir Thomas Phillips, he exhibited clear signs of mental illness. Dadd's mad behavior, which culminated in the murder of his father, led to his confinement from 1844 on, first at Bethlem Hospital and later at Broadmoor. In both institutions he was allowed to continue his activity as a painter and watercolorist. During his long imprisonment he produced a haunting series of works which at times focused on historical themes and romantic legends and at other times seemed to spring from a more private realm of fantasy. (Even prior to his illness, Dadd had tended towards imaginative representations, with the characters from *A Midsummer Night's Dream* particular favorites.) The acknowledged masterpieces of his period of confinement are two oils, "Oberon and Titania" (1854-1858) and "The Fairy Feller's Master-Stroke" (c. 1855-1864), both done at Bethlem. Dadd died of consumption at Broadmoor and was buried on the hospital grounds.

64 "Songe de la Fantasie," 1864
Pen, ink and watercolor, 15¹⁄₁₆ x 12⅜"
Signed and dated at u.l.: "Songe de la Fantasie . Rᵈ Dadd Novʳ 1864."
Ref.: John Rickett, "Rd. Dadd, Bethlem and Broadmoor," *The Ivory Hammer* (Sotheby's), 2 (1964); David Greysmith, *Richard Dadd: The Rock and Castle of Seclusion*, pp. 124-125, 181, Pl. 93; Patricia Allderidge, *The Late Richard Dadd*, no. 192, pp. 126-127.
FITZWILLIAM MUSEUM, CAMBRIDGE

This watercolor is a replica of the artist's masterpiece in oil, "The Fairy Feller's Master-Stroke" (Tate Gallery, London), which Dadd had worked on between 1855 and 1864. The painting remained at Bethlem when he was transferred to Broadmoor. "Songe de la Fantasie" was painted shortly after the artist's arrival at Broadmoor and while it is in most respects an extremely faithful reprise of the first version of the subject, there are several significant differences. Most noticeable is a change from the deep, earthy tones of the oil to soft, pastel tonalities. There is also a more intense decorative patterning created by the less naturalistic, more calligraphic rendering of the grasses and stems. The characters in both works are a broad representation of the fairy kingdom, including Queen Mab, Oberon and Titania, several elves, nymphs, dwarf conjurers and numerous others.

65 "Fantasie de l'Hareme Egyptienne," 1865
Pen, ink and watercolor heightened with white, 10⅛ x 7"
Signed, dated and inscribed at u.r.: "Fantasie de l'Hareme Egyptienne — par Monsʳ Rd. Dadd — quasi — Octobre 1865 — Broadmoor — Berks —"
Ref.: David Greysmith, *Richard Dadd: The Rock and Castle of Seclusion*, pp. 125, 181 and Pl. 96; Patricia Allderidge, *The Late Richard Dadd*, no. 195, p. 130.
LENT BY THE VISITORS OF THE ASHMOLEAN MUSEUM, OXFORD

Although by its very nature exotic and intriguing, this harem scene is made even more fantastic by the combination of extreme insistence on the ornamental excesses of the architectural setting and the disturbingly cryptic cast of characters, which includes a strange, robed figure at the center of the scene and a most elegant and self-possessed cat in the foreground.

Francis Danby, 1793-1861

Danby was born in Wexford, Ireland, and moved with his family to Dublin as a small child. He studied art at the Royal Dublin Society Schools and under the tutelage of the landscape painter James O'Connor. In 1813 he traveled to England with O'Connor, eventually settled for ten years in Bristol, and then later moved to London. From 1821 until his death, he exhibited frequently at the Royal Academy. Although he was elected to associate membership in the Academy in 1825, he was never promoted to full membership. This, along with other disappointments, precipitated his departure from England for the Continent, where he spent close to a dozen years, living primarily in Switzerland. He then returned to England and finally established himself permanently in Exmouth. Danby's work ranged from poetic landscapes and marines to mythologies and visionary fantasies suggestive of the work of John Martin. In 1961 the Arts Council of Great Britain devoted an exhibition to his *oeuvre*.

66 "Scene from *A Midsummer Night's Dream*" by William Shakespeare, 1837
 Watercolor and bodycolor, 6 x 8⅛"
 YALE CENTER FOR BRITISH ART, PAUL MELLON COLLECTION

A dealer's inscription on the drawing's original mount, now lost, recorded the title, artist and date of the sheet as "Oberon and Titania — Francis Danby, A.R.A., 1837." A similar watercolor, dated 1832 and illustrating Act II, Scene i of Shakespeare's play, is in the Municipal Art Gallery, Oldham. Danby's tenebrous and delicate portrayal provides a link between the eighteenth-century visionary tradition represented by the work of John Martin, Blake and others and the important genre of fairy painting which blossomed during the mid-nineteenth century.

William Frend De Morgan, 1839-1917

The son of a mathematician and professor of philosophy, De Morgan was born in London and studied at the Royal Academy Schools (1859-1862). He soon met Burne-Jones, Lord Leighton and Rossetti, but was most influenced by William Morris. He began designing stained glass, tiles and, occasionally, painted furniture for Morris, Marshall, Faulkner and Company which was founded in 1861. Developing an interest in ceramics, De Morgan set up a small kiln at his home in Fitzroy Square. In 1871, he moved to Chelsea where he established a pottery works, although at first he primar-

ily decorated commercially-supplied pottery and tiles. He was much influenced by Near Eastern ceramic decoration, using "Persian" (often Syrian and Isnik) designs and colors as well as lustre glazes more immediately derived from early European examples. In 1882 he is recorded as moving with Morris to Merton Abbey, where he continued to produce a great many decorative wares for Morris & Company (founded in 1875 as the successor to Morris, Marshall, Faulkner and Company). Six years later, in partnership with the architect Halsey Ricardo, De Morgan established a pottery at Sands End, Fulham, which remained the center of his production until his retirement in 1905. Failing health had forced De Morgan into reduced activity at the pottery before 1905, but he turned his creative energies to writing and produced several novels, including the popular *Joseph Vance*, prior to his death in 1917.

67 Dish with dragon motif, c. 1882-1888
 Staffordshire earthenware with ruby lustre decoration, 14" diameter
 Ref.: Roger Pinkham, *Catalogue of Pottery by William De Morgan*, no. 5, pp. 26, 34.
 VICTORIA AND ALBERT MUSEUM, LONDON

De Morgan's early ruby lustre pieces, like this dragon dish, were done on earthenware blanks purchased from Staffordshire. Morris' influence is evident in the decorative patterning of the background against which the fearsome beast seems to be attacking its tail.

68 Covered jar
 Glazed earthenware with painted decoration in ruby lustre, 13¾" h.
 Signed with the impressed mark: "W. De Morgan & Co. Sands End Pottery"
 Ref.: Rowland and Betty Elzea, *The Pre-Raphaelite Era 1848-1914*, no. 4-68, pp. 98-99.
 LENT BY THE METROPOLITAN MUSEUM OF ART, EDWARD C. MOORE, JR., GIFT FUND, 1923

During the existence of the Sands End pottery at Fulham, De Morgan produced some of his finest works. The covered jar, which was purchased from Morris & Company in 1923, is an excellent example of De Morgan's "revivalism." The body decoration is derived from an Italian brocade of the fourteenth century, while the radiating pattern on the cover was undoubtedly inspired by designs on Italian majolica pottery of the late fifteenth century.

69 Plate
 Earthenware with underglaze painted decoration, 16" diameter
 Signed with initials on the reverse: "C.P."
 Ref.: Rowland and Betty Elzea, *The Pre-Raphaelite Era 1868-1914*, no. 4-69, pp. 98-99.
 LENT BY THE METROPOLITAN MUSEUM OF ART, EDWARD C. MOORE, JR., GIFT FUND, 1923

Purchased from Morris & Company in 1923, this plate in De Morgan's "Persian" style is signed with the initials of Charles Passenger, who, with his brother Fred, did much of the fine painting of De Morganware during the Fulham period. Most of De Morgan's so-called Persian designs were

actually combinations of Syrian and Isnik motifs, but he also imitated the drawing style of Persian manuscripts. Persian manuscript illumination was an equally if not more important source of inspiration for book illustrators, and the work of Edmund Dulac is most often cited in this regard.

70 Footed plate
Earthenware with underglaze painted decoration, 4 h. x 9⅜" diameter
Signed with a painted signature on base: "W.De.Morgan. .I.P Fulham" and "C.P." and also stamped "Wedgwood"
Ref.: Roger Pinkham, *Catalogue of Pottery by William De Morgan,* no. 45, p. 66 (similar example).
MUSEUM OF ART, RHODE ISLAND SCHOOL OF DESIGN, GIFT OF MISS ELLEN D. SHARPE

The painted decoration, which depicts a fantastic half-human monster in Italianate style, is in warm red and pink tones, while a similar piece in the Victoria and Albert Museum is in shades of blue. Both pieces are signed by De Morgan's painter Charles Passenger, but only the Rhode Island dish bears the Wedgwood mark.

Edward Julius Detmold, 1883-1957; Charles Maurice Detmold, 1883-1908

Edward Julius Detmold and his twin brother, Charles Maurice, were born in London, the sons of an engineer. Despite a lack of formal training, the talented brothers exhibited at the Royal Academy at the age of thirteen. According to Campbell Dodgson, the precocious twins "seemed as one soul divided between two bodies, inspired by the same ideal, using the same means of expression, possessing the same quickness of eye and deftness of hand." The pair became skilled printmakers, most of their early work consisting of etchings of various natural history subjects conceived with a decorative flair influenced by oriental art, particularly Japanese color prints. From 1899 onward, the brothers often collaborated on one etching plate. In that year a book, *Pictures from Birdland,* reproducing their watercolor drawings was published by J. M. Dent; another collaborative set of watercolors, illustrating Rudyard Kipling's *The Jungle Book,* appeared in 1903 (republished in a smaller format five years later). In 1908, at the age of twenty-five, Charles Maurice committed suicide by taking poison. His brother continued to produce drawings, primarily for publication. A hallmark of his style is the frequent combination of extremely naturalistic detail with a preciousness and delicacy of coloring reminiscent of Persian and Indian miniature painting, so that even the natural history subjects seem to be representatives of some otherworldly realm. This is perhaps best seen in his illustrations to *The Fables of Aesop* (1909) and *Fabre's Book of Insects* (1921). In 1924 he issued *The Arabian Nights (Tales from the Thousand and One Nights)* with a series of elegant plates again influenced by Eastern miniature painting. In later life he left London for northern Wales, but little is known of his activity there.

71 An Eastern scene
Pencil, 13⅞ x 8⅜"
VICTORIA AND ALBERT MUSEUM, LONDON

This haunting portrayal by Charles Maurice Detmold would appear to be a study for an illustration, possibly for a projected edition of *The Arabian Nights.* Almost two decades after his brother's suicide, Edward Detmold, who presented this drawing to the Victoria and Albert Museum, published his own enchanting illustrations to this enormously popular compilation of exotic tales.

72 "Study of Peacocks," 1900
Pencil, 13¾ x 9⅞"
Signed and dated at l.l.: "EJ Detmold. 1900"
Ref.: Campbell Dodgson, "Maurice and Edward Detmold," *The Print Collector's Quarterly,* 9, No. 4 (December 1922), p. 401.
TRUSTEES OF THE BRITISH MUSEUM

Although the peacocks have been drawn with precise ornithological accuracy, the presence of the mounted knight in the background combined with the bold jump in scale from foreground to background serve to disorient the viewer, and the image can only be understood as a form of fantasy.

73 "Shere Khan in Jungle" from *Sixteen Illustrations of subjects from Kipling's Jungle Book*
Color half-tone plate from portfolio, 13⅛ x 8⅝"
Signed at l.l.: "ED"
Ref.: Campbell Dodgson, "Maurice and Edward Detmold," *The Print Collector's Quarterly,* 9, No. 4 (December 1922), pp. 380, 383; David Larkin, ed., *The Fantastic Creatures of Edward Julius Detmold,* Pl. 1.
JOHN D. MERRIAM

Macmillan & Company published this deluxe portfolio of color reproductions after the Detmolds' drawings in 1903. The illustrations were reissued in a smaller and less expensive book format five years later. The brothers have combined a detailed and accurate rendering of the various animals with a careful but quite decorative treatment of their surroundings. The beasts are seen in close-up amidst lush vegetation or softly colored desert-like settings. The end result of this incongruous joining together of the quasi-scientific and the ornamental is an image which is both fanciful and often rather disturbing. This representation of Shere Khan by Edward Detmold, one of the most beautiful in the series, exhibits the artist's effective use of the lessons he learned from Japanese prints.

74 *The Fables of Aesop,* 1909
Bound volume, deluxe edition, cover design stamped in gold on white cloth, 12½ x 10¼"
Inscribed and dated on cover: "Edward · J · Detmold · London · 1909 · "
THE FREE LIBRARY OF PHILADELPHIA

This copy is number 330 of a deluxe edition of 750 published by Hodder & Stoughton. In contrast to the less elaborate trade editions, these deluxe copies were frequently gilt-stamped and bound in vellum or in a white buckram or another heavy cloth simulating vellum. The cover design

itself represents a phoenix (actually a hawk) with a nimbus around its head. It is a reprise of Edward Detmold's black and white etching of 1889 which appears in some impressions with the nimbus printed in gold. The decorative quality of the overall design and the ornamental detailing of the phoenix, besides reflecting the influence of oriental art, tend to place the carefully rendered creature in a world far removed from reality.

75 "The Praying Mantis" from *Fabre's Book of Insects,* retold by Mrs. Rodolph Stawell, 1920
Color half-tone plate from bound volume, 6$\frac{15}{16}$ x 6″
Signed with monogram and dated at l.l.: "EJD • 20"
Ref.: David Larkin, ed., *The Fantastic Creatures of Edward Julius Detmold,* Pl. 25.
PRIVATE COLLECTION

This edition of Fabre's *Souvenirs entomologiques* (originally translated by Alexander Teixeira de Mattos) was published by Hodder & Stoughton in 1921. The text describes the habits, habitats and origins of various members of the insect world. In Edward Detmold's illustrations, entomologically exact as one would expect, each insect and its setting is presented with such attention to design, pattern and color that the scenes no longer seem connected to the real world. Although isolated in close-up as they would be in most scientific manuals, the creatures perform with consummate grace amidst delicate flowers or branches in an imaginary realm devoid of ugliness or brutality.

76 "Revealing such treasure as surely mortal eyes had never before gazed upon," frontispiece (from "The Story of Baba Abdalla") to *The Arabian Nights,* 1922
Watercolor, 34$\frac{1}{4}$ x 24$\frac{1}{2}$″
Signed with monogram and dated at l.r.: "EJD • 22 • "
ROBERT ISAACSON

These remarkable designs for *The Arabian Nights* were published by Hodder & Stoughton in 1924. Drawing inspiration from Persian and Indian manuscript illuminations, Detmold was able to combine exquisitely detailed description with a subtle sense of mystery in his depictions of this fabulous world. The ornamental elegance of the scenes is heightened by the finely executed watercolor borders.

77 "On this dome is a brazen horseman, mounted on a brazen horse" from "The Story of the Third Calender" in *The Arabian Nights,* 1922
Watercolor, 31 x 22″
Signed with initials at l.r.: "EJD"
ROBERT ISAACSON

Not until around the turn of the century did it become both economically and technically practical to reproduce this type of delicately colored, dreamlike image in book illustration. By that time the revolution in the methods of color printing had greatly expanded the possibilities for fantasy illustrators like Detmold.

78 "One day there came to him Sindbad the Landsman" from "The First Voyage of Sindbad the Sailor" in *The Arabian Nights,* 1922

Watercolor, 32 x 23$\frac{1}{2}$″
Signed with monogram and dated at l.r.: " • EJD • 22 • "
ROBERT ISAACSON

Except perhaps for the paintings of John Frederick Lewis, the splendors of the East have rarely been portrayed with such lush color and attention to exotic detail.

Gustave Doré, 1832-1883

Doré was born into a well-to-do French family living in Strasbourg on the French-German border. A talented and precocious child, he published his first lithographs around 1845. Two years later his family visited Paris, and Doré's talent was brought to the attention of the publisher Charles Philippon. The young artist was placed under contract to Philippon as a lithographer of caricatures for the publisher's newly established *Journal pour rire.* Doré rose rapidly to success as an illustrator of books and periodicals. His wood-engraved illustrations for an 1854 edition of the works of Rabelais (with the remarkable designs for *Gargantua et Pantagruel*) firmly established his reputation. During the next three decades, Doré published several dozen illustrated volumes, among which were editions of Balzac's *Contes drôlatiques* (1855), Dante's *L'Enfer* (1861) and *Le Purgatoire et le paradis* (1868), Cervantes' *Don Quichotte* (1863), La Fontaine's *Fables* (1868) and Ariosto's *Roland furieux* (1879). Doré considered his wood-engraved illustrations a challenge to the new realism of photography and therefore painted his images directly onto the woodblocks in wash for maximum expressive effect. Despite his renown as an illustrator, he aspired to be a successful Salon painter, exhibiting large-scale oils from the 1850s onward. This ambition was never realized in Paris, but the artist found a sympathetic audience in London, where the Doré Gallery was established in 1868 for the sale of his paintings and printed works. That year he made the first of several trips across the Channel. Also from this period date the French artist's most important English publications, including illustrated editions of Milton's *Paradise Lost* (Cassell, Petter and Gilpin, 1866), Tennyson's *The Story of King Arthur and Queen Guinevere* (Moxon, 1868), Blanchard Jerrold's *London: A Pilgrimage* (Grant, 1872) and Coleridge's *The Rime of the Ancient Mariner* (Doré Gallery, 1875/1876). Towards the end of his life Doré turned to sculpture, but public response in France to this work was as disappointing as it had been to his large paintings.

79 "The ice was here, the ice was there, The ice was all around." from *The Rime of the Ancient Mariner* by Samuel Taylor Coleridge, 1876
Wood-engraved plate from bound volume, 20 x 15″
Signed at l.l.: "G Doré" and by the engraver at l.r.: "Jonnard"
Ref.: Henri Leblanc, *Catalogue de l'oeuvre complet de Gustave Doré,* p. 74; Nigel Gosling, *Gustave Doré,* pp. 74-75.
MR. AND MRS. CLIVE WAINWRIGHT

Doré's illustrations to Coleridge's poem were first published in 1875 by the Doré Gallery, London, with Doré underwriting the expenses. (A second printing, published by the Doré Gallery and Hamilton Adams & Co. in 1876, is often incorrectly listed as the first edition.) In 1877 the work was issued in both a French and an American edition. A master of chiaroscuro, Doré created many extremely evocative plates for Coleridge's poem, among which this is one of the most striking. The publication was not a financial success, however, and around 450 unbound copies of the English edition were found in the artist's studio after his death.

Richard Doyle, 1824-1883

Born in London, Richard Doyle was the son of the caricaturist John Doyle and exhibited evidence of his own artistic talent while still a child. He received his early training under his father and in the shop of the wood engraver Joseph Swain. Following in his father's footsteps, he joined the staff of *Punch* in 1843. Despite his many successes on the staff of this paper, among which was his famous design for its cover, Doyle resigned from *Punch* in 1850, unable to reconcile his Catholic beliefs with the paper's anti-papal bias. Doyle readily found a second career in book illustration, having already illustrated several volumes during the *Punch* years, including Grimm's *The Fairy Ring* (1845) and Mark Lemon's *The Enchanted Doll* (1849). In 1851 his illustrations to Ruskin's fairy tale *The King of the Golden River* were published. Doyle's masterpiece, *In Fairyland,* appeared in 1870, with wood-engraved illustrations in color accompanied by a poem by the Irish poet William Allingham. These designs later inspired Andrew Lang to write a new story, and the illustrations with Lang's text were reissued in smaller format under the title *The Princess Nobody* (1884). Doyle also designed relatively straightforward illustrations for such works as William Makepeace Thackeray's *The Newcomes* (1854-1855) and his own *Birds-eye Views of Modern Society* (1864, reprinted from *The Cornhill Magazine,* 1861-1862). But fairy themes were his specialty and he exhibited fairy subjects at the Royal Academy in 1868 and 1871 and at the Grosvenor Gallery shortly before his death. His younger brother Charles, the father of Sir Arthur Conan Doyle, shared this interest, and although he never became a professional artist, his charming watercolors of fairies are much sought after.

80 "Girls combing the beards of goats"
Pen, ink and watercolor, 5⅞ x 9¹³⁄₁₆"
Signed with monogram at l.r.: "ЯD"
Ref.: Brigid Peppin, *Fantasy, The Golden Age of Fantastic Illustration,* p. 61.

This charming watercolor is apparently unpublished. The psychosexual overtones frequently associated with this type of scene appear to be absent in Doyle's representation.

81 "Triumphal March of the Elf-King" from *In Fairyland, A Series of Pictures from the Elf-World,* with a poem by William Allingham, 1870
Wood-engraved plate from bound volume, 8 x 12"
Signed with monogram at l.l.: "ЯD"
Ref.: New York, The Pierpont Morgan Library, *Early Children's Books and Their Illustration,* no. 168, p. 180; Brigid Peppin, *Fantasy, The Golden Age of Fantastic Illustration,* pp. 64-65; Gordon N. Ray, *The Illustrator and the Book in England from 1790 to 1914,* no. 146, p. 90 and Pl. 72.

In Fairyland, perhaps the single most popular and influential series of fairy illustrations ever produced, was published by Longmans, Green, Reader, & Dyer in 1870. Edmund Evans was responsible for the beautifully printed color plates, of which the "Triumphal March" is the best known. The oft-quoted text beneath the title of this plate is almost as enchanting as the image and deserves to be repeated once again:

> This important personage, nearly related to the Goblin family, is conspicuous for the length of his hair, which on state occasions it requires four pages to support. Fairies in waiting strew flowers in his path, and in his train are many of the most distinguished Trolls, Kobolds, Nixies, Pixies, Wood-sprites, birds, butterflies, and other inhabitants of the kingdom.

82 "He finds her, and this is the consequence" from *In Fairyland, A Series of Pictures from the Elf-World,* with a poem by William Allingham
Pen, ink and watercolor, 2⅜ x 3⅛"
Signed with monogram at l.r.: "ЯD."

This coy but appealing image is one of three vignettes appearing on page 14 of *In Fairyland* which depict an elf's pursuit of his fairy love.

83 "The May Queen," *c.* 1870
Pen and watercolor over pencil, 8½ x 11⅝"
Ref.: London, The Maas Gallery, *Victorian Fairy Paintings, Drawings & Water-colours,* no. 43.

In style and handling this graceful scene is close to the images in Doyle's *In Fairyland* (1870) and probably dates from the same period. There is no notation by the artist on this apparently unpublished drawing to indicate the specific nature of his subject.

Edmund Dulac, 1882-1953

Dulac was born in Toulouse, France. While studying law at the university in Toulouse, he also attended classes at the École des Beaux-Arts. After two years he gave up his legal studies and eventually made his way to Paris, where he attended the Académie Julian (under Jean-Paul Laurens). Already an Anglophile and deeply interested in book illustration, Dulac emigrated to England in 1904 (becoming a

British subject in 1912). By 1905 his first set of book illustrations, a series of designs for J. M. Dent's new edition of the Brontë sisters' novels, appeared in his adopted country. During this period he became a regular contributor to *The Pall Mall Magazine* and joined the London Sketch Club. The Leicester Galleries commissioned Dulac to paint a set of watercolor illustrations for Laurence Housman's version of tales from *The Arabian Nights,* and on their recommendation Dulac was retained by the publishers Hodder & Stoughton. The *Stories from the Arabian Nights* became a popular Christmas Gift Book in 1907. In the same year, the Leicester Galleries exhibited his original drawings for the volume as well as other watercolors, and the show was sold out. In 1908 Dulac's illustrations to Shakespeare's *The Tempest* were published and these were followed by *The Rubáiyát of Omar Khayyám* (1909), *The Sleeping Beauty and Other Fairy Tales* (1910), *Stories from Hans Andersen* (1911) and Poe's *The Bells and other poems* (1912), all works from his "Blue Period." From about 1914 on, the influence of Persian manuscript illustration and Eastern art in general, always an important element in his work, became even more prominent. At the same time he created the first in a long series of caricatures and cartoons. In 1916 Dulac began the last of his Gift Books for Hodder & Stoughton, Hawthorne's *Tanglewood Tales* (published in 1918), which combined Persian and Far Eastern elements with borrowings from Greek vase painting. During the 1920s he derived much of his income from portraiture, but he also designed stage sets, began to contribute cover designs to *American Weekly* on a regular basis, and helped to found the Film Society as well as illustrating several books (including an edition of *Treasure Island*). He designed a room for *The Daily Mail*'s Ideal Home Exhibition of 1929 and the "Cathay Lounge" for the ocean liner *Empress of Britain* (1930). Dulac began in 1930 but never completed a series of illustrations to the Book of Revelation which showed the influence of the typical hard curves of the Art Deco movement. Throughout the 1930s most of his commissions were for American periodicals like *American Weekly* and *Good Housekeeping* or commercial designs for playing cards, medals, stamps and the like. During the war years Dulac designed bank notes and stamps for the Free French. Among his last works were an edition of Pushkin's *The Golden Cockerel* for the Limited Editions Club (1950), a series of *Arabian Nights* illustrations for *American Weekly* and a postage stamp design to commemorate the coronation of Queen Elizabeth II in 1952.

84 "The Entomologist's Dream" from *Le Papillon Rouge,* 1909
Pen, ink and watercolor, 10⅜ x 11⅜"
Signed and dated at l.r.: "Edumund Dulac~09"
Ref.: Colin White, *Edmund Dulac,* pp. 41, 47, 58.
VICTORIA AND ALBERT MUSEUM, LONDON

"The Entomologist's Dream" was one of three illustrations plus a headpiece which Dulac created for the fantasy tale

Le Papillon Rouge published in the French periodical *L'Illustration.* The magazine was owned by the publisher Henri Piazza, who became an important patron of the young artist after the success of this initial venture. Dulac submitted this drawing and an illustration of "The Owls" (after Edmond Rostand) to the Barcelona International Exhibition in 1911 and won two gold medals.

85 "She found herself face to face with a stately and beautiful lady" from "Beauty and the Beast" in *The Sleeping Beauty and Other Fairy Tales,* retold by Sir Arthur Quiller-Couch, 1910
Pen, ink and watercolor, 12½ x 10⅛"
Signed and dated at l.l.: "Edmund Dulac ʃ 10"
Ref.: Brigid Peppin, *Fantasy, The Golden Age of Fantastic Illustration,* p. 124; Colin White, *Edmund Dulac,* pp. 46-47.
VICTORIA AND ALBERT MUSEUM, LONDON

Dulac supplied the illustrations for a series of tales Quiller-Couch selected from the compilations of Grimm and Perrault. The volume was published by Hodder & Stoughton in 1910 and became an instant and enormous success. Dulac designed thirty color plates, including this graceful winged figure, one of the most elegant portrayals from his "Blue Period." Stylistically the illustrations in *The Sleeping Beauty* exhibit Dulac's inventive powers at their broadest, ranging from exotic orientalism to a kind of rococo revival.

86 "Fairy-land" from the poem "Fairy-Land" in *The Bells and other poems* by Edgar Allan Poe
Watercolor and bodycolor, 16 x 11¾"
Ref.: Colin White, *Edmund Dulac,* pp. 54-56.
VICTORIA AND ALBERT MUSEUM, LONDON

The Bells was Dulac's major effort for the publishers Hodder & Stoughton in 1912. The illustrations were generally somber in color and feeling, and a few, like the frontispiece to the volume, reached a rather intense emotional pitch seldom found in Dulac's work. Inscribed "Fairyland — No. 19," this nocturnal scene from the artist's "Blue Period" is a particularly haunting image.

87 "The Princess Badoura," frontispiece to *Princess Badoura, A Tale from the Arabian Nights,* retold by Laurence Housman, 1913
Watercolor and pencil, 11¼ x 9⅜"
Signed and dated at l.l.: "Edmund Dulac 13"
Ref.: Brigid Peppin, *Fantasy, The Golden Age of Fantastic Illustration,* p. 129; Colin White, *Edmund Dulac,* pp. 61, 70-71.
TRUSTEES OF THE BRITISH MUSEUM

Princess Badoura was published by Hodder & Stoughton in 1913. While Dulac tended to look most frequently to Persian and Indian manuscripts for inspiration for his exotic scenes, he was also deeply interested in Far Eastern art and borrowed from both Japanese and Chinese sources. Here he has created an image which appears as a moment frozen in time. "Princess Badoura" has the quality of an elegant scene from Chinese opera, with touches of Japanese influence apparent in the setting. Dulac has ignored all the rules of

perspective so basic to Western art in order to concentrate upon the decorative presentation of the image.

88 "The Princess burns the Elfrite to death" from "The Story of the Three Calenders" in *Sinbad the Sailor and other Stories from the Arabian Nights*, 1914
Pen, ink, watercolor and pencil, 12¾₁₆ x 9⅝"
Signed and dated at l.l.: "Edmund Dulac 14"
Ref.: Brigid Peppin, *Fantasy, The Golden Age of Fantastic Illustration*, p. 137.
TRUSTEES OF THE BRITISH MUSEUM

In the fall of 1913 Dulac joined several friends on a Mediterranean cruise which included visits to several North African ports. The trip gave fresh stimulus to his intense interest in both Islamic art and exotic themes, and the striking illustrations to *Sinbad the Sailor*, published by Hodder & Stoughton in 1914, reflect this renewed enthusiasm.

89 "The Ice Maiden" or "Everything about her was white" from *The Dreamer of Dreams* by Queen Marie of Roumania, 1915
Watercolor and bodycolor, 12 x 10"
Signed and dated at l.l.: "Edmund Dulac 15"
Ref.: Colin White, *Edmund Dulac*, pp. 76, 120-121.
THE ROYAL PAVILION, ART GALLERY & MUSEUMS, BRIGHTON

Among the most remarkable of Dulac's illustrations, "The Ice Maiden" forms part of a series of designs illustrating a fairy story by the granddaughter of Queen Victoria, Queen Marie of Roumania. Hodder & Stoughton published the volume in 1915, and its great success led to the publication in the following year of another book by Queen Marie with Dulac as illustrator, *The Stealers of Light*.

90 Assemblage of fairy tale and nursery rhyme characters
Pen, ink and watercolor, 13⅜ x 9⅝"
Signed at l.l.: "Edmund Dulac"
Ref.: Brigid Peppin, *Fantasy, The Golden Age of Fantastic Illustration*, pp. 132-133.
TRUSTEES OF THE BRITISH MUSEUM

A delightful catalogue of fairy tale and nursery rhyme scenes, this clever fantasy was apparently never published.

91 "The God of Night," *c.* 1920
Pen, ink, watercolor and white heightening, 12⁹₁₆ x 9⅜"
COOPER-HEWITT MUSEUM, THE SMITHSONIAN INSTITUTION'S NATIONAL MUSEUM OF DESIGN, GIFT OF MARTIN BIRNBAUM

Very much in Dulac's "Persian" style, the drawing is inscribed along the bottom margin: "He closed his hand upon her bosom and tore out the clays & sands —," a quotation the exact source of which has not been identified.

92 "Yet it was not so sweet as the song of the sirens" from "Circe's Palace" in *Tanglewood Tales* by Nathaniel Hawthorne, 1918
Watercolor and bodycolor, 12 x 11"
Signed and dated at l.r.: "Edmund Dulac 18"
Ref.: Colin White, *Edmund Dulac*, pp. 97-99.
SPENCER COLLECTION, THE NEW YORK PUBLIC LIBRARY, ASTOR, LENOX AND TILDEN FOUNDATIONS

Tanglewood Tales, published in 1918, was Dulac's last Gift Book for Hodder & Stoughton. The illustrations, which ex-hibit the combined influences of Greek vase painting, Persian miniatures, Chinese and Japanese art and the theatrical designs of Léon Bakst, were extremely well received despite this bold mixture of styles.

93 "Drawing his sword he rushed at the monster" ("Cadmus and the dragon") from "The Dragon's Teeth" in *Tanglewood Tales* by Nathaniel Hawthorne, 1918
Watercolor and bodycolor, 12 x 11"
Signed and dated at l.l.: "Edmund Dulac 18"
Ref.: Colin White, *Edmund Dulac*, p. 97.
SPENCER COLLECTION, THE NEW YORK PUBLIC LIBRARY, ASTOR, LENOX AND TILDEN FOUNDATIONS

Here, as elsewhere in his illustrations for this book, Dulac has drawn upon a variety of sources and stylistic conventions: the strong outlines and elegant linearism of Greek vase painting, the lush colors and rich patterning of Persian manuscript illumination, and the motifs of the Chinese theater (for the figure of the dragon).

94 "The Four Horsemen of the Apocalypse" from the Book of Revelation, 1930
Watercolor, 12½ x 10"
Signed and dated at l.r.: "Edmund Dulac 30"
Ref.: Colin White, *Edmund Dulac*, pp. 88-89, 142.
DRUSILLA AND COLIN WHITE

This drawing and "The Scarlet Woman of Babylon" were the only designs Dulac completed for a projected series illustrating the Book of Revelation which he hoped to submit to the *American Weekly*. Despite the power of the images and their timely Art Deco feeling, Dulac could not raise support for the project, and he had to abandon the idea. Perhaps "The Four Horsemen" indicated to publishers that the series might have limited appeal, for Dulac's admirers would not expect this type of horrific imagery from his hand.

Alexander Fisher, 1864-1936

Born in Stoke-on-Trent, Fisher trained from 1881 as a painter at the South Kensington Schools in London. He developed an interest in the art of enameling after attending a lecture by the French artist Dalpayrat and shortly thereafter went to Paris on a scholarship to study enameling techniques. In 1887 he set up his own studio in London to design jewelry, sculpture and decorative wares. He taught enameling at the Central School of Arts and Crafts in London from 1896, and in 1904 he established his own school in Kensington. In addition to contributing articles on enameling to such periodicals as *The Studio* and *The Art Journal*, he was a frequent exhibitor at the Arts and Crafts Exhibition Society and showed his work at the major international exhibitions. Among his best-known works are a table centerpiece for Lord Carmichael in the form of an electrically illuminated silver ship amidst mermaids, and an elaborate enameled triptych portraying the "Life of St. Patrick" (now in the National Museum of Ireland, Dublin).

95 Triptych with a medieval scene
Silver-plate and enamel, 13⅞" h.
Signed on central enamel panel at l.r.: "Alex Fisher"
Ref.: M. P.-Verneuil, "Alexandre Fisher," *Art et Décoration*, 22 (1907), p. 83.
MACKLOWE GALLERY, NEW YORK

Fisher's work in enamel ranged from naturalistic portraiture to haunting fantasies like the panels of this triptych. This "shrine" to imaginative allegory is one of the more remarkable creations by this central figure in the Arts and Crafts Movement.

John Anster Fitzgerald, 1819-1906

While little is known about Fitzgerald's life, records indicate that he exhibited at the Royal Academy from 1845 to 1902 as well as at the Royal Institute of Painters in Water Colours, the Society of British Artists and the British Institution. He was also a member of the Maddox Street Sketching Club. Although specializing in fairy subjects and other imaginative themes, he did portraits, genre and allegorical paintings. Fitzgerald is last noted as exhibiting at the Royal Academy in 1902; his single contribution for that year bore the title "Alice in Wonderland."

96 A rabbit among the fairies
Watercolor and bodycolor, 22 x 30¼"
Signed at l.l.: "J A FitzGerald"
PRIVATE COLLECTION

Fitzgerald's juxtaposition of the real and fairy worlds in this scene is handled with effective subtlety. Included among the group of lively sprites and fairies are several of the artist's typical Boschian creatures, who add a somewhat menacing note. This rather ambiguous, disturbing quality is less apparent in this delicately colored drawing, however, than in many of Fitzgerald's other works like the small painting entitled *The Fairy Lake* (Tate Gallery, London), in which the insect-like creatures derived from Bosch play a more central role.

Henry Justice Ford, 1860-1941

Ford was born in London and spent most of his life there. He was an extremely successful student, and was graduated from Repton and then from Clare College, Cambridge. Shortly thereafter he entered the Slade School of Fine Art where he studied with Alphonse Legros and also attended the School of Art at Bushey (under Sir Hubert von Herkomer). Although he was active as a painter of histories, landscapes and imaginative themes, exhibiting at the Royal Academy for more than a decade, he is best known for his work as a book illustrator. In 1889 he began a long and profitable association with Andrew Lang and his wife Leonora B. Lang, a collaboration which included his doing most of the illustrations for the Coloured Fairy Book series. In 1895 an exhibition of his watercolors at the Fine Art

Society, London included drawings for *The Yellow Fairy Book*. Among Ford's other commissions were designs for *The Arabian Nights Entertainments* (Andrew Lang, 1898), *The Book of Princes and Princesses* (Leonora Lang, 1908) and an edition of John Bunyan's *The Pilgrim's Progress* (1921).

97 Placida and the dame from "Prince Vivien and the Princess Placida" in *The Green Fairy Book*, edited by Andrew Lang, 1892
Photoengraved plate from bound volume, 7¼ x 5" (page)
Ref.: Una des Fontaines, *Wedgwood Fairyland Lustre*, p. 264.
JOHN D. MERRIAM

The Green Fairy Book was published by Longmans, Green, and Company in 1892, the third in the series of Coloured Fairy Books edited by Andrew Lang. The story of "Prince Vivien and the Princess Placida" was taken from the French fairy tale "Nonchalante et Papillon." Ford's popular illustrations to Lang's volumes frequently served as sources of imagery for other artists. One such admirer was the ceramicist Daisy Makeig-Jones, who borrowed numerous motifs from Ford and translated them into designs on her Fairyland Lustreware for Wedgwood (see cat. no. 134).

98 Cover design for *The Violet Fairy Book*, edited by Andrew Lang, 1901
Bound volume, gilt-stamped cloth cover, 7½ x 5¼"
Signed with initials at l.r.: "HJF"
JOHN D. MERRIAM

The Violet Fairy Book was published by Longmans, Green, and Company in 1901. It was the seventh in this series of twelve enormously popular volumes of fairy stories, which appeared between 1889 and 1910. As Andrew Lang's principal collaborator on the Coloured Fairy Books, Ford designed both illustrations and covers for the volumes.

Annie French, 1873-1965

Annie French was born in Glasgow, the daughter of a metallurgist. Following her initial artistic training at the Glasgow School of Art under Francis Newbery and Jean Delville, she apparently returned to the Design School there to take over a teaching post formerly held by Jessie Marion King. She spent five years in that position (1909-1914), and in 1914 she married the painter, designer and author George W. Rhead. French exhibited at the Royal Academy with great frequency between 1904 and 1924. Like Jessie King, she was active as a designer, decorator and illustrator. Her watercolors and drawings exhibit, like King's, an elegant combination of fluid line with quick, delicate touches of color, a similarity which led Philippe Jullian, in his *Dreamers of Decadence,* to describe both artists as "those charming lace-makers."

99 "Marauders"
Watercolor on paper laid down on board, 10 x 14"
Signed at l.r.: "Annie French"

Ref.: Toronto, Canadian National Exhibition, *Catalogue of Paintings and Sculpture by British, Spanish and Canadian Artists and International Graphic Art*, no. 1173.

ART GALLERY OF ONTARIO, GIFT OF THE CANADIAN NATIONAL EXHIBITION ASSOCIATION, 1965

These charming maidens are typical inhabitants of the insubstantial world created by Annie French. They seem to be spirits composed of cobwebs rather than creatures of flesh and blood. As in many of the artist's other designs, there is but a limited suggestion of a setting or sense of place that might form a bridge to the real world.

Henry Fuseli (Johann Heinrich Füssli),
1741-1825

Fuseli was born in Zurich, the second son of a painter and writer on art with whom he studied art history. At his father's behest he trained to become a Zwinglian minister and took holy orders in 1761. Under the influence of friends like the scholar Johann Bodmer and the young Johann Lavater, Fuseli involved himself in a variety of scholarly and political causes which eventually forced him to leave Switzerland in 1763. The following year he visited England, where he published an English translation of Winckelmann's *Reflections on the Paintings and Sculptures of the Greeks* (1765). In 1768 he met Sir Joshua Reynolds who encouraged him to become a painter, and two years later he left to study art in Italy. He spent eight years there and his dramatic paintings based on themes from mythology, Shakespeare and Milton caused a great stir in Italian art circles. After a brief visit to Zurich in 1778, Fuseli returned to England and settled in London. His painting "The Nightmare" (1781), which was exhibited at the Royal Academy in 1782, established his reputation throughout Europe, and the publication of an edition of Lavater's *Physiognomische Fragmente* with illustrations by Fuseli (1781-1786) further increased his renown. Between 1786 and 1789 Fuseli devoted much of his time to producing work for John Boydell's "Shakespeare Gallery," which was intended to be a permanent exhibition of paintings of Shakespearean scenes; among his contributions were several remarkable representations for *A Midsummer Night's Dream*. During this period he also formed a productive friendship with William Blake. In 1790 Fuseli was elected to full membership in the Royal Academy and began a series of paintings illustrating Milton, his own "Milton Gallery," which occupied his efforts until the opening exhibition in 1799. (Neither the "Milton Gallery" nor the "Shakespeare Gallery" was a financial success.) Although he had been elected Professor of Painting at the Royal Academy, he decided to reopen the "Milton Gallery" exhibition, but again public response disappointed him. Between 1801 and his resignation as Professor of Painting in 1805, he lectured on painting at the Academy. He was elected Keeper to the Academy at the end of 1804, and in 1810 he was reelected Professor of Painting and allowed to retain his position of Keeper as well. In the remaining years of his life he was occupied with his painting, Academy lectures and other critical writings.

He died in the presence of his wife, several friends, and his future biographer John Knowles, and was buried in St. Paul's Cathedral.

100 "The Shepherd's Dream" from *Paradise Lost* by John Milton, 1786-1793
Pencil, watercolor and oil on paper, 14½ x 20⅜"
Ref.: Gert Schiff, *Johann Heinrich Füssli, 1741-1825*, no. 1762a, Part I, p. 634, Part II, p. 567; Roger Mandle, "A Preparatory Drawing for Henry Fuseli's Painting 'The Shepherd's Dream,'" *Master Drawings*, 11, No. 3 (Autumn 1973), pp. 272-276 and Pl. 28.
THE ART MUSEUM, PRINCETON UNIVERSITY

Fuseli has chosen to illustrate Milton's verses from *Paradise Lost*, I, 781 ff. which compare the fallen angels in hell to the woodland fairies who bewitch a young sleeping shepherd. The artist has drawn upon a variety of literary and artistic sources, including English folklore, to elaborate upon Milton's compelling theme. The image of the dreamer appeared with increasing frequency during the nineteenth century, sometimes linked to allegory as here, but more often used as the central motif in a representation of horrific or fairy fantasy, with the figure shown amidst a crowd of assorted pixies, goblins or other imaginary beings. A large version in oil of this subject done in 1793 is in the Tate Gallery, London, identified as Painting No. 4 from Fuseli's "Milton Gallery." According to Mandle, the Princeton drawing is actually Fuseli's preparatory study for the Tate picture, derived from an earlier drawing now in the Albertina, Vienna (1786). Schiff suggests, however, that the Princeton example is a later version of the Albertina picture, squared and reinforced by another hand (possibly that of Moses Haughton).

Sir John Gilbert, 1817-1897

Gilbert was born in Blackheath in 1817 and died in the same town eighty years later. In 1836 he left his position with an estate agent to devote himself to art. He became an accomplished and versatile artist, working as an engraver and etcher as well as painting in oils and watercolor. He first contributed to the Royal Academy exhibitions in 1838, but his early reputation rested largely on his black and white book illustrations, which ranged from designs for Shakespeare, Wordsworth and Sir Walter Scott to biblical subjects. He was enormously prolific and contributed literally thousands of illustrations to *The Illustrated London News* from its founding in 1842. Gilbert was elected to full membership in the Royal Society of Painters in Water Colours in 1854 and became its president in 1871, the same year which saw him knighted by Queen Victoria. He did not become a full member of the Royal Academy until 1876. Later in life, he retained much of the work he produced, and in 1893 he presented his collection to various museums throughout England.

101 "The Enchanted Forest," *c.* 1886
Pen, ink and watercolor, 10½ x 16½"
Signed with initials at l.l.: "J.G."

CITY OF MANCHESTER ART GALLERIES

This watercolor is a preliminary study for a larger version of the same subject in oil (1886).

Warwick Goble, -1943

Goble was born in London on a date which is apparently not recorded. He trained at the Westminster School of Art and was for several years employed by a printing firm which specialized in chromolithography and commercial design work. He contributed illustrations to various newspapers and periodicals before joining the staff of *The Pall Mall Gazette*. From 1893 he exhibited at the Royal Academy, but his reputation rests upon the charm of his color book illustrations. Among the best of these are his designs for Charles Kingsley's *The Water-Babies* (1909), Grace James' *Green Willow and Other Japanese Fairy Tales* (1910), Mrs. Craik's *The Fairy Book* and several delightful drawings for the anthology, *The Book of Fairy Poetry*. Although Goble was considered something of a hermit during his lifetime, he is known to have traveled widely and to have been particularly fond of the Far East. He spent the last years of his life in Surrey.

102　　"From which great trout rushed out on Tom" from *The Water-Babies; A Fairy Tale for a Land-Baby* by Charles Kingsley
　　　Color half-tone plate in bound volume, 5 x 7″
　　　Signed at l.l.: "Warwick Goble"
　　　JOHN D. MERRIAM

The Water-Babies was first published in 1863 with illustrations by Sir Joseph Noël Paton. This edition of Kingsley's famous story, with Goble's contributions, was published by Macmillan in 1909. Although at times overly precious and somewhat derivative in his designs, Goble's skill as a colorist compensates for his lack of intensity as an illustrator.

Florence Gower,

Active Early 20th Century

No biographical information could be located for Florence Gower other than that she studied at Regent Street Polytechnic in London and showed at the exhibition of prize works in the National Art Competition, South Kensington in 1910.

103　　Mirror decorated with the story of "Snow White and The Seven Dwarfs," c. 1910
　　　Oil paint on wood with mirror glass, 24″ diameter (with frame)
　　　Ref.: W. T. Whitley, "The National Competition of Schools of Art, 1910, at South Kensington," *The Studio*, 50 (1910), pp. 296, 298.
　　　MR. AND MRS. D. J. COOPER

The mirror is inscribed with numerous quotations from the legend of "Snow White," beginning with the famous question "Oh Mirror Mirror On The Wall Who Is The Fairest Of Us All?" and including the artist's personal variation on the usual title, "Snow White and The Seven Dwarfs A Sad Tale of Jealousy." This finely executed and quite splendid example of medievalism would have been at home in a Pre-Raphaelite setting — its creation in 1910, long after the heyday of the medieval revival, attests to the persistence of that stylistic mode.

Kate Greenaway
(Catherine Greenaway), 1846-1901

Kate Greenaway was the daughter of a draughtsman and engraver residing in London. As a child she was an avid reader of both fairy tales and Shakespeare. Her formal training in art began at the National Art Training School at South Kensington. She also studied at the Heatherley School of Fine Art and the newly founded Slade School of Fine Art. Kate Greenaway's earliest commercial successes were several illustrations for *People's Magazine* and a series of designs for valentine cards done for Marcus Ward & Company. Not long after, in 1871, she received a commission to illustrate an edition of "Bluebeard" and other stories (*Madame d'Aulnoy's Fairy Tales*). During this period she also began contributing to *Little Folks*, *The Illustrated London News* and *Cassell's Magazine*. She exhibited for the first time at the Royal Academy in 1877, and in the following year she did her first book with the printer Edmund Evans, *Under the Window*. This work was an enormous success and marked the start of a long and profitable partnership. In rapid succession such volumes as *Kate Greenaway's Birthday Book for Children* (1880), *London Lyrics* (with Randolph Caldecott, 1881), *Little Ann and Other Poems* (1883), the first of the *Almanacks* (1884) and the *Language of Flowers* (1884) appeared. Along with Walter Crane and her good friend Caldecott, she found herself at the top of her field, much admired by critics from John Ruskin to Ernest Chesneau. The purified world she created, populated only by the most charmingly pretty children and young people, appeared again and again in works like *Marigold Garden* (1885) and even in "adventure" tales like Bret Harte's *The Queen of the Pirate Isle* (1886) and Browning's normally rather disturbing poem, *The Pied Piper of Hamelin* (1888). A decade before her death, Kate Greenaway was accorded her first "one-man" show when her watercolors were exhibited at The Fine Art Society in London.

104　　"Playtime" from *A Day in a Child's Life* with music by Myles B. Foster
　　　Pen, ink and watercolor, 5 7/16 x 7 1/2″
　　　Signed with initials at l.l.: "KG"
　　　Ref.: Bryan Holme, *The Kate Greenaway Book*, pp. 51-57.
　　　TRUSTEES OF THE BRITISH MUSEUM

A Day in a Child's Life was published by George Routledge in 1881 and printed by Edmund Evans. Flowers play a major role in the ornamentation of this song book, which received mixed reviews from the critics, some of whom found it too "pretty."

105 Christening set, *c.* 1882
Silver cup with gold-washed interior, 3½″ h.; silver knife, 8″ long; silver fork, 6¾″ long; silver spoon, 6½″ long
Each piece is signed and dated in hallmark with the maker's mark "SM" (not identified) and date letter "G"
PRIVATE COLLECTION

Apparently designed as a display or exhibition piece, the christening set is an impressive translation into another medium of Kate Greenaway's popular illustrations for *Under The Window*, published four years earlier.

106 Letter rack, *c.* 1885
Wood with gesso and painted decoration, 5³⁄₁₆ h. x 4⁵⁄₁₆ w. x 2³⁄₁₆″ d. at maximum points
VICTORIA AND ALBERT MUSEUM, LONDON

Kate Greenaway presented the letter rack to Sir Hugh Anderson, whose initials, "HA," appear on the front of the piece above the word "Proserpine" (the sides are labeled "Flora Pomona" and "Hesperides").

107 "Where waters gushed and fruit trees grew, and flowers put forth a fairer hue" frontispiece to *The Pied Piper of Hamelin* by Robert Browning, 1887
Pen, black ink and watercolor, 8⅝ x 7⅝″
Signed with initials at l.l.: "KG"
Ref.: New York, The Pierpont Morgan Library, *Early Children's Books and Their Illustration*, no. 172, p. 182 and frontispiece; Bryan Holme, *The Kate Greenaway Book*, pp. 106 and 121.
THE PIERPONT MORGAN LIBRARY, GIFT OF MRS. GEORGE NICHOLS

Kate Greenaway met Robert Browning in 1882 when the author was seventy. Six years later George Routeledge published Browning's poem with Greenaway's illustrations. The color printing was by Edmund Evans. In 1900 the book was reissued by Frederick Warne, and this edition has been reprinted many times. Kate Greenaway did thirty-five watercolors for *The Pied Piper*, among which the frontispiece is the most spectacular.

108 "And out of the houses rats came tumbling" from *The Pied Piper of Hamelin* by Robert Browning, 1887
Pen, black ink and watercolor, 8⅞ x 7¹⁵⁄₁₆″
Signed with initials at l.l.: "KG"
Ref.: New York, The Pierpont Morgan Library, *Early Children's Books and Their Illustration*, no. 172, p. 182; Bryan Holme, *The Kate Greenaway Book*, p. 106.
THE PIERPONT MORGAN LIBRARY, GIFT OF AN ANONYMOUS DONOR

Even the most terrible moments are quite restrained in Kate Greenaway's art. Here the rats create only a mild and fashionable sort of panic, and the action is kept to the background of the representation. The foreground is occupied by a disconsolate but extremely graceful young woman.

109 "Frieze of Girls"
Watercolor, 8⅜ x 16¹⁵⁄₁₆″
Signed with initials at l.l.: "KG"
THE FREE LIBRARY OF PHILADELPHIA

The "Frieze" is a highly finished and, as its name implies, quite classical representation of Greenaway's fanciful and

elegant world. The watercolor does not seem to have been intended for publication. From about 1888 on, the artist devoted much time to producing individual watercolor paintings, these efforts culminating in her first "one-man" show in 1891. "Frieze of Girls" is quite probably a work from this period.

Elsie Gregory (Mrs. J. A. C. Osborne), ACTIVE 1900-1933

Elsie Gregory, an English artist about whom few personal details are known, gained her reputation as a miniature painter, specializing in portraits. Active in London, she is recorded as exhibiting at the Royal Society of Miniature Painters, the Royal Institute of Painters in Water Colours and with some frequency at both the Royal Academy (from 1900) and the Walker Art Gallery in Liverpool. Her contributions to the Royal Academy included an illustration to the fairy tale of Rapunzel.

110 "A Pixie Ring," 1906
Pen, ink and watercolor, 9½ x 9″
Signed and dated at l.l.: "Elsie Gregory 1906"
CITY OF MANCHESTER ART GALLERIES

Unlike many fairy pictures in which only the inhabitants of the fairy kingdom are portrayed, here two obviously human children join the viewer in witnessing the scene.

Ernest Henry Griset, 1844-1907

Griset was born in France but spent most of his working life in England. He gained a reputation both as an animal artist and as a caricaturist, his work in the latter vein owing much to the example of J. J. Grandville's *Scènes de la vie privée et publique des animaux*. His anthropomorphic fantasies and illustrations, many of them created for the Dalziel Brothers, appeared in such popular periodicals as *Punch* and *Hood's Comic Album*. He was also active as a book illustrator. Among the volumes to his credit are an edition of *Aesop's Fables* and several collections of his own work, including *Vikram the Vampire* and *Griset's Grotesques*. He chose, understandably, to live in the Kentish Town section of London near the zoo.

111 "The Crab Pot" or "Affecting farewell"
Pen, ink and watercolor, 6 x 9⅝″
Signed at l.l.: "Ernest Griset"
VICTORIA AND ALBERT MUSEUM, LONDON

Inscribed in pencil on the mount is the notation "affecting farewell (The Crabpot)." Griset's depiction of this sad moment is a gentler, anglicized version of the type of precisely realized anthropomorphism found in Grandville's work.

112 "The Dream of the Fisherman"
Pen, ink and watercolor, 6⅝ x 10½″
Signed at l.r.: "Ernest Griset"

Ref.: Lionel Lambourne, "Anthropomorphic Quirks: The Work of Ernest Griset," *Country Life*, 161, No. 4149 (January 6, 1977), pp. 26-28.
VICTORIA AND ALBERT MUSEUM, LONDON

The title of this splendid example of Griset's wit is inscribed on the mount, although the activity of the pelican and his well-trained cormorants scarcely needs comment.

E. R. Herman, ACTIVE 1890-1930

No biographical information could be located on this British illustrator, who was much influenced by the Art Nouveau book designs of Aubrey Beardsley and William Heath Robinson as well as by Century Guild artists like Arthur Mackmurdo and Selwyn Image.

113 "The Reader and the Book" from *Fables* by Robert Louis Stevenson
Pen and India ink, 10½ x 8⅞"
LENT BY THE METROPOLITAN MUSEUM OF ART, THE ELISHA WHITTELSEY FUND, 1973

Stevenson's *Fables* with illustrations by E. R. Herman was published by Longmans & Company, London, in 1914.

Vernon Hill, 1887-

Hill was born at Halifax, Yorkshire, and was apprenticed as a youth to a lithographer. Several years later he worked for the illustrator and poster designer John Hassall. His own artistic activity encompassed sculpture in both wood and bronze, and intaglio and lithographic printing. Hill tended toward evocative themes, and among the books he illustrated were *The New Inferno* by Stephen Phillips (1911) and Richard Chope's *Ballads Weird and Wonderful* (1912).

114 "The Purgatorial House," Canto vii, from *The New Inferno* by Stephen Phillips, 1911
Photoengraved plate from bound volume, 8⅝ x 6⅛"
Signed at u.r.: "VHill"
Ref.: Brigid Peppin, *Fantasy, The Golden Age of Fantastic Illustration*, pp. 157-158.
JOHN D. MERRIAM

Hill's very personal and often horrifying illustrations to Phillips' strange reprise of Dante's *Inferno* were published by John Lane in 1911. Hints of the influence of William Blake, the Symbolists and Harry Clarke can be seen in Hill's work, but his fantastic images are nevertheless highly imaginative and quite original. His use of a stipple technique gives his figures a three-dimensionality which enhances the tension of the portrayals and prevents them from being mere decorative patterns in black and white.

Henry Holiday, 1839-1927

Holiday was born in London and as a young man studied at Leigh's Academy and the Royal Academy Schools. He was a versatile artist, with a reputation as a painter of his-torical subjects in a Pre-Raphaelite mode, a sculptor, an illustrator, an enamelist and a designer of stained glass. Around 1861 he followed in the footsteps of Burne-Jones in designing stained glass for Powell and Sons. He also carried out commissions from William Burges for glass designs and other decorative objects, including a painting of "The Sleeping Beauty" for the headboard of a bed designed by Burges in 1867 for his own use. Holiday exhibited at the Royal Academy from 1856 on in a variety of media. During his long career, he also designed innumerable windows for English and American churches, among them Holy Trinity Church in Boston (1878). In 1890 he opened his own glassworks in the London borough of Hampstead and concentrated on the production of stained glass, enamels and mosaics. His most popular work as an illustrator is *The Hunting of the Snark — an Agony in Eight Fits* by Lewis Carroll (1876), with its boldly conceived wood engravings.

115 "The Crew was Complete" from *The Hunting of the Snark* by Lewis Carroll
Proof wood engraving, 3½ x 5⅛"
Signed at bottom center: "h.h." and by the engraver towards right edge: "Swain.Sc"
Ref.: Malcolm C. Salaman, *British Book Illustration Yesterday and To-Day*, pp. 29, 98 (published version).
PRINCETON UNIVERSITY LIBRARY. MORRIS L. PARRISH COLLECTION

This sheet is a unique copy of a proof of Holiday's original sketch for the illustration. The lower right-hand section of the scene differs quite substantially from the published version (Macmillan, 1876). In the published engraving the monocled figure in the proof appears turned in profile, *sans* monocle, and partially hidden behind a portion of the ship. Both caricature and extreme distortions in scale are brought into play here to create a very inventive and successful form of fantasy.

116 "The Snark's Uncle" from *The Hunting of the Snark* by Lewis Carroll, 1876
Wood-engraved plate from the first edition, 5¼ x 3½"
Signed by the engraver at l.r.: "Swain Sc."
PRINCETON UNIVERSITY LIBRARY. MORRIS L. PARRISH COLLECTION

Laurence Housman, 1865-1959

Housman was born in Bromsgrove, Worcestershire, into a talented family which included his brother, the writer A.E. Housman, and his sister Clemence, a wood engraver and active suffragette as well as an author. Both Laurence and Clemence studied wood engraving at the City and Guilds Technical School. From 1883 Housman studied at the Lambeth School of Art and then at South Kensington. Before failing eyesight forced him to give up illustration in 1901, he had created numerous designs for such tales as Christina Rossetti's *Goblin Market* (1893), Jan Barlow's *The End of Elfin-Town* (1894), Shelley's *The Sensitive Plant* (1898) and two of George MacDonald's books, *At the Back of the*

North Wind and *The Princess and the Goblin* (both 1900). He also illustrated several of his own stories, including *A Farm in Fairyland* (1894) and *The House of Joy* (1895). Clemence did much of the actual engraving of her brother's drawings onto woodblocks. Housman served as art critic for *The Manchester Guardian* from 1895 until 1911. Writing took up the major part of his time after 1901, and he eventually gained a reputation as a playwright, *Victoria Regina* being his best-known play. Along with his sister he became a Socialist and ardent pacifist. He died in Glastonbury in 1959 at the age of ninety-four.

117 "Come buy our orchard fruits" from *Goblin Market* by Christina Rossetti, 1893
 Wood-engraved plate from bound volume, 9¾ x 6⅝"
 Signed with initials at l.l.: "LH"
 Ref.: Cambridge, The Houghton Library, Harvard University, *The Turn of a Century 1885-1910*, no. 22, p. 26.
 JOHN D. MERRIAM

Housman's illustrations to Christina Rossetti's poem were published by Macmillan in 1893, three decades after Dante Gabriel Rossetti did the designs for the first edition of his sister's work. While owing a debt to Rossetti's illustrations, Housman's compositions have none of their dreamlike quality and are far more horrific in nature. The author was not, in fact, pleased and noted that her goblins were not intended to be so ugly. Nevertheless, when *Goblin Market* is mentioned Housman's intense images usually come to mind rather than Rossetti's. This volume is one of 160 copies of the large paper edition (1893).

118 Title page to *The House of Joy* by Laurence Housman, 1895
 Pen and black ink, 5³⁄₁₆ x 3⅛"
 Signed with initials at l.l.: "LH" and dated as part of the title and publication information across the top of the design
 VICTORIA AND ALBERT MUSEUM, LONDON

In the margin is the inscription: "To be reduced . . . in order to fit into ornamental border used for title page of 'Farm in Fairyland.'" Housman was author and illustrator of *The House of Joy*, a collection of eight fairy tales published by Kegan Paul, Trench Trubner & Company in 1895 (one year after the publication of *A Farm in Fairyland*). Although hints of the work of William Morris and of Housman's friend Charles Ricketts appear in the ornamental borders and title page designs for both books, these highly refined, medievalizing decorations remain very much Housman's own.

119 "The Galloping Plough" from *The Field of Clover* by Laurence Housman
 Pen and ink on paper laid down on card, 7 x 4½"
 Signed with initials at l.l.: "LH"
 FITZWILLIAM MUSEUM, CAMBRIDGE

Housman was both author and illustrator of *The Field of Clover*, which was published by Kegan Paul in 1898. While the subject itself is fantastic in nature, he has represented the setting of the scene with a descriptive precision reminiscent of Millais' illustrations several decades earlier,

rather than seeking to enhance the disturbing qualities of the image or to exploit its decorative possibilities as he did in many other instances.

Frederick A. Hudson,

Active Late 19th-Early 20th Centuries

Hudson specialized in spirit photography and was, in fact, the first and best-known Victorian practitioner of this form of "portraiture." He seems to have had his first success photographing spirits in 1872, and to obtain his images often worked with various mediums, among them the famous Florence Cook. Hudson maintained a studio in London at Palmer Terrace which was frequented by most of the prominent Spiritualists, including William Howitt and William Stainton Moses.

120 Mr. and Mrs. Lacey and a spirit
 Black and white photograph, 5⅞ x 4"
 MARY EVANS PICTURE LIBRARY AND THE SOCIETY FOR PSYCHICAL RESEARCH

Although undocumented, this spirit photograph has been attributed to Frederick Hudson on the basis of both its style and the inclusion of the chaise with a scrollwork armrest — a studio prop found in works known to be his. The photograph, which is typical of this fascinating class of object, portrays an attractive spirit garbed in the usual white robes.

Edward Robert Hughes, 1857-1914

The nephew of the Pre-Raphaelite painter Arthur Hughes, Edward Robert Hughes was born in London and trained at the Royal Academy Schools. He also studied with his uncle and a founding member of the Pre-Raphaelite Brotherhood, William Holman Hunt, whose assistant he became later in his career. Hughes' own work consisted mainly of portraits, genre scenes and romantic subjects, the last frequently drawn from literary sources such as Boccaccio or contemporary novels. He exhibited at the Royal Academy, the British Institution and the Grosvenor Gallery, among other places, and served as the vice-president of the Royal Society of Painters in Water Colours from 1901 to 1903.

121 "Night with her train of stars and her great gift of sleep"
 Watercolor, 29¾ x 49"
 Signed at l.l.: "E. R. Hughes, R.W.S."
 Ref.: Philippe Jullian, *Dreamers of Decadence*, p. 90.
 CITY MUSEUMS AND ART GALLERY, BIRMINGHAM

Essentially a touching and sentimental Victorian allegory on death, this remarkable watercolor derives its title from William Ernest Henley's poem "Margaritae Sorori" (Part XXXV of his "Echoes") of 1876. Like Holman Hunt's "The Triumph of the Innocents," such images served, in this period of shockingly high infant mortality, to solace and reassure an audience too frequently confronted with the harsh reality of a child's death.

Henry Weston Keen, 1899-1935

Little information is available on the personal life of the short-lived English artist Henry Keen. He seems to have been active primarily as an illustrator and printmaker. His work in the latter category apparently consisted chiefly of lithographs which he exhibited at The Senefelder Club in London (so named in honor of the inventor of lithography). His book illustrations include designs for Richard Garnett's *The Twilight of the Gods* (1924), Wilde's *The Picture of Dorian Gray* (1925), Voltaire's *Zadig* (1926) and Webster's *The Duchess of Malfi* (1930), all done for the publisher John Lane. Keen died in Switzerland after many years of failing health. A memorial exhibition of his work was held at the Twenty-One Gallery, London, in the year of his death.

122 "Cornucopia," 1923
 Pen and black ink, 18 x 12⅞"
 Signed at l.l.: "Henry Keen" and dated at l.r.: "1923"
 VICTORIA AND ALBERT MUSEUM, LONDON

Keen's bizarre scene is very much in the horrific-humorous style of Sidney Sime, with overtones of Beardsley in such details as the hermaphroditic nature of the cornucopia and the dancing fetus in the center.

Jessie Marion King, 1875-1949

Scottish by birth, Jessie King studied at the Glasgow School of Art and then at South Kensington. She visited France and Italy on a traveling fellowship and was much attracted to the art of the early Renaissance, particularly the linear delicacy of Botticelli. After marrying the artist Ernest Archibald Taylor, she settled in Kirkcudbright. She was a designer of book covers, jewelry, ceramics, fabrics, murals and mosaics, as well as an illustrator of numerous books, including Kipling's *Jungle Book*, William Morris' *The Defence of Guenevere and Other Poems* (1904), Milton's *Comus* (1906) and Oscar Wilde's *A House of Pomegranates* (1915). She taught at the Glasgow School of Art and was an early member of the "Glasgow School" with her better-known contemporaries, Charles Rennie Mackintosh and his wife Margaret Macdonald Mackintosh. In 1902, she exhibited with the Mackintoshes at the important Turin International Exhibition of Modern Decorative Art and won a gold medal for her drawings and watercolors.

123 "The Little Maid and the White Hart"
 Pencil, pen, ink and gold paint on vellum, 7¾ x 10¼"
 Ref.: Peter Nahum, ed., *Jessie M. King and E. A. Taylor, Illustrator and Designer*, no. 173.
 JUSTIN G. SCHILLER, LTD., NEW YORK CITY

Beneath the scene is inscribed: "He would lay at her feet if he only could meet the loveliest maiden under the sun." The lacy calligraphic style which Jessie King shared with designers like Annie French is here joined with the more formalized Celtic linearism typical of the Glasgow School.

124 "The Sea Voices" from "Seven Happy Days"
 Pen, ink, watercolor and silver paint, 7¼ x 10⅜"
 Signed at l.r.: "Jessie M. King"
 Ref.: Jessie M. King, " 'Seven Happy Days' A Series of Drawings by Jessie M. King with quotations from John Davidson & Others," *The Studio*, New Year's Supplement (January 1914), unpaginated; Brigid Peppin, *Fantasy, The Golden Age of Fantastic Illustration*, p. 113.
 VICTORIA AND ALBERT MUSEUM, LONDON

"The Sea Voices" was one of fifteen illustrations which Jessie King contributed to a New Year's supplement to *The Studio* for January 1914. Quotations from the Scottish writer John Davidson and other poets appear as titles and inscriptions on the individual drawings.

125 "Sleeping Beauty and the Prince," *c*. 1928
 Pen, ink and watercolor on vellum, 13¼ x 18½"
 Signed at l.r.: "Jessie M. King"
 DRUSILLA AND COLIN WHITE

This apparently unpublished drawing is a fine example of Jessie King's later style. The lively yet delicate touches of color and the angular rendering of forms create a more staccato rhythm than the fluid lines of her earlier work in the Art Nouveau style.

Edward Lear, 1812-1888

Lear was born in Holloway, the youngest of twenty-one children. His father was a stockbroker who fell upon hard times when Lear was a youth. By the age of fifteen, Lear was already receiving payment for his art work, despite his lack of formal art training. A love of animals and birds led him to spend a great deal of time at the London Zoological Gardens, where he was employed as a draughtsman in 1831. An early series of lithographed studies of parrots brought him to the attention of the naturalist Lord Stanley, thirteenth Earl of Derby, who became his patron. For the children in Lord Derby's family, Lear began to make up limericks and nonsense verses which eventually led to the publication in 1846 of his first illustrated nonsense book, appropriately titled *A Book of Nonsense*. In the same year he served as drawing master to Queen Victoria. In 1850 he decided to study at the Royal Academy Schools and shortly thereafter he worked under the Pre-Raphaelite painter William Holman Hunt. Although he published *Nonsense Songs, Stories, Botany and Alphabets* in 1871 and two more nonsense volumes in 1872 and 1877, he spent much of the later part of his life traveling abroad, especially in the Mediterranean, doing topographical landscape paintings and watercolors. Beginning in 1862 he also worked on a series of haunting illustrations to various poems by Tennyson. Despite the fact that he suffered from bronchial disease and petit mal epilepsy throughout his life, Lear lived into his seventies, dying at San Remo in 1888.

126 "A visit from the two considerate Frogs" from an unpublished letter to Lady Duncan, 7 January 1865
 Pen and ink, 10⅝ x 8¼"
 Signed and dated within the body of the letter
 PRIVATE COLLECTION

In this drawing, inserted into the text of his letter to Lady Duncan, Lear has portrayed himself in the company of the two amphibians. It was not unusual for the fortunate recipients of the artist's correspondence to find a witty illustrated verse or story included within the letter.

127 "A: The Absolutely Abstemious Ass" from *More Nonsense, Pictures, Rhymes, Botany, Etc.* by Edward Lear
Pen, ink and pencil on ivory laid paper, 6½ x 4¼"
Ref.: Holbrook Jackson, ed., *The Complete Nonsense of Edward Lear*, p. 348.
DEPARTMENT OF PRINTING AND GRAPHIC ARTS, THE HOUGHTON LIBRARY, HARVARD UNIVERSITY, GIFT OF PHILIP HOFER

The artist's inscription beneath the image reads: "The Absolutely Abstemious Ass, who resided in a barrel, and only lived on Soda Water, and Pickled Cucumbers." This drawing is a thoroughly delightful example of Lear's "nonsense," which took various forms: limericks, poems, botanical fantasies, alphabets and vocabularies, songs, stories and letters. He frequently did several versions as well as numerous variations of many of these forms, of which a moderate sampling appeared in print during his lifetime. *More Nonsense* was published by Robert John Bush in 1871 (dated 1872). The drawing was later included in *The Complete Nonsense of Edward Lear*, a volume issued to commemorate the centenary of the publication of Lear's first nonsense book in 1846.

128 "The Fork Tree"
Pen and ink on light blue wove paper, 7¾ x 5⅝"
Ref.: Angus Davidson and Philip Hofer, *Teapots and Quails and Other New Nonsenses by Edward Lear*, p. 57.
DEPARTMENT OF PRINTING AND GRAPHIC ARTS, THE HOUGHTON LIBRARY, HARVARD UNIVERSITY, GIFT OF PHILIP HOFER

"The Fork Tree," which is not included in Lear's own published botanical whimsies, is a typical and splendid example of the manner in which his wit found both literary and artistic expression. His description of the "Tree" reads: "This pleasing and amazing Tree never grows above four hundred and sixty feet in height, — nor has any specimen hitherto produced above forty thousand silver forks at one time. If violently shaken it is most probable that many forks would fall off, — and in a high wind it is highly possible that all the forks would rattle dreadfully, and produce a musical tinkling to the ears of the happy beholder."

Maxwell Gordon Lightfoot, 1886-1911

Lightfoot was born in Liverpool, but moved to Cheshire with his family around 1896. He attended the Chester Art School and, upon the family's return to Liverpool, studied at the newly founded Sandon Studios under Gerard Chowne and Herbert MacNair (*c.* 1905-1907). During this period he also worked as an apprentice in chromolithography for the printing firm of Turner and Dunnett. In 1907 he left for London to study at the Slade School of Fine Art, where he won the Nettleship prize for figure drawing. Artists as varied as Alphonse Legros, Gauguin, and Puvis de Chavannes influenced his painting style. With Augustus John, Stanley Spencer, Walter Sickert and others, Lightfoot helped to found the Camden Town Group and exhibited in its first show at the Carfax Gallery, London, in 1911. He resigned from the Group immediately after the exhibition, however, and three months later died by his own hand. In 1972 the Walker Art Gallery, Liverpool, held a retrospective exhibition of Lightfoot's work.

129 Design for a bookjacket to *A Midsummer Night's Dream* by William Shakespeare, *c.* 1905-1907
Pen, ink, watercolor and silver paint, 7⅟₁₆ x 6⅟₁₆"
Signed on the verso: "Lightfoot"
Ref.: Liverpool, Walker Art Gallery, *Maxwell Gordon Lightfoot,* no. 5, Pl. 3.
WALKER ART GALLERY, LIVERPOOL

This design dates from Lightfoot's student days, and in its reliance on a linear stylization derived from Celtic imagery clearly reflects the influence of his teacher J. Herbert MacNair.

Thomas Mackenzie, 1887-1944

Born in Bradford, Yorkshire, of Scottish parents, Mackenzie studied at the Bradford College of Art, where he was a close friend of the young J. B. Priestley, and then at the Slade School of Fine Art in London on a scholarship. Upon completion of his studies in 1913, he was immediately offered a commission by the publisher James Nisbet to do watercolor illustrations for an edition of *Arthur and His Knights.* Among the other works he illustrated are Arthur Ransome's *Aladdin and His Wonderful Lamp* (1919), James Stephens' *The Crock of Gold* (1926) and Walter Pater's *Marius the Epicurean* (1929). In addition to his book illustrations, Mackenzie, an expert etcher and engraver in black and white, contributed to such periodicals as *The Sketch.* Much of his work was rather strongly influenced by Beardsley, Harry Clarke and Kay Nielsen, and he seems to have been at his dramatic best when he was able to rely upon artists such as these for inspiration. Despite his achievements in graphics, he hoped to attain a reputation as a serious painter and sought inspiration in the works of Cézanne and Piero della Francesca. Feeling that his efforts lacked appropriate recognition, he left England for France in 1929 but returned shortly afterward at the onset of the Great Depression. He spent much of the remainder of his life doing topographical etchings of Oxford and making inexpensive jewelry. He died in Cornwall following a long illness.

130 "Eagles and insects," after Charles Baudelaire, *c.* 1913
Pen and ink, 13½ x 9¼"
Signed at l.r.: "Mackenzie"
DRUSILLA AND COLIN WHITE

Beneath Mackenzie's drawings is the pencil inscription: " 'Eagles and insects, streams and woods Stand still to hear him chaunt his dolorous moods.' Baudelaire." The illustra-

tion is apparently unpublished, but the iconographic source of the image is well known. Colin White has pointed out that the seated figure is taken from Beardsley's frontispiece to *Le Morte d'Arthur*, "How King Arthur saw the Questing Beast," although Mackenzie has shown the figure reversed. In handling, Mackenzie's drawing suggests the influence of both Beardsley and Harry Clarke, with the latter's influence most visible in the intensity of detail, a kind of decorative *horror vacui*.

131 A combat, 1915
 Pen, ink and watercolor, 12¾ x 10¼"
 Signed and dated at l.l.: "Mackenzie: 15"
 DRUSILLA AND COLIN WHITE

The literary source for this unpublished illustration has not been identified; however, Mackenzie obviously owes a stylistic debt to the work of Harry Clarke. The central figure with raised sword derives, in fact, from one of Clarke's black and white illustrations to *The Rime of the Ancient Mariner*. The Clarke design is reproduced in Malcolm C. Salaman's *Modern Book Illustrators and Their Work*, 1914, p. 57.

Margaret Macdonald Mackintosh,
1865-1933

Margaret Macdonald was born in Newcastle-under-Lyme, Staffordshire in 1865, and her sister Frances in 1874. Both sisters enrolled at the Glasgow School of Art under Francis H. Newbery in 1891, and thereafter were associated with that city rather than with their native England. While students, the two young women met the designers Charles Rennie Mackintosh and J. Herbert MacNair; Frances married MacNair in 1899 and in the following year Margaret married Mackintosh. Known as "The Four" or "The Four Macs" even before marriage, the two couples became the primary representatives of the distinctive Glasgow School version of Art Nouveau. They showed decorative designs and crafts at numerous exhibitions throughout Europe, including the Arts and Crafts Exhibition Society in London (1896), the Eighth Secession Exhibition in Vienna (1900) and the International Exhibition of Modern Decorative Art in Turin (1902). Examples of their work were illustrated in periodicals like *The Studio* and *The Yellow Book*. Although their stylized designs were considered shocking in England, they found a more enthusiastic response in Austrian and German circles and had a definite influence upon such artists as Gustave Klimt. Margaret collaborated with her husband on many projects, outstanding among which were the decorations for Miss Cranston's Tea Rooms, including The White Cockade and The Willow (between 1900 and 1904), and the renovation and decoration of Miss Cranston's estate, Hous'hill. Margaret's particular contributions were panels in gesso and stained glass, metal plaques and other decorative items, while her husband specialized in architectural renovation and furniture designs. Together the

Mackintoshes also executed twelve oil and tempera panels of scenes inspired by Maeterlinck's poem "The Dead Princess" for the music salon of Frau Wärndorfer's home in Vienna in 1902. Although the couple continued to collaborate until Charles Rennie Mackintosh's death in 1928, the Glasgow School *per se* dissolved early in the twentieth century. Margaret died in Chelsea in 1933.

132 "The Four Queens," 1909
 Painted and gilded gesso on four wooden panels, 22½ x 15¾" (each panel)
 Signed with monogram at l.r. of each panel: "MMM" and dated within monogram: "09"
 Ref.: *The Studio Year-Book of Decorative Art*, 1917, p. 79; Thomas Howarth, *Charles Rennie Mackintosh and the Modern Movement*, 2nd ed. (1977), pp. 113-117; Rowland and Betty Elzea, *The Pre-Raphaelite Era 1848-1914*, no. 8-93, pp. 214-215.
 SYDNEY AND FRANCES LEWIS

Currently mounted in two paneled doors, the four panels were designed and made by Margaret Macdonald Mackintosh for the cardroom at Hous'hill, Nitshill, Glasgow, the home of Major and Mrs. Cochrane. (Mrs. Cochrane was the former Miss Cranston, owner of The Willow Tea-Rooms and several similar establishments.) The alteration and general redecoration scheme of Hous'hill was largely in the hands of Charles Rennie Mackintosh, but his wife contributed much decorative work as well. Major Cochrane died in 1917, and three years later his wife sold the house. It was later damaged by fire and demolished shortly thereafter to make way for a housing estate.

Daisy Makeig-Jones
(Susannah Margaretta Makeig-Jones),
1881-1945

Daisy Makeig-Jones was born in the Welsh mining village of Wath-upon-Dearne, the eldest child of a doctor. As a young girl she was an avid reader of Andrew Lang's Coloured Fairy Books. In 1899 the family moved to Torquay, where she studied art at Torquay (now Torbay) School of Art. Following a brief period of study in London, she joined Wedgwood in 1909 as a trainee in ceramic design, and by 1914 she had become a full member of their design staff. Although her earliest work at Wedgwood had been designs for rather simple sets of nursery china and the like, she soon began creating more imaginative patterns, frequently drawing upon Far Eastern motifs. Towards the end of 1915 the first examples of the Fairyland Lustreware which would eventually make her reputation appeared. From this period until her forced retirement in 1931 following a dispute with the managing director of the firm, Daisy Makeig-Jones produced a spectacular array of Fairyland Lustre for Wedgwood in addition to other lustre designs. She sought inspiration for her work in many areas and enthusiastically borrowed motifs from Chinese, Japanese, Indian, Persian and Celtic art. Perhaps her greatest debt was to that group of artists whose work was inspired by similar sources — the illustra-

tors of fairy tales. Among these, such artists as H. J. Ford, Arthur Rackham, Edmund Dulac and Kay Nielsen can be singled out for comparison.

133 Covered vase in "Candlemas" pattern
 Bone china with multicolored lustre glaze, 11¾" h.
 Unsigned, but marked on the base with the maker's name and the pattern number: "Wedgwood Made in England Z5157" (and the Wedgwood emblem of the Portland vase)
 Ref.: Una des Fontaines, "Fairyland Lustre," *Proceedings of the Wedgwood Society,* No. 5 (1963), pp. 42, 45 (group II); Una des Fontaines, *Wedgwood Fairyland Lustre,* pp. 168-172.
 MR. AND MRS. DAVID E. ZEITLIN, MERION, PA.

Candlemas Day, February 2, marked the end of the forty days of Christmas. According to custom, all Christmas decorations had to be removed from the churches before Candlemas, or various horrors — from death to the appearance of goblins — might result. The festival of Candlemas combined Roman, early Christian and folk rituals and provided a rich source of inspiration for Daisy Makeig-Jones' designs. Here, for example, little goblins hang upon church bell-ropes, and the festival candle has grown a head instead of a wick. The Candlemas pattern was first introduced in the fall of 1917.

134 Bowl in "Firbolgs and Thumbelina" pattern, *c.* 1919
 Bone china with multicolored lustre glaze, 10⅞" diameter
 Unsigned, but marked with the maker's name and the pattern number: "Wedgwood * England Z5200" (and the Wedgwood emblem of the Portland vase)
 Ref.: Una des Fontaines, "Fairyland Lustre," *Proceedings of the Wedgwood Society,* No. 5 (1963), pp. 43, 45; Una des Fontaines, *Wedgwood Fairyland Lustre,* pp. 173-180, 263-265.
 MR. AND MRS. DAVID E. ZEITLIN, MERION, PA.

The outside of the "Firbolgs and Thumbelina" bowl is decorated with a version of Daisy Makeig-Jones' "Firbolgs" design upon a ruby-red ground. Although the term "Firbolgs" actually had a legitimate historical derivation (*fir =* men, *bolg =* the Celtic tribe of Belgae or Bolgi from Gaul, but also sack or bag), in popular terminology the word came to refer to a species of quasi-mythological little creatures or "Men of the Bags." The artist's "Firbolgs" are agitated souls who spend their time popping about amidst imaginary oriental shrubbery composed of branches from plum, bamboo and pine trees. The inside of the bowl features a series of characters from Hans Christian Andersen's story of Thumbelina. Thumbelina herself appears in a roundel at the center of the bowl with the mouse, the mole and other little figures ranged about the sides. Makeig-Jones drew heavily upon the fairy-tale illustrations of H. J. Ford for her designs. The roundel, for example, is closely derived from a Ford illustration to "Prince Vivien and the Princess Placida" (cat. no. 97) in Andrew Lang's *Green Fairy Book* (1892).

135 Covered vase in "Lahore" pattern, *c.* 1920
 Bone china with multicolored lustre glaze, 8⅜" h.
 Unsigned, but marked on the base with the maker's name

and the pattern number: "Wedgwood * England Z5266" (and the Wedgwood emblem of the Portland vase)
 Ref.: Una des Fontaines, *Wedgwood Fairyland Lustre,* pp. 232-234.
 MR. AND MRS. DAVID E. ZEITLIN, MERION, PA.

This bold, supposedly Indian design was in production between 1920 and 1929. The combination of black, mother-of-pearl and bright bands of gemlike color creates a particularly striking effect. In addition to the typically Indian motif of the elephant, the artist has included several creatures unfortunately not found on the Indian subcontinent, among them a giraffe and an ostrich.

136 Octagon bowl in "Moorish" pattern, *c.* 1925
 Bone china with multicolored lustre glaze, 8" diameter
 Unsigned, but marked on the base with the maker's name and the pattern number: "Wedgwood * England Z5126" (and the Wedgwood emblem of the Portland vase)
 Ref.: Una des Fontaines, *Wedgwood Fairyland Lustre,* pp. 162-163, Pl. 35.
 MR. AND MRS. DAVID E. ZEITLIN, MERION, PA.

On the exterior of the bowl a series of vaulted archways frame such figures as a dragon-like monster, a fountain and a willow tree. The interior is divided by ornate columns into individual compartments, within which are distant views of Middle Eastern scenery. Fairies, clusters of flowers or a brazier with curling ribbons of smoke appear upon or behind the connecting parapet in the foreground.

Mark Villars Marshall, -1912

Marshall was a prolific ceramicist and sculptor who left abundant examples of his talent as a designer and craftsman but few details of his personal life. He trained with the Martin Brothers before joining the staff of Doulton's pottery around 1876. Marshall remained with Doulton's throughout his life and concentrated on decorated stoneware using both incised and relief ornamentation. Highly imaginative designs of dragons, crawling beasts and other grotesque creatures frequently populated his justly renowned vases, jugs and decorative wares, and these fantasies became a hallmark of his style. He also designed individual figures in a similar mode for use as paperweights or small table objects. In 1900 he exhibited two large vases at the Paris Exhibition. During this period he created some of his best work, brilliant in color and much influenced by Art Nouveau designs.

137 Paperweights in the form of the Cheshire Cat and the Mock Turtle, *c.* 1902
 Glazed stoneware: Cheshire Cat 3½" long, Mock Turtle 2¼" high
 Unsigned, but stamped "Royal Doulton England" on the base of each figure.
 Ref.: Richard Dennis, *Catalogue of an Exhibition of Doulton Stoneware and Terracotta 1870-1925,* nos. 416 and 419.
 ALBERT GALLICHAN AND PETER ROSE

Many of Marshall's most elaborate vases and grotesqueries for Doulton were individual pieces rather than production items. The small paperweights, however, are known to exist

in multiple examples with different color glazes (generally brown or blue). While the sources for the paperweight designs are by no means certain; these two whimsical figures are generally considered to have been inspired by Lewis Carroll's Cheshire Cat and Mock Turtle.

138 Vase with grotesque motif, 1904
 Glazed stoneware, 10½" high
 Initials on base: "M.V.M." with the circle mark, lion and
 crown for Doulton and the date letter for 1904
 Ref.: Richard Dennis, *Catalogue of an Exhibition of
 Doulton Stoneware and Terracotta 1870-1925*, no. 400.
 RICHARD DENNIS, LONDON

The vase is a particularly fine example of Marshall's imaginative modeling. The strange and fabulous creature which attaches itself to the surface of the piece is rather more than a dragon, clearly less than human, and altogether very bizarre.

John Martin, 1789-1854

Martin was born into a large impoverished family residing in Hexham, Northumberland. He was first apprenticed to a coach painter but soon began studies under Boniface Musso, an Italian painter and draughtsman living in Newcastle. In 1806 he left with Musso and his family for London, where he spent several years decorating china and glass, teaching, and studying architecture and perspective when he could. In 1811 he submitted his initial entry, a landscape, to the Royal Academy. In the following year he exhibited the first in a long series of dramatically colored paintings largely inspired by biblical themes. These remarkable pictures were frequently crowded with milling, tormented figures in fantastic settings illuminated with almost supernatural light. Many of these works were shown at the Royal Academy or the British Institution and understandably caused much comment. Despite criticism, he won great popular acclaim, and in 1816 he was appointed historical landscape painter to Princess Charlotte and Prince Leopold. Martin produced a series of mezzotints after several of his most spectacular pictures, such as "Belshazzar's Feast," "The Deluge" and "The Fall of Babylon." Between 1825 and 1827 he issued a series of mezzotint illustrations to Milton's *Paradise Lost*, followed by another set, *Illustrations of the Bible*, which appeared in ten parts from 1831 to 1835. He did all the mezzotint work for both series himself. Caught up in the ideals of the Industrial Revolution, he also devoted much energy to schemes for municipal improvement, seeking thereby to better London's water supply, sewage disposal system and docks.

139 "The Deluge," 1828
 Proof mezzotint, 18¹⁵⁄₁₆ x 28¼"
 Ref.: Christopher Johnstone, *John Martin*, p. 63; William
 Feaver, *The Art of John Martin*, pp. 92-97 and Pl. IV.
 HENRI ZERNER

Martin's first essay on this dramatic theme, a subject to which he would return numerous times, was an illustration he designed for *A Midsummer Day's Dream* by Edwin Ath-erstone (1824). In 1826 he exhibited at the British Institution a large painting entitled "The Deluge," which he described as being as close to an accurate reconstruction of this event in Genesis as it was possible for him to create. The large mezzotint version (here in a fine proof state) was engraved in 1828 and dedicated to Czar Nicholas I of Russia. This version was followed in 1834 by yet another large painting of the scene, which Martin stated was his favorite picture. The 1834 painting was shown the following year at the Paris Salon, where it won a gold medal.

Martin Brothers:
Robert Wallace Martin, 1843-1923;
Charles Martin, 1846-1910;
Walter Martin, 1859-1912;
Edwin Bruce Martin, 1860-1915

The Martin Brothers' Pottery, active for more than three decades at Southall, was the joint enterprise of four talented brothers. The eldest of the four, Robert Wallace Martin, was the central figure of the group. He was born in London and trained at the Lambeth School of Art and the Royal Academy Schools. From 1863 on, he exhibited reliefs, medallions and sculpture at the Royal Academy on an occasional basis. His involvement with the rebuilding of the Houses of Parliament, carving stone decorations in a Gothic style going back to the designs of Pugin, led to a life-long love of humorous and grotesque ornament. The two youngest brothers, Walter and Edwin Bruce Martin, attended the Lambeth School of Art and later became assistants at the Doulton pottery. In 1873 the four brothers opened their first family studio at Fulham which concentrated on the production of salt-glaze stoneware, and four years later they moved to Southall. The responsibilities of the studio were divided among the four men. Robert Wallace designed the grotesque figures and animal forms, in particular incredible birds with ingratiating expressions. Walter Martin served as technical advisor, while Edwin specialized in surface decoration, both incised and relief patterns. At first Charles Martin had assisted his brother Edwin, but he later took over the administrative side of the business. Stylistically the Martin Brothers' work followed a succession of stages which paralleled those of other producers of decorative ware. The rather medieval character of the work of the 1870s was succeeded by an Italianate and then a Japanese phase. A visit to the Paris Exhibition of 1900 exposed the Martins to the designs of continental Art Nouveau, and their late work, with its emphasis on organic forms, reflects this influence.

140 Grotesque bird, 1885
 Stoneware glazed in shades of brown, beige and blue,
 12¾" h. (without base)
 Signed on the base of the head: "Martin Brs. London &
 Southall" and on the interior rim of the neck: "Martin
 Brothers London" and at the base of the tail: "R. W.
 Martin Sc. London & Southall 6.1885."
 MR. ERIC SILVER AND DR. GAIL EVRA

This well-dispositioned fellow is a splendid early example of a Martinware bird. These endearing creatures appeared in the early 1880s and to some degree find soul-mates in the assorted crows, ravens and other feathered types which populate Arthur Rackham's fantasy kingdom.

141 Handled jug, 1889
Glazed stoneware with incised decoration, 16″ h.
Signed and dated on the base: "Martin Brothers London Southall 5 1889"
LEO KAPLAN ANTIQUES, NEW YORK

This finely executed jug, with its extremely naturalistic and rather terrifying incised designs of fish, is quite oriental in feeling and clearly owes much to the influence of Japanese ceramics. The Martin Brothers' works of this type were decorated in varied glazes, all of which tended to be rather subtle.

142 Face jug, 1896
Stoneware body modeled with two smiling faces; honey-brown glaze, eyes glazed in black and white, 9″ h.
Signed and dated on the base: "10-1896 Martin Bros. London & Southall"
MR. ERIC SILVER AND DR. GAIL EVRA

143 Grotesque bird, 1902
Glazed stoneware, 9½″ h.
Signed and dated on the interior rim of the neck: "3-1902 Martin Bros. London & Southall" and along the base: "3-1902 Martin Bros. London & Southall"
LEO KAPLAN ANTIQUES, NEW YORK

David McBirney and Company, (Belleek)

On the advice of Robert William Armstrong, an Irish architect who was artistic director at the Royal Porcelain Works in Worcester, the Dublin merchant David McBirney financed the founding of a porcelain manufactory in the village of Belleek, County Fermanagh, Ireland. Armstrong became art director of this new enterprise which seems to have opened its doors around 1857 (some sources indicate 1863). Several other craftsmen were lured from Staffordshire, and the Belleek factory soon gained a reputation for producing high-quality porcelain overlaid with a fine iridescent glaze. Armstrong and his wife were among the main designers for the firm, which specialized in decorative ware of a fanciful nature. Marine forms and mythical creatures were perhaps the most popular designs, highly favored by Queen Victoria and the British aristocracy. The Belleek displays at the Paris Exhibition of 1867 attracted much attention, and by the time of the 1872 Dublin Exhibition, the company's display was the largest in the show. David McBirney and R. W. Armstrong both died in 1884, but the factory has remained in production as the Belleek Pottery Works Ltd.

144 Tea urn and stand, 1872
Parian porcelain with overglaze colors, gilt and iridescent lustre glaze, 14⅛″ h.

Marked with the Belleek factory trademark and a Patent Office Design Registry mark for 1872
Ref.: Rowland and Betty Elzea, *The Pre-Raphaelite Era 1848-1914*, no. 4-76, pp. 104-105.
PHILADELPHIA MUSEUM OF ART, GIFT OF MISS MARY K. GIBSON

Most probably designed as an exhibition piece for the 1872 Dublin Exhibition, this remarkable ceramic fantasy is known to exist in several other versions. Referred to as the "Chinese tea urn and stand," the piece exemplifies the type of extravagant "Victorian chinoiserie," which might be termed a thunderous echo of the more restrained chinoiserie style of the previous century.

Ernestine Evans Mills, 1871-1959

The English artist Ernestine Evans Mills (also recorded as Mrs. Ernestine Bell Mills) was active as both a watercolorist and a silversmith. Much of her metalwork included enameling, which she had studied at the Royal College of Art under Alexander Fisher. She also studied at the Slade School of Fine Art with Frederic Shields, whose biography she wrote in 1912. She exhibited at the Royal Academy and the Royal Society of Miniature Painters as well as at the Paris Salon, where she is listed as winning a silver medal for her enamelwork as late as 1955. Like many of her fellow craftswomen, Ernestine Mills was a member of the Society of Women Artists.

145 Enamel plaque with mermaid, c. 1910
Enamel on copper with silver frame, 7¼″ diameter
Signed with initials at l.r.: "EM"
Ref.: Dora Jane Janson, *From slave to siren*, p. 102 and cover; Rowland and Betty Elzea, *The Pre-Raphaelite Era 1848-1914*, no. 6-53, pp. 152-153.
DELAWARE ART MUSEUM

William Morris, 1834-1896

Morris was born in Walthamstow and educated at Marlborough College in Wiltshire. He later entered Exeter College, Oxford in 1853 intending to study for holy orders. The following year he visited Belgium and the cathedrals of northern France with Edward Burne-Jones, whom he had met at Oxford. In 1856, having abandoned his plans to enter the ministry, he became articled to the architect George Edmund Street and shared rooms with Burne-Jones in Bloomsbury. The two men moved to Red Lion Square in the next year and decorated their rooms in the medieval style. Like Burne-Jones, Morris had come under the influence of Dante Gabriel Rossetti and worked with him on the murals for the Oxford Union. In 1859 Morris married Jane Burden, whose sensuous yet classical features became a prototype image of womanhood for the Pre-Raphaelite painters. He was a founding member and guiding force of the firm of Morris, Marshall, Faulkner and Company, set up in 1861 to produce church and domestic furnishings, including wallpapers, tiles, textiles and furniture. Several of their creations

were exhibited in 1862 at the London International Exhibition. The firm was reorganized as Morris & Company in 1875 under Morris' sole direction. Enormously productive as a designer, poet and writer of fantasy literature, he became more and more involved in a variety of political and social causes during his later years; his activities included the founding of the Society for the Protection of Ancient Buildings (1877), membership in the Democratic Federation (1883), the formation of the Socialist League (1885) and the establishment of the Hammersmith Socialist Society (1890). He was also an active participant in the Art Workers' Guild and the Arts and Crafts Exhibition Society. He began studying Icelandic in 1868 and made his first visit to Iceland in 1871. Nordic and medieval cultures were the major influences upon his literature and art. Deeply interested in fine printing since his student days at Oxford, Morris had been concerned with various publishing ventures throughout his career, but his lasting fame in this area rests upon the establishment of the Kelmscott Press in 1891 at Kelmscott House in Hammersmith. Among the Kelmscott publications are many of Morris' own writings (such as *The Wood Beyond the World* and *The Story of the Glittering Plain*), but the masterpiece of the press was *The Works of Geoffrey Chaucer* (1896) with designs by Morris and wood-engraved illustrations by Burne-Jones. Morris died shortly after the publication of the *Chaucer* and was buried in Kelmscott churchyard.

146 Design for the printer's mark in *The Works of Geoffrey Chaucer*
Wood-engraved plate with original design in pencil, pen and ink, 15¼ x 10½"
Ref.: Paul Needham, ed., *William Morris and the Art of the Book*, no. 93E, p. 135 and Pl. C.
THE PIERPONT MORGAN LIBRARY, GIFT OF JOHN M. CRAWFORD, JR.

Morris created a new printer's mark for use in the Kelmscott *Chaucer*. He worked up his design for the mark on a proof of the last page of this magnificent volume, which bears Burne-Jones' final illustration to *Troilus and Criseyde* within ornamental borders by Morris. The resultant sheet is a fantasy of ornamental design.

John Hamilton Mortimer, 1741-1779

The son of a mill owner, Mortimer was born in Eastbourne and was sent to London as a youth to study art under Thomas Hudson. He also studied at the Duke of Richmond's sculpture gallery, the Academy in St. Martin's Lane and with Giovanni Battista Cipriani and Sir Joshua Reynolds. He became a member of and exhibited with the Incorporated Society of Arts, and was elected vice-president of the Society in 1773. He concentrated on history paintings, genre scenes and literary subjects. In 1778 he exhibited at the Royal Academy for the first time and was created a full academician by royal decree the following year, but he died of a fever before he could receive his diploma. Mortimer was much influenced by the work of the seventeenth-century

Italian painter Salvator Rosa and did numerous drawings and etchings after Rosa's compositions. He also contributed etched illustrations to such publications as *Bell's British Theatre* (1776-1778) and *Bell's Edition. The Poets of Great Britain complete from Chaucer to Churchill* (109 volumes, 1777-1783).

147 "Tritons"
Pen, brown ink and watercolor, 5⁷⁄₁₆ x 7½"
Signed at l.l.: "J. Mortimer"
Ref.: Providence, Museum of Art, Rhode Island School of Design, *Prints and Drawings with a Classical Reference*, no. 44.
MUSEUM OF ART, RHODE ISLAND SCHOOL OF DESIGN

Mortimer's drawing was undoubtedly inspired by earlier etchings on the same theme by Salvator Rosa, such as the "Battle of Tritons" (Bartsch 12).

Kay Nielsen, 1886-1957

Nielsen was born in Copenhagen, the son of an actor-turned-director and an actress versed in both the classical French theater and Danish folklore. As a youth, he met many of the great Scandinavian playwrights, writers and musicians. He soon developed an interest in drawing and illustration, and at the age of seventeen he left Denmark to study art in Paris, where he attended both the Académie Julian and the Collarossi. In his free time he began to illustrate Heine, Verlaine and Hans Christian Andersen, among others. Encouraged in this activity by English acquaintances, Nielsen left Paris for London in 1911. In the following year, Sir Arthur Quiller-Couch's *In Powder and Crinoline* appeared, the first in a series of books illustrated by Nielsen for publication in England. During this period Nielsen's drawings were exhibited at the Leicester Galleries in London. He then began work on a Danish translation of *The Arabian Nights* (never published) and designed sets for the Royal Theater in Copenhagen (1918-1922). Nielsen acknowledged that his work was influenced by the art of the early Italian Renaissance, but most of all by oriental art and the art of the Middle East. Like the work of so many of his contemporaries, his illustrations show more than a hint of Beardsley's influence as well. In 1939 Nielsen moved to California, where he designed film sets and murals and also worked as an actor and director. One of his first commissions there was to work on the film *Fantasia* for Walt Disney Studios. He died in Hollywood in 1957.

148 " 'Your soul!—My soul!' they kept saying in hollow tones, according as they won or lost" from "John and the Ghosts" in *In Powder and Crinoline, Old Fairy Tales*, retold by Sir Arthur Quiller-Couch, 1912
Pen, ink and watercolor, 11¾ x 10¼"
Signed and dated at u.l.: "Kay Nielsen 12."
Ref.: Brigid Peppin, *Fantasy, The Golden Age of Fantastic Illustration*, p. 149.
KENNETH KENDALL, LOS ANGELES

In Powder and Crinoline was published by Hodder & Stoughton in 1912, and republished the following year by

George Duran Company, New York, under the title *The Twelve Dancing Princesses*. While many of the other designs for the volume are rendered in Nielsen's linear "fashion-plate" style, this equally elegant and highly finished illustration combines the artist's interest in the extravagances of costume with the creation of a haunting and evocative atmosphere.

149 "Platonic Love," 1913
 Pen, ink, watercolor and gold paint, 15¾ x 7¾"
 Signed and dated at right side: "Kay Nielsen 1913"
 JOHN D. MERRIAM

This apparently unpublished drawing is typical of the "fashion-plate" style of several of Nielsen's illustrations to *In Powder and Crinoline* (1912), such as those for the story "Minon-Minette."

150 "And flitted away as far as they could from the Castle that lay East of the Sun and West of the Moon," from *East of the Sun and West of the Moon, Old Tales from the North* by P. C. Asbjörnsen and Jorgen Moe, 1913
 Pen, ink, watercolor and gold paint, 13⅞ x 10³⁄₁₆"
 Signed and dated at l.r.: "Kay Nielsen •1913•"
 Ref.: David Larkin, ed., *The Fantastic Kingdom*, Pl. 27.
 KENNETH KENDALL, LOS ANGELES

This plate, which illustrates the last lines of the story "East of the Sun and West of the Moon," is perhaps the best-known image from Nielsen's most famous book, published by Hodder & Stoughton in 1914. The influence of Japanese art is reflected in the overall composition and in the manner in which pattern is used, as well as in specific designs like the waves and the tree.

151 Endpaper design for *East of the Sun and West of the Moon, Old Tales from the North* by P. C. Asbjörnsen and Jorgen Moe
 Pencil, pen and black ink, 11⅛ x 9¹⁄₁₆"
 VICTORIA AND ALBERT MUSEUM, LONDON

The title of the book and the notations "End paper" and "to be done in gold" appear in pencil at the lower right beneath the image. Although undated, the endpaper design undoubtedly was done during the period when Nielsen worked on the illustrations for *East of the Sun and West of the Moon*, most of which are dated 1913 and 1914 (the year of publication).

152 "La Vision," 1914
 Pencil and watercolor on Whatman drawing board, 14¼ x 9½"
 Signed and dated at u.r.: "Kay Nielsen 1914"
 MUSEUM OF FINE ARTS, BOSTON. ANONYMOUS GIFT IN MEMORY OF KAY NIELSEN

In this apparently unpublished drawing illustrating a scene from the life of Joan of Arc, Nielsen has treated this event from French history as if it were part of a charming fairy tale. He has elegantly personified the vision and set the figures against a background of delicate trees and flowers which is more like a medieval tapestry in its decorative patterning than a landscape.

Frank Cheyne Papé, 1878-

Although few biographical references are available on the personal life of this English artist, evidence of his artistic career exists in an admirable series of designs for book illustrations, periodicals and bookplates. His works include commissions from most of the major publishers during the early years of the twentieth century. To his credit are illustrations for such volumes as *Hans Andersen's Fairy Tales* (Nister, 1910), *The Pilgrim's Progress* (Dent, 1910), *The Gateway to Spenser* (Thomas Nelson, 1911), *At the Back of the North Wind* (Blackie, 1911) and *The Indian Story Book* (Macmillan, 1914). He also illustrated the fantasy romances of James Branch Cabell, *Jurgen* (1921), *Figures of Earth* (1925), *The Cream of the Jest* (1927), *The Silver Stallion* (1928), *Something about Eve* (1929), *The Way of Ecben* (1929) and *Domnei* (1930), all published by John Lane, and *The High Place* (1923), published by R. M. McBride, New York. In an unpublished letter written in July 1933 to a Mr. Frank House in Brooklyn, New York, Papé made a poignant comment on the current state of book illustration: "As high class book work seems to be a dead horse I have devoted most of my time to trying to get other kinds of work — for papers and what-not. There is a proverb: 'When the devil is starving he will eat flies.' "

153 "Manuel would be there too, of course" (Book V, "Mundus Vult Decipi," Chap. xxxiii) from *The Silver Stallion* by James Branch Cabell
 Pencil, pen, black ink and white heightening on buff paper, 14¾ x 9"
 Signed at u.r.: "Frank C. Papé"
 JOHN D. MERRIAM

The Silver Stallion, A Comedy of Redemption was first published in 1926 by John Lane (London) and McBride (New York) without illustrations. Two years later the firms published an edition with photogravure plates after designs by Papé. Although less horrific than his designs for Cabell's symbolic fantasy *Jurgen*, Papé's illustrations to *The Silver Stallion* appropriately paralleled the combination of humor and fantasy in the author's text and were not unlike the work of Sidney Sime in this respect. Dom Manuel was Count of Poictesme, a mythical land created by Cabell out of what he referred to as "an illicit union between Poictiers and Angoulesme" with touches of Tunbridge Wells thrown in. Mysterious as this sounds, Tunbridge Wells was Papé's home, and the choice of Tunbridge Wells as a partial inspiration for Poictesme attests to the strength of the relationship between the American author of fantasy and the British illustrator.

Sir Joseph Noël Paton, 1821-1901

Joseph Noël Paton was born in Dunfermline, Scotland, the son of a damask designer. He was first apprenticed in the field of industrial design, but, like his younger brother Waller Hugh Paton, he was destined to become a painter. After study at the Edinburgh Academy, he transferred in 1843 to

the Royal Academy Schools in London. The following year he sent his first entry to the Royal Scottish Academy and, from 1856 on, submitted paintings to the Royal Academy as well. He was elected an Associate of the Royal Scottish Academy in 1846 and was promoted to full membership four years later. In 1866 Queen Victoria named him Her Majesty's Limner for Scotland and bestowed upon him the attendant knighthood. Paton also wrote and published poetry, and contributed illustrations to volumes by other authors. He executed two designs for the first edition in book form of Charles Kingsley's *The Water-Babies: A Fairy Tale for a Land-Baby* (1863). His work also attracted the attention of Lewis Carroll who, after a disagreement with Tenniel, offered Paton the commission to illustrate *Through the Looking-Glass*, a project which he declined. Paton's early work had much in common stylistically with the paintings of the Pre-Raphaelite Brotherhood, especially in its laborious attention to expressive detail, but he never officially joined that group. Among his most popular and original works were those devoted to fairy subjects, but after 1870 he tended to focus more on religious imagery, and his painting style became rather coldly academic.

154 "Elves and Fairies: A Midsummer Night's Dream"
 Oil on millboard, 11⅞ x 9¹⁵⁄₁₆″
 YALE CENTER FOR BRITISH ART, PAUL MELLON FUND

Noël Paton, like Richard Doyle, devoted much of his talent to producing fairy pictures, although his cast of characters is generally more full-bodied and Boschian in nature than Doyle's. "Elves and Fairies" is derived from one of Paton's major fairy oils, "The Quarrel of Oberon and Titania" (1849), now in the National Galleries of Scotland, Edinburgh. "The Quarrel" illustrates Act II, Scene ii of Shakespeare's play and includes, in addition to the central figures in the scene, a large supporting cast of elves and fairies. The cluster of assorted creatures in the Yale painting is a variant upon a similar group in the center of the larger composition.

155 "The Water Babies" from *The Water-Babies: A Fairy Tale for a Land-Baby* by Charles Kingsley
 Pen and ink, 8¼″ diameter
 Signed with a monogram at bottom center: " ℵ "
 PRIVATE COLLECTION

This delightful drawing is for one of the two illustrations by Paton which appeared in the first edition of Kingsley's classic tale published by Macmillan in 1863.

Willy Pogány
(William Andrew Pogány), 1882-1955

Born in Szeged, Hungary to a family of limited means, Pogány nevertheless managed to enter the university in Budapest to study engineering. Deciding to train as an artist, he studied briefly in Budapest and Munich before moving to Paris where he began to submit caricatures of contemporary figures to various periodicals. After two years in Paris

he planned to go to America with a brief stop in London. He remained in London for ten years, however, where he gained much success as a book illustrator. His commissions included a volume of Hungarian fairy tales as well as several major works for the publisher George Harrap, among them *The Rubaiyat of Omar Khayyam, The Rime of the Ancient Mariner, Lohengrin, La Belle Dame Sans Merci* and *Parsifal*. Pogány eventually reached America in 1915 and settled first in New York City. He continued to illustrate books (including a splendid series for the legends retold by Padraic Colum, such as *The Children of Odin*), and he also painted murals for public and private clients, designed interiors for several large hotels and created a series of stage settings and costumes for the New York theater. While there he joined the Salmagundi Club and the Architectural League. Around 1930, he moved to Hollywood, where he became an art director for Warner's First National Studios, but after several years in California, he returned to New York City.

156 "I watched the water-snakes" from *The Rime of the Ancient Mariner* by Samuel Taylor Coleridge, 1910
 Color half-tone plate tipped onto nacred paper, from the deluxe edition, 12⅜ x 8⅞″
 JOHN D. MERRIAM

George G. Harrap published this deluxe volume of Coleridge's poem with illustrations by Pogány in 1910. The edition was limited to only twenty-five copies, of which this is number four. The book is a tour de force of printing, both in the quality of the color and in the elegance of the total design of the volume. The printer's skill has allowed the artist to use extremely subtle changes in color and tone to heighten the sense of fantasy and mystery.

Beatrix Potter, 1866-1943

The daughter of the gentleman barrister and amateur photographer Rupert Potter, Helen Beatrix Potter was born in London and remained with her parents in their South Kensington home until she was nearly forty. She led a sheltered life, was entirely self-taught as an artist and, like the Detmold brothers, became an avid and competent student of natural history. When she was almost seventeen, her parents employed a young woman named Annie Carter to act as her companion and teacher. The two women became lifelong friends and it was for Annie's young son Noel Moore that Beatrix Potter later began her tale about Peter Rabbit. In 1893, when Noel was ill, she sent him the first of a succession of "picture letters" which eventually led to the publication in 1901 of her first book, *The Tale of Peter Rabbit*. Although the 1901 edition was privately printed with only one color plate and the remaining illustrations in black and white, late in 1902 Frederick Warne published a commercial edition in full color. This initiated the famous series now referred to as the "Peter Rabbit" books, which includes such classics as *The Tailor of Gloucester* (1902 and 1903), *The*

Tale of Squirrel Nutkin (1903), *The Tale of Benjamin Bunny* (1904), *The Tale of Mr. Jeremy Fisher* (1906) and *The Tale of Jemima Puddle-Duck* (1908). In 1905 Beatrix Potter bought Hill Top Farm in the Westmorland village of Near Sawrey, and it is this locale which serves as the setting for most of her later books. At the age of forty-seven she married William Heelis, an attorney, and from then on devoted her energies more to farming than to writing or illustration. She died in Sawrey just before Chrstmas 1943, after bequeathing Hill Top to the National Trust.

157 "The White Rabbit" after *Alice's Adventures in Wonderland* by Lewis Carroll, *c.* 1895
Pen, ink and watercolor, two designs in one mount, each 4¼ x 3⁹⁄₁₆″
Signed with initials at l.r. of each design: "HBP" (left image), "HBP." (right image)
Ref.: London, The National Book League and the Trustees of the Linder Collection, *The Linder Collection of the works and drawings of Beatrix Potter*, p. 34.
THE LINDER COLLECTION, HOUSED AT THE NATIONAL BOOK LEAGUE, LONDON

Each drawing is inscribed on the verso in Beatrix Potter's hand with a quote from the Carroll tale: "The White Rabbit, splendidly dressed, with a pair of white kid gloves and a fan." "The Rabbit started violently, dropped the white kid gloves and the fan, and skurried [sic] away into the darkness as hard as he could go —." Beatrix Potter never published an edition of *Alice in Wonderland,* and only six *Alice* drawings by her are known. As a young woman, many years before she produced the first of her own volumes, she did illustrations to several of her favorite books for her own amusement. In addition to the *Alice* watercolors, these early efforts include designs for *Cinderella, Puss in Boots, The Sleeping Beauty* and *Uncle Remus.* While Beatrix Potter's *Alice* illustrations owe a clear debt to Tenniel, they have an undeniable charm of their own and are admirable forerunners to her later published work.

158 Illustration for "Dornröschen" after Ludwig Richter, 1899
Pen, ink and watercolor, 11⅞ x 9⁷⁄₁₆″
Signed and dated at l.r.: "HBP Feb.99"
THE FREE LIBRARY OF PHILADELPHIA

Beatrix Potter did several "Sleeping Beauty" drawings after woodcut illustrations by the German artist and illustrator Ludwig Richter (1803-1884). These, like her illustrations to *Alice in Wonderland,* were done for her own pleasure and instruction and predate her books by several years. In this drawing, she has copied the woodcut in pen and ink and surrounded the scene with a delicate border of roses in watercolor. She has carefully documented her work, inscribing the word "copy." at the lower left corner of the image in addition to listing the source, the artist and the appropriate verses of the German text at the bottom of her sheet. Without overstating the influence of Richter's designs upon Beatrix Potter's own illustrations, one can see that his feeling for picturesque detail and his precise yet delicate rendering of figures and setting find echoes in Potter's art.

159 "The Day's News"
Pen, ink and watercolor, 6½ x 4⅛″
Signed with initials at l.r.: "HBP."
Ref.: Enid Linder, Leslie Linder and A. C. Moore, *The Art of Beatrix Potter,* p. 196; London, The National Book League and the Trustees of the Linder Collection, *The Linder Collection of the works and drawings of Beatrix Potter,* p. 32.
THE LINDER COLLECTION, HOUSED AT THE NATIONAL BOOK LEAGUE, LONDON

This small undated drawing was apparently completed quite some time before the appearance of the published work to which it is most closely related. According to Anne Clarke, Mark Longman Librarian at the National Book League, the mouse may be considered an early version or prefiguration of the charming frontispiece to *The Tailor of Gloucester* (1903). In the actual frontispiece illustration a thread spool replaces the little wicker chair as a resting place for the furry reader.

160 "Pigling Bland," a duplicate version of the frontispiece to *The Tale of Pigling Bland* by Beatrix Potter
Pen, ink and watercolor, 7⁹⁄₁₆ x 6⅛″
Ref.: Leslie Linder, *A History of the Writings of Beatrix Potter,* pp. 213-217; London, The National Book League and the Trustees of the Linder Collection, *The Linder Collection of the works and drawings of Beatrix Potter,* p. 42; Margaret Lane, *The Magic Years of Beatrix Potter,* p. 195.
THE LINDER COLLECTION, HOUSED AT THE NATIONAL BOOK LEAGUE, LONDON

The drawing is inscribed on the verso in a hand most probably Beatrix Potter's: "This is much better than the one used in book." Here, as opposed to the published version (1913), both Alexander and Pigling Bland wear green jackets instead of one green and one brown, and their step and expression have altogether more animation. The setting for the scene is the crossroads at Sawrey, a location near the artist's now-famous home, Hill Top.

Alfred Powell, -1960

Originally trained as an architect under Richard Norman Shaw, the English artist Alfred Powell also produced paintings and watercolors, primarily of architectural subjects. Around 1904 he married Louise Lessore, granddaughter of the ceramic decorator Émile Lessore. The Powells then established their own pottery at Millwall (East London), but later moved to Red Lion Square, where they specialized in tin-glazed decoration. Both artists also worked for Wedgwood (*c.* 1904-1939) and were responsible for establishing a school of handpainting at the Wedgwood factory. In addition to the design and decoration of ceramics, the Powells decorated furniture by such designers as Ernest Gimson, W. R. Lethaby and Sidney Barnsley.

161 Plate, *c.* 1920
Hand-painted earthenware, 18½″ diameter
Signed on the reverse with Alfred Powell's personal mark and impressed: "Wedgwood" and "455"

Ref.: London, The Royal Academy of Arts, *Victorian and Edwardian Decorative Art, The Handley-Read Collection*, E62, p. 92.
FITZWILLIAM MUSEUM, CAMBRIDGE

The regularized foliate ornamentation radiates from a central roundel containing the fierce image of an owl. Other birds and animals are interlaced among the foliage forming a band about the center. Like De Morgan, Powell was influenced by Persian design and this highly decorative plate is one of the finest and purest examples of this aspect of his work.

Arthur Rackham, 1867-1939

Rackham was born in London and educated at the City of London School. Following a visit to Australia in 1884 with two family friends, he entered the Lambeth School of Art. In 1885 he joined the Westminster Fire Office as an insurance clerk, but left this position in 1892 to become a staff artist on *The Westminster Budget*. In 1902 he was elected an associate member of the Royal Society of Painters in Water Colours and was promoted to full membership six years later. He joined the Art Workers' Guild in 1909 (becoming Master of the Guild in 1919). His first book illustrations, in black and white, were for Thomas Rhodes' *To the Other Side* (1893), a travelogue about America. By the turn of the century Rackham had become a frequent contributor to such periodicals as *Cassell's Magazine* and *Little Folks*, and he began to develop a reputation as a book illustrator with early successes like *The Ingoldsby Legends* of Richard Barham (1898). Influences upon his work were many and varied, from George Cruikshank, Richard Doyle, Aubrey Beardsley and Edmund J. Sullivan to Dürer and Japanese prints. With the publication of *Rip Van Winkle* (1905) and the remarkable *Peter Pan in Kensington Gardens* (1906), Rackham's reputation as an illustrator of colored books was assured. These triumphs were followed by a seemingly endless stream of color-plate volumes, including *Alice's Adventures in Wonderland* (1907), *Undine* (1909), *Siegfried and the Twilight of the Gods* (1911), *Little Brother and Little Sister* (1917), *Comus* (1921), *The Tempest* (1926) and the posthumously published *The Wind in the Willows* (1940). Rackham exhibited his original drawings with some frequency at the Leicester Galleries in London, and these works were in demand throughout Europe and America as well. Although he failed to achieve election to the Royal Academy, he continued to exhibit at the Royal Watercolor Society and remained an active member of the Art Workers' Guild. In 1927 he visited America and four years later traveled to Denmark with his daughter, where he viewed the gravesite of Hans Christian Andersen and did numerous sketches for a series of illustrations to Andersen's *Fairy Tales* published the following year. Despite failing health, he was able to complete his final illustration for *The Wind in the Willows* shortly before his death in the fall of 1939.

162 "The Long-Armed Giant," 1904
Pen, ink and watercolor, 6⅜ x 8¼"
Signed and dated at u.r.: "Arthur Rackham 1904"
THE FREE LIBRARY OF PHILADELPHIA

In this unpublished and as yet unidentified scene, Rackham makes straightforward and effective use of extreme distortions in scale and perspective.

163 "Advice from a Caterpillar" from *Alice's Adventures in Wonderland* by Lewis Carroll, 1907
Pen, ink and watercolor, 9½ x 6⅛"
Signed and dated at l.r.: "Arthur Rackham 07"
Ref.: Margery Darrell, ed., *Once Upon A Time*, pp. 91-96.
PRIVATE COLLECTOR, SWITZERLAND

Rackham's *Alice in Wonderland* was published by William Heinemann in 1907, and has since become one of his most sought-after volumes. Among the more than one hundred artists who tried their hand at illustrating Carroll's classic, Tenniel and Rackham stand out as the most extraordinary and original: it is almost impossible to contemplate *Alice* without picturing the designs of one or the other of the two men. This scene of Alice with the rather fatherly-looking caterpillar is one of the best-known and most appealing illustrations in the book.

164 "O monstrous! O strange!," Act III, Scene i, from *A Midsummer Night's Dream* by William Shakespeare, 1908
Pen, ink and watercolor, 7 x 10½"
Signed and dated at l.l.: "Arthur Rackham 08" and also on the mount within inscription
SPENCER COLLECTION, THE NEW YORK PUBLIC LIBRARY, ASTOR, LENOX AND TILDEN FOUNDATIONS

On the mount of the drawing is an inscription in Rackham's hand: "A Midsummer Night's Dream. 1908. Act.III.Sc.I. O monstrous! O Strange! we are haunted. Pray, master! Fly, Masters! Help! Arthur Rackham." Rackham illustrated *A Midsummer Night's Dream* on three separate occasions, and this drawing appeared in the first of these compilations, a volume published by William Heinemann in 1908 in both a deluxe and a trade edition. The designs in this book ranged from charming and gentle depictions of fairies to more disturbing images like "O monstrous! O strange!" Rackham returned to *A Midsummer Night's Dream* in 1928 after receiving a commission to do a manuscript version from the Spencer Collection at The New York Public Library and again, shortly before his death in 1939, when The Limited Editions Club, New York, published an edition with six color plates.

165 "Raging, Wotan Rides to the rock!" frontispiece to *The Rhinegold & The Valkyrie* by Richard Wagner, 1910
Pen, ink and watercolor, 14¹³⁄₁₆ x 10⅜"
Signed and dated at l.r.: "Arthur Rackham 1910"
MUSEUM OF FINE ARTS, BOSTON. BEQUEST OF JOHN T. SPAULDING

Rackham's illustrations to Wagner's *The Ring of the Nibelung* appeared in two parts. *The Rhinegold & The Valkyrie* was published by William Heinemann in 1910, *Siegfried & The Twilight of the Gods* in the following year. These two

volumes, with their concentration on the heroic drama of the Norse myths, were something of a departure for Rackham, and by no means unsuccessful. In 1912, for example, the Société Nationale des Beaux Arts invited the artist to exhibit the Wagner drawings in Paris and awarded him a gold medal. Despite the appeal of these illustrations, Rackham returned rather quickly to a somewhat lighter vein, issuing an *Aesop's Fables* and a new edition of *Peter Pan in Kensington Gardens* in 1912 and a *Mother Goose* in 1913.

166 "The Owl and the Birds" from *Aesop's Fables*, 1912
 Pen, ink and watercolor, 8 x 6″
 Signed and dated at l.r.: "Arthur Rackham 1912"
 Ref.: Roland Baughman, *The Centenary of Arthur Rackham's Birth, September 19, 1867* (catalogue of the Berol Collection), no. A99.
 RARE BOOK AND MANUSCRIPT LIBRARY, COLUMBIA UNIVERSITY

Aesop's Fables was published in 1912 by William Heinemann with an introduction by G. K. Chesterton. In the book, "The Owl and the Birds" appears in black and white without the pictorial border. Since an elaborate color drawing was more marketable, Rackham frequently added color to drawings originally published in black and white or executed watercolor versions of his pen and ink designs. Despite the fact that the cluster of feathered creatures lacks some of the more obvious external trappings of mankind such as clothing, Rackham is in this drawing once again working within that borderland between the human and animal worlds which he portrays so effectively. There is about the gathering a suggestively human purposefulness combined with an array of expressions which the Martin Brothers would envy. Although Rackham quite possibly drew upon Tenniel's illustration of a similar grouping in *Alice in Wonderland,* the final result is his own. The fanciful border which Rackham has added is particularly appealing and forms a link in that long tradition of marginal grotesques which in England reached its height in medieval manuscript illuminations.

167 "Little Miss Muffet" from *Mother Goose. The Old Nursery Rhymes*, 1912
 Pen, ink and watercolor, 10⅚ x 7″
 Signed and dated at l.r.: "Arthur Rackham. 12"
 PRIVATE COLLECTION

Rackham's *Mother Goose* was published by William Heinemann in 1913. The artist's highly successful use of negative space and his fine sense for the overall design of the page are beautifully expressed in this portrayal of "Miss Muffet." The decorative spider web at the top of the sheet effectively balances the figures upon a hillock in the lower half of the composition. Rackham has carefully chosen the moment just before the spider makes himself known to the unsuspecting girl, leaving the actual "surprise" to the imagination of the reader.

168 "When her husband saw her, he shouted, 'Hi! come to me here.'" from "The Young Giant" in *Little Brother & Little Sister and other tales* by the Brothers Grimm

Pen, ink and watercolor, 7³⁄₁₆ x 6″
Signed at l.l.: "Arthur Rackham." and beneath inscription at bottom of mount: "Arthur Rackham"
MUSEUM OF ART, RHODE ISLAND SCHOOL OF DESIGN, GIFT OF MRS. GUSTAV RADEKE

Inscribed on the mount beneath the drawing is a notation in the artist's hand: "The Bailiff & his wife floating about in the air where they'd been kicked by — The Young Giant. Grimm's Fairy Tales vol. Little Brother & Little Sister. Arthur Rackham." This drawing of the unfortunate couple was reproduced in black and white in the book, which was published by Constable & Company in 1917.

169 "The Thirteenth Fairy" from *The Sleeping Beauty*, retold by Charles S. Evans
 Pen, ink, ink wash and watercolor, 10³⁄₁₆ x 8⅛″
 Signed at l.r.: "ARackham"
 JOHN D. MERRIAM

The Rackham edition of *The Sleeping Beauty* was published by William Heinemann in 1920. It contained a full-color frontispiece, several three-color illustrations and numerous black and white silhouettes. Although this drawing for "The Thirteenth Fairy" includes background washes in color, in the book the design appeared as one of the black and white silhouettes.

170 "There's whispering from tree to tree" from *A Dish of Apples* by Eden Phillpotts
 Pen, ink and watercolor, 15⅛ x 10¼″
 Signed at l.r.: "Arthur Rackham"
 Ref.: Malcolm C. Salaman, *British Book Illustration Yesterday and To-Day*, p. 130.
 JOHN D. MERRIAM

"Whispering Trees" appeared as a black and white plate in Phillpotts' book, which was published by Hodder & Stoughton in 1921. Rackham has added not only color to this version of the design but a cluster of sprites in winter costumes who nestle in the animated trees. A small group of figures has also been added to the background.

171 "Little People"
 Pen, ink and watercolor, 14½ x 10½″
 Signed at l.l.: "Arthur Rackham"
 Ref.: Roland Baughman, *The Centenary of Arthur Rackham's Birth, September 19, 1867* (catalogue of the Berol Collection), no. C35.
 RARE BOOK AND MANUSCRIPT LIBRARY, COLUMBIA UNIVERSITY

The literary source for this delightful undated illustration has not been identified. Within a rather pastoral setting a typical Rackhamesque transformation is taking place as a number of apparently normal toadstools clustered beneath the trees begin to turn themselves into rather devilish-looking gnomes. This change occurs in the presence of two tiny figures who seem quite charmed by the event. The metamorphosis of natural objects into forms exhibiting a varied range of more or less human characteristics is one of the major and recurrent themes in Rackham's illustrations.

172 "Witches' Meeting"
Pen, ink and watercolor, 14⅞ x 10⅜"
Signed at l.r.: "Arthur Rackham"
THE FREE LIBRARY OF PHILADELPHIA

This drawing apparently has not been published nor has its exact source been identified. The eight gnarled figures in the scene are a varied group, presenting what might be termed a Rackham catalogue of witches. The title of the work is taken from a label in Rackham's hand on the original frame for the drawing.

173 "The three grey women groping for the eye" from "The Gorgon's Head" in *A Wonder Book* by Nathaniel Hawthorne
Pen, ink and watercolor, 14¾ x 10½"
Signed at l.r.: "Arthur Rackham"
Ref.: Roland Baughman, *The Centenary of Arthur Rackham's Birth, September 19, 1867* (catalogue of the Berol Collection), no. A187.
RARE BOOK AND MANUSCRIPT LIBRARY, COLUMBIA UNIVERSITY

Hodder & Stoughton published *A Wonder Book* in 1922. Rackham's illustrations for the Hawthorne volume exhibit an impressively broad stylistic range. "The three grey women" recaptures much of the disturbing quality found in the artist's two early books of Wagner illustrations, while his depiction of Pandora opening the box, for example, is quite "twenties" in feeling — the nubile young Pandora displays a bobbed haircut. The published version of the "grey women" is cropped and more subdued in color than this drawing, but these changes do not prevent its being the most dramatic and horrific image in the book.

174 "Sometimes he suspected that he loved them as God does — at a judicious distance," frontispiece to *Where the Blue Begins* by Christopher Morley, 1924
Pen, ink and watercolor, 11 x 8"
Signed and dated at l.r.: "Arthur Rackham • 24"
Ref.: Roland Baughman, *The Centenary of Arthur Rackham's Birth, September 19, 1867* (catalogue of the Berol Collection), no. A188.
RARE BOOK AND MANUSCRIPT LIBRARY, COLUMBIA UNIVERSITY

Morley's tale was published by William Heinemann in 1925. This drawing is one of the few instances, aside from his early work, in which Rackham has dealt with a contemporary setting, however bizarre.

175 Frontispiece ("Act II, Scene ii, A Fairy Song") to *A Midsummer Night's Dream* by William Shakespeare, c. 1928-1929
Pen, ink and watercolor, 13½ x 10"
Signed with initials at l.l. of central image: "AR"
Ref.: Derek Hudson, *Arthur Rackham, His Life and Work*, p. 125; William Shakespeare, *A Midsummer Night's Dream*, with designs by Arthur Rackham and calligraphy by Graily Hewitt (reproduced 1977), frontispiece.
SPENCER COLLECTION, THE NEW YORK PUBLIC LIBRARY, ASTOR, LENOX AND TILDEN FOUNDATIONS

In April of 1928 Rackham was commissioned to design a version of *A Midsummer Night's Dream* for the Spencer Collection at The New York Public Library. The manuscript, with illustrations by Rackham and calligraphy by Graily Hewitt, was completed in 1929. The frontispiece is among Rackham's most decorative designs and, perhaps because it was a special commission, is far more elaborate than most of his illustrations.

176 "Put his strange case before old Solomon Caw," original illustration on the half-title page of a copy of *Peter Pan in Kensington Gardens* by Sir James Barrie, 1931
Pen, ink and watercolor, 5½ x 7"
Signed and dated: "Arthur Rackham 10-4-31"
RARE BOOK AND MANUSCRIPT LIBRARY, COLUMBIA UNIVERSITY

Peter Pan in Kensington Gardens was first published by Hodder & Stoughton in 1906 and later reissued in 1912 with additional and reworked plates. *Peter Pan* firmly established Rackham's reputation as an illustrator of colored books, and it is still considered one of his greatest achievements. The drawing is a reprise of a much more highly finished plate in the book itself. The addition of an original drawing to the half-title page of an already published deluxe volume was not unusual, and Rackham seems to have done these sketches not only for friends but also for commercial advantage as well.

177 Costume design for the "Ballet of Witches" in *Hansel and Gretel*, 1933
Pencil and watercolor, 9 x 6¾"
Unsigned, but inscribed with pencil notations by the artist
Ref.: Roland Baughman, *The Centenary of Arthur Rackham's Birth, September 19, 1867* (catalogue of the Berol Collection), no. D6.
RARE BOOK AND MANUSCRIPT LIBRARY, COLUMBIA UNIVERSITY

In 1933 Rackham was commissioned by Sydney Carroll to design the costumes and scenery for Basil Dean's production of *Hansel and Gretel*, which opened at the Cambridge Theatre in London on December 26 of that year. The *Hansel and Gretel* designs were Rackham's only attempt at transferring his fantasies from the printed page to the professional theater. Although the artist was apparently not entirely pleased with the results, the reviewers were enthusiastic. His lively representations splendidly capture the essence of "witchliness."

178 Costume design for the "Ballet of Witches" in *Hansel and Gretel*, 1933
Pencil and watercolor, 9 x 6¾"
Unsigned, but inscribed with pencil notations by the artist
Ref.: Roland Baughman, *The Centenary of Arthur Rackham's Birth, September 19, 1867* (catalogue of the Berol Collection), no. D10.
RARE BOOK AND MANUSCRIPT LIBRARY, COLUMBIA UNIVERSITY

There were twelve witches in the "Ballet of Witches" and Rackham did numerous carefully annotated sketches for

their costumes; indeed, the notations on the sketches are a delightful accompaniment to the drawings themselves. Here, for example, he has indicated such salient characteristics as "great nose," "goggle eyes," "a tooth or two," and "enormous shuffling feet."

179 "He . . . presently reappeared, somewhat dusty, with a bottle of beer in each paw" from *The Wind in the Willows* by Kenneth Grahame
Pen, ink and watercolor, 9 x 6½"
Signed at l.l.: "ARackham"
Ref.: Roland Baughman, *The Centenary of Arthur Rackham's Birth, September 19, 1867* (catalogue of the Berol Collection), no. A322.
RARE BOOK AND MANUSCRIPT LIBRARY, COLUMBIA UNIVERSITY

Kenneth Grahame's classic *The Wind in the Willows* was Rackham's last book, published posthumously in a deluxe edition by The Limited Editions Club, New York, in 1940. (It was not published in England until ten years later.) This cosy, intimate scene of Mole and Rat in Mole's abode comes at the end of a long line of anthropomorphized representations which Rackham created with unparalleled sensitivity and charm throughout his career.

Charles de Sousy Ricketts, 1866-1931

Ricketts was born in Geneva to an English father and a French mother, and spent his early years in France and Italy. Upon his arrival in England, he studied wood engraving as an apprentice to an engraver at the City and Guild Technical School in London. He then enrolled at the Lambeth School of Art where he first met Charles Shannon, who became his life-long friend and professional associate. His first major collaboration with Shannon was in the publication of *The Dial* magazine, five numbers of which were issued between 1889 and 1897. For *The Dial* and many later published works the two artists generally cut their own wood blocks, taking full responsibility for much of the execution as well as the fine design of their publications. In 1896 they founded The Vale Press, named after the house they shared in Chelsea ("The Vale"). The Vale Press remained in existence until 1904 and produced, among other works, thirty-nine volumes of The Vale Shakespeare. The two men collaborated on the illustrations for several important editions, including Wilde's *A House of Pomegranates* (1891) and the *Daphnis and Chloe* (1893) of Longus Sophista. Both men also contributed illustrations to such journals as *Black and White* and *The Pageant*. After the closing of The Vale Press, Ricketts concentrated his efforts on painting, sculpture and stage design. Although he had exhibited at the Royal Institute of Painters in Water Colours early in his career (1886-1887), from 1906 on he exhibited with the International Society of Sculptors, Painters and Gravers, and eventually became a member. He was elected an Associate of the Royal Academy in 1922 and a full member in 1928. From 1924 until his death, Ricketts served as an advisor to the Na-

tional Gallery of Canada, and during this period he also wrote several books on art. His early treatise, *A Defence of the Revival of Printing* (1899), is an important document of late Victorian fine printing. (See also under Shannon.)

180 "The Teacher of Wisdom" from "Poems in Prose" by Oscar Wilde
Pen and brown ink, 9¹⁄₁₆ x 6¹⁄₁₆"
Signed with monogram at l.r.: "CR"
Ref.: Rowland and Betty Elzea, *The Pre-Raphaelite Era 1848-1914*, no. 8-4, pp. 184-185; Brigid Peppin, *Fantasy, The Golden Age of Fantastic Illustration*, p. 51.
MUSEUM OF ART, RHODE ISLAND SCHOOL OF DESIGN, GIFT OF THE ESTATE OF MRS. GUSTAV RADEKE

Ricketts and Wilde formed something of a mutual admiration society, although Wilde, with his usual acerbic wit, referred to Ricketts and Charles Shannon as "Orchid" and "Marigold." The two artists together illustrated Wilde's second volume of fairy tales, *A House of Pomegranates* (1891), while Ricketts alone was responsible for the designs to *The Sphinx* (1894). "Poems in Prose" was originally included in Wilde's first collection of fairy stories, *The Happy Prince and other tales,* which was published by David Nutt in May 1888, but the poems were omitted from most subsequent editions of the tales, and this illustration by Ricketts to the last of the six poems in the series is possibly unpublished. Stylistically "The Teacher of Wisdom" exemplifies the cold linearism, derived in part from early Italian engraving, which Ricketts favored at various times throughout his career.

181 "Daphnis Finds Upon the Sands the Purse of Silver of which the Nymphs Had Warned Him in a Dream" from *Daphnis and Chloe* by Longus Sophista (translated by George Thornley)
Wood engraving on tissue, 6½ x 4⅞"
Ref.: John Russell Taylor, *The Art Nouveau Book in Britain*, pp. 71-92; Cambridge, The Houghton Library, Harvard University, *The Turn of a Century 1885-1910*, no. 9, pp. 15-16.
MUSEUM OF ART, RHODE ISLAND SCHOOL OF DESIGN, GIFT OF MRS. GUSTAV RADEKE

Shannon and Ricketts shared responsibility for the illustrations to *Daphnis and Chloe*, although Ricketts alone drew the designs upon the woodblocks, revising them as he worked. *Daphnis and Chloe* was published by Elkin Mathews and John Lane in 1893 and, despite the fact that its publication preceded the actual establishment of The Vale Press, Ricketts (and others) considered it an early Vale book. This wood engraving of Daphnis with the dolphin is undoubtedly a proof. An alternate version of this scene, in reverse, was one of two designs used in the prospectus for the book. The prospectus illustrations were accompanied by the explanation: "Two original woodcuts in the Italian Manner designed and executed on wood by Charles Ricketts and Charles Shannon" This notation confirms the Renaissance inspiration of much of Ricketts' and Shannon's work in contrast to the primarily Gothic influences found in William Morris' Kelmscott Press publications.

182 Title page and first text page of *Hero and Leander* by Christopher Marlowe and George Chapman, 1894
Wood-engraved plate and text plate from bound volume, each 7⅞ x 4⅞"
Title page signed with initials at center beneath decorative border: "CR"
Ref.: Cambridge, The Houghton Library, Harvard University, *The Turn of a Century 1885-1910*, no. 11, pp. 19-20; Gordon N. Ray, *The Illustrator and the Book in England from 1790 to 1914*, no. 261, p. 162.
PRIVATE COLLECTION

Although *Hero and Leander* was published by Elkin Mathews and John Lane in 1894 and, like *Daphnis and Chloe*, predates the establishment of The Vale Press, it is nevertheless generally considered to be an early Vale Press book. This copy, which belonged to Campbell Dodgson, bears a Vale Press monogram on the final leaf. Shannon contributed an equal share of the designs for the volume, but Ricketts was responsible for all the drawing upon the woodblocks. The artists were much influenced by Italian Renaissance models, and the colophon indicates that *Hero and Leander* was issued to commemorate the publication of Musaeus' *Hero and Leander* in Venice in 1494.

183 Title page design to *Hero and Leander* by Christopher Marlowe and George Chapman, 1894
Proof wood engraving on tissue, 7⅜ x 4½"
Signed below image at l.r.: "C. Ricketts" and on block at center beneath decorative border: "CR"
Ref.: Cambridge, The Houghton Library, Harvard University, *The Turn of a Century 1885-1910*, no. 11, pp. 19-20; Gordon N. Ray, *The Illustrator and the Book in England from 1790 to 1914*, no. 261, p. 162.
MUSEUM OF ART, RHODE ISLAND SCHOOL OF DESIGN, GIFT OF MRS. GUSTAV RADEKE

184 "Sphinx and Minotaur" from *The Sphinx* by Oscar Wilde
Pen and black ink on paper toned pink, 7⅝ x 6¹¹⁄₁₆"
Signed with initials at l.l.: "CR"
Ref.: T. Sturge Moore, *Charles Ricketts, R.A.*, Introduction and Pl. 33.
LENT BY THE VISITORS OF THE ASHMOLEAN MUSEUM, OXFORD

At the author's request, Ricketts agreed to design and illustrate the first edition of Wilde's poem, *The Sphinx*, which was published by John Lane in 1894. Ricketts carried through the commission in its totality, designing every aspect of the work from type to binding, as well as the illustrations. He indicated that his delicate line drawings for the volume were intended to suggest "what one might imagine as possible in one charmed moment or place." The "Sphinx and Minotaur," formerly in the collection of Charles Shannon, is one of the most successful designs for this superb book and sensitively combines hints of Ingres and Gustave Moreau filtered through the lyrical grace of English Art Nouveau. Two decades later Ricketts did a second, bolder series of "Sphinx" drawings which remained unpublished. Seven of these are in the Winthrop Collection at the Fogg Art Museum.

185 "Pegasus drinking from the fountain of Hippocrene," 1901

Gold locket ornamented with enamel, pearls and semi-precious stones, 4 x 2"
Signed with initials on the enclosed miniature: "CR"
Ref.: T. Sturge Moore, *Charles Ricketts, R.A.*, Pl. 58; London, Victoria and Albert Museum, *Catalogue of an Exhibition of Victorian & Edwardian Decorative Arts*, no. W82, p. 129; Charlotte Gere, *Victorian Jewelry Design*, pp. 137-138 and Pl. 63.
FITZWILLIAM MUSEUM, CAMBRIDGE

Ricketts designed this locket in 1899 for "Michael Field," the pseudonym of the poets Katherine H. Bradley and Edith Emma Cooper. He also painted the miniature of Miss Cooper which the striking "neo-Renaissance" locket encloses. Like much Victorian jewelry in this style, the piece was executed by the jeweler Carlo Giuliano. The British Museum has the original drawing for the "Pegasus" pendant in a small sketchbook by Ricketts inscribed inside the front cover "Designs for Jewellery done In Richmond 1899." A possible antique source for the Pegasus figure is illustrated in a standard reference work of the late nineteenth century, August Oskar Seyffert's *A Dictionary of Classical Antiquities, Mythology, Religion, Literature & Art* (London, 1891, p. 465).

186 "Psyche descending into Hell," 1903
Gold pendant ornamented with enamel, pearls and semi-precious stones, 5 x 6¼"
Ref.: London, Victoria and Albert Museum, *Catalogue of an Exhibition of Victorian & Edwardian Decorative Arts*, no. W80, p. 129.
FITZWILLIAM MUSEUM, CAMBRIDGE

The "Psyche" pendant was designed by Ricketts and executed by Carlo Giuliano for the 1903 wedding of Mrs. Sturge Moore. Although the available reference sources do not provide more specific information, it is most probable that Mrs. Sturge Moore was the wife of Ricketts' great friend and biographer, Thomas Sturge Moore. The couple's initials, "TM" and "MA," appear on the reverse of the jewel.

Charles Robinson, 1870-1937

The son of the wood engraver and illustrator Thomas Robinson, Charles Robinson, like his brothers and fellow artists Thomas Heath and William Heath Robinson, was born in London. Unlike his brothers, however, he was never able to study art full time: he attended the Highbury School of Art for a short period before being apprenticed to a lithographic printer, studied briefly at the Royal Academy Schools and then attended evening classes at the West London School of Art and Heatherley's. His first major success as an illustrator came with his black and white designs for Robert Louis Stevenson's *A Child's Garden of Verses* (1895). Although he drew upon the work of Aubrey Beardsley and the aesthetic ideas of John Ruskin, William Morris and Walter Crane, Robinson's charming and highly decorative interpretations of Stevenson's verses were sufficiently original to gain both critical and popular acclaim. From this fine beginning, he went on to illustrate over one hundred books,

primarily collections of fairy tales and children's nursery rhymes. Like Crane and many other illustrators of this period, Robinson was deeply concerned with the total design of his volumes and executed numerous decorative book covers, endpapers and page arrangements. Dürer had a major effect upon his work, and his influence was reflected both in Robinson's precise draughtsmanship and in the borrowing of specific motifs such as the Gothic townscapes, which Robinson translated into fairy kingdoms. Japanese prints were another favorite source of inspiration, and his great skill as a colorist undoubtedly owed much to their example. A gregarious man, Robinson was a member of the London Sketch Club (serving as its president from 1926 to 1927) and an exhibitor at the Royal Academy and the Royal Institute of Painters in Water Colours.

187 "The house was filled with slaves bearing basons of massy gold" from "Aladdin; or The Wonderful Lamp" in *The Big Book of Fairy Tales*, edited by Walter Jerrold
 Pen, ink, watercolor and bodycolor, 10¼ x 7⅛"
 Signed at l.r.: "Charles Robinson"
 VICTORIA AND ALBERT MUSEUM, LONDON

This scene served as the frontispiece to *The Big Book of Fairy Tales* which was published by Blackie and Son in 1911. The design is bordered in a rich pattern of "Islamic" arches, as if the sheet were a leaf from a Persian manuscript. The descriptive text is worked into the lower portion of the border. A penciled notation outside the image misleadingly cites the title "Big Book of Nursery Tales."

188 "The rich making merry in their beautiful houses while the beggars were sitting at the gates" from *The Happy Pirnce, and other tales* by Oscar Wilde
 Pen, ink, watercolor and bodycolor, 12¾ x 9⅝"
 Signed to right of pillar towards l.r.: "Charles Robinson"
 Ref.: Brigid Peppin, *Fantasy, The Golden Age of Fantastic Illustration*, pp. 76-77; Robert Swain, *A History of Children's Book Illustrations 1750-1940*, no. 101 and reproduction.
 VICTORIA AND ALBERT MUSEUM, LONDON

Robinson's illustrations to *The Happy Prince* were published by Duckworth in 1913. While many of his designs exhibit a degree of coyness or overrefinement, this splendid drawing avoids both faults and represents Robinson at his best. The powerful juxtaposition of figures and setting is balanced by a sensitive and subtle handling of color, creating the kind of elegant equilibrium often found in Japanese prints.

Frederick Cayley Robinson, 1862-1927

Robinson was born at Brentford-on-Thames and trained at St. John's Wood Academy before entering the Royal Academy Schools in 1885. His earliest paintings were seascapes and coastal scenes. In 1891 he moved to Paris to study at the Académie Julian. Robinson shared the French enthusiasm for the work of Burne-Jones and Rossetti and this was reflected in much of his work prior to his eventual return to England in 1906. Of the three one-man shows accorded him during his lifetime, the first was at Baillie's Gallery, London in 1904, where he showed tempera paintings influenced by his study of both Italian Quattrocento painting and the work of Puvis de Chavannes. In addition to painting, Robinson also designed murals and posters as well as theater sets and book illustrations. Among his best-known and most admired works are the stage designs he created for a theatrical production of Maurice Maeterlinck's *The Blue Bird* in 1909 and the cool, elegant fantasies he produced for the 1911 book edition of the same work. In 1911 he had the third of his one-man exhibitions, at the Leicester Galleries, London. From 1914 until 1922 he held the position of Professor of Figure Composition and Decoration at the Glasgow School of Art, although he continued to maintain permanent residence in London until his death. In 1921 Robinson was elected to the Royal Academy, despite the fact that he had exhibited more frequently at the Royal Society of Painters in Water Colours and elsewhere.

189 "The Dance of the Hours," Act I, from *The Blue Bird* by Maurice Maeterlinck, 1911
 Pencil, chalk, watercolor and bodycolor on gray card, 15⅞ x 12¹⁵⁄₁₆"
 Signed and dated at l.l.: "Cayley-Robinson 1911"
 Ref.: MaryAnne Stevens, "Frederick Cayley Robinson," *The Connoisseur*, 196, No. 787 (September 1977), pp. 31, 33-34.
 FITZWILLIAM MUSEUM, CAMBRIDGE

The stage production of Maeterlinck's *The Blue Bird* opened at the Haymarket Theatre in London on December 8, 1909. Robinson designed the costumes and all the stage sets except for three, which were done by Sidney Sime. The popular fairy play was revived for the Christmas season the following year and ran for more than four hundred performances. Maeterlinck had written *L'Oiseau bleu* in 1908, and in 1909 Methuen published an English translation which went through several editions. The success of the volume led the publishers to reissue the story in 1911 with illustrations by Robinson. For several of the images the artist drew directly upon his earlier designs for the play. Maeterlinck was delighted with the results and praised Robinson for the appropriate fairylike charm of his interpretations. In 1911 the Leicester Galleries exhibited a selection of finished pictures derived from the *Blue Bird* illustrations.

190 "The Graveyard," Act IV, Scene ii, from *The Blue Bird* by Maurice Maeterlinck
 Pencil, chalk, watercolor and bodycolor on gray card, 16 x 13"
 Signed at l.r.: "Cayley-Robinson"
 Ref.: MaryAnne Stevens, "Frederick Cayley Robinson," *The Connoisseur*, 196, No. 787 (September 1977), pp. 31, 33-34.
 FITZWILLIAM MUSEUM, CAMBRIDGE

William Heath Robinson, 1872-1944

Heath Robinson was born in London and trained at the Islington School of Art and the Royal Academy Schools.

After attaining little success as a landscape painter, he followed the example of his father, the wood engraver and illustrator Thomas Robinson, and his two elder brothers, Thomas and Charles, and turned to illustration for his livelihood. His early work included designs for such classics as *Danish Fairy Tales and Legends of Hans Andersen* (1897), *The Poems of Edgar Allan Poe* (1900), Kipling's *A Song of the English* (1909) and Shakespeare's *A Midsummer Night's Dream* (1914). He acknowledged the influence upon his work of artists as varied as his brothers, Aubrey Beardsley, Sir John Gilbert, Sidney Sime, Walter Crane, Kate Greenaway, Arthur Rackham and masters of the Japanese woodblock like Hiroshige. In addition to doing book illustrations, he was a frequent contributor to such periodicals as *The Sketch* and *The Bystander*. Perhaps his greatest fame came from the cast of fantastic characters he himself developed, including those in the delightful *Uncle Lubin* (1902) and *Bill the Minder* (1912). His fruitful imagination also created an entire world of ridiculously absurd machines and contraptions which came to bear their designer's name, as the Rube Goldberg inventions did in the United States. He designed a home full of such gadgets for *The Daily Mail's* Ideal Home Exhibition in 1934. He also designed theatrical scenery and created murals for the ocean liner *Empress of Britain* (1930). Towards the end of his life he collaborated first with Kenneth R. G. Browne (grandson of the Dickens illustrator "Phiz") and then with H. Cecil Hunt on a series of comic manuals, such as *How to Live in a Flat* (1936) and *How to Build a New World* (1941).

191 "He quickly anchored his ship and climbed up the side" from "Second Adventure, The Air-Ship" in *The Adventures of Uncle Lubin* by William Heath Robinson
Photoengraved plate from bound volume, 8 1/16 x 6 1/4"
Signed with initials at l.r.: "W.H.R."
JOHN D. MERRIAM

First published by Grant Richards in 1902, *Uncle Lubin* was both written and illustrated by Heath Robinson. This plate is from the revised edition of the book published in 1925 by Chatto & Windus, London and Frederick A. Stokes Company, New York. Although this amazingly inventive work was not a great financial success, it marked an important moment in the artist's career. Shortly after its publication, the Toronto businessman Charles Edward Potter commissioned Robinson to do some advertisements in a similar vein, a venture which marked the beginning of his profitable and artistically rewarding alliance with commerce and industry.

192 "Some busybody will come along" from "The Kelpie of Snooziepool" in *Topsy-Turvy Tales* by Elsie Smeaton
Pen and black ink over traces of pencil, 14 1/4 x 8 1/2"
Signed at l.r.: "W. Heath Robinson"
LENT BY THE METROPOLITAN MUSEUM OF ART, THE ELISHA WHITTELSEY FUND, 1967

Topsy-Turvy Tales was published by John Lane, The Bodley Head, in 1923. The book contained six color plates and over thirty black and white drawings by Heath Robinson.

The juxtaposition of incongruous and unlikely elements is at the heart of Heath Robinson's brand of fantasy. This ridiculous scene of the "busybody" and the "baby" is a thoroughly successful expression of the artist's sense of the absurd.

193 "Over farms & fields & rivers & ponds" from "Cosey Hokie" in *Topsy-Turvy Tales* by Elsie Smeaton
Pen and black ink over traces of pencil, 14 1/2 x 10 1/2"
Signed at l.l.: "W. Heath Robinson"
LENT BY THE METROPOLITAN MUSEUM OF ART, THE ELISHA WHITTELSEY FUND, 1967

194 "And glared at the dear old woman" from "Hanky Panky" in *Topsy-Turvy Tales* by Elsie Smeaton
Pen and black ink over traces of pencil, 14 3/4 x 10 3/4"
Signed at l.l.: "W. Heath Robinson"
LENT BY THE METROPOLITAN MUSEUM OF ART, THE ELISHA WHITTELSEY FUND, 1967

195 "The End," tailpiece from *Topsy-Turvy Tales* by Elsie Smeaton
Pen and black ink, 4 1/2 x 4 3/8"
LENT BY THE METROPOLITAN MUSEUM OF ART, THE ELISHA WHITTELSEY FUND, 1967

This delightful image is appropriately inscribed at the lower right "The End."

Dante Gabriel Rossetti
(Gabriel Charles Dante Rossetti), 1828–1882

The poet and painter Dante Gabriel Rossetti was born in London, the son of a political exile from Naples who became professor of Italian at King's College, London. He was educated first at King's College School and then at King's College, where he studied drawing with John Sell Cotman. After spending four years at F. S. Cary's drawing academy, he entered the Royal Academy Schools. During 1848 he studied briefly with Ford Madox Brown and then shared a studio with William Holman Hunt. At this time, together with Hunt and John Everett Millais, he formed the Pre-Raphaelite Brotherhood whose various artistic principles included absolute fidelity to nature combined with a poetic idealism. Rossetti also contributed poetry and other writings to the Pre-Raphaelite perodical *The Germ,* founded in 1850 and edited by his brother William Michael Rossetti. Throughout his career as a poet-painter, Rossetti was influenced by the writings of his namesake Dante Alighieri. In 1857, he organized and contributed to the painting of the Oxford Union murals. He was joined in this enterprise by several young artists, among them Edward Burne-Jones. That same year Edward Moxon first published his now famous edition of Tennyson's *Poems* which included five illustrations by Rossetti. After a long courtship, Rossetti married his favorite model, Elizabeth Siddal, in 1860 and her death two years later deeply affected both his personal life and his art. During the 1860s he was actively involved in designing stained glass and tiles for Morris, Marshall,

Faulkner and Company; he published his book *The Early Italian Poets* (1861), illustrated his sister's poem *Goblin Market* (1862), contributed to Alexander Gilchrist's biography of William Blake (published in 1863) and worked on an important series of paintings of idealized women. Jane Morris, the wife of William Morris, became his most famous model and from 1871 to 1874 he shared Kelmscott Manor with the Morrises. Towards the end of his life Rossetti became something of a recluse and an invalid, suffering from the effects of various drugs, particularly chloral.

196 "Sir Galahad at the Ruined Chapel," 1859
Watercolor and bodycolor, 11½ x 13½"
Signed with monogram at lower center: "DGR"
Ref.: Virginia Surtees, *The Paintings and Drawings of Dante Gabriel Rossetti (1828-1882)*, no. 115, p. 70.
CITY MUSEUMS AND ART GALLERY, BIRMINGHAM

During 1855-1856 Rossetti produced his five designs for wood engravings to illustrate Edward Moxon's projected edition of Tennyson's *Poems*. The Moxon *Tennyson* was published in 1857 and included, in addition to Rossetti's contributions, numerous illustrations by Millais, Holman Hunt, Mulready and others. Of the five designs which Rossetti executed for the publication, three were later carried out in watercolor, among them the "Sir Galahad."

197 Study for the first version of "Dantis Amor," c. 1859-1860
Pen, brown ink and pencil, 9⅞ x 9½"
Ref.: Birmingham, City of Birmingham Museum and Art Gallery, *Catalogue of the Permanent Collection of Drawings*, no. 238'04, p. 344; Virginia Surtees, *The Paintings and Drawings of Dante Gabriel Rossetti (1828-1882)*, no. 117A, pp. 73-74.
CITY MUSEUMS AND ART GALLERY, BIRMINGHAM

This drawing is possibly a study for the oil painting which formed the central panel of a cabinet executed for William Morris at the Red House, Upton. Rossetti also did two side panels, "Dante Meeting Beatrice in Florence" and "Dante and Beatrice in Paradise." The oil version of "Dantis Amor" was never finished, and in 1865 it was detached from the cabinet (along with the two side panels) and later sold. It is now in the Tate Gallery. The "Dantis Amor" is an allegory of love portrayed in a fantastic manner. The figure of Love as a pilgrim is represented in the center of the scene with the head of Christ as the sun at the upper left and Beatrice as the moon at the lower right. The rays of the "sun" and the stars of night are agitated designs which form the patterned background to the figural elements in the composition.

198 "The Question or The Sphinx," 1875
Pencil, 18¾ x 16⅟₁₆"
Signed with monogram and dated at l.r.: "DGR 1875"
Ref.: Birmingham, City of Birmingham Museum and Art Gallery, *Catalogue of the Permanent Collection of Drawings*, no. 239'04, p. 338; Virginia Surtees, *The Paintings and Drawings of Dante Gabriel Rossetti (1828-1882)*, no. 241, pp. 139-140; New Haven, Conn., Yale University Art Gallery, *Dante Gabriel Rossetti and the Double Work of Art*, nos. 63 and 64, pp. 100-101, 114-115.
CITY MUSEUMS AND ART GALLERY, BIRMINGHAM

The title, "The Question," is inscribed at the lower left. Although decidedly fantastic, this complex work is essentially an allegory on life and death. It exists in two versions, the highly finished drawing in Birmingham and a pencil sketch at the Fogg Art Museum, Harvard University. Rossetti borrowed heavily from Ingres' painting of "Oedipus and the Sphinx," but the design nevertheless had a very personal meaning for him. Rossetti wrote to Jane Morris that the idea of the work was man's questioning of the unknown: the youth has died before he could ask his question, the man gazes into the eyes of the Sphinx but receives no answer, and the old man struggles on to have the chance to ask his futile question. According to Surtees, Rossetti in his portrayal of the fallen youth had in mind Ford Madox Brown's son, who had recently committed suicide despite his great promise as a painter and writer. Less than a week before his own death, Rossetti composed two sonnets to be used in conjunction with "The Question" in a volume of poetry he had hoped to publish with Theodore Watts.

Thomas Rowlandson, 1756-1827

The son of an unsuccessful textile merchant, Rowlandson was born in Old Jewry, London on July 14, 1756 (although some sources record the year of his birth as 1757). Following his father's bankruptcy, he was raised by relatives and eventually entered the Royal Academy Schools at the age of sixteen. Between 1775 and 1787 he exhibited regularly at the Academy, both subject pictures and caricatures. In the 1790s he began a long association with the important publisher and bookseller Rudolph Ackermann for whom he did some of his most famous printed plates, including *The Microcosm of London* (with Augustus Pugin, 1808-1811), the three *Tours of Doctor Syntax* (1812-1821), *The English Dance of Death* (1814-1816) and *The Dance of Life* (1817). He also did a great many individual caricatures for the publisher Thomas Tegg in Cheapside, but these were generally less distinctive than his work for Ackermann. Rowlandson was extremely gregarious and led a vigorous life which included frequent visits to the Continent. His creative energies did not ebb until he became seriously ill two years before his death.

199 "Squirrel" and "Red Gurnett"
Pen, ink and watercolor, 8⅞ x 7⅟₁₆"
Signed at l.r.: "Rowlandson"
ALBERT H. WIGGIN COLLECTION, BOSTON PUBLIC LIBRARY

Rowlandson did many of these "comparative anatomies," which form something of a counterpart in popular caricature to the type of imagery found in J.C. Lavater's physiognomic studies. Lavater's renowned *Physiognomische Fragmente* was first published in Leipzig between 1775 and 1778 but soon appeared in numerous editions and translations, including a three-volume English translation (1792) with illustrations and an introduction by Henry Fuseli.

John Ruskin, 1819-1900

Ruskin was born in the Bloomsbury section of London, the only child of a wealthy wine merchant and art collector. His early education was largely in the hands of private tutors until he entered Oxford in 1836. Four years later he met J. M. W. Turner whose genius was to be a major artistic and literary influence on Ruskin's own work. Samuel Prout and J. D. Harding were also much admired by the young Ruskin. The first volume of Ruskin's revolutionary work of art criticism, *Modern Painters* (originally to be entitled *Turner and the Ancients*) appeared in 1843. The fifth and last volume of this didactic yet lively series was published in 1860. By the time he wrote the second volume of *Modern Painters* (1846), which contained his theories of beauty and imagination, Ruskin had changed the scope of his work from a polemic defense of modern landscape painters to an all-encompassing theory of beauty, criticism and the arts. In rapid succession he issued *The Seven Lamps of Architecture* (1849) and *The Stones of Venice* (1851-1853), while in 1851 his original fairy tale, *The King of the Golden River*, appeared with illustrations by Richard Doyle. During this period Ruskin had married Euphemia Gray, the girl for whom he had written *The King of the Golden River*, but the marriage was annulled in 1854 and she married John Everett Millais in the following year. Despite this upheaval in his personal life, Ruskin remained enormously productive — lecturing, drawing, traveling and writing critiques of the Royal Academy exhibitions. He became, in fact, the pre-eminent dictator of Victorian tastes in art and the major apostle of the Pre-Raphaelite movement. In addition to these achievements, he wrote about political and economic issues, in part influenced by the ideas of his friend Thomas Carlyle. He became increasingly dedicated to promulgating his proto-Keynesean theories of welfare-state economics, though he never ceased lecturing, drawing and writing on the arts. Among the artists he wrote about and particularly admired during his last years was Kate Greenaway. From 1869 to 1878 and again from 1883 to 1884, Ruskin held the Slade Professorship of Fine Arts at Oxford, which he finally resigned in a dispute over vivisection. However, his intellectual powers, weakened by intermittent attacks of madness, had begun to fail seriously in these later years. Six years after he resigned his professorship, following a period of poor health, he died of influenza. In his own watercolors Ruskin had at various times emulated Harding, Prout, David Roberts and Turner. Among his most evocative works are those in which precisely realized topographical elements are set within a dreamlike surrounding.

200 "View of Amalfi," 1844
 Watercolor and gouache over graphite on gray paper, 13⅛ x 19¼″
 Ref.: Paul H. Walton, *The Drawings of John Ruskin*, pp. 55-58 and Pl. 36; Joseph R. Goldyne, *J. M. W. Turner: Works on Paper from American Collections*, no. 71, pp. 200-201.
 FOGG ART MUSEUM, HARVARD UNIVERSITY, CAMBRIDGE, MASSACHUSETTS, GIFT OF MR. AND MRS. PHILIP HOFER

One of Ruskin's most inspired Turneresque watercolors, the "View of Amalfi" was painted for Sir Robert Inglis in 1844. This splendid disembodied image, which has many affinities with John Martin's dramatic mountainscapes, is derived from a pencil drawing of 1841. Only transparent layers of watercolor, however, could so effectively render this moonlit scene which seems more to suggest a fairy kingdom than a topographical landscape.

William Bell Scott, 1811-1890

The seventh child of the Edinburgh engraver Robert Scott, William Bell Scott studied printmaking under his father and also trained at the Trustees' Academy. In 1831 he spent several months in London, drawing from antique sculpture at the British Museum. Before moving to London in 1837, he worked with his father as an engraver and at about the same time began writing poetry. Like his brother, the painter David Scott, he decided to devote his efforts to painting, but he continued to develop his talents as a writer and poet. He was appointed Master of the Government School of Design in Newcastle in 1843, a position he retained until his retirement in 1864. During this period he developed a lasting friendship with Rossetti, a great admirer of his poetry, and contributed several poems to the Pre-Raphaelite publication *The Germ*. He completed two mural cycles which remain his best-known paintings. The first of these, executed around 1855 for the Trevelyan family home at Wallington Hall, portrayed scenes from the history of Northumbria. In 1868 he painted a series of designs entitled "The King's Quhair," based on the poem by James I of Scotland, for Miss Alice Boyd's estate, Penkill Castle, Ayrshire. Although Scott exhibited at the Royal Academy until 1869 and bought a house in London in the following year, much of his time was spent at Penkill. He entertained Rossetti and other members of the Pre-Raphaelite circle at the Ayrshire castle as well as in his London home. Scott's activity in his last years was limited by a severe heart condition, and he died at Penkill in 1890. His autobiography, published posthumously in two volumes, recorded his rather frank opinions about various contemporary artists and poets.

201 "Cockcrow," 1856
 Oil on canvas, 22 x 28⅛″ (arched top)
 Signed on gravestone at l.r.: "William B. Scott" and signed and dated on verso: "William B. Scott. 1856."
 Ref.: London, The Maas Gallery, *Victorian Fairy Paintings, Drawings & Water-colours*, no. 23; Beatrice Phillpotts, "Victorian Fairy Painting," *The Antique Collector*, 49, No. 7 (July 1978), p. 80.
 MUSEUM OF ART, RHODE ISLAND SCHOOL OF DESIGN, HELEN M. DANFORTH FUND

"Cockcrow" illustrates several lines from the poem "A Fairy Tale" by the eighteenth-century poet Thomas Parnell (1679-1718). The title, the appropriate verses (slightly altered) and the poet's name are inscribed on the stretcher: "Cockcrow. Here ended all the phantom show, They smelt the fresh ap-

proach of day, And heard a cock to crow. Parnell." The painting, still in its original frame, expresses many of the central concerns and themes of the period: the love of Gothic ruins, the fascination with fairy subjects, the intense interest in minute details of landscape and the consistent Pre-Raphaelite interweaving of literature and the arts. Bell Scott presented "Cockcrow" to Alice Boyd in March 1862 to commemorate the third anniversary of their meeting.

Charles Haslewood Shannon, 1863-1937

Shannon was born in Sleaford, Lincolnshire. In 1882 he entered the Lambeth School of Art to study wood engraving and there formed a life-long friendship with a fellow student, Charles Ricketts. Together they founded *The Dial* magazine (published from 1889 to 1897) and later established The Vale Press, active from 1896 to 1904. Their other collaborations produced several important decorated volumes, including *A House of Pomegranates* (1891), *Daphnis and Chloe* (1893) and *Hero and Leander* (1894). Much of Shannon's early work was in lithography. He contributed designs in this medium to journals such as *The Hobby Horse, The Savoy* and *The Pageant,* and also served as art editor for the last publication. Around the turn of the century, he devoted himself to painting, producing portraits, biblical scenes and romantic mythological images. He returned to lithography after 1904 and a large number of prints can be assigned to the following decade and a half. Shannon's work was much exhibited, most often at the Grosvenor Gallery (1885-1899), the International Society (1898-1919), the New English Art Club (1897-1900), the Society of British Artists, the New Gallery and the Royal Academy (intermittently from 1885 to 1928). He was elected to associate and full membership in the Academy in 1911 and 1920 respectively. He died in London in 1937, eight years after a bad fall had ended his artistic career. Much of the art collection he had amassed with Charles Ricketts was bequeathed to the Fitzwilliam Museum, Cambridge. (For entries, see Ricketts.)

Ernest Howard Shepard, 1879-1976

A native of London, Shepard attended St. Paul's School and then studied art at the Heatherley School of Fine Art (1896-1897) and the Royal Academy Schools (1897-1902). From 1901 on, he exhibited intermittently at the Royal Academy and also showed his works in oil and watercolor at the Sporting Gallery, London, and at the Paris Salon. Having first contributed to *Punch* in 1907, Shepard served on the staff of that famous periodical for many years. He illustrated numerous books, though his best-known works by far were the drawings for A. A. Milne's Christopher Robin stories: *When We Were Very Young* (1924), *Winnie-the-Pooh* (1926), *Now We Are Six* (1927) and *The House at*

Pooh Corner (1928). In addition to other illustrations to Milne's work, Shepard's commissions included designs for Kenneth Grahame's *The Wind in the Willows* (1931) and L. W. Kingsland's 1961 translation of Hans Christian Andersen's fairy tales. He wrote two books tracing his own life as an artist, *Drawn from Memory* (1957) and *Drawn from Life* (1963). In 1972 he was awarded the Order of the British Empire.

202 "Kanga Preparing the Bath" from Chapter vii in *Winnie-the-Pooh* by A. A. Milne
Pen and black ink on white drawing board, scratched in white lead, 5½ x 7⅜"
THE PIERPONT MORGAN LIBRARY, GIFT OF MR. AND MRS. MALCOLM P. ALDRICH

Winnie-the-Pooh was published by Methuen & Company in 1926. It was the second of four volumes devoted to the adventures of Christopher Robin and his bear Pooh. The text and illustrations now seem inseparable. Both author and artist have managed to depict in subtly matter-of-fact terms an unforgettable imaginary world which is almost impossible not to accept as real.

203 "Piglet's Bath" from Chapter vii in *Winnie-the-Pooh* by A. A. Milne
Pen and black ink on white drawing board, scratched in white lead, 5 3/16 x 6⅛"
Signed with initials at l.l.. "EHS/."
THE PIERPONT MORGAN LIBRARY, GIFT OF MR. AND MRS. MALCOLM P. ALDRICH

204 "Winnie-the-Pooh" wallpaper frieze
Block-printed design on paper, 21½" h. (13-yard roll)
COOPER-HEWITT MUSEUM, THE SMITHSONIAN INSTITUTION'S NATIONAL MUSEUM OF DESIGN, GIFT OF STANDARD COATED PRODUCTS

The subject of the frieze is Christopher Robin's and Pooh's "expotition" to the North Pole from A. A. Milne's *Winnie-the-Pooh*. Although no maker's name is indicated on the paper, the registry number appears in the margin: "R' Nº 733152."

George Sheringham, 1884-1937

Sheringham was a life-long resident of London. He began his artistic training at the Slade School of Fine Art (1899-1901) and subsequently studied in Paris from 1904 to 1906. He first showed his work at the Paris Salon and later exhibited in London. He worked primarily as a designer and decorative painter, creating sets and costumes for the theater and opera as well as posters, book illustrations and painted fans. The fans, executed in watercolors on silk, became one of his best-known specialties. Among the books he illustrated was an edition of Edmond Rostand's *La Princesse lointaine.*

205 "Fan, Blue and Gold," *c.* 1922
Watercolor on silk, 9½ x 18½"
Signed at l.l.: "George Sheringham"

Ref.: Toronto, Canadian National Exhibition, *Catalogue of Paintings and Sculpture by British, Spanish and Canadian Artists and International Graphic Art*, no. 1205.

ART GALLERY OF ONTARIO, GIFT OF THE CANADIAN NATIONAL EXHIBITION ASSOCIATION, 1965

Sidney Herbert Sime, 1867-1941

Sime was born in Manchester and worked in the Yorkshire coal mines as a youth. He decided upon a career in art and trained at the Liverpool School of Art. After moving to London in 1893, he began doing illustrations for inexpensive comic papers. In 1895 the first of his contributions to *Pick-me-up* appeared, marking the true start of his career as a successful illustrator in black and white. In addition to *Pick-me-up*, Sime's work began to appear regularly in such periodicals as *The Idler*, *Eureka* and *The Pall Mall Magazine*. The majority of his illustrations are delightfully fantastic in nature and exhibit a unique blend of humor and horror. They owe a stylistic debt to the work of both Beardsley and Blake as well as to Japanese prints. From 1899 to 1901 Sime was owner and co-editor of *The Idler*. In 1905, following a brief period in the United States working for William Randolph Hearst, he began his association with Lord Dunsany by illustrating the latter's fantasy tale, *The Gods of Pegāna*. This was followed by designs for several other Dunsany volumes, including *The Sword of Welleran* (1908), *A Dreamer's Tales* (1910) and *Tales of Wonder* (1916). In addition to Dunsany, Sime worked with the fantasy writers Arthur Machen and William Hope Hodgson, and produced as well his own small book entitled *Bogey Beasts* (1923), which contained drawings and jingles by Sime and musical scores by Josef Holbrooke. During the 1920s, he exhibited in a variety of media at St. George's Gallery in London, but by the time of his death at Worplesdon (near Guildford) in 1941 he was virtually unknown. Many of the richly colored fantastic landscapes of his later career are housed in the Sime Memorial Art Gallery at Worplesdon, which is devoted entirely to his art, and there is now renewed interest in the work of this artist whose reputation has been eclipsed for almost half a century.

206 "Ye Shades," *c.* 1895
 Black crayon, black and gray wash, and white heightening, 19⁷⁄₁₆ x 13½"
 Signed at l.l.: "S. H. Sime"
 Ref.: George Locke, *From an Ultimate Dim Thule*, p. 50; Paul W. Skeeters, *Sidney H. Sime Master of Fantasy*, p. 124.
 JOHN D. MERRIAM

The caption accompanying the drawing records the conversation of this motley assortment of ghosts: "Hoarse Enquiry 'What have you got?' Luguburious Answer '120°' Fahrenheit.'" This witty image of Hades appeared in *Pick-me-up* for October 26, 1895.

207 "The Mermaid," *c.* 1897
 Pen, India ink and white heightening on gray-green card, 9⁹⁄₁₆ x 6½"

 Signed at l.l.: "S. H. Sime."
 Ref.: George Locke, *From an Ultimate Dim Thule*, pp. 12, 55, 59.
 FITZWILLIAM MUSEUM, CAMBRIDGE

"The Mermaid" first appeared in the periodical *Eureka* in the fall of 1897. It was then reproduced in an article on Sime by Arthur Lawrence entitled "The Apotheosis of the Grotesque," which was published in *The Idler* of January 1898.

208 "The Felon Flower" from "The Legend of the Mandrake, *c.* 1897
 Pen and India ink, 14¼ x 9⅞"
 Signed at bottom center: "S.H.Sime"
 Ref.: George Locke, *From an Ultimate Dim Thule*, p. 58; Brigid Peppin, *Fantasy, The Golden Age of Fantastic Illustration*, p. 75.
 VICTORIA AND ALBERT MUSEUM, LONDON

"The Felon Flower" was published in *Eureka* for September 1897. It accompanied a poem written by Knight Ryder, an appropriate name for an author of fantastic verse and certainly in keeping with the weird nature of both poem and illustration.

209 A demon carrying a coal scuttle, *c.* 1897
 Pen and India ink, 5⅛ x 3½"
 Signed towards l.r.: "S. H. Sime"
 Ref.: George Locke, *From an Ultimate Dim Thule*, p. 53.
 PRIVATE COLLECTION

The "demon" appeared as a quarter-page drawing in the special Christmas number of *Pick-me-up*, December 1897. Sime indicated in an interview with Arthur Lawrence that he had drawn coal-black imps and similar figures before he began work in the Yorkshire coal mines, but then admitted that the five years he spent in the mines undoubtedly influenced his work.

210 "The Brother of Ali Baba in the Wood," *c.* 1899
 Pen and India ink, 8¾ x 6⅝"
 Signed at l.r.: "S. H. Sime."
 Ref.: George Locke, *From an Ultimate Dim Thule*, p. 55.
 THE FINE ART SOCIETY LTD., LONDON

This Beardsleyesque illustration appeared in the March 1899 issue of *The Idler*. Sime drew heavily upon Beardsley's drawing of "Ali Baba in the Wood" which appeared in Leonard Smither's 1897 publication *A Book of Fifty Drawings by Aubrey Beardsley* (see cat. no. 16).

211 "The sudden discovery of that infamous den" from "The Fantasy of Life. As Seen by S. H. Sime. Drawings to Unknown Tales," *c.* 1901
 Pen, India ink, wash and white heightening, 20¼ x 14⅜"
 Signed at l.r.: "S. H. Sime"
 Ref.: George Locke, *The Land of Dreams, S. H. Sime 1905-1916*, pp. 6, 30; Brigid Peppin, *Fantasy, The Golden Age of Fantastic Illustration*, pp. 74-75; Paul W. Skeeters, *Sidney H. Sime Master of Fantasy*, p. 84.
 VICTORIA AND ALBERT MUSEUM, LONDON

This grisly scene was one of several drawings by Sime published in *The Tatler* for August 28, 1901. As was so often

the case, the artist managed to combine the utmost horror, namely the contents of the boiling pot, with unmistakable touches of humor.

212 "The Dollar Princess" from "The Aurae of the Drama," c.1910
Pen, India ink and watercolor, 14½ x 10⅞"
Signed towards l.r.: "S. H. Sime"
Ref.: George Locke, *The Land of Dreams, S. H. Sime 1905-1916,* pp. 6, 8, 38; Paul W. Skeeters, *Sidney H. Sime Master of Fantasy,* p. 114.
FITZWILLIAM MUSEUM, CAMBRIDGE

"The Dollar Princess" appeared in *The Sketch* for March 30, 1910. It was one of eight drawings Sime contributed to the periodical between March 16 and May 4 of that year under the series title "The Aurae of the Drama." Sime's love of the theatre found specific expression in the stage designs he did for several plays, among them Maeterlinck's *The Blue Bird,* but he also drew upon the theatre as a more general source of inspiration. "The Aurae of the Drama" represented Sime's visual response to impressions he received from attending several theatrical performances, rather than illustrations to or designs for particular episodes in the plays themselves. According to the text which accompanied the reproduction of "The Dollar Princess" in *The Sketch,* the story of the Fox and the Goose is presented in the Garden of Opulence, "instigated by an imitation Eros."

213 "The Wily Grasser" from *Bogey Beasts* by Sidney Sime with Josef Holbrooke, 1923
Pen, India ink and gray wash, 8¹⁵⁄₁₆ x 6⅝"
Ref.: George Locke, *From an Ultimate Dim Thule,* p. 6; Paul W. Skeeters, *Sidney H. Sime Master of Fantasy,* p. 78.
FITZWILLIAM MUSEUM, CAMBRIDGE

The title is inscribed in the artist's hand at the lower right of the sheet. The disconsolate, chicken-like "Grasser" is one of a series of fifteen weird beasts invented by Sime which appear in *Bogey Beasts,* a rather rare volume published by Goodwin & Tabb Ltd., London in 1923. Sime did the illustrations and wrote the jingles for the book, and Josef Holbrooke composed the musical scores — these last, as George Locke has suggested, "for any child with nerve left to raise a voice in song." *Bogey Beasts* later appeared as *The Sime Zoology: Beasts That Might Have Been.*

John Simmons, 1832-1876

Noted by Jeremy Maas in his *Victorian Painters* as an obscure but very competent painter of fairy subjects, John Simmons is not to be confused with his namesake in the eighteenth century, John Simmons of Bristol (c.1715-1780). From known examples of his work, the fairy painter Simmons concentrated heavily on watercolors illustrating characters or scenes from that most popular source for fairy illustrations, Shakespeare's *A Midsummer Night's Dream.* He appears to have produced most of these works during the 1860s.

214 "The honey bugs steal from the humble bees," Act III, Scene i, from *A Midsummer Night's Dream* by William Shakespeare, 1866
Watercolor and bodycolor, 13½ x 10½" (arched top)
Signed and dated at l.l.: "J. Simmons 1866"
Ref.: London, The Maas Gallery, *Victorian Fairy Paintings, Drawings & Water-colours,* no. 77 and no. 76 (related example).
CITY MUSEUM & ART GALLERY, BRISTOL

Another version of this charming depiction of Titania is in an English private collection.

Marc-Louis-Emanuel Solon, 1835-1913

Solon was born in Montauban, France, and trained at the Atelier Lecoq in Paris. Developing his skills as a painter, draughtsman and etcher, he became interested in ceramics and began working on the ornamentation of porcelain plaques for the Paris dealer Eugène Rousseau. During this period he first used the pseudonym "Milès." In 1857 he joined the Sèvres factory, where he became a specialist in their new technique of *pâte-sur-pâte* (decoration built up with liquid clay called slip). At the beginning of the Franco-Prussian war, Solon emigrated to England (1870). He immediately began work at the Minton factory, where he remained for the rest of his career, retiring in 1904. At Minton's he built his reputation as a master of *pâte-sur-pâte* and had the responsibility of training other craftsmen in the procedure. Although he concentrated on neoclassical designs, Solon frequently achieved a degree of fantasy and whimsy previously not often found in works of this type. In addition to his accomplishments as an artist, he was a recognized collector of Staffordshire pottery as well as the author of several books on ceramics, including texts on French faïence and Italian majolica.

215 "Pilgrim bottle" vase, 1888
Parian porcelain with *pâte-sur-pâte* decoration and gilding, 13¹³⁄₁₆ x 7¾"
Signed within the *pâte-sur-pâte* design: "L. Solon 88." and marked with the Minton trade mark, the date mark for 1869 and the printed mark of "Messrs. Caldwell & Co. Philadelphia"
Ref.: Rowland and Betty Elzea, *The Pre-Raphaelite Era 1848-1914,* no. 4-82, pp. 106-107.
PHILADELPHIA MUSEUM OF ART, GIFT OF MRS. FLOYD T. STARR

Although this piece was made by Minton for the American market, it is a delightful example of the type of Victorian "neoclassical" fancy which was popular on both sides of the Atlantic. Despite the classical subject, there is no rigid attempt to recreate an antique original. The whimsy of the rather madly fluttering putti is typical of the nineteenth century, as is the amazingly eclectic conception of the vase. The pilgrim flask or costrel form, for example, is most closely associated wth the Middle Ages, while the gilded decoration appears to combine medieval, oriental and baroque elements.

Harold Stabler, 1872-1945;
Phoebe McLeish Stabler, -1955

Harold Stabler studied art at the Kendal Art School in his native Westmorland. He headed the metalwork department at the Keswick School of Industrial Art and worked at the Liverpool University Art School before moving to London. There he joined the staff of the Sir John Cass Technical Institute, where he served as head of its Art School from 1907 to 1937. During this period he was a teacher at the Royal College of Art (1912-1926), a prime mover in the founding of the Design & Industries Association and a founding member and active partner in the pottery design firm of Carter, Stabler & Adams (from 1921). Stabler designed the tiles for St. Paul's underground station in London, made figures for the Worcester porcelain factory and produced numerous designs for presentation pieces in precious metals, enamel and jewels. His wife Phoebe studied at the Royal College of Art. She was elected a Fellow of the Royal Society of British Sculptors in 1923 and exhibited widely as a sculptor in stone, terracotta and bronze. Together the Stablers maintained a studio at Hammersmith, where they designed and made jewelry, enamels and pottery figures.

216 Enamel pendant with faun, 1921
Cloisonné enamel on copper set in silver frame, 4¼ x 2¹⁵⁄₁₆"
Signed and dated on the reverse: "London 1921 Phoebe and Harold Stabler" and impressed twice on the suspension ring: "Stabler"
COOPER-HEWITT MUSEUM, THE SMITHSONIAN INSTITUTION'S NATIONAL MUSEUM OF DESIGN, GIFT OF J. LIONBERGER DAVIS

Edmund Joseph Sullivan, 1869-1933

Sullivan was born in London and began his education at Chesterfield. He later studied art in Hastings under his father. At the age of twenty, he joined the staff of *The Graphic* in London as an illustrator. From 1890 to 1892 he held a similar position on *The Daily Graphic* before moving to *The Pall Mall Budget*. He exhibited at the Royal Academy, the Royal Scottish Academy and the Royal Society of Painters in Water Colours (to the last of which he was elected an associate in 1913 and a full member in 1929). Two years later he was elected a Fellow of the Royal Society of Painter-Etchers and Engravers. He also served as Master of the Art Workers' Guild. Although extremely active as a magazine illustrator, Sullivan is equally known for his book illustrations, among which are his popular sketches for Thomas Hughes' *Tom Brown's School-Days* (1896) and designs for Carlyle's *Sartor Resartus* (1898), Sir Walter Scott's *The Pirate* (1898), Tennyson's *A Dream of Fair Women* (1901) and an edition of *The Rubaiyat of Omar Khayyam* (1913). He had an enormous influence upon fellow illustrators like Arthur Rackham, and in 1921 he published his own reflections upon his field, *The Art of Illustration*.

217 Scene in the potter's shop from *The Rubaiyat of Omar Khayyam*, 1907
Pen and black in, 6½ x 6"
Signed and dated at l.r.: "Edmund J. Sullivan 1907—"
VICTORIA AND ALBERT MUSEUM, LONDON

Sullivan's illustrations to Edward Fitzgerald's translation of *The Rubaiyat* were published by Methuen in 1913. The artist's descriptive facility with line and his imaginative approach to illustration are made apparent in this representation of the magical transformation which takes place in the potter's shop as several of the jugs begin to speak. These aspects of Sullivan's art were much admired by Arthur Rackham, and echoes of figures like the grinning jug at the lower left of the composition can be found in Rackham's work.

Sir John Tenniel, 1820-1914

Born in London, Tenniel had little formal art training other than that which he received from brief attendance at the Royal Academy Schools. Between 1837 and 1880 he exhibited intermittently at the Royal Academy. He was a major and regular contributor to *Punch* for half a century (1851-1901) and succeeded John Leech as the magazine's principal political cartoonist in 1864. Although justly famous for his *Punch* designs, Tenniel's lasting renown rests upon certain of his book illustrations. His first illustrations were produced for an edition of *Undine* (1845), which was followed by an *Aesop's Fables* (1848) and designs for works by such diverse authors as Poe, Milton and Thomas Moore. Then in 1864 Lewis Carroll persuaded Tenniel to illustrate his recently completed manuscript, *Alice's Adventures in Wonderland*. The first edition of the book appeared in July 1865, but Tenniel was dissatisfied with the reproductions. With Carroll's concurrence, this edition was withdrawn and a corrected second edition was published later in 1865 (but dated 1866). *Alice* was an instant success, and Carroll decided to do a sequel. Tenniel at first rejected Carroll's proposal that he illustrate this second volume because he found the author difficult to work with, but he eventually relented. *Through the Looking-Glass and What Alice Found There* (1871-1872), like its predecessor, was an immediate and enormous success. Tenniel was knighted in 1893.

218 "The Fish-Footman" and "The Frog-Footman" from *Alice's Adventures in Wonderland* by Lewis Carroll, *c.* 1864
Pencil, 3½ x 2¹⁵⁄₁₆" image on 6 x 4½" sheet
Signed with monogram at l.r.: "JT"
Ref.: William H. Bond, "The Publication of *Alice's Adventures in Wonderland*," *Harvard Library Bulletin*, 10, No. 3 (Autumn 1956), pp. 306-324; Percy Muir, *Victorian Illustrated Books*, p. 110.
THE HOUGHTON LIBRARY, HARVARD UNIVERSITY, GIFT OF MRS. HARCOURT AMORY

Tenniel generally produced his illustrations by first making a finished pencil drawing of his subject on Bristol board, next tracing the main outlines of the drawing on thin paper

and then transferring the tracing (in reverse) to the wood-block. He would then work up the tracing on the block in final preparation for the cutting by the engraver, in this case the Dalziels. Once cut, the blocks were electrotyped, and it was the electrotypes rather than the original woodblocks which were used in printing the plates for the volume. For the image of "The Frog-Footman" in this famous scene Tenniel undoubtedly drew upon J. J. Grandville's depiction of an elegant toad stirring up the patriotic fervor of some bears in the French artist's *Scènes de la vie privée et publique des animaux* (1841-1842).

219 "The Hatter" and "A Mad Tea-Party" from *Alice's Adventures in Wonderland* by Lewis Carroll, *c*. 1864
Pencil, 5⅞ x 8¹³⁄₁₆″
Signed with monogram at l.l. of the party scene: "JT"
Ref.: William H. Bond, "The Publication of *Alice's Adventures in Wonderland*," *Harvard Library Bulletin*, 10, No. 3 (Autumn 1956), pp. 306-324.
THE HOUGHTON LIBRARY, HARVARD UNIVERSITY, GIFT OF MRS. HARCOURT AMORY

Although Carroll wrote *Alice in Wonderland* for Alice Liddell and her two sisters, he sent a photograph of another child, Mary Hilton Badcock, to Tenniel to be used as a model for Alice. Carroll also suggested that Tenniel base his figure of the Hatter on an eccentric furniture dealer named Theophilus Carter who lived near Oxford. How far Tenniel accepted the author's advice in each case is open to dispute, for there is some evidence that Tenniel used the daughter of *Punch* editor Mark Lemon as his model for Alice, rather than Mary Badcock.

220 "The Jabberwock" from *Through the Looking-Glass and What Alice Found There* by Lewis Carroll
Original pencil tracing on tracing paper, and proof wood engraving; 5⅜ x 3½″ (drawing), 7⅞ x 4¾″ (engraving, total sheet)
Drawing unsigned; wood engraving signed with monogram at l.l.: "JT" and inscribed with the name of the engraver: "Dalziel"
Ref.: Falconer Madan, ed., *The Lewis Carroll Centenary in London 1932*, no. 471; Martin Gardner, *The Annotated Alice*, pp. 191-198.
PRIVATE COLLECTION

This rare volume, containing wood engravings in corrected proof state and original tracings by the artist, was originally part of Harold Hartley's famous collection. *Through the Looking-Glass* was published by Macmillan and appeared in time for Christmas 1871, although the first edition was dated 1872. Once Tenniel had been persuaded by Carroll to do the illustrations for this sequel to *Alice's Adventures in Wonderland,* he was apparently able to exercise more control over the designs than the author had previously allowed him. He created fifty illustrations for *Through the Looking-Glass*, eight more than had appeared in *Alice*. Tenniel would have used his pencil tracing of the fearsome Jabberwock to transfer the essential outlines of his original drawing to the woodblock. The outline would then have been worked up on the block in preparation for the actual engraving by the Dalziels. The artist intended to have this terrible monster

serve as the frontispiece to the book, but the results of a private poll he took decided him against this course and the quite harmless picture of the White Knight was used instead.

221 "Tweedledum" from *Through the Looking-Glass and What Alice Found There* by Lewis Carroll
Annotated proof of a wood engraving, 2½ x 2⅞″
VICTORIA AND ALBERT MUSEUM, LONDON

The proof is inscribed in Tenniel's hand: "All right — Please send complete proof." Tenniel took great care with every detail of the illustrations and he must have considered careful proofing at all stages of production even more of a necessity after his disappointment with the first printing of *Alice's Adventures in Wonderland*.

222 "Alice arming Tweedledum and Tweedledee" from *Through the Looking-Glass and What Alice Found There* by Lewis Carroll
Annotated proof of a wood engraving, 2⅞ x 3¾″
VICTORIA AND ALBERT MUSEUM, LONDON

Tenniel's dissatisfaction with a detail of Alice's anatomy is expressed in his precise instructions: "Clean away the outline of nose leaving only the lower portion." The rather minute change was made, and the "corrected" nose appears in the final proofs and the printed illustration.

223 "Alice arming Tweedledum and Tweedledee" from *Through the Looking-Glass and What Alice Found There* by Lewis Carroll
Proof wood engraving, 2⅞ x 3¾″
Signed with monogram at l.r.: "JT"
VICTORIA AND ALBERT MUSEUM, LONDON

This final proof shows the illustration exactly as it would appear in the book. The name of the printer Dalziel appears at the lower left.

224 "Kingdom of Fairies"
Wood engraving, 10³⁄₁₆ x 16⁹⁄₁₆″
Signed with monogram at l.l.: "JT" and with the name of the engraver at l.r.: "Swain Sc"
LENT BY THE METROPOLITAN MUSEUM OF ART, HARRIS BRISBANE DICK FUND, 1927

For this elaborate political caricature Tenniel has wittily borrowed the general compositional scheme and many of the figural types from a source like Richard Doyle's *In Fairyland* (see cat. no. 81).

George Tinworth, 1843-1913

Tinworth was born at Walworth, the son of a ne'er-do-well wheelwright. Like his life-long friend, the potter Robert Wallace Martin (one of the four Martin brothers), Tinworth studied at the Lambeth School of Art under John Sparkes. While still in school, he created a series of large terracotta medallions patterned after antique coins, and terracotta relief work, much of it devoted to religious subjects, remained one of his specialties throughout his career. He joined the staff of Doulton's in 1866 and stayed with the firm until his

death. In 1871 Tinworth did the modeling for a fountain designed by Sparkes which was Doulton's major entry in the South Kensington Exhibition for that year. Four years later, three large religious pieces in terracotta which Tinworth exhibited at the Royal Academy won high praise from Ruskin. In addition to important commissions for decorative work at York Minster and the Guards' Chapel, Birdcage Walk, London, Tinworth also decorated vases and other wares and made numerous small, charming human and animal groups, the latter often engaged in human occupations. Following his death, a London street was named in his honor.

225 "Steeplechase," c. 1875
 Glazed stoneware, 5 x 6"
 Signed along right edge of base: "GT" and stamped with
 "Doulton Lambeth" mark at back edge of base
 Ref.: Richard Dennis, *Catalogue of an Exhibition of
 Doulton Stoneware and Terracotta 1870-1925*, no. 643.
 MR. AND MRS. DAVID E. ZEITLIN, MERION, PA.

The title of this wild scene is inscribed along the front edge of the base. The blue-green glaze of the water and the warm brown tones of the frantic competitors make this ceramic fantasy one of the most striking of Tinworth's animal sculptures.

226 "Play Goers," 1886
 Glazed stoneware, 5 x 4½"
 Signed with monogram on the reverse: "GT" and im-
 pressed with the rosette mark of Doulton, Lambeth
 Ref.: Richard Dennis, *Catalogue of an Exhibition of
 Doulton Stoneware and Terracotta 1870-1925*, no. 642.
 ALBERT GALLICHAN AND PETER ROSE

The title "Play Goers" is inscribed on the base of this typical Tinworth whimsy. Another Doulton artist, John Broad, apparently assisted him in the creation of this work. Mice and frogs are the favored actors in Tinworth's representations, and "Play Goers" is one of the more complicated of his animal groups, matched only by such elaborate anthropomorphized fantasies as the "Steeplechase."

Turnbull and Stockdale Ltd.

One of the major textile printing firms in England during the late Victorian and Edwardian eras, Turnbull and Stockdale printed the fabric designs of such artists as C.F.A. Voysey, Christopher Dresser and Lewis Foreman Day. Day, a prolific writer as well as a designer, was one of the founders of both the Art Workers' Guild and the Arts and Crafts Exhibition Society, and in 1881 he became art director of Turnbull and Stockdale. The firm was responsible for printing much of the fabric sold by Liberty & Company, which first opened its doors in May 1875.

227 Textile after designs by May Gibbs, 1929
 Printed cotton, 24½ x 30"
 VICTORIA AND ALBERT MUSEUM, LONDON

This delightful fabric design is by the Australian illustrator May Gibbs and represents scenes from her "Gum Nut" world. A registration number (269984), which indicates the date of the pattern as 2 January 1929, appears at the edge of the textile.

Paul Turpin,
Active Early Twentieth Century

Almost no relevant information seems to be available concerning Paul Turpin's career other than the fact that he was an architectural decorator who maintained offices both at Berners Street in London and in association with the firm of P. H. Rémon in Paris. He is mentioned in a handwritten note by the artist Frank Brangwyn in a document on file at the Victoria and Albert Museum which states that a cabinet Brangwyn designed and decorated was "Made by Turpin." (For entry, see Brangwyn.)

Mrs. Alaric Watts
(Anna Mary Howitt Watts), 1824-1884 or 1903

The daughter of the novelist and pioneering English spiritualist William Howitt (1792-1879), Mrs. Watts seems to have been an amateur artist with an accomplished talent for pattern and design. She began to practice automatic or spirit writing which changed into drawing when she attempted to control her "gift." The forms which appeared in her automatic drawings at various times also came to her in visions. Most of her drawings were done on tracing paper, a technique which allowed her to rework her complicated designs in order to make the images clearer. In 1883 she published a volume entitled *Pioneers of the Spiritual Reformation* which contained biographical sketches of her father and the German poet, physician and spiritualist Dr. Justinus Kerner.

228 Automatic drawing, c. 1870
 Reed pen with colored inks and watercolor on tracing
 paper, 5½" diameter
 Ref.: John Morley, *Death, Heaven and the Victorians*,
 p. 110 and Pl. 28.
 THE SOCIETY FOR PSYCHICAL RESEARCH

Patten Wilson, 1868-

Wilson, born in Cleobury Mortimer in Shropshire, was the younger brother of the architect and designer Henry Wilson. He studied briefly at the Kidderminster School of Art and worked as secretary to the director of a gymnasium in Liverpool before he moved to London. After training as an assistant to a manufacturer of wallpapers, he began to do free-lance design work and studied evenings at the Westminster School of Art under Frederick Brown. His first important commission came from the publisher John Lane, for whom he illustrated a book of miracle plays (1895). This was followed by other book illustrations, including designs for J. S. Fletcher's *Life in Arcadia* (1896), Shake-

speare's *King John* (1899) and Andrew Lang's *Selections from Coleridge* (1898). Wilson also contributed illustrations to various periodicals, among them *The Yellow Book* and *The Pall Mall Magazine.* Ornamental title pages, decorative tail-pieces and the like were a specialty of his, and he did many of these for John Lane. He is also recorded as exhibiting at the Royal Academy from 1893.

229 Illustrated decorations for *The Tremendous Twins* by Ernest Fitzroy Ames
Pen, ink and watercolor; four drawings are 11¼ x 1½″ and one is 1½ x 4¾″
Two of the five drawings are initialed "P.W." at l.r.
Ref.: Walter Shaw Sparrow, "Some Drawings by Patten Wilson," *The Studio*, 23 (1901), pp. 186-196.
VICTORIA AND ALBERT MUSEUM, LONDON

An accompanying inscription notes the title of the book and the information: "With pictures in colors by Mrs. Ernest Ames and verses by Ernest Ames. Oblong folio 3/6." *The Tremendous Twins,* published by Grant Richards in 1900, included verses by Ernest Ames, colored drawings by his wife and decorative sidepieces and similar ornamentation by Wilson.

Paul Woodroffe, 1875-1955

Although born at the Madras Residency in India, Woodroffe spent his childhood in Bath. He studied at Stonyhurst College and at the Slade School of Fine Art. In addition to his activities as a book illustrator, he designed stained glass (including the "Rosary" windows for the Lady Chapel in St. Patrick's Cathedral, New York), heraldic devices, book plates and typography. From 1902 he was a member of the Art Workers' Guild, and he also belonged to the Master Glass Painters' Guild. His book illustrations include *Ye Booke of Nursery Rhymes* (1895), *Second Book of Nursery Rhymes* (1896), *Songs from the Plays of Shakespeare* (1898), *Of Aucassin and Nicolette* (1902), Tennyson's *The Princess and other poems* (1904) and *Thirty Old-Time Nursery Songs* (1907).

230 Cover design for *Nursery Songs,* 1907
Pen, black ink, watercolor and pencil on board, 14 x 10¾″
Initialed within the image to the left of the cat's head: "PW" and dated on the verso: "1907"
JUSTIN G. SCHILLER, LTD., NEW YORK CITY

Nursery Songs (also titled *Thirty Old-Time Nursery Songs*) was published in 1907 by T. C. & E. C. Jack in London and Frederick A. Stokes Co. in New York. The volume included familiar songs, from "Jack and Jill" to "Three Blind Mice," in arrangements by Joseph Moorat with numerous imaginative illustrations rendered by Woodroffe in an intriguing hyper-realistic style.

231 "Humpty Dumpty" from *Nursery Songs,* 1906
Pen, black ink, watercolor and pencil on board, 14⅜ x 9¾″
Initialed within the lower image on either side of the broken egg: "PW" and dated on the verso: "1906"
JUSTIN G. SCHILLER, LTD., NEW YORK CITY

In a witty burst of rather tongue-in-cheek "orientalism," Woodroffe has portrayed an ultra-sophisticated, turbaned Humpty Dumpty smoking a decorative, vine-like hookah.

Plates

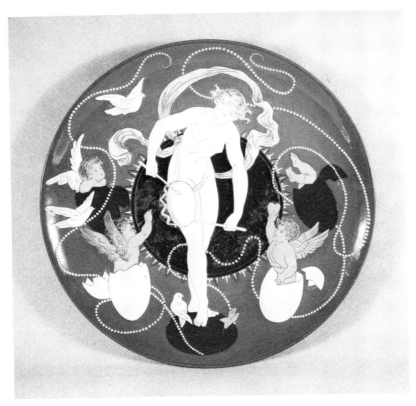

3 ANONYMOUS, BRITISH

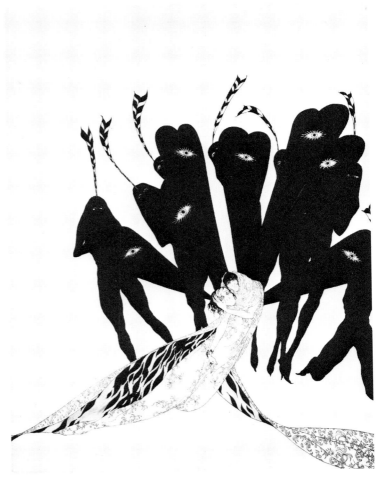

4 ALASTAIR

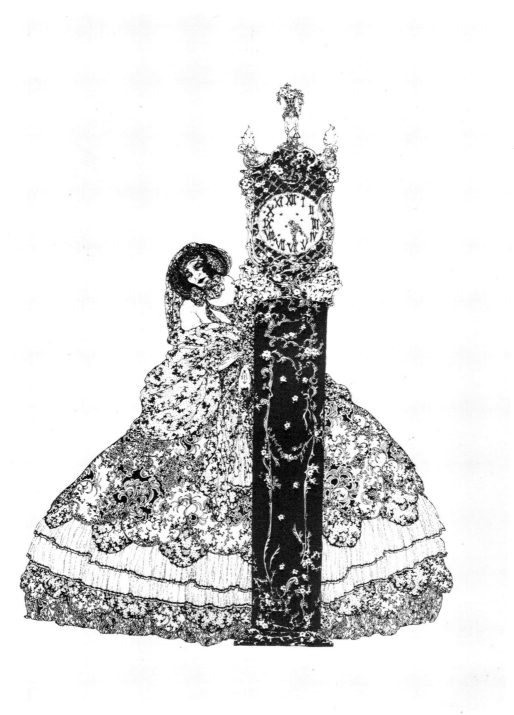

5 ALASTAIR

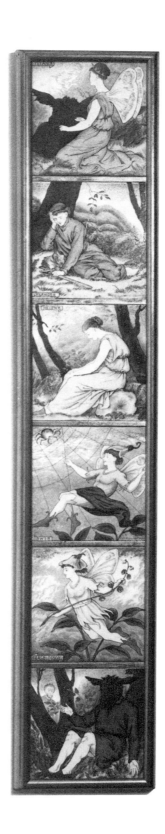

6 ALLEN

9 BAYES

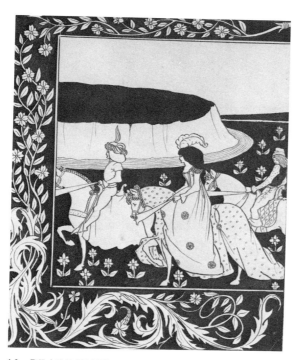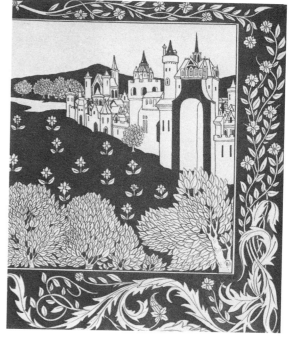

10 BEARDSLEY

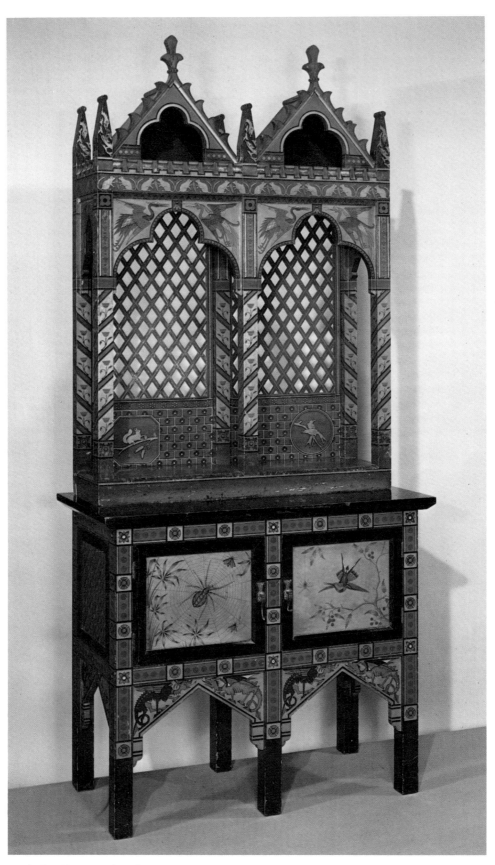

7 AUDSLEY, attributed to

8 AUDSLEY

11 BEARDSLEY

Because one figure was undressed
This little drawing was suppressed
It was unkind —
But never mind
Perhaps it all was for the best —

Alfred Lambart from Audrey Beardsley

12 BEARDSLEY

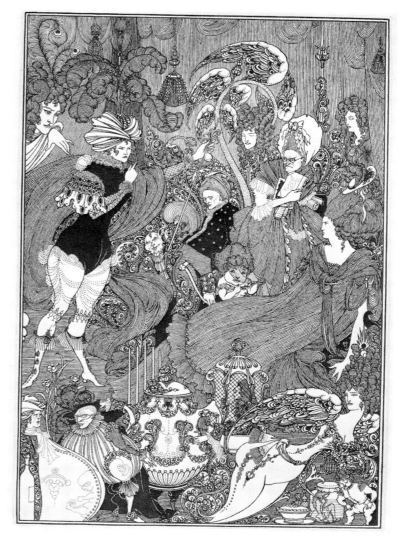

13 BEARDSLEY

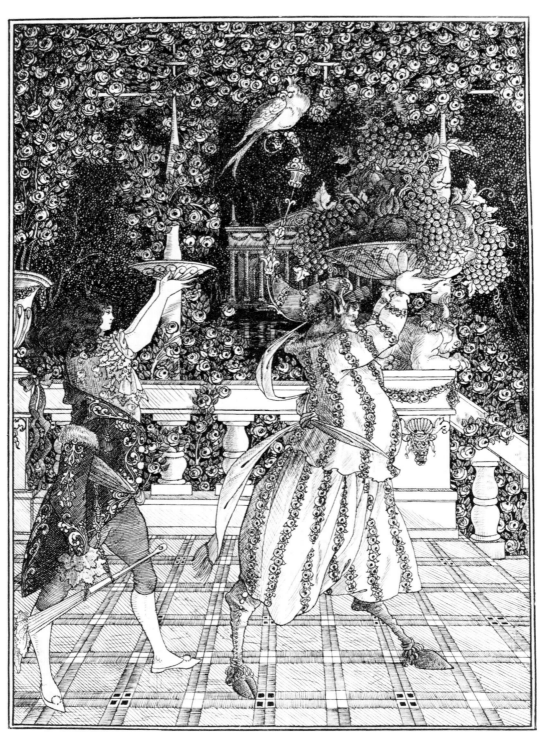

14 BEARDSLEY

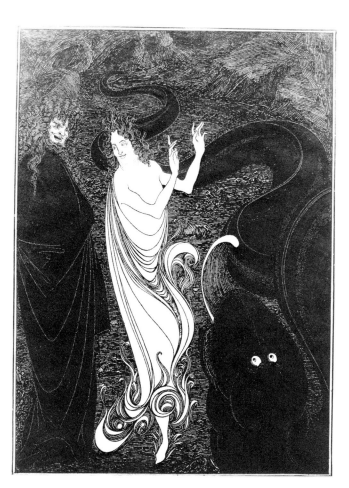

15 BEARDSLEY

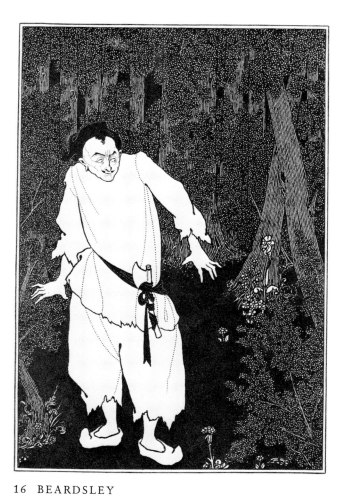

16 BEARDSLEY

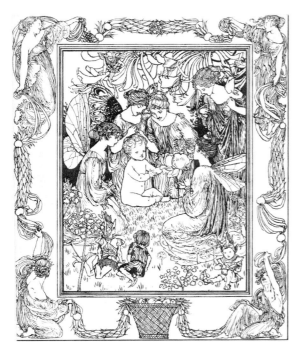

17 BELL

18 BENTLEY

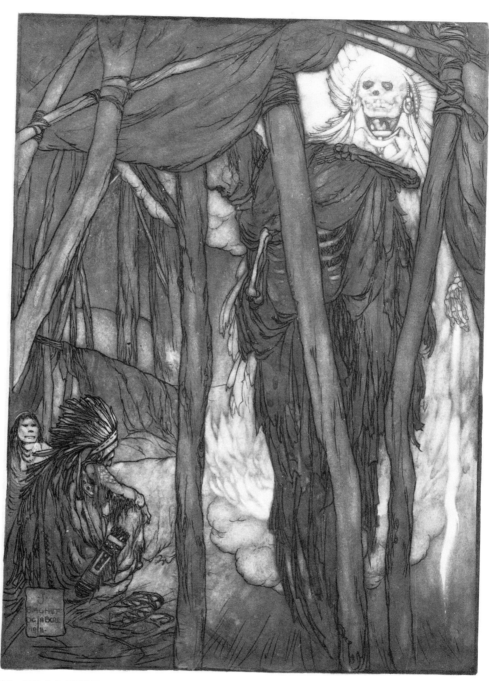

19 DE LA BERE

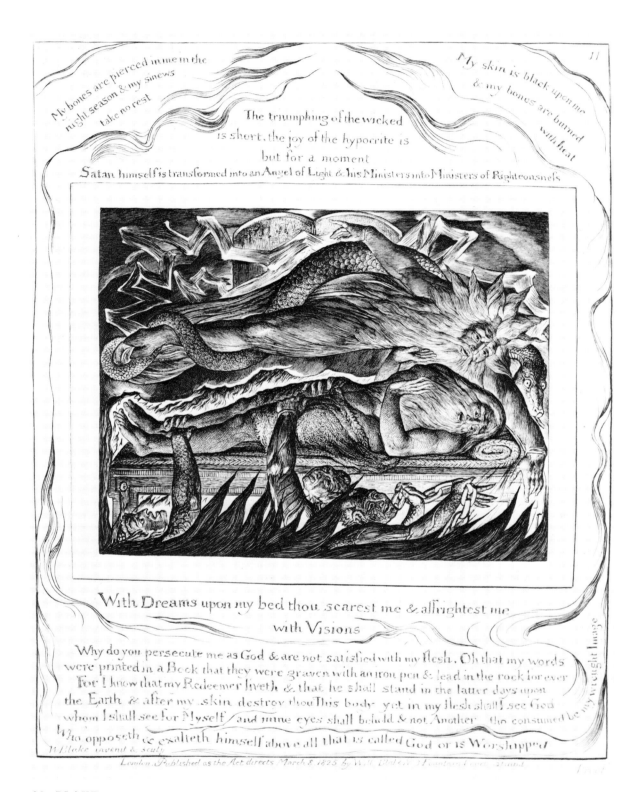

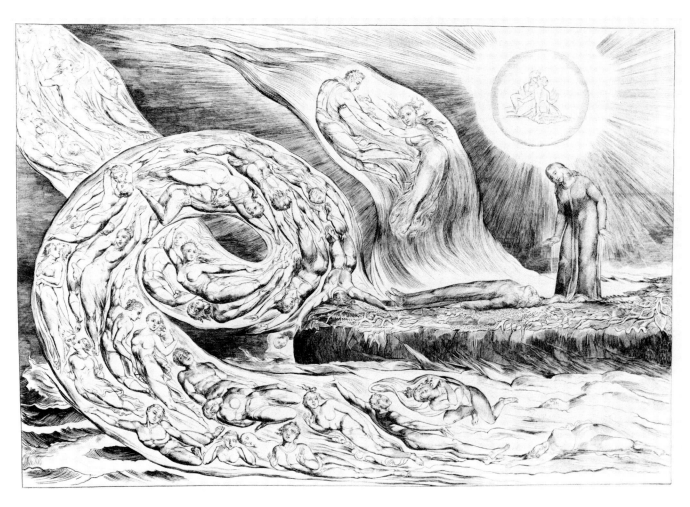

21 BLAKE

114

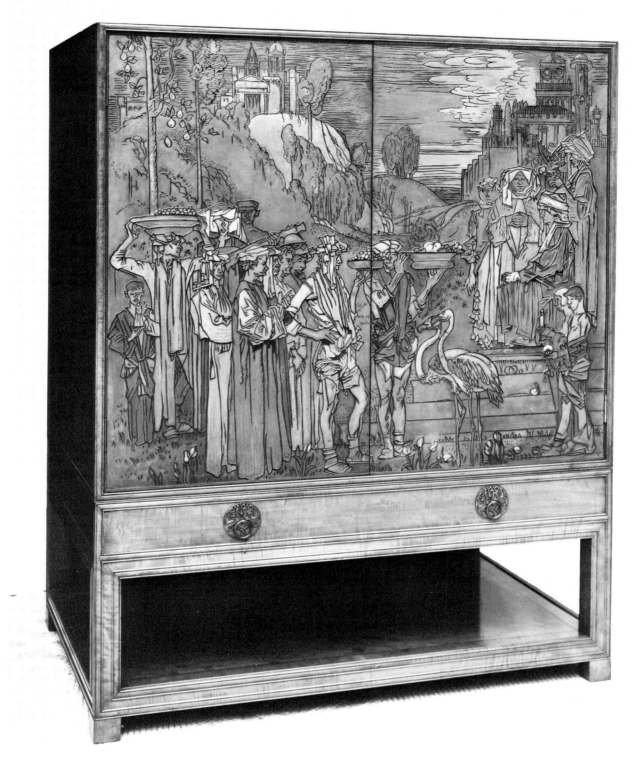

23 BRANGWYN

22 DE BOSSCHÈRE

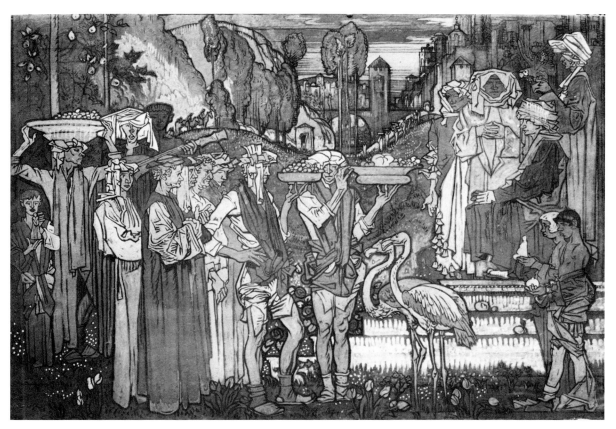

24 BRANGWYN

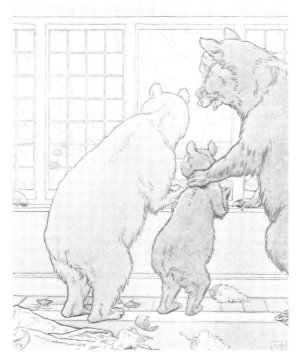

25 L. L. BROOKE

26 W. H. BROOKE

27 BURGES

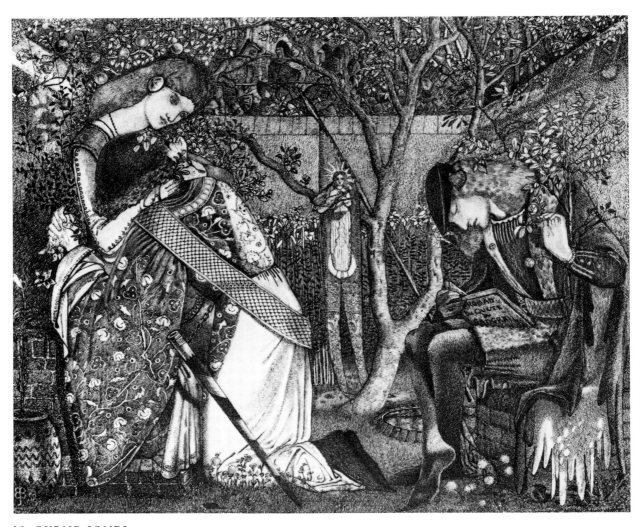

28 BURNE-JONES

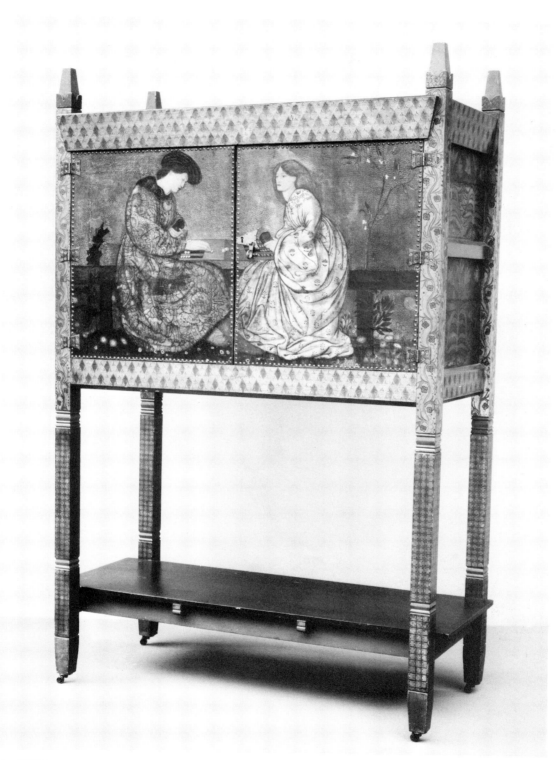

29 BURNE-JONES

31 BURNE-JONES

32 BURNE-JONES

33 BURNE-JONES

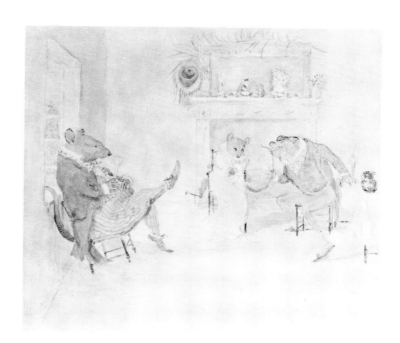

34b CALDECOTT

35 CLARKE

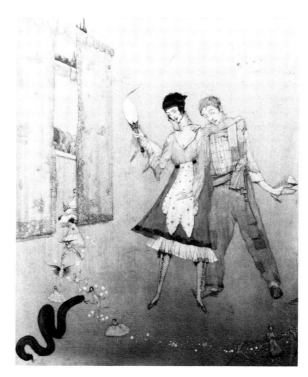

36 CLARKE

37 CLARKE

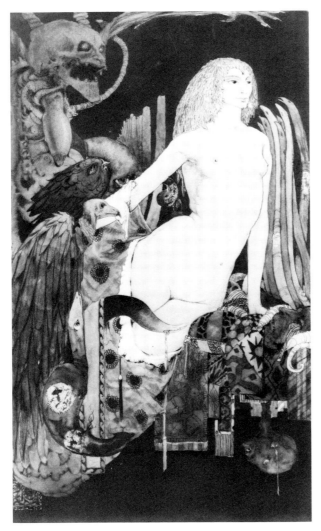

38 CLARKE

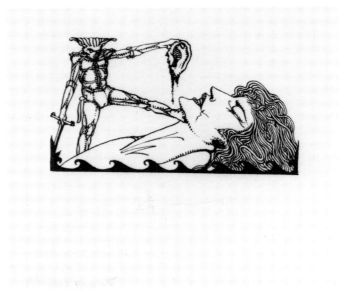

39 CLARKE

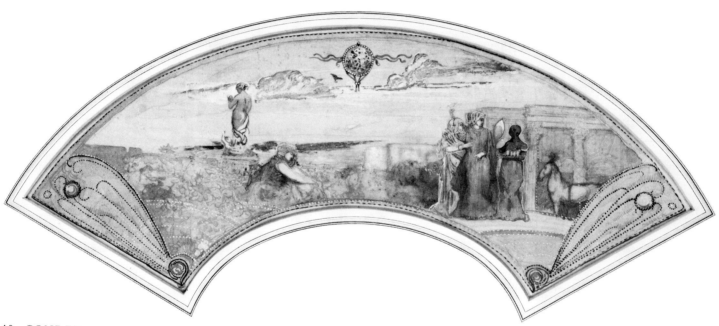

40 CONDER

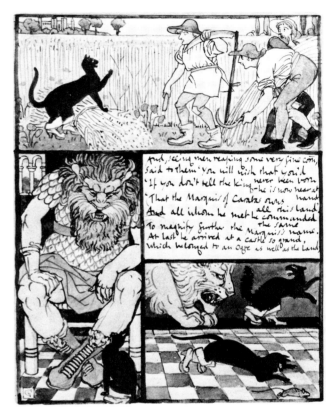

42 CRANE

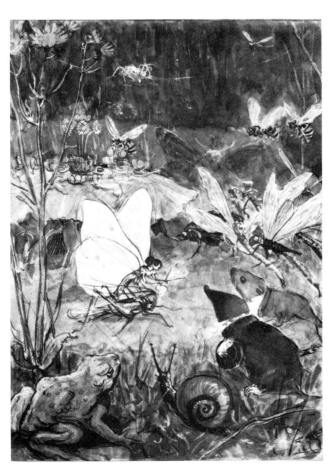

41 CRANE

43 CRANE

THE SLEEPING BEAUTY.

45 CRANE

44 CRANE

46 CRANE

48 CRANE

49 CRANE

50 CRANE

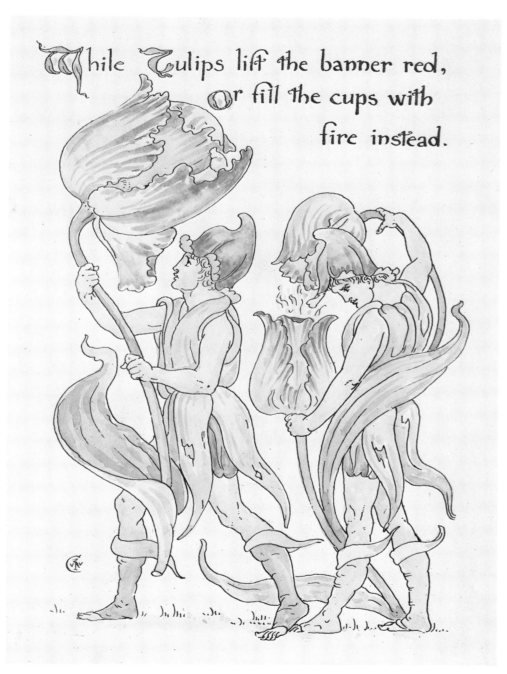

While Tulips lift the banner red,
or fill the cups with
fire instead.

51 CRANE

134

52 CRANE

55 CRANE

56 CRANE

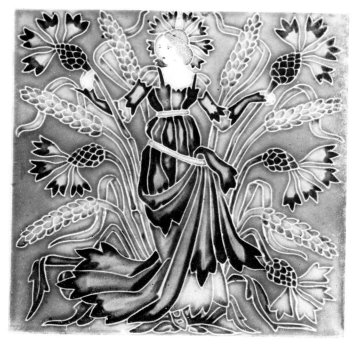

57 CRANE

58 CRANE

53 CRANE

54 CRANE

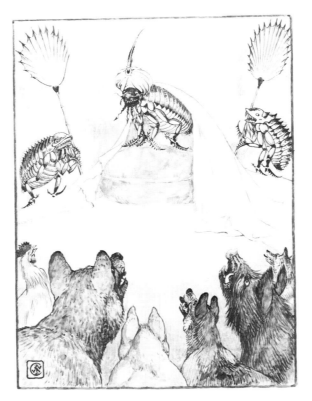

59 CRANE

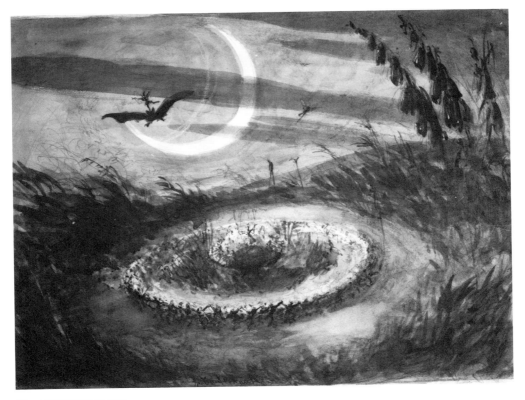

61 CRUIKSHANK

63 CRUIKSHANK

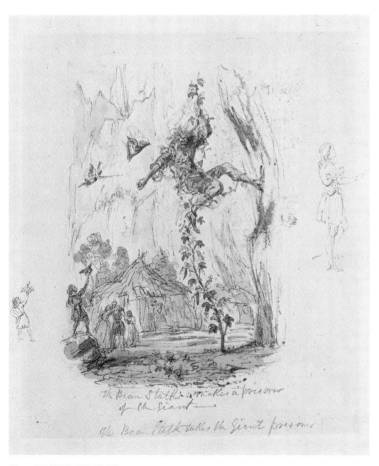

The Bean Stalk makes a prisoner
of the Giant

The Bean Stalk takes the Giant prisoner

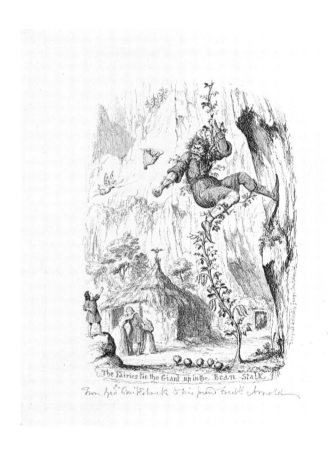

The Fairies tie the Giant up in the Bean Stalk

From Geo Cruikshank to his friend Fred.k Arnold

62 CRUIKSHANK

64 DADD

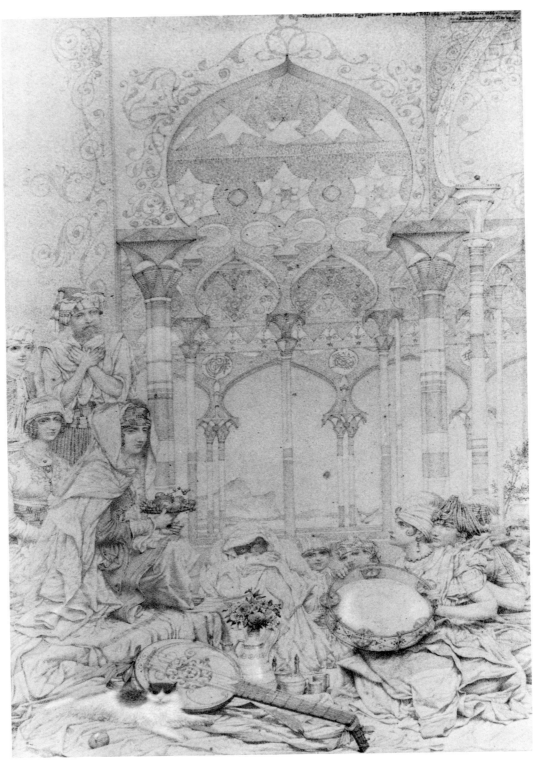

65 DADD

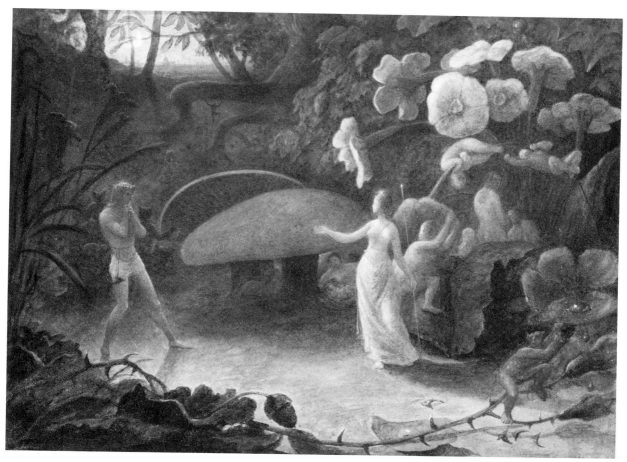

66 DANBY

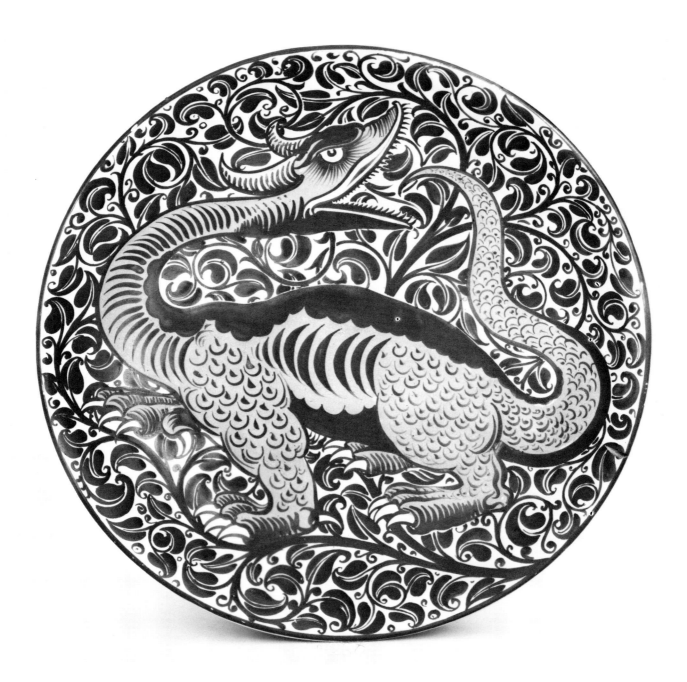

67 DE MORGAN

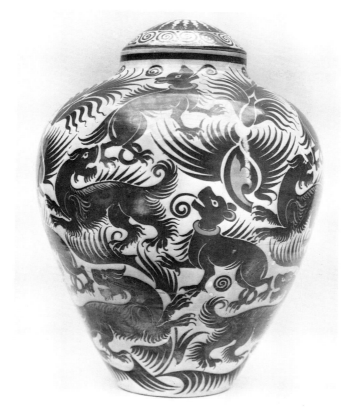

68 DE MORGAN

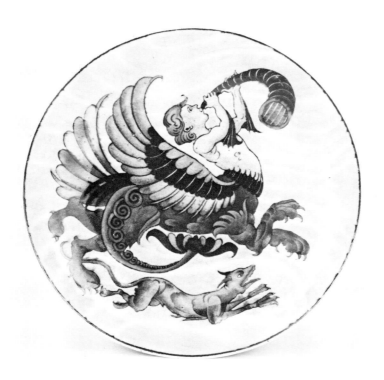

70 DE MORGAN

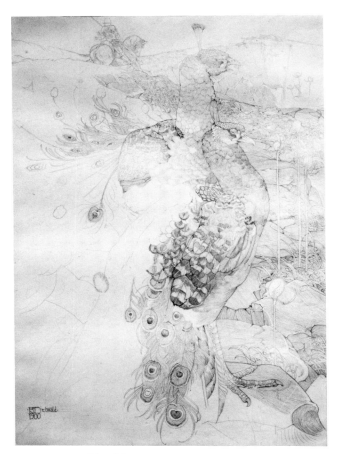

72　E. J. DETMOLD

71　C. M. DETMOLD

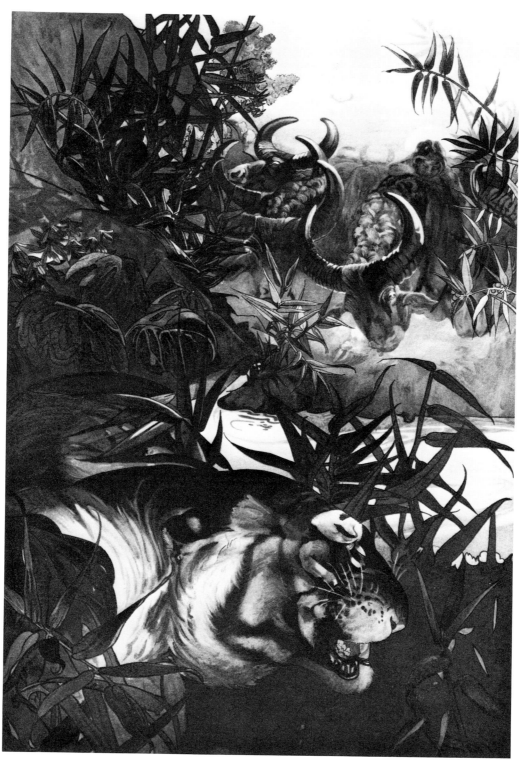

73 E. J. DETMOLD

74 E. J. DETMOLD

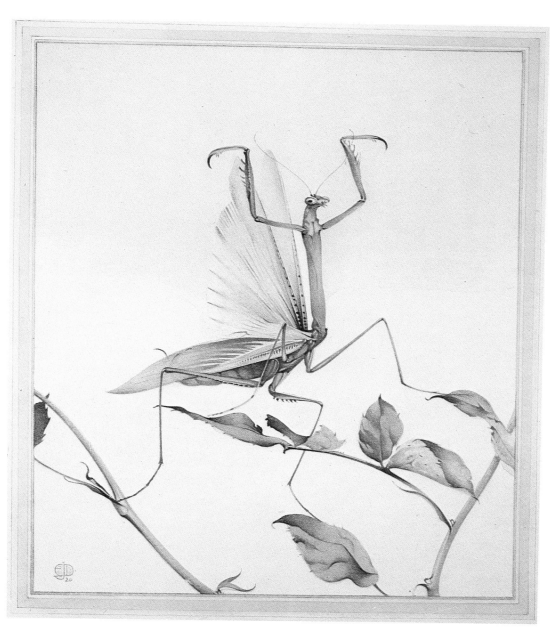

75 E. J. DETMOLD

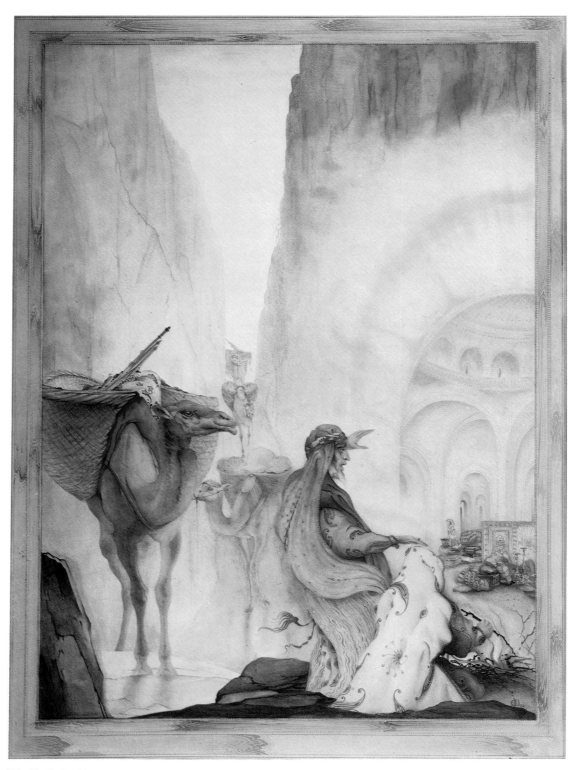

76 E. J. DETMOLD

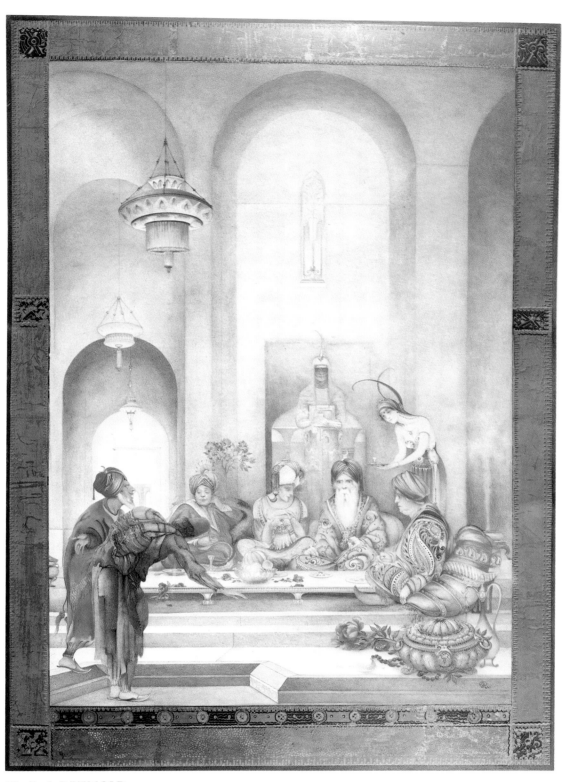

78 E. J. DETMOLD

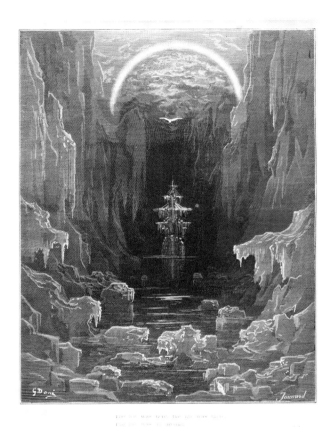

79 DORÉ

80 DOYLE

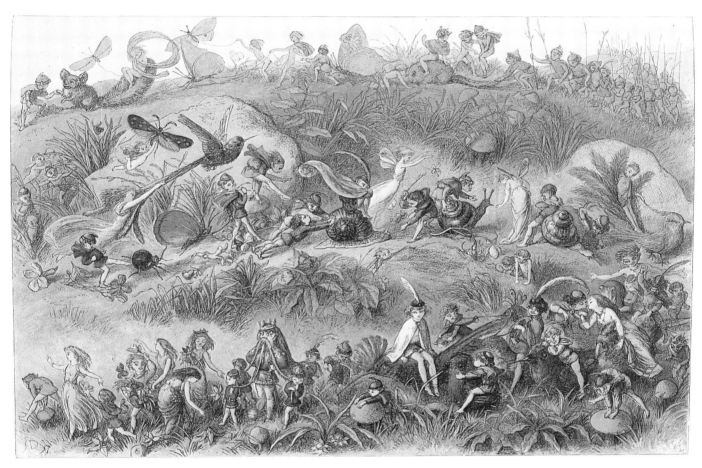

Triumphal March of the Elf-King.

This important personage, nearly related to the Goblin family, is conspicuous for the length of his hair, which on state occasions it requires four pages to support. Fairies in waiting strew flowers in his path, and in his train are many of the most distinguished Trolls, Kobolds, Nixies, Pixies, Wood-sprites, birds, butterflies, and other inhabitants of the kingdom.

81 DOYLE

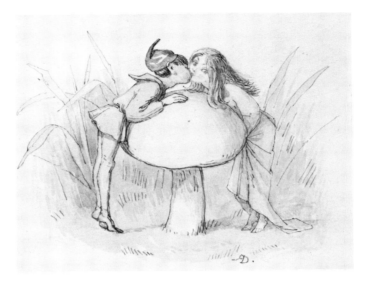

82 DOYLE

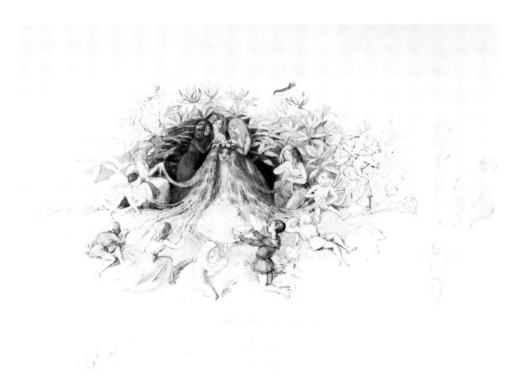

83 DOYLE

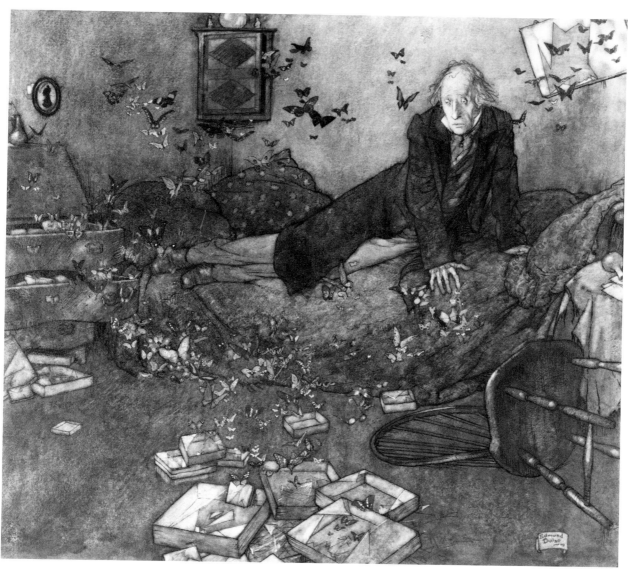

84 DULAC

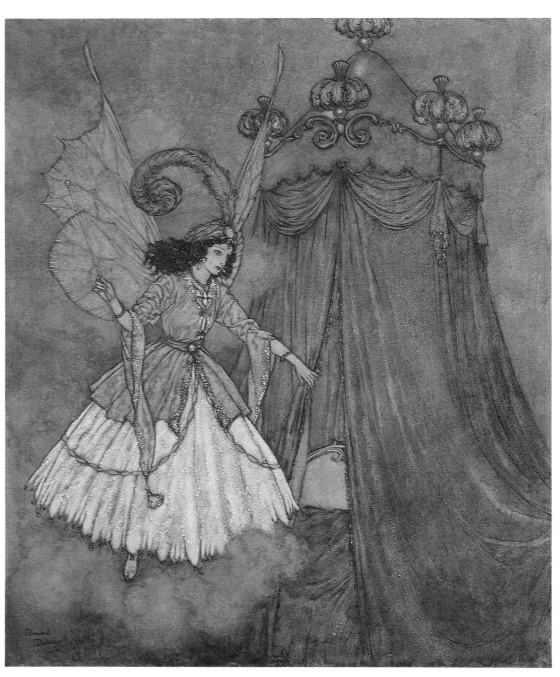

85 DULAC

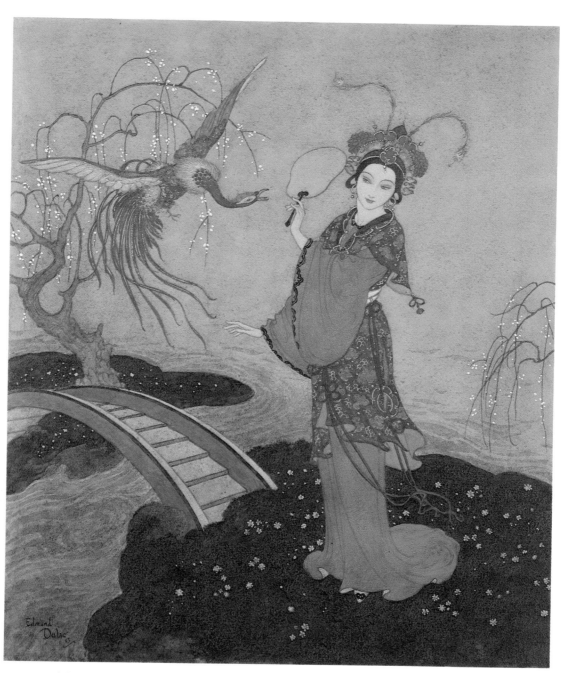

87 DULAC

86 DULAC

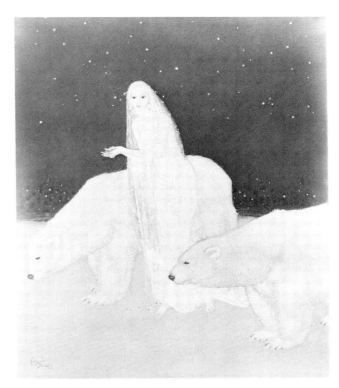

89 DULAC

90 DULAC

88 DULAC

92 DULAC

91 DULAC

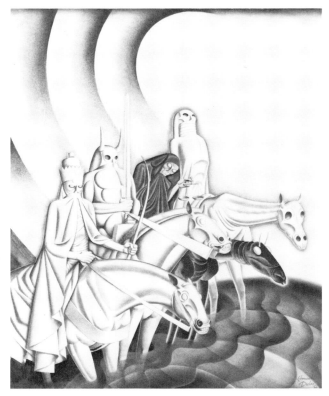

94 DULAC

162

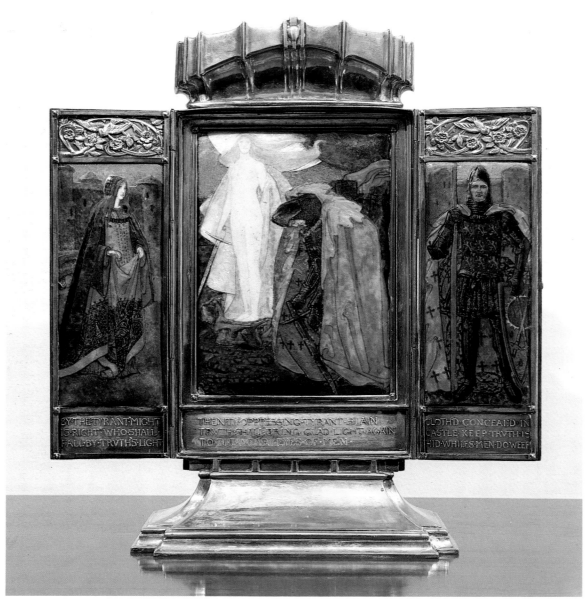

95 FISHER

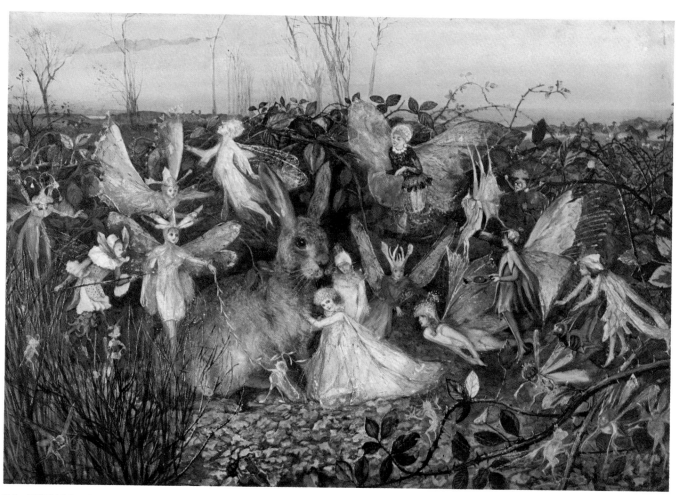

96 FITZGERALD

98 FORD

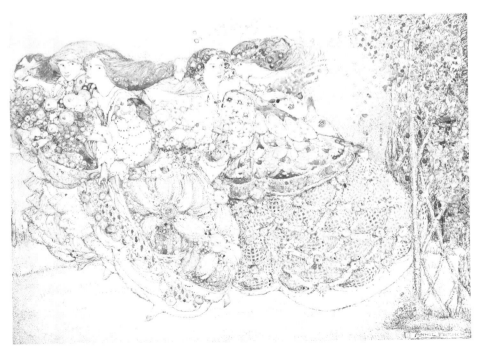

99 FRENCH

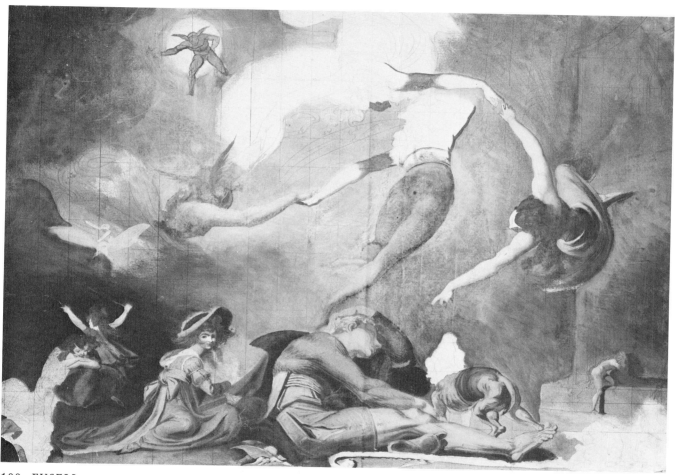

100 FUSELI

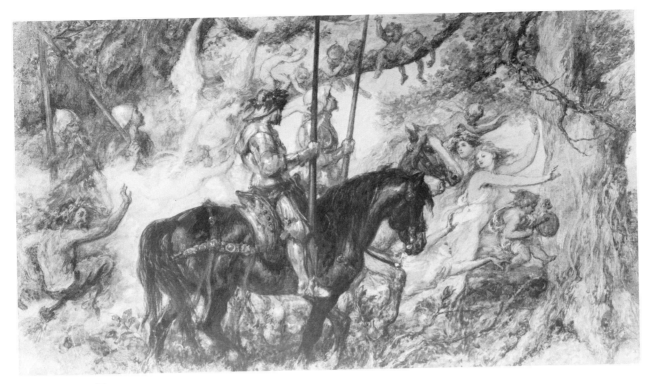

101 GILBERT

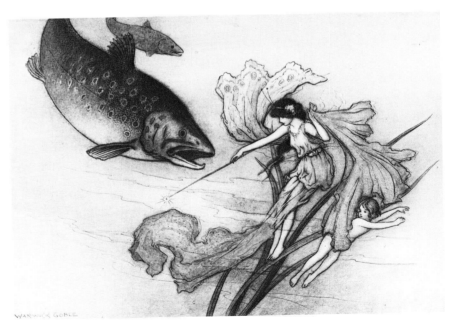

102 GOBLE

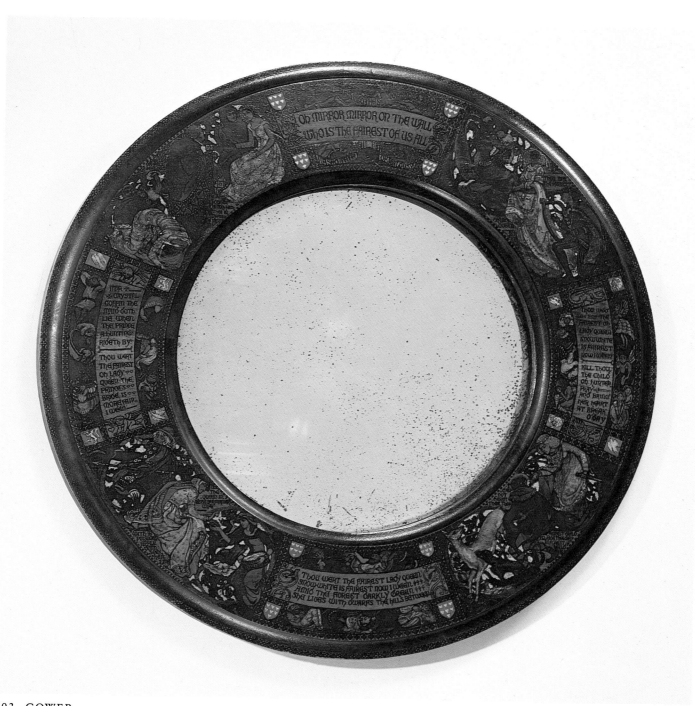

Oh MIRROR MIRROR ON THE WALL
WHO IS THE FAIREST OF US ALL

HER CRYSTEL COFFIN THE MAID DOTH LIE WHEN THE PRINCE A HUNTING RIDETH BY

THOU WERT THE FAIREST OH LADY QUEEN THE PRINCES BRIDE IS MORE FAIR I WEEN

THOU WERT THE FAIREST OH LADY QUEEN SNOW WHITE IS FAIREST NOW I WEEN

KILL THOU THE CHILD OH HUNTER PRAY AND BRING HER HART AT BREAK O DAY

THOU WERT THE FAIREST LADY QUEEN SNOW WHITE IS FAIREST NOW I WEEN AMID THE FOREST DARKLY GREEN SHE LIVES WITH DWARFS THE HILLS BETWEEN

103 GOWER

104 GREENAWAY

106 GREENAWAY

107 GREENAWAY

108 GREENAWAY

109 GREENAWAY

110 GREGORY

111 GRISET

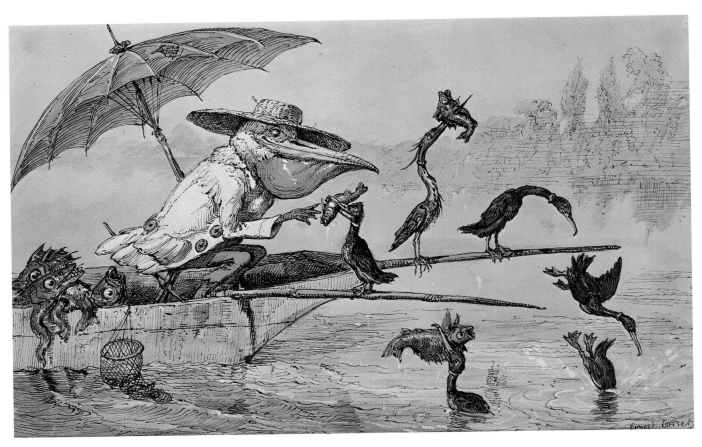

112 GRISET

113 HERMAN

114 HILL

115 HOLIDAY

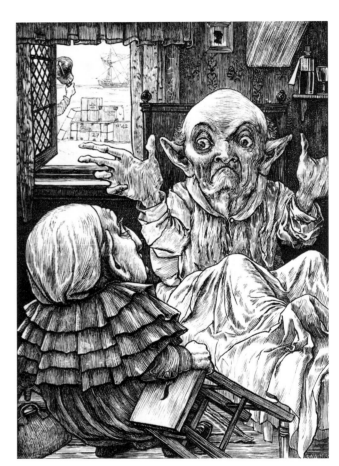

116 HOLIDAY

117 HOUSMAN

118 HOUSMAN

120 HUDSON, attributed to

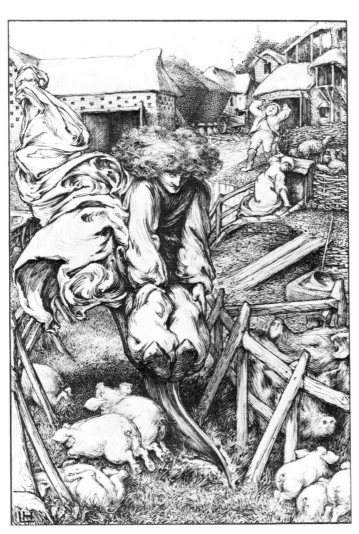

119 HOUSMAN

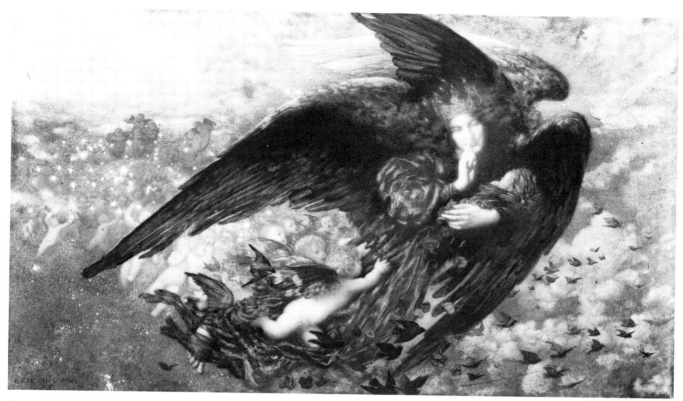

121 HUGHES

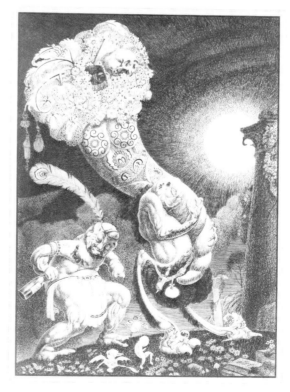

122 KEEN

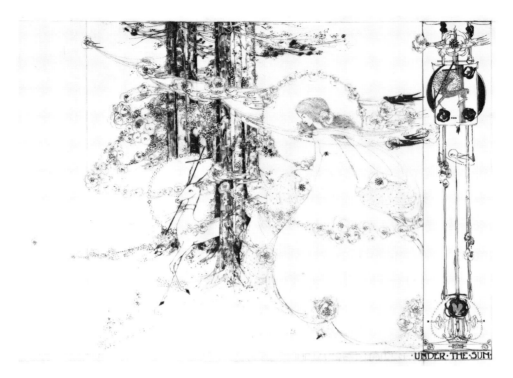

123 KING

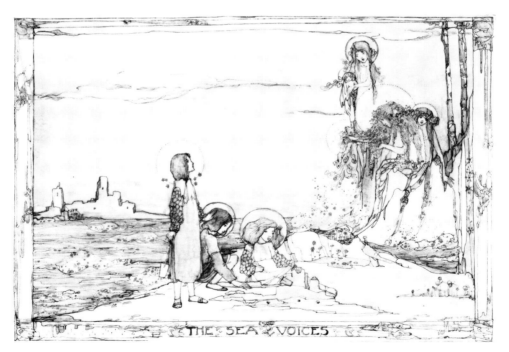

124 KING

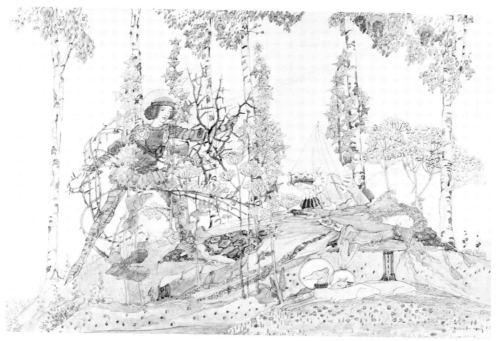

125 KING

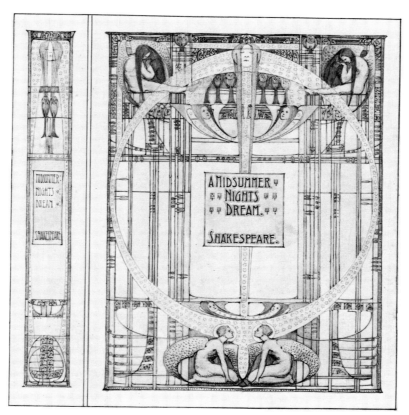

129 LIGHTFOOT

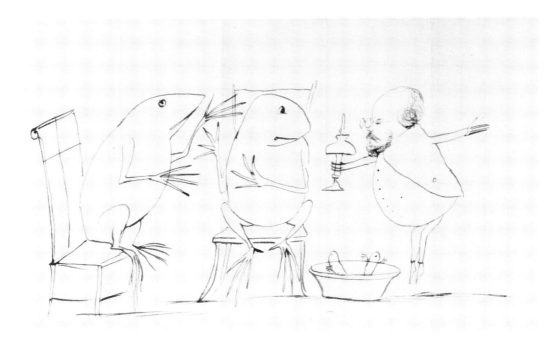

126 LEAR

The Absolutely Abstemious Ass,
who resided in a barrel, and only
lived on Soda Water, and Pickled Cucumbers.

127 LEAR

The Fork Tree

This pleasing and amazing Tree never grows above four hundred
and sixty three feet in height, — nor has any specimen hitherto
produced above forty thousand silver forks at one time.
If violently shaken it is most probable that many forks would
fall off, — and in a high wind it is highly possible that all the forks
would rattle dreadfully, and produce a musical tinkling
to the ears of the happy beholder.

128 LEAR

130 MACKENZIE

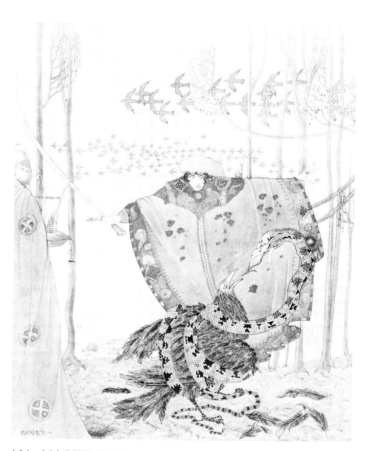

131 MACKENZIE

 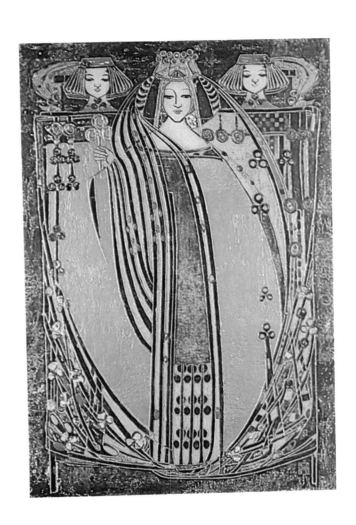

132 MACKINTOSH

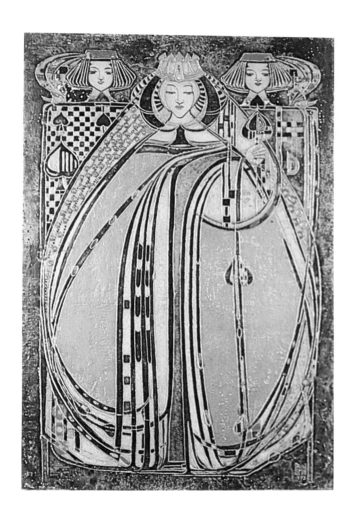
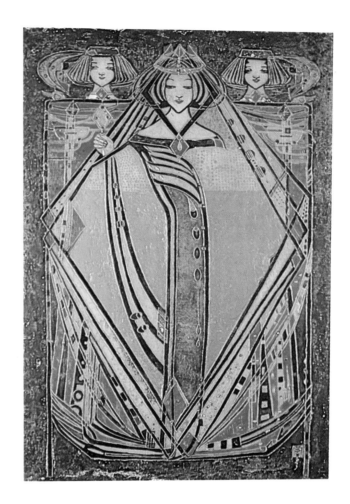

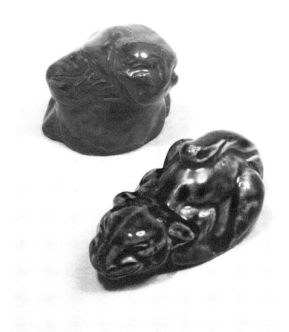

137 MARSHALL

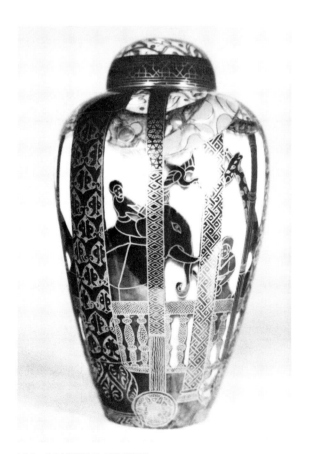

135 MAKEIG-JONES

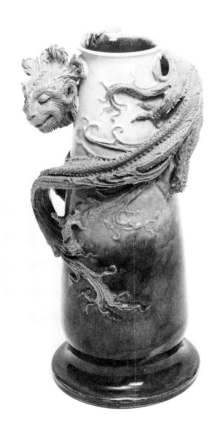

138 MARSHALL

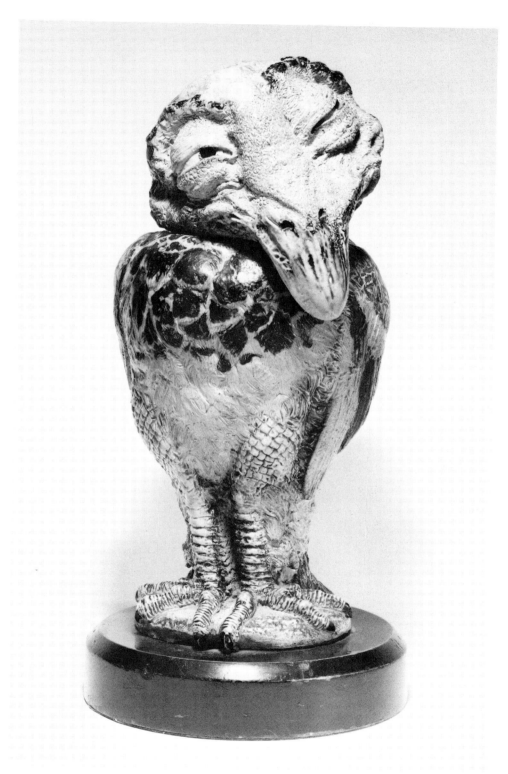

140 MARTIN BROTHERS

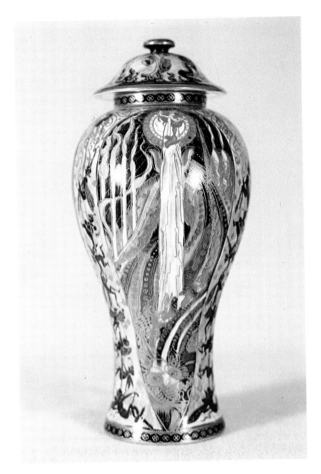

133 MAKEIG-JONES

136 MAKEIG-JONES

142 MARTIN BROTHERS

141 MARTIN BROTHERS

145 MILLS

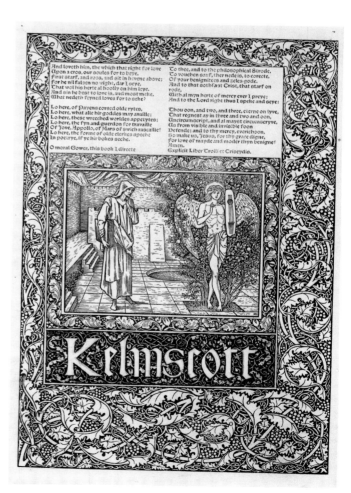

146 MORRIS

148 NIELSEN

149 NIELSEN

150 NIELSEN

192

151 NIELSEN

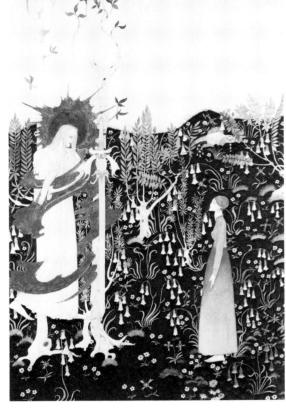

152 NIELSEN

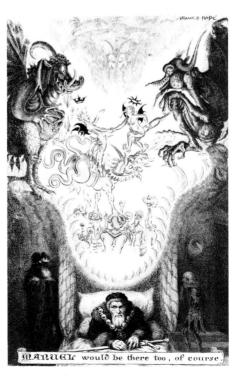

153 PAPÉ

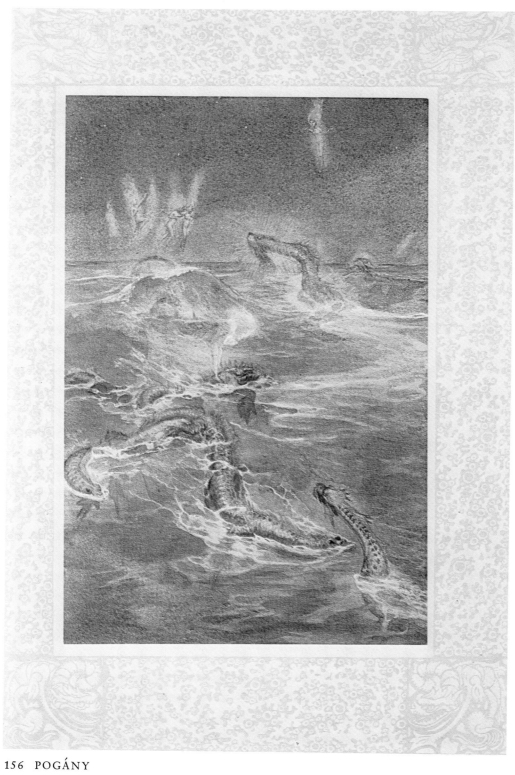

156 POGÁNY

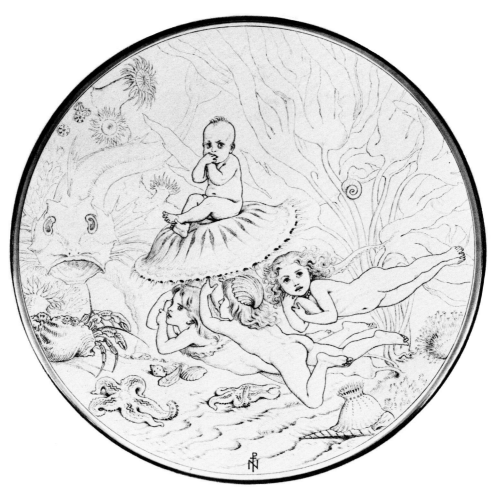

155 PATON

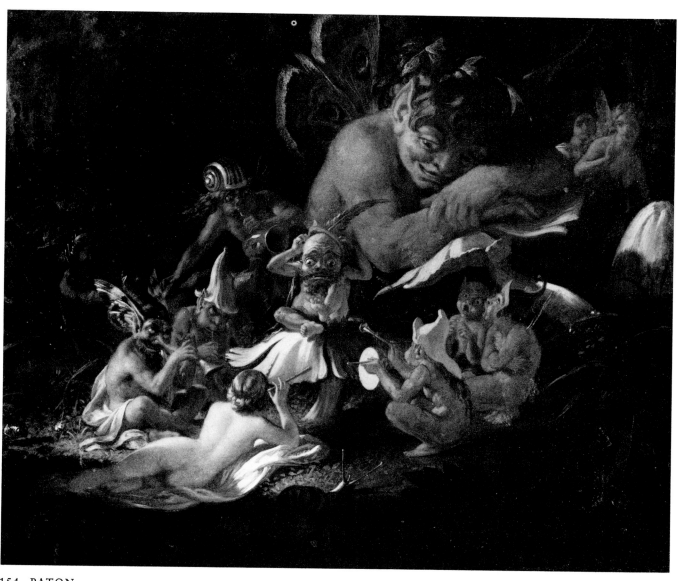

154 PATON

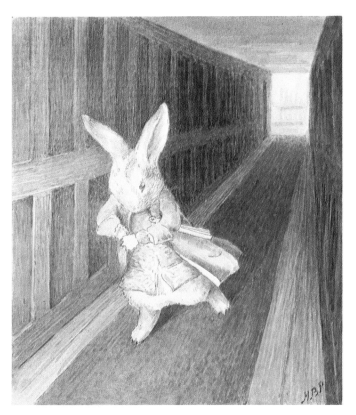

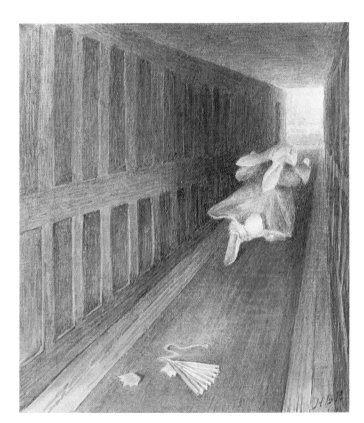

157a POTTER

157b POTTER

158 POTTER

159 POTTER

160 POTTER

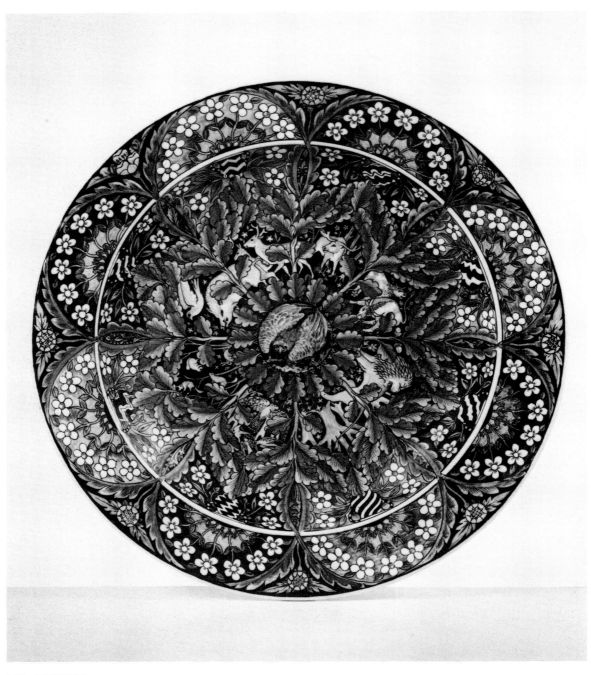

161 POWELL

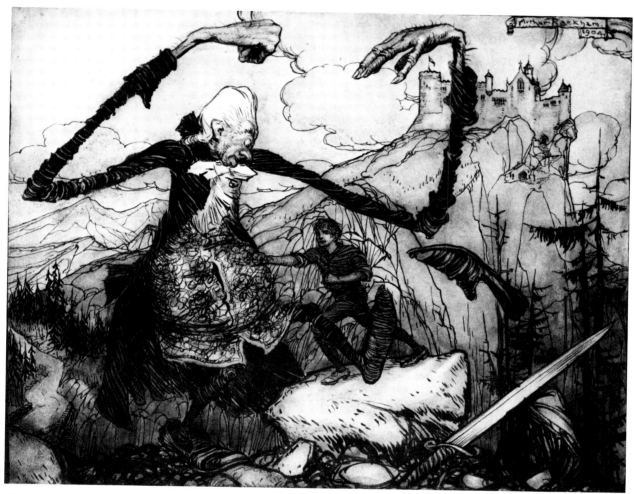

162 RACKHAM

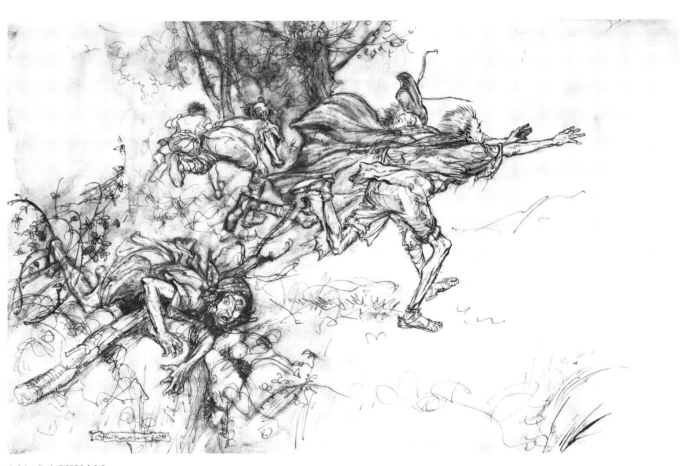

164 RACKHAM

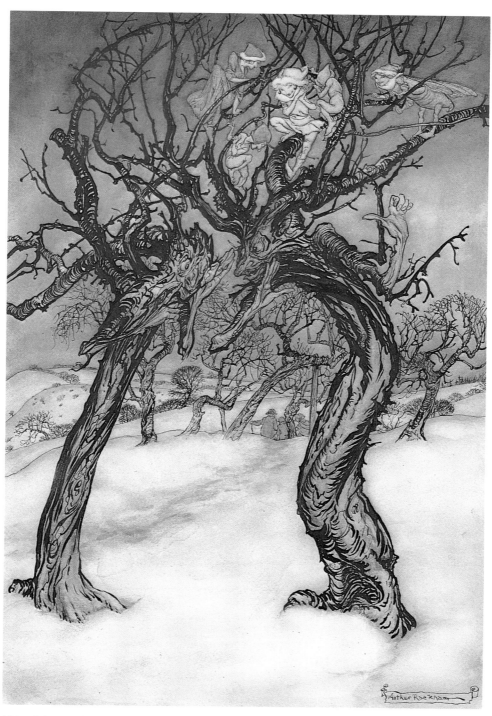

170 RACKHAM

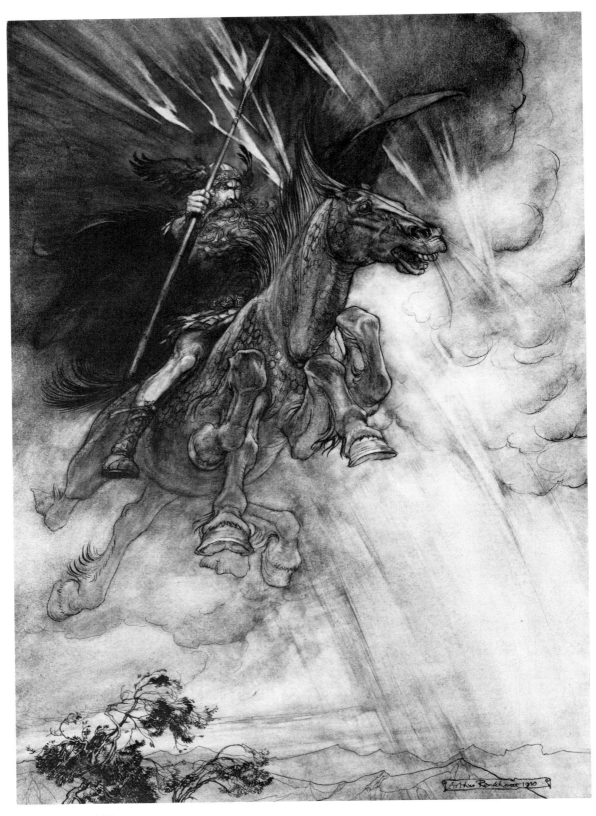

165 RACKHAM

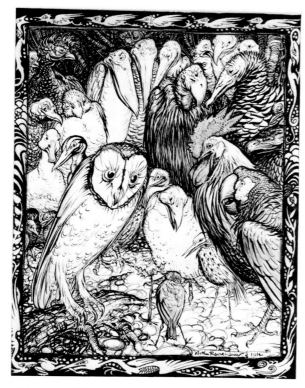

166 RACKHAM

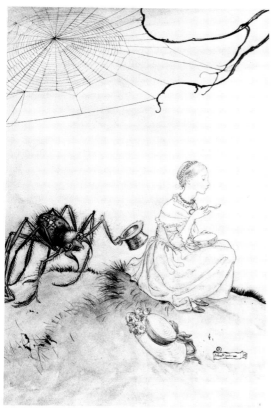

167 RACKHAM

169 RACKHAM

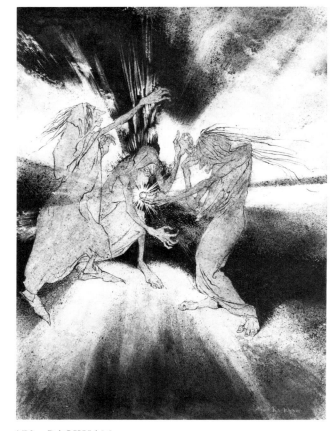

173 RACKHAM

171 RACKHAM

174 RACKHAM

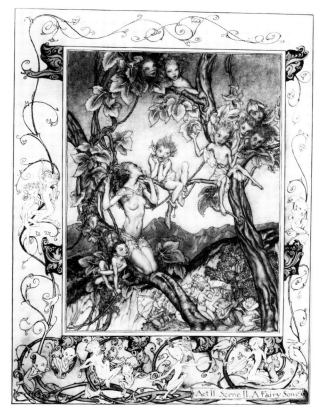

175 RACKHAM

Peter Pan

In Kensington Gardens

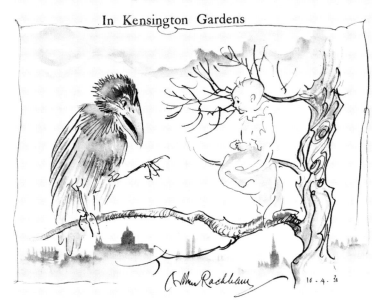

176 RACKHAM

177 RACKHAM

178 RACKHAM

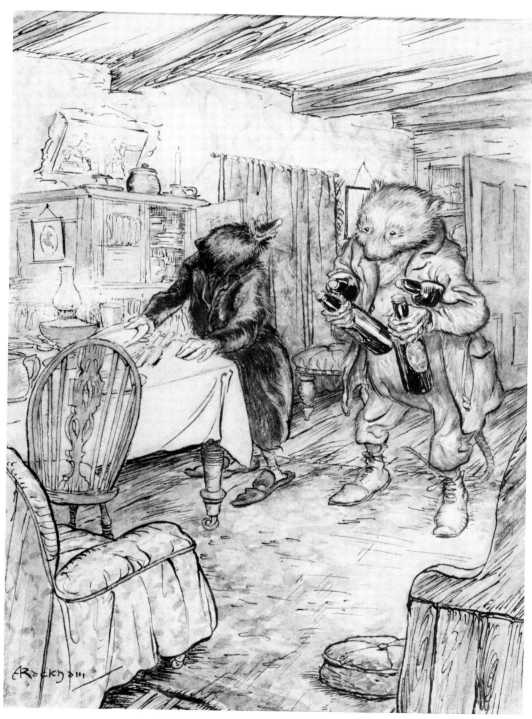

179 RACKHAM

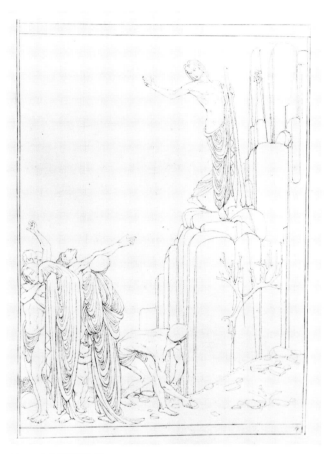

180 RICKETTS

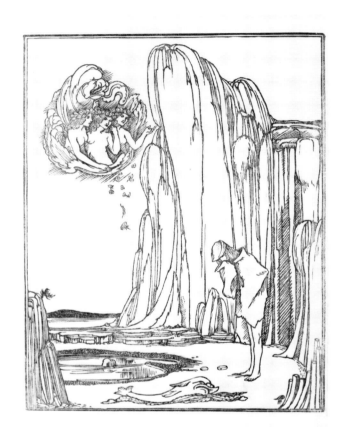

181 RICKETTS AND SHANNON

182 RICKETTS AND SHANNON

183 RICKETTS AND SHANNON

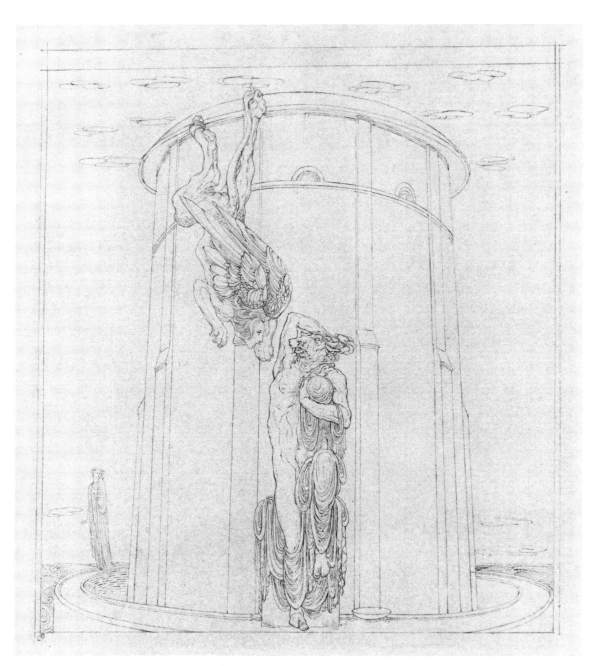

184 RICKETTS

185 RICKETTS

186 RICKETTS

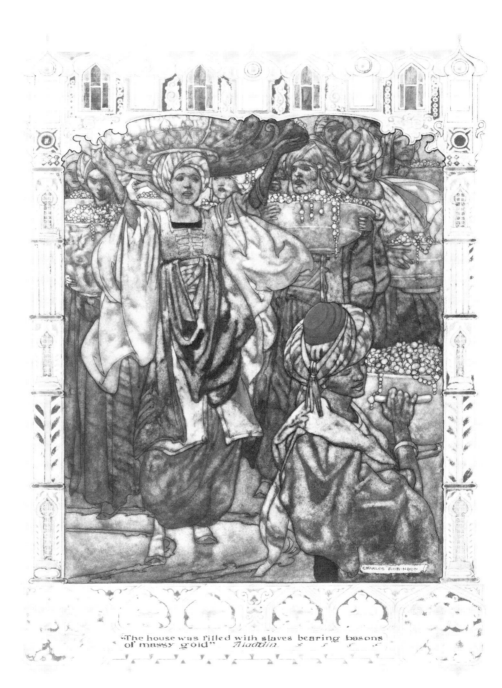

"The house was filled with slaves bearing basons of massy gold" *Aladdin*

187 C. ROBINSON

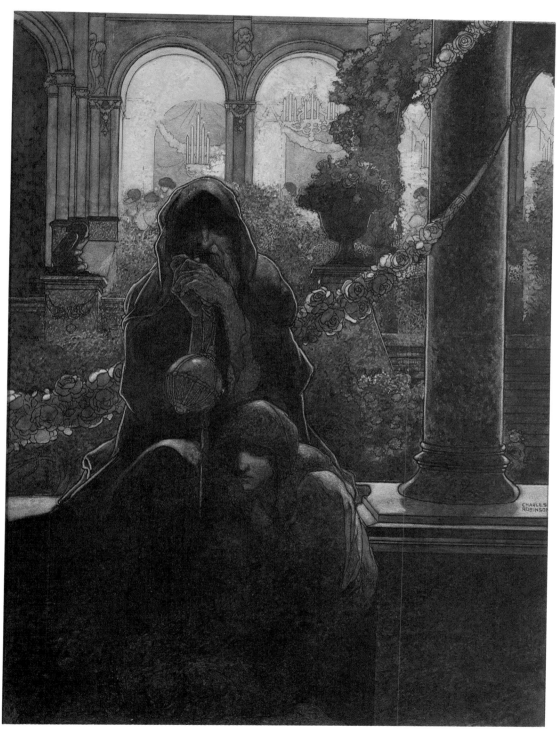

188 C. ROBINSON

189 F. C. ROBINSON

190 F. C. ROBINSON

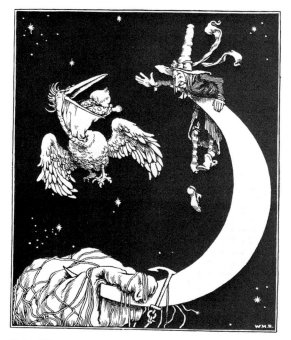

191 W. H. ROBINSON

195 W. H. ROBINSON

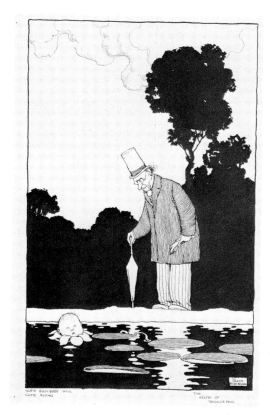

192 W. H. ROBINSON

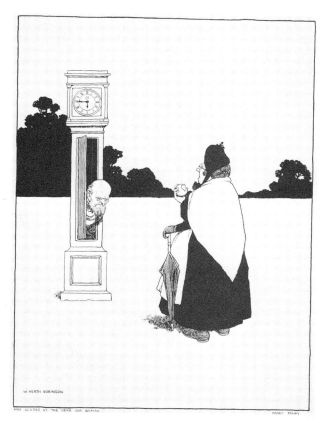

193 W. H. ROBINSON

197 ROSSETTI

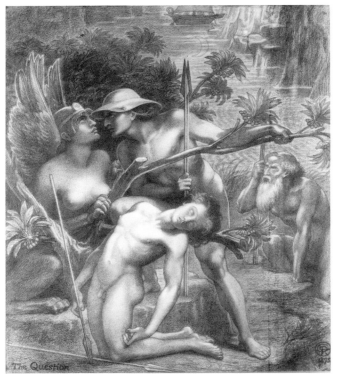

198 ROSSETTI

201 SCOTT

218

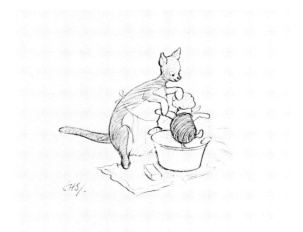

202 SHEPARD

203 SHEPARD

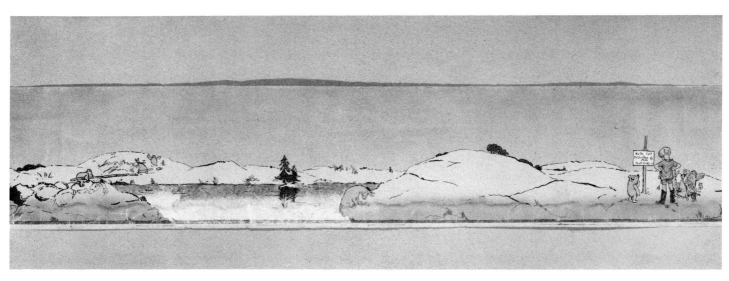

204 SHEPARD, after

205 SHERINGHAM

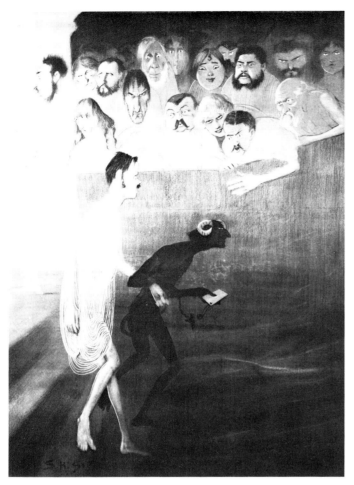

206 SIME

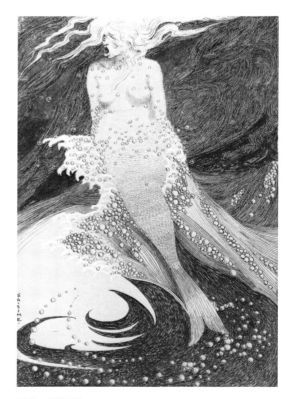

207 SIME

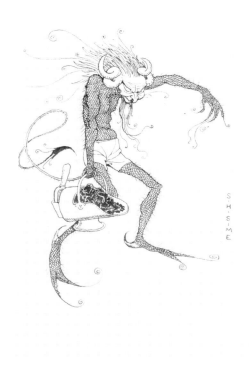

209 SIME

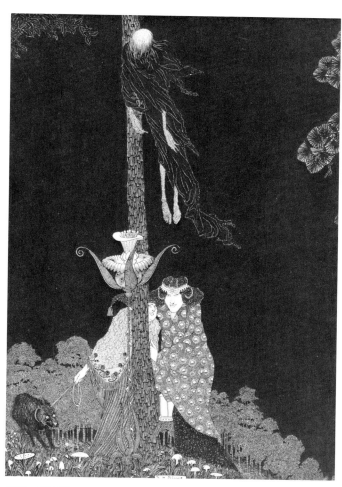

208 SIME

222

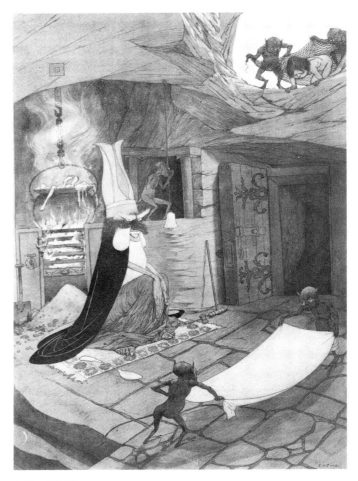

211 SIME

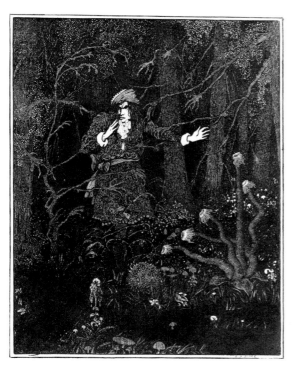

210 SIME

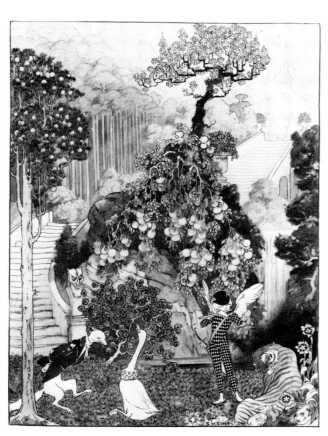

212 SIME

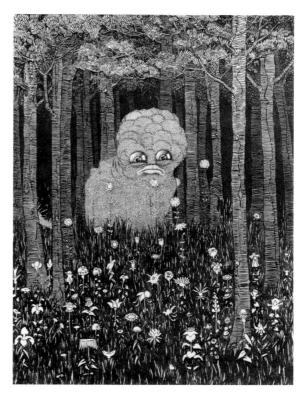

213 SIME

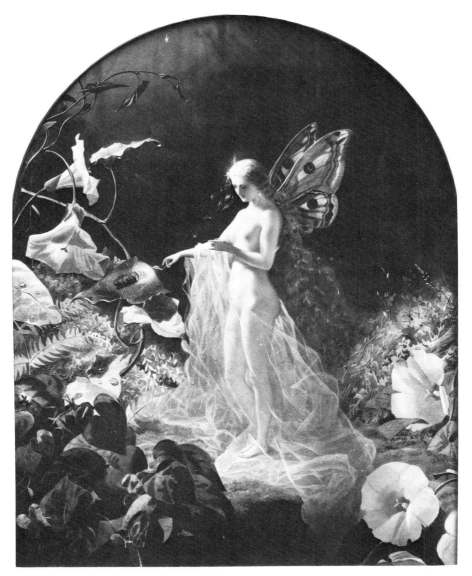

214 SIMMONS

216 STABLER

217 SULLIVAN

219 TENNIEL

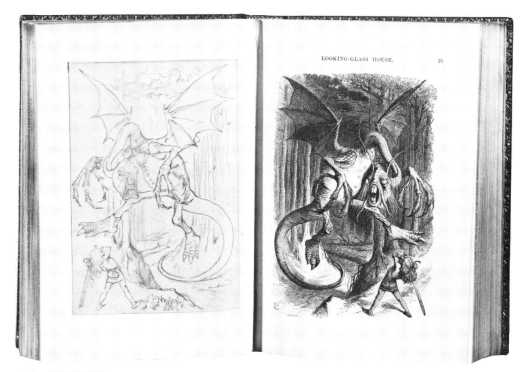

220 TENNIEL

222 TENNIEL

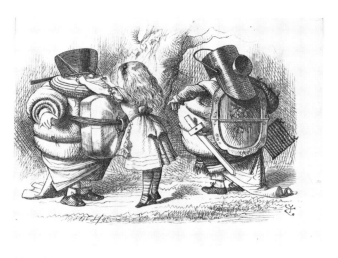

223 TENNIEL

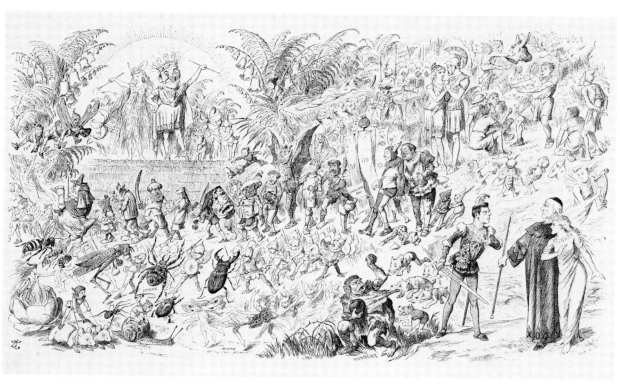

221 TENNIEL

224 TENNIEL

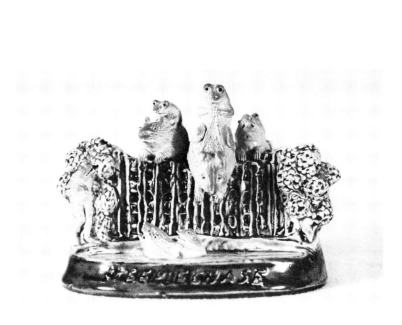

225 TINWORTH

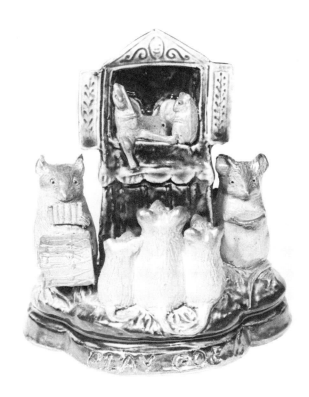

226 TINWORTH

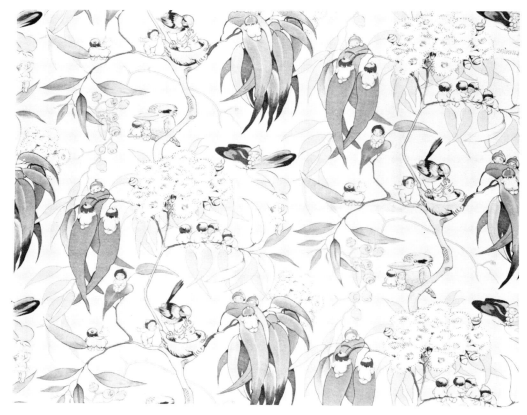

227 TURNBULL AND STOCKDALE LTD.

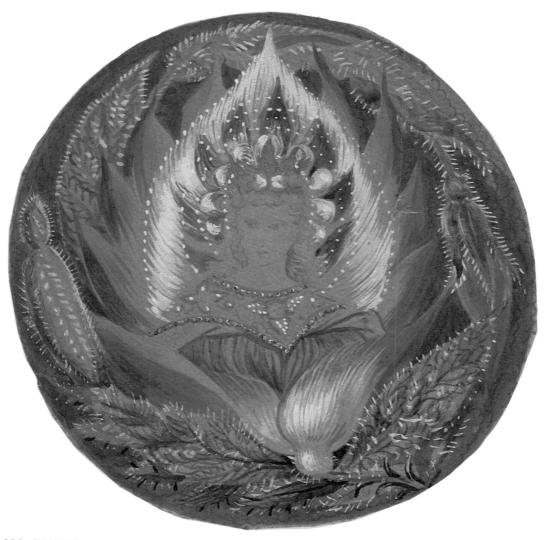

228 WATTS

229 WILSON

230 WOODROFFE

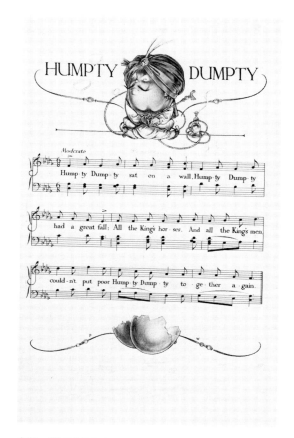

231 WOODROFFE

Bibliography

Adams, Eric. *Francis Danby: Varieties of Poetic Landscape,* New Haven and London, published for the Paul Mellon Centre for Studies in British Art (London) Ltd. by Yale University Press, 1973.

Alastair (Hans Henning von Voight). *Fifty Drawings by Alastair,* with an introduction by Carl Van Vechten, New York, Alfred A. Knopf, 1925.

Allderidge, Patricia. *The Late Richard Dadd,* exhibition catalogue, London, The Tate Gallery, 1974.

Altholz, Josef L., ed. *The Mind and Art of Victorian England,* Minneapolis, University of Minnesota Press, 1976.

Arnott, Brian and Richard Studing. *Fantastic Shakespeare,* exhibition catalogue, Stratford, Ontario, The Gallery/Stratford, 1978.

Aslin, Elizabeth. *The Aesthetic Movement,* New York, Frederick A. Praeger, Publishers, 1969.

————. *Nineteenth-century English Furniture,* London, Faber & Faber, 1962.

Baldry, A. L. "Some New Decorative Panels and Fans by George Sheringham," *The Studio,* 52, No. 207 (May 1914), pp. 174-187.

Barnard, Julian. *Victorian Ceramic Tiles,* London, Studio Vista Publishers, 1972.

Baughman, Roland. *The Centenary of Arthur Rackham's Birth, September 19, 1867,* catalogue of the Berol Collection, New York, Columbia University Libraries, 1967.

Beard, Charles R. *A Catalogue of The Collection of Martinware Formed by Mr. Frederick John Nettlefold Together with a Short History of The Firm of R. W. Martin and Brothers of Southall,* London, printed privately for the owner by Waterlow & Sons, Ltd., 1936.

Beck, Hilary. *Victorian Engravings,* London, Victoria and Albert Museum, 1973.

Bell, Malcolm. *Edward Burne-Jones, A Record and Review,* London and New York, George Bell & Sons, 1892.

Bell, Quentin. *Victorian Artists,* Cambridge, Mass., Harvard University Press, 1967.

Bentley, G. E., Jr. *The Blake Collection of Mrs. Landon K. Thorne,* exhibition catalogue, New York, The Pierpont Morgan Library, 1971.

Bettelheim, Bruno. *The Uses of Enchantment,* New York, Alfred A. Knopf, 1976.

Binyon, Laurence. *The Engraved Designs of William Blake,* New York, Da Capo Press, 1967.

Birmingham, City of Birmingham Museum and Art Gallery. *Catalogue of the Permanent Collection of Drawings,* Derby and Birmingham, Bemrose & Sons, Limited, 1939.

Blacker, J. F. *The ABC of English Salt-Glaze Stone-Ware from Dwight to Doulton,* London, Stanley Paul & Co., 1922.

Bland, David. *A History of Book Illustration,* Berkeley and Los Angeles, University of California Press, 1969.

Bond, William H. "The Publication of *Alice's Adventures in Wonderland,*" *Harvard Library Bulletin,* 10, No. 3 (Autumn 1956), pp. 306-324.

Boston, Museum of Fine Arts. *Catalogue of Paintings and Drawings in Water Color,* Boston, Museum of Fine Arts, 1949.

Bridgeman, Harriet and Elizabeth Drury, eds. *The Encyclopedia of Victoriana,* New York, Macmillan Publishing Co., Inc., 1975.

Briggs, Katharine M. *An Encyclopedia of Fairies,* New York, Pantheon Books, 1976.

————. *The Fairies in Tradition and Literature,* London, Routledge and Kegan Paul, 1967.

Brion, Marcel. *Romantic Art,* London, Thames and Hudson, 1960.

Butlin, Martin. *William Blake,* exhibition catalogue, London, The Tate Gallery, 1978.

Cambridge, The Houghton Library, Harvard University, *The Turn of a Century 1885-1910,* exhibition catalogue, Cambridge, Mass., Department of Printing and Graphic Arts, The Houghton Library, 1970.

Carrington, Fitzroy. *Pictures of Romance and Wonder by Sir Edward Burne-Jones, Bart.,* New York, R. H. Russell, 1902.

Clark, Kenneth. *Another Part of the Wood,* New York, Harper & Row, Publishers, 1974.

Cohn, Albert M. *George Cruikshank, A Catalogue Raisonné,* London, "The Bookman's Journal," 1924.

The Collector's Encyclopedia, London, William Collins Sons, 1974.

Cook, Olive. "The Fabric of a Dream," *The Saturday Book,* edited by John Hadfield, London, Hutchinson & Co., Ltd., 1975, pp. 184-201.

Cromey-Hawke, N. "William Morris and Victorian Painted Furniture," *The Connoisseur,* 191, No. 767 (January 1976), pp. 32-43.

Cushion, John P. *Animals in Pottery and Porcelain,* New York, October House Inc., 1966.

Darrell, Margery, ed. *Once Upon a Time, The Fairy-Tale World of Arthur Rackham,* New York, The Viking Press, 1972.

Darton, F. J. Harvey. *Children's Books in England,* Cambridge, Cambridge University Press, 1958.

————. *Modern Book-Illustration in Great Britain & America,* London, The Studio Limited, 1931.

Davidson, Angus and Philip Hofer. *Teapots and Quails and Other New Nonsenses by Edward Lear,* Cambridge, Mass., Harvard University Press, 1953.

de Lisle, Fortunée. *Burne-Jones,* London, Methuen & Co., 1904.

Dennis, Richard. *Catalogue of an Exhibition of Doulton Stoneware and Terracotta 1870-1925,* Part I, exhibition catalogue, London, Richard Dennis, 1971.

————. *Doulton Pottery from the Lambeth and Burslem Studios 1873-1939,* Part II, exhibition catalogue, London, Richard Dennis, 1975.

De Vries, Leonard. *Little Wide-Awake. An Anthology from Victorian Children's Books and Periodicals in the Collection of Anne and Fernand G. Renier,* Cleveland and New York, The World Publishing Company, 1967.

The Dictionary of National Biography, London, Oxford University Press, H. Milford, 1937-1938 and supplements.

Dodgson, Campbell. "Maurice and Edward Detmold," *The Print Collector's Quarterly,* 9 (December 1922), pp. 373-405.

Doyle, Brian. *The Who's Who of Children's Literature,* London, Hugh Evelyn, 1968.

Durant, Stuart. *Victorian Ornamental Design,* London, Academy Editions, 1972.

Easton, Malcolm. *Aubrey and the Dying Lady: A Beardsley Riddle,* Boston, David R. Godine, 1972.

Elzea, Rowland and Betty. *The Pre-Raphaelite Era 1848-1914,* exhibition catalogue, Wilmington, The Wilmington Society of the Fine Arts, 1976.

Engen, Rodney K. *Walter Crane as a Book Illustrator,* London, Academy Editions and New York, St. Martin's Press, 1975.

————. *Randolph Caldecott,* London, Oresko Books Ltd., 1976.

Feaver, William. *The Art of John Martin,* Oxford, Clarendon Press, 1975.

————. *George Cruikshank,* exhibition catalogue, London, Arts Council of Great Britain, 1974.

Fitzgerald, Penelope. *Edward Burne-Jones: A Biography,* London, Michael Joseph, 1975.

Fleming, John and Hugh Honour. *The Penguin Dictionary of Decorative Arts,* London, Allen Lane (Penquin Books Ltd.), 1977.

des Fontaines, Una. "Fairyland Lustre," *Proceedings of the Wedgwood Society,* No. 5 (1963), pp. 43, 45.

————. *Wedgwood Fairyland Lustre. The Work of Daisy Makeig-Jones,* New York, Born-Hawes and London, Sotheby Parke Bernet, 1975.

Fredeman, William E. *Pre-Raphaelitism: A Bibliocritical Study,* Cambridge, Mass., Harvard University Press, 1965.

————, ed. *An Issue Devoted to the Work of William Morris, Victorian Poetry,* 13 (1975).

de Freitas, Leo. *Charles Robinson,* London, Academy Editions and New York, St. Martin's Press, 1976.

Gallatin, A. E. *Aubrey Beardsley, Catalogue of Drawings and Bibliography,* New York, The Grolier Club, 1945.

Gardner, Edward J. *Fairies, The Cottingley Photographs and Their Sequel,* London, The Theosophical Publishing House, Ltd., 1966.

Gardner, Martin. *The Annotated Alice: Alice's Adventures in Wonderland & Through the Looking Glass,* New York, Bramhall House (Clarkson N. Potter, Inc.), 1960.

Gere, Charlotte. *Victorian Jewelry Design,* Chicago, Henry Regnery Company, 1972.

Gettings, Fred. *Arthur Rackham,* New York, Macmillan Publishing Co., Inc., 1975.

Gibson, Frank. *Charles Conder, His Life and Work,* London, John Lane, The Bodley Head, 1914.

Godden, Geoffrey A. *An Illustrated Encyclopedia of British Pottery and Porcelain,* London, Jenkins, 1966.

————. *Jewitt's Ceramic Art of Great Britain, 1800-1900.* London, Barrie & Jenkins, 1972.

————. *Minton Pottery & Porcelain of the First Period 1793-1850,* New York, Frederick A. Praeger, 1968.

Goldyne, Joseph R. *J. M. W. Turner: Works on Paper from American Collections,* exhibition catalogue, Berkeley, California, University Art Museum, 1975.

Gosling, Nigel. *Gustave Doré,* New York and Washington, Praeger Publishers, 1974.

Graves, Algernon. *The Royal Academy of Arts: A Complete Dictionary of Contributors and their work from its foundation in 1769 to 1904,* 4 volumes, Yorkshire, S. R. Publishers Ltd. and Bath, Kingsmead Reprints, 1970.

Greysmith, Brenda. *Wallpaper,* New York, Macmillan Publishing Co., Inc., 1976.

Greysmith, David. *Richard Dadd: The Rock and Castle of Seclusion,* London, Studio Vista, 1973.

Hagger, Reginald G. "Thomas Allen," *Proceedings of the Wedgwood Society,* No. 6 (1966), pp. 61-68.

Hammelmann, Hans and T. S. R. Boase. *Book Illustrators in Eighteenth-century England,* New Haven and London, published for the Paul Mellon Centre for Studies in British Art (London) Ltd. by Yale University Press, 1975.

Hardie, Martin. *English Coloured Books,* Bath, Kingsmead Reprints, 1973.

————. *Water-colour Painting in Britain, III The Victorian Period,* New York, Barnes & Noble, Inc., 1968.

Harrison, Martin and Bill Waters. *Burne-Jones,* London, Barrie and Jenkins 1973.

Haslam, Malcolm. *English Art Pottery 1865-1915,* London, The Antique Collectors' Club, 1975.

Hayward, Helena, ed. *World Furniture,* Secaucus, New Jersey, Chartwell Books Inc., 1976.

Henderson, Philip. *William Morris: His Life, Work and Friends,* New York, McGraw-Hill, 1967.

Hillier, Bevis. *Pottery and Porcelain, England, Europe and North America,* New York, Meredith Press, 1968.

Holland, Vyvyan. "Once Upon a Time . . . ," in *The Complete Fairy Stories of Oscar Wilde,* London, Duckworth, 1971, pp. 193-203.

Holme, Bryan. *The Kate Greenaway Book,* New York, The Viking Press, 1976.

Horne, Alan. *The Art of William Heath Robinson,* exhibition catalogue, Toronto, University of Toronto Library, 1977.

Howarth, Thomas. *Charles Rennie Mackintosh and the Modern Movement,* 2nd edition, London, Routledge & Kegan Paul, 1977.

Hudson, Derek. *Arthur Rackham, His Life and Work,* New York, Charles Scribner's Sons, 1960.

Hürlimann, Bettina. *Three Centuries of Children's Books in Europe,* Cleveland and New York, The World Publishing Company, 1968.

Hyde, H. Montgomery. *Oscar Wilde,* New York, Farrar, Straus and Giroux, 1975.

Jackson, Holbrook, ed. *The Complete Nonsense of Edward Lear,* London, Faber & Faber, 1947.

James, Philip. *Children's Books of Yesterday,* The Studio Special Autumn Number, London, The Studio, Ltd., 1933.

Janson, Dora Jane. *From slave to siren: the Victorian woman and her jewelry from neoclassic to art nouveau,* exhibition catalogue, Durham, North Carolina, Duke University Museum of Art, 1971.

Jervis, Simon. *High Victorian Design,* exhibition catalogue, Ottawa, The National Gallery of Canada, 1974.

Johnson, J. and A. Greutzner. *The Dictionary of British Artists 1880-1940,* Woodbridge, Suffolk, The Antique Collectors' Club, 1976.

Johnstone, Christopher. *John Martin,* London, Academy Editions, 1974.

Jordan, Robert Furneaux. *Victorian Architecture,* Harmondsworth, Penguin Books, 1966.

Jullian, Philippe. *Dreamers of Decadence,* New York, Washington, London, Praeger Publishers, 1971.

Kayser, Wolfgang. *The Grotesque in Art and Literature,* trans. Ulrich Weisstein, New York, McGraw-Hill, 1966.

Kelly, Alison. *The Story of Wedgwood,* New York, The Viking Press, 1975.

King, Jessie M. " 'Seven Happy Days' A Series of Drawings by Jessie M. King with quotations from John Davidson & Others," *The Studio,* New Year's Supplement (January 1914), unpaginated.

King René's Book of Love (Le Cueur d'Amours Espris), Introduction and commentaries by F. Unterkircher, trans. Sophie Wilkins, New York, George Braziller, 1975.

Kloet, Christine A. *After 'Alice',* exhibition catalogue, London, The Library Association and the Victoria and Albert Museum, Museum of Childhood, Bethnal Green, 1977.

Konody, P. G. *The Art of Walter Crane,* London, George Bell & Sons, 1902.

Lambourne, Lionel. "Anthropomorphic Quirks: The Work of Ernest Griset," *Country Life,* 161, No. 4149 (January 6, 1977), pp. 26-28.

———. "Two 'Books Full of Nonsense' and other works by Richard Doyle," *The Burlington Magazine,* 120, No. 902 (May 1978), pp. 290-291, 293.

Landow, George P. *The Aesthetic and Critical Theories of John Ruskin,* Princeton, Princeton University Press, 1971.

Lane, Margaret. *The Magic Years of Beatrix Potter,* London and New York, Frederick Warne, 1978.

Larkin, David, ed. *The Fantastic Creatures of Edward Julius Detmold,* New York, Charles Scribner's Sons, 1976.

———. *The Fantastic Kingdom,* with biographical notes by Margaret Maloney, New York, Ballantine Books, 1974.

Leblanc, Henri. *Catalogue de l'oeuvre complet de Gustav Doré,* Paris, Charles Bosse, 1931.

Lewis, C. S. *Of Other Worlds: Essays and Stories,* ed. Walter Hooper, New York, Harcourt Brace Jovanovich, 1966.

Lewis, John. *Heath Robinson: Artist and Comic Genius,* London, Constable & Co., Ltd., 1973.

———. "The Fantasy World of Sidney Sime," *The Saturday Book,* edited by John Hadfield, London, Hutchinson & Co., Ltd., 1975, pp. 202-215.

Linder, Enid, Leslie Linder and A. C. Moore. *The Art of Beatrix Potter,* London, Frederick Warne & Co., 1972.

Linder, Leslie. *A History of the Writings of Beatrix Potter Including Unpublished Work,* London and New York, Frederick Warne & Co., 1971.

Lindsay, Jack. *William Morris: His Life and Work,* London, Constable, 1975.

Lister, Raymond. *Victorian Narrative Paintings,* London, Museum Press, 1966.

Liverpool, Walker Art Gallery. *Maxwell Gordon Lightfoot,* exhibition catalogue, Liverpool, Walker Art Gallery, 1972.

———. *The Taste of Yesterday,* exhibition catalogue, Liverpool, Walker Art Gallery, 1970.

———. *Victorian Watercolours from the Collection of the Walker Art Gallery,* Liverpool, Walker Art Gallery, 1974.

Locke, George. *From an Ultimate Dim Thule,* London, Ferret Fantasy Ltd., 1973.

———. *The Land of Dreams, S. H. Sime 1905-1916,* London, Ferret Fantasy Ltd., 1975.

London, Anthony d'Offay Fine Art. *Dream and Fantasy in English Painting, 1830-1910,* exhibition catalogue, London, Anthony d'Offay Fine Art, [1967].

London, Arts Council of Great Britain. *Burne-Jones,* exhibition catalogue by John Christian, London, Arts Council of Great Britain, 1975.

———. *French Symbolist Painters,* exhibition catalogue, London, Arts Council of Great Britain, 1972.

London, The Fine Art Society, Ltd. *The Aesthetic Movement and the Cult of Japan,* exhibition catalogue, London, The Fine Art Society, Ltd., 1972.

London, British Museum. *British Museum General Catalogue of Printed Books,* London, The Trustees of the British Museum, 1960- and supplements.

London, The Maas Gallery. *Victorian Fairy Paintings, Drawings, & Water-colours,* exhibition catalogue, London, The Maas Gallery, 1978.

London, The National Book League. *The Linder Collection of the works and drawings of Beatrix Potter,* London, The National Book League and the Trustees of the Linder Collection, 1971.

London, The Royal Academy of Arts. *Victorian and Edwardian Decorative Art, The Handley-Read Collection,* exhibition catalogue, London, The Royal Academy of Arts, 1972.

London, The Tate Gallery. *Henry Fuseli,* exhibition catalogue, London, Tate Gallery Publications Department, 1975.

London, Victoria and Albert Museum. *Aubrey Beardsley,* exhibition catalogue by Brian Reade and Frank Dickinson, London, Victoria and Albert Museum, 1966.

———. *Catalogue of an Exhibition of Victorian & Edwardian Decorative Arts,* exhibition catalogue, London, Her Majesty's Stationery Office, 1952.

———. *Liberty's 1875-1975,* exhibition catalogue, London, Victoria and Albert Museum, 1975.

———. *A Nonsense Alphabet, by Edward Lear,* London, Her Majesty's Stationery Office, 1952.

Maas, Jeremy. *Victorian Painters,* London, Barrie and Rockliff, 1969.

MacCarthy, Fiona. *All Things Bright & Beautiful, Design in Britain 1830 to Today,* Toronto and Buffalo, University of Toronto Press, 1972.

Madan, Falconer, ed. *The Lewis Carroll Centenary in London 1932,* London, Messrs. J. & E. Bumpus, Ltd., 1932.

Mahony, Bertha E. and Elinor Whitney. *Contemporary Illustrators of Children's Books,* Boston, The Bookshop for Boys & Girls, Women's Educational and Industrial Union, 1930.

Mahony, Bertha E., Louise Payson Latimer and Beulah Folmsbee. *Illustrators of Children's Books 1744-1945*, Boston, The Horn Book, Inc., 1947.

Mallalieu, H. L. *The Dictionary of British Watercolour Artists up to 1920*, Woodbridge, Suffolk, The Antique Collectors' Club, 1976.

Mandle, Roger. "A Preparatory Drawing for Henry Fuseli's Painting 'The Shepherd's Dream,' " *Master Drawings*, 11, No. 3 (Autumn 1973), pp. 272-276 and Pl. 28.

Marillier, Henry Currie. *History of the Merton Abbey Tapestry Works founded by William Morris*, London, Constable & Company, 1927.

McLean, Ruari. *Victorian Book Design and Colour Printing*, 2nd edition, Berkeley and Los Angeles, University of California Press, 1972.

Moore, T. Sturge. *Charles Ricketts, R. A.*, London, Cassell & Company Limited, 1933.

Morley, John. *Death, Heaven and the Victorians*, London, Studio Vista, 1971.

Muir, Percy. *English Children's Books 1600 to 1900*, New York, Frederick A. Praeger, 1954.

———. *Victorian Illustrated Books*, New York and Washington, Praeger Publishers, 1971.

Nahum, Peter, ed. *Jessie M. King and E. A. Taylor, Illustrator and Designer*, Edinburgh and London, Paul Harris Publishing Company and Sotheby's Belgravia, 1977.

Needham, Paul, ed. *William Morris and the Art of the Book*, New York, The Pierpont Morgan Library and Oxford University Press, 1976.

New Haven, Conn., Yale University Art Gallery. *Dante Gabriel Rossetti and the Double Work of Art*, exhibition catalogue by Maryan Wynn Ainsworth *et al.*, New Haven, Yale University Art Gallery, 1976.

New York, The Gallery of Modern Art (Including the Huntington Hartford Collection). *Aubrey Beardsley*, exhibition catalogue by Brian Reade, New York, The Gallery of Modern Art, 1967.

New York, The Pierpont Morgan Library. *Early Children's Books and Their Illustration*, New York, The Pierpont Morgan Library and Boston, David R. Godine, 1975.

Noakes, Vivien. *Edward Lear: The Life of a Wanderer*, Boston, Houghton Mifflin, 1968.

Nochlin, Linda. *Realism*, Harmondsworth, Penguin Books, 1971.

Ovenden, Graham, ed., with John Davis. *The Illustrators of Alice in Wonderland and Through the Looking Glass*, London, Academy Editions, 1972.

Oxford, Ashmolean Museum and London, The National Book League. *Drawings by J.R.R. Tolkien*, exhibition catalogue, Oxford and London, published jointly in cooperation with George Allen & Unwin Ltd., 1976.

Patten, Robert L., ed. *George Cruikshank: A Revaluation*, a special issue of *The Princeton University Library Chronicle*, 35 (1973-1974).

Parry, Marian. "Flowers and Gardens in *Queen Anne* Children's Books," *Fenway Court* (Isabella Stewart Gardner Museum), Boston, Trustees of the Isabella Stewart Gardner Museum Incorporated, 1977.

Peppin, Brigid. *Fantasy, The Golden Age of Fantastic Illustration*, New York, Watson-Guptill Publications, 1975.

Phillpotts, Beatrice. "Victorian Fairy Painting," *The Antique Collector*, 49, No. 7 (July 1978), pp. 80-82.

Pinkham, Roger. *Catalogue of Pottery by William De Morgan in the Victoria and Albert Museum*, London, Victoria and Albert Museum, 1973.

Poltarnees, Welleran. *All Mirrors are Magic Mirrors*, La Jolla, California, The Green Tiger Press, 1972.

Providence, Museum of Art, Rhode Island School of Design. *Prints and Drawings with a Classical Reference*, exhibition catalogue, Providence, Museum of Art, Rhode Island School of Design, 1965.

Pullan, Richard Popplewell, ed. *The House of William Burges, A. R. A.*, London, B. T. Batsford, 1886.

Quayle, Eric. *The Collector's Book of Children's Books*, New York, Clarkson N. Potter, Inc., 1971.

Rabkin, Eric S. *The Fantastic in Literature*, Princeton, Princeton University Press, 1976.

The Random House Collector's Encyclopedia, Victoriana to Art Deco, New York, Random House, 1974.

The Random House Encyclopedia of Antiques, New York, Random House, 1973.

Ray, Gordon N. *The Illustrator and the Book in England from 1790 to 1914*, New York, The Pierpont Morgan Library and Oxford University Press, 1976.

Reade, Brian. *Aubrey Beardsley*, Victoria and Albert Museum Large Picture Book No. 32, London, Her Majesty's Stationery Office, 1966.

———. *Aubrey Beardsley*, New York, Bonanza Books, a division of Crown Publishers, Inc., 1967.

Redgrave, Samuel. *A Dictionary of Artists of the English School*, Amsterdam, G. W. Hissink & Co., 1970.

Reid, Forrest. *Illustrators of the Sixties*, London, Faber & Gwyer Limited, 1928.

Reynolds, Graham. *Victorian Painting*, London, Studio Vista, 1966.

Rickett, John. "Rd. Dadd, Bethlem and Broadmoor," *The Ivory Hammer* (Sotheby's), 2 (1964).

Riely, John. *Rowlandson Drawings from the Paul Mellon Collection*, exhibition catalogue, New Haven, Yale Center for British Art, 1977.

Salaman, Malcolm C. *British Book Illustration Yesterday and To-Day*, London, The Studio, Ltd., 1923.

———. *Modern Book Illustrators and Their Work*, London, The Studio, Ltd., 1914.

———. *Shakespeare in Pictorial Art*, London, The Studio, Ltd., 1916.

Schiff, Gert. *Johann Heinrich Füssli, 1741-1825*, 2 volumes, Zürich, Verlag Berichthaus and Munich, Prestel-Verlag, 1973.

Shakespeare, William. *A Midsummer Night's Dream*, with designs by Arthur Rackham and calligraphy by Graily Hewitt, facsimile manuscript, New York, Abaris Books, Inc., 1977.

Skeeters, Paul W. *Sidney H. Sime Master of Fantasy*, Pasadena, California, Ward Ritchie Press, 1978.

Sketchley, R. E. D. *English Book-Illustration of To-day*, London, Kegan Paul, Trench, Trübner and Co., Ltd., 1903.

Slythe, Margaret R. *The Art of Illustration, 1750-1900*, London, The Library Association, 1970.

Sparrow, Walter Shaw. "Some Drawings by Patten Wilson," *The Studio*, 23 (1901), pp. 186-196.

Spencer, Charles, ed. *The Aesthetic Movement 1869-1890,* exhibition catalogue (London, The Camden Arts Centre), London, Academy Editions and New York, St. Martin's Press, 1973.

Spencer, Isobel. *Walter Crane,* New York, Macmillan Publishing Co., Inc., 1975.

Spielmann, M. H. and G. S. Layard. *Kate Greenaway,* London, Adam and Charles Black, 1905.

Stanford, Stanford Art Gallery, Stanford University. *Morris & Co.,* exhibition catalogue by Betsy G. Fryberger *et al.,* Stanford, Department of Art, Stanford University, 1975.

St. Armand, Barton Levi. *The Roots of Horror in the Fiction of H. P. Lovecraft,* Elizabethtown, New York, Dragon Press, 1977.

Stevens, MaryAnne. "Frederick Cayley Robinson," *The Connoisseur,* 196, No. 787 (September 1977), pp. 23-35.

Studio Dictionary of Design & Decoration, New York, The Viking Press, 1973.

The Studio Year-Book of Decorative Art, London, The Studio, 1914, pp. 7-8, 60-61.

The Studio Year-Book of Decorative Art, London, The Studio, 1917, p. 79.

Surtees, Virginia. *The Paintings and Drawings of Dante Gabriel Rossetti (1828-1882): A Catalogue Raisonné,* 2 volumes, Oxford, Clarendon Press, 1971.

Swain, Robert. *A History of Children's Book Illustrations 1750-1940,* exhibition catalogue, Stratford, Ontario, The Gallery/Stratford, 1978.

Symonds, Robert Wemyss and Bruce Blundell Whineray. *Victorian Furniture,* London, Country Life, 1962.

Tattersall, Bruce. "Victorian Wedgwood," *The Antique Collector,* 45, No. 3 (May 1974), pp. 67-72.

Taylor, John Russell. *The Art Nouveau Book in Britain,* London, Methuen & Co. Ltd., 1966.

"Textiles in Detroit," *The Magazine Antiques,* 114, No. 3 (September 1978), p. 392.

Thompson, Paul. *The Work of William Morris,* London, Heinemann, 1967.

Thorpe, James. *English Illustration: The Nineties,* New York, Hacker Art Books, 1975.

Toronto, Canadian National Exhibition. *Catalogue of Paintings and Sculpture by British, Spanish and Canadian Artists and International Graphic Art,* Toronto, 1922.

Treble, Rosemary. *Great Victorian Pictures,* exhibition catalogue, London, Arts Council of Great Britain, 1978.

Vallance, Aymer. "Some examples of tapestry designed by Sir. E. Burne-Jones and Mr. J. H. Dearle," *The Studio,* 36, No. 141 (November 1908), pp. 13-24.

Verneuil, M. P.-. "Alexandre Fisher," *Art et Décoration,* 22 (1907), pp. 81-86.

Vogler, Richard. *George Cruikshank: Printmaker (1792-1878),* exhibition catalogue, Santa Barbara, California, Santa Barbara Museum of Art, 1978.

Wakefield, Hugh. *Victorian Pottery,* London, Herbert Jenkins, 1962.

Walthamstow, William Morris Gallery. *Catalogue of the Morris Collection,* London Borough of Waltham Forest, William Morris Gallery, 1969.

Walton, Paul H. *The Drawings of John Ruskin,* Oxford, Clarendon Press, 1972.

Wark, Robert R. "English Fantasy Drawing," *Calendar,* San Marino, California, Huntington Library, Art Gallery, Botanical Gardens (November 1976), pp. 1-2.

Waters, Grant M. *Dictionary of British Artists working 1900-1950,* Eastbourne, Eastbourne Fine Art, 1975.

Watkinson, Raymond. *Pre-Raphaelite Art and Design,* Greenwich, Conn., New York Graphic Society Ltd., 1970.

Weibel, Adele C. "The Passing of Venus," *Bulletin of the Detroit Institute of Arts,* 8, No. 7 (April 1927), pp. 78-80.

Weintraub, Stanley. *Beardsley, A Biography,* New York, George Braziller, 1967.

Whalley, Joyce Irene. *Cobwebs to Catch Flies, Illustrated Books for the Nursery and Schoolroom 1700-1900,* London, Elek Books Ltd., 1974.

White, Colin. *Edmund Dulac,* New York, Charles Scribner's Sons, 1976.

Whitley, W. T. "The National Competition of Schools of Art, 1910, at South Kensington," *The Studio,* 50 (1910), pp. 294-304.

Wilmington, Delaware, The Wilmington Society of the Fine Arts. *The Samuel and Mary R. Bancroft English Pre-Raphaelite Collection,* Wilmington, The Wilmington Society of the Fine Arts, 1962.

Wood, Christopher. *Dictionary of Victorian Painters,* Woodbridge, Suffolk, The Antique Collectors' Club, 1971.

Zimmerman, Eva. "Der Pilger im Garten oder Das Herz der Rose," *Jahrbuch der Staatlichen Kunstsammlungen in Baden-Württemberg,* 10 (1973), pp. 212-214.

THE END.

7000 copies of this catalogue
designed by Malcolm Grear Designers
typeset by Dumar Typesetting, Inc.
have been printed by Eastern Press, Inc.
in March 1979
on the occasion of the exhibition
Fantastic Illustration and Design in Britain, 1850 - 1930